THE NEW POLI
THE HANDMAI

THE NEW POLITICS OF THE HANDMADE

Craft, Art and Design

**Edited by
Anthea Black and
Nicole Burisch**

BLOOMSBURY VISUAL ARTS
LONDON • NEW YORK • OXFORD • NEW DELHI • SYDNEY

BLOOMSBURY VISUAL ARTS
Bloomsbury Publishing Plc
50 Bedford Square, London, WC1B 3DP, UK
1385 Broadway, New York, NY 10018, USA
29 Earlsfort Terrace, Dublin 2, Ireland

BLOOMSBURY, BLOOMSBURY VISUAL ARTS and the Diana logo are trademarks of
Bloomsbury Publishing Plc

First published in Great Britain 2021
Reprinted 2021 (twice)

Cover design by Louise Dugdale
Cover image: Shinique Smith, *Bale Variant No. 0021* (*Christmas*), 2011–2017, courtesy of the
artist and SAS Studio

A catalogue record for this book is available from the British Library.

Library of Congress Cataloging-in-Publication Data
Names: Black, Anthea, editor. | Burisch, Nicole, 1980– editor.
Title: The new politics of the handmade: craft, art and design /
edited by Anthea Black and Nicole Burisch.
Description: London; New York : Bloomsbury Visual Arts, 2020. |
Includes bibliographical references and index.
Identifiers: LCCN 2020011227 (print) | LCCN 2020011228 (ebook) |
ISBN 9781784538248 (paperback) | ISBN 9781788316552 (hardback) |
ISBN 9781788316569 (epub) | ISBN 9781788316576 (pdf)
Subjects: LCSH: Handicraft–Political aspects. | Handicraft–Economic aspects.
Classification: LCC TT145 .N49 2020 (print) | LCC TT145 (ebook) | DDC 745.5–dc23
LC record available at https://lccn.loc.gov/2020011227
LC ebook record available at https://lccn.loc.gov/2020011228

ISBN: HB: 978-1-7883-1655-2
PB: 978-1-7845-3824-8
ePDF: 978-1-7883-1657-6
ePub: 978-1-7883-1656-9

Typeset by Newgen KnowledgeWorks Pvt. Ltd., Chennai, India
Printed and bound in India

To find out more about our authors and books visit www.bloomsbury.com
and sign up for our newsletters

Research for this book was supported by Ontario Arts Council – Conseil des Arts de L'Ontario,
Canada Council for the Arts – Conseil des arts du Canada, and The Center for Craft.

CONTENTS

ILLUSTRATIONS

All images courtesy of the artist or designer unless otherwise noted. Every effort has been made by the authors and editors to obtain copyright permissions for all the illustrations which appear in this book. If any proper acknowledgement has not been made, copyright holders are invited to inform the publisher of the oversight.

ACKNOWLEDGEMENTS

The editors would like to express their appreciation to the contributors included in *The New Politics of the Handmade: Craft, Art and Design* for their hard work and exciting scholarship. Thank you to the artists, galleries and institutions that granted permission for the reproduction of artworks. We are grateful to our many colleagues who have long encouraged and inspired our efforts, particularly Sandra Alfoldy (1969–2019), Maria Elena Buszek, Amy Gogarty, Jamelie Hassan, Leopold Kowolik, Judith Leemann, Elaine Cheasley Paterson, Mireille Perron, Kirsty Robertson, Jennifer Salahub, Erik Scollon, Diana Sherlock, Shannon R. Stratton, Kelly Thompson, Laura Vickerson, and Namita Gupta Wiggers, and to Pablo Rodriguez and Caitlynn Fairbarns who provided essential editing and image permission support. Thank you to our many colleagues and students at the Core Program/Museum of Fine Arts, Houston, The National Gallery of Canada, OCAD University and California College of the Arts.

We are grateful to our original editor Philippa Brewster at I.B. Tauris for her enthusiasm for the project, offering to publish this volume just days after seeing us present at *Subversive Stitch Revisited* at the Victoria & Albert Museum, and to our editors at Bloomsbury for carrying the project to completion. We remain inspired and thankful to the *Subversive Stitch Revisited* conference organizers, as well as Lisa Vinebaum, Ruth Scheuing, Ingrid Bachmann, Janna Hiemstra, Kathleen Morris and Lynne Heller for their invitations to present at the Textile Society of America Symposium 2012 and Craft Ontario's *Crafting Sustainability* conference.

The editors both wish to acknowledge generous research support from the Canada Council for the Arts Grants to Critics and Curators program; Lisa Whorle and the Ontario Arts Council Craft Connections program; and the Center for Craft Research Fund. We appreciate their commitments to recognize the academic and artistic labour of all the writers and artists who contributed to this project.

Finally, the contributors each thank the many colleagues, institutions, conferences and publications that supported their research. Heather Anderson acknowledges the OAC's Craft Projects: Research and Development program and Carleton University Art Gallery. Anthea Black acknowledges the Vermont Studio Center grants to artists and writers' program, and Janice Black Stewart and Murray

Stewart (1949–2018). Noni Brynjolson received support from the Social Sciences and Humanities Research Council and the Manitoba Arts Council. Nicole Burisch extends her thanks to her family and friends, especially Heather Davis, Mikhel Proulx and Olya Zarapina, as well as the support of residencies at Artexte and Est-Nord-Est. Elke Gaugele wishes to thank the Clean Clothes Campaign, Austria and ITC Ethical Fashion Initiative, Geneva. Blanca Serrano Ortiz de Solórzano is grateful to Ernesto Oroza, as well as Francis Acea, Diango Hernández, René Francisco Rodríguez and Los Carpinteros. Diana Sherlock thanks Peter Boyd, David Bynoe, Andrew Calvo, Hayley Erza, Kerry Harmer, Shannon and Marie Hoover, Byron Hynes, Wolf Jeschonnek, Janet Mader, Rene Martin, Steven Pilz and Krišjānis Rijnieks. Ellyn Walker would like to acknowledge the work of all authors, artists and communities her text engages with – for, without their work, her own work would not be possible. She wishes to recognize the generous support, collaboration and feminist dialogue offered by Anthea Black and Nicole Burisch in shaping this text. Ellyn also gives thanks to her family, Dot Tuer, and the Hemispheric Institute of Performance and Politics whose 2013 residency in Chiapas, Mexico, enabled her the opportunity to do unique fieldwork related to this research.

The Editors would also like to acknowledge the groundbreaking work of Canadian craft scholar and historian Sandra Alfoldy (1969–2019), whose career and dedication to the field was an inspiration to all of us. Alfoldy's unpublished manuscript *Craftwashing: The Uses and Abuses of Craft in Popular Culture* was unfinished at the time of her tragic passing, and would have been a significant contribution to contemporary craft studies and an important complement to the ideas explored in this publication.

Thank you to Janice Helland for her support in citing Sandra's research. Please see: Janice Helland, 'Sandra Alfoldy (August 1, 1969–February 24, 2019): a Reflection,' *The Journal of Modern Craft*, 12:2 (2019), 141–5.

CONTRIBUTORS

Heather Anderson is Curator at the Carleton University Art Gallery, where she integrates an artist-centred approach to research within a university environment. Her exhibitions include *Making Otherwise: Craft and Material Fluency in Contemporary Art* (2014), *Linda Sormin: Fierce Passengers* (2018) and *Re: Working Together/Re: Travailler ensemble* (2019). Combining her art school training (BFA, Emily Carr Institute of Art and Design, 1998) with an interdisciplinary MA in women's studies (with a thesis on feminist performance art from Dalhousie University and Nova Scotia College of Art and Design in Canada, 2003) and curatorial training (École du Magasin International Curatorial Training Program, 2004–5), along with experience as Assistant Curator in Contemporary Art and Modern Canadian Art at the National Gallery of Canada (2006–12), Heather seeks to engage the social, political and emotional complexities of experiences through aesthetic encounters across a range of media and approaches.

Laura August, PhD, is a writer and curator based in Guatemala City and Houston, Texas. Her writing has been published in various international journals, artist monographs and exhibition catalogues. August is a recipient of the Creative Capital | Andy Warhol Foundation Arts Writers Grant for her writing about Central America, and she served as Critic-in-Residence at the Core Program at the Museum of Fine Arts, Houston, from 2016 to 2018. In 2018, August co-curated the Paiz Biennial, and her curatorial projects have included work at artist-run spaces, galleries, museums and universities in the United States and Central America. She is founding director of Yvonne, a residential project space in Guatemala City that has hosted artists, writers, and anthropologists whose work is embedded in that place. August is currently at work on a book-length essay about mud, corn and historical violence in the Americas.

Alexis Anais Avedisian is a researcher invested in topics such as social media theory, surveillance capitalism and internet art. After finishing graduate school at New York University Steinhardt, she began working as communications manager for the NYC Media Lab, a consortium of technology and digital studies programs

at universities including NYU, Columbia and the New School. She holds an MA from NYU Steinhardt.

Anthea Black is a Canadian artist, writer and cultural worker based in Oakland and Toronto. Her studio work has been exhibited in Canada, the United States, the Netherlands, France and Norway and her writing has been published in *Making Otherwise: Craft and Material Fluency in Contemporary Art*, *Bordercrossings*, *No More Potlucks* and *FUSE Magazine*; and with Nicole Burisch in *The Craft Reader* (2010) and *Extra/ordinary: Craft and Contemporary Art* (2011). She is co-editor of *HANDBOOK: Supporting Queer and Trans Students in Art and Design Education* with Shamina Chherawala, designer and co-publisher of *The HIV Howler: Transmitting Art and Activism* with Jessica Whitbread, and curator of *Super String*, *Pleasure Craft*, and *No Place: Queer Geographies on Screen*. She was faculty at OCAD University from 2012 to 2017 and is an Assistant Professor of Printmedia and Graduate Fine Arts at the California College of the Arts.

Julia Bryan-Wilson is the Doris and Clarence Professor of Modern and Contemporary Art at the University of California, Berkeley. She is the author of *Fray: Art and Textile Politics* (2017), which won the Association for the Study of the Arts of the Present Book Prize, the Frank Mather Jewett Award and the Robert Motherwell Book Award. She co-curated the exhibition *Cecilia Vicuña: About to Happen*, and in 2019 was appointed adjunct curator of contemporary art at the Museu de Arte de São Paulo, Brazil.

Noni Brynjolson, PhD, researches socially engaged art practices in US cities that respond to uneven urban development through experimental forms of community building. She is interested in looking at how artists address the politics of housing and gentrification, as well as the informal practices that emerge within these projects. Noni is a member of the editorial collective of *FIELD: A Journal of Socially Engaged Art Criticism*, and her writing has been published in *FIELD* as well as in *Hyperallergic*, *Akimbo*, *Geist* and *Craft Journal*. She is Assistant Professor of Art History at the University of Indianapolis.

Nicole Burisch is a Canadian critic and curator. Her research with Anthea Black is included in *The Craft Reader* (2010) and *Extra/ordinary: Craft and Contemporary Art* (2011). Her writing has appeared in periodicals *No More Potlucks*, *FUSE Magazine*, *dpi: Feminist Journal of Art and Digital Culture*, *Textile: The Journal of Cloth and Culture*, *Cahiers métiers d'art-Craft Journal* and in numerous exhibition catalogues. Burisch was a 2014–2016 Core Fellow Critic-in-Residence with the Museum of Fine Arts, Houston, and is Assistant Curator, Contemporary Art at the National Gallery of Canada.

Sonya Clark is a Professor of Art at Amherst College in Massachusetts. From 2006 to 2017, she served as Chair of the Craft and Material Studies Department at Virginia Commonwealth University and received the university's highest award, the Commonwealth Professorship. Clark has exhibited in over 350 museums and galleries worldwide, and her work is in the permanent collections of the Museum of Fine Arts Boston, Philadelphia Museum of Art, National Museum of Women in the Arts, Indianapolis Museum of Art and Virginia Museum of Fine Art, among others. She is the recipient of numerous awards, including a Pollock-Krasner Grant, the Grand Juror's Award at Art Prize for the *Hair Craft Project*, a Smithsonian Artist Research Fellowship, a Rockefeller Foundation Fellowship, a Civitella Ranieri Fellowship, an American Academy in Rome Affiliated Fellowship, an Anonymous Was a Woman Award, a United States Artist Fellowship and Black Rock Senegal Residency.

Wesley Clark was born in Washington, DC, and currently resides in Hyattsville, MD. He received his BFA in painting from Syracuse University and MFA from the George Washington University where he was awarded the Morris Lewis Fellowship. Clark's works can be found in permanent collections such as the Asheville Art Museum in North Carolina and the Studio Museum in Harlem. He's been commissioned by the American Alliance of Museums to create a temporary public artwork which has led to several public artworks in the Washington, DC, area. Clark infuses social and political criticisms into his mixed media wood assemblages, merging the historical with the contemporary, to speak on issues faced by Blacks in America. As part of Clark's practice, he regularly mentors young artists and apprentices, providing the hands-on experience of a professional art practice and entrepreneurship as an owner of an art installation company.

Peggy Deamer is Professor Emeritus of Architecture at Yale University. She is a principal in the firm of Deamer Studio and formerly, Deamer + Phillips, Architects. She received a BArch. from Cooper Union and a PhD from Princeton University. Articles by Deamer have appeared in *Assemblage, Praxis, Log, Perspecta* and *Harvard Design Magazine*. She is the editor of *The Millennium House* (2004); *Architecture and Capitalism: 1845 to the Present* (2014); and *The Architect as Worker: Immaterial Labor, the Creative Class, and the Politics of Design* (2015). She is co-editor of *Building in the Future: Recasting Architectural Labor* (2010) and *Re-Reading Perspecta* (2004). She is the founding member of the Architecture Lobby, a group advocating for the value of architectural design and labour. Her current research explores the relationship between subjectivity, design and labour in the current economy.

Elke Gaugele, PhD, is a writer, curator and Professor of Fashion and Styles at the Academy of Fine Arts Vienna and Chair of a design studio program at the Institute

for Education in the Arts. She has held positions at the University of Cologne, Goldsmiths University and as the Maria-Goeppert Mayer Guest Professor in Lower Saxony. Her recent work as international researcher, lecturer and author focuses on the epistemologies of fashion and design, on gender, biopolitics and aesthetic politics, on postcolonial approaches in fashion and design studies. She is the co-editor of *Craftista! Handarbeit als Aktivismus* (2011), *The Aesthetic Politics of Fashion* (2014), and *Fashion and Postcolonial Critique* (2019).

Nasrin Himada is a Palestinian writer, curator and editor from Tio'tia:ke (Montréal), in Kanien'kehá:ka territory. Nasrin's writing has appeared in *Canadian Art*, *C Magazine*, *Critical Signals* and *The Funambulist*, among others. Most recently, Nasrin co-curated a time-based, video art exhibition entitled *deep-time construction* at the CCA Wattis Institute for Contemporary Arts. Other recent projects include *For Many Returns*, a series designed and developed as a way to explore the possibilities of art writing as a kind of performative gesture. Since its debut at Dazibao in Montréal, it has toured across Canada, the United States and Europe. Nasrin has been the co-editor of several contemporary arts magazines and journals, including the online platform *Contemptorary*.

Anna Khachiyan is a writer living in New York. She writes about architecture and technology as means of exploring the psychology of neoliberalism. Her work has appeared in *Artwrit*, *Art in America*, *Hopes&Fears* and *Metropolis*. Anna has a master's degree in Art History from the Institute of Fine Arts, New York University.

Leopold Kowolik has degrees in History and Art History from the University of Chicago and the University of Edinburgh. He has worked in public and private galleries in the United States, the UK and Canada and from 2011 to 2019, he was the Editor in Chief of *Studio Magazine*. Kowolik has written for *The Journal of Modern Craft*, *Craft Research*, *The Journal of William Morris Studies* and *Ornamentum*. He teaches histories and theories of art, design and craft at Sheridan College, Ontario, and is currently working on a PhD in the program of Social and Political Thought at York University in Toronto, Canada.

Bibiana Obler is Associate Professor of Art History at George Washington University. Her book, *Intimate Collaborations: Kandinsky and Münter, Arp and Taeuber* (2014), investigates the role of artist couples in the emergence of abstract art. Her second monograph, tentatively entitled *Anti-Craft*, examines relations between art and craft in the late twentieth century. Obler recently made her first foray into curating; with Phyllis Rosenzweig, she co-curated *Fast Fashion / Slow Art* and co-edited the accompanying catalogue (2019). Organized for the Bowdoin College Museum of Art, Brunswick, Maine, the exhibition opened first at the Corcoran School of the Arts & Design, Washington, DC.

Kirsty Robertson is an Associate Professor of Contemporary Art and Museum Studies at Western University, Canada. Her research focuses on activism, visual culture and changing economies. She has published widely on these topics, including the recent book *Tear Gas Epiphanies: Protest, Museums, Culture* (2019). Since 2008, she has worked on textiles, the textile industry and textile-based arts, writing about textiles and technology, craftivism and petrotextiles. Robertson has an ongoing interest in critical museum studies and is starting a project focused on small-scale collections that work against traditional museum formats. Her co-edited volumes *Imagining Resistance: Visual Culture, and Activism in Canada* and *Negotiations in a Vacant Lot* were released in 2011 and 2014, and her tri-authored volume *Putting IP in Its Place: Rights Discourse, Creativity and the Everyday* was published in 2013.

Mary Savig is the Lloyd Herman Curator of Craft at the Smithsonian American Art Museum's Renwick Gallery. She was previously Curator of Manuscripts at the Archives of American Art, where she curated *What Is Feminist Art?* as part of the Smithsonian American Women History Initiative and *Ephemeral and Eternal: The Archive of Lenore Tawney* as part of the *Mirror of the Universe* exhibitions series at the John Michael Kohler Arts Center. She is author of *Pen to Paper: Artist's Handwritten Letters from the Smithsonian's Archives of American Art* (2016*), Handmade Holiday Cards from 20th Century Artists* (2011), and *Artful Cats: Discoveries from the Archives of American Art* (2019). She holds an MA in art history from the George Washington University and a PhD in American Studies from the University of Maryland, College Park.

Dr Joyce J. Scott, MacArthur Fellow, is best known for her figurative sculpture and jewellery using bead weaving techniques, as well as blown glass and found objects. She earned her BFA from the Maryland Institute College of Art, her MFA from the Instituto Allende in Mexico, and was conferred honorary doctorates from MICA and California College of the Arts. As an African American, feminist artist, Scott unapologetically confronts diverse and difficult themes as her subjects, which include race, misogyny, sexuality, stereotypes, gender inequality, economic disparity, history, politics, rape and discrimination. Scott's work is included in many important private and public museum collections worldwide, and she has been the recipient of countless commissions, grants, awards, and prestigious honours from institutions including the National Endowment for the Arts, the Louis Comfort Tiffany Foundation, Anonymous Was a Woman, American Craft Council, National Living Treasure Award, Lifetime Achievement Award from the Women's Caucus for the Arts, Mary Sawyers Imboden Baker Award, New York University Fellowship and the Smithsonian Visionary Artist Award.

Blanca Serrano Ortiz de Solórzano is Project Director at the Institute for Studies on Latin American Art (ISLAA). She is an art historian specializing in modern and contemporary art from Latin America and the Caribbean, and her current research focuses on discourses of intellectual and manual labour in Cuban art. Blanca received her PhD from the Institute of Fine Arts, New York University. Her most recent work as an independent curator includes the 2017 exhibition *Bitter Bites: Tracing the Fruit Market in the Global South* at Cuchifritos Gallery in New York.

Diana Sherlock is a Canadian independent curator, writer and educator. Current curatorial projects include *Mary Shannon Will: People, Places and Things* (Nickle Galleries, Calgary), co-authored curatorial assessments for the City of Calgary and City of Edmonton public art collections, and the development of an art strategy for the Calgary Cancer Center with CMCK Public Art. Recent projects include: *New Maps of Paradise* (2016) with Eric Moschopedis and Mia Rushton (Nickle Galleries, Calgary); and *In the making* (2014–15) (Illingworth Kerr Gallery, Calgary and Kenderdine College Art Galleries, Saskatoon). Sherlock has published over 80 texts in gallery catalogues and contemporary art journals internationally. She is the volume editor for *Rita McKeough: Works*, a monograph on this Canadian artist's performances and installations. Sherlock is currently developing a mid-career monograph about the work of Vancouver-born, Berlin-based artist Larissa Fassler. Sherlock teaches at the Alberta University of the Arts in Calgary.

Shannon R. Stratton works in contemporary art and craft – curating, writing, teaching and building frameworks and platforms for cultural production and presentation. She co-founded and was the executive director of Threewalls, an artist-focused, Chicago-based non-profit from 2003 to 2015. With Threewalls she launched *PHONEBOOK* with Green Lantern Press, and the Hand-in-Glove Conference for grass-roots arts organizing, which lead to the founding of Commonfield. Her other projects include: *Fearful Symmetries*, the first retrospective of the work of Faith Wilding and *Gestures of Resistance: Craft, Performance, and the Politics of Slowness* with Judith Leemann (Museum of Contemporary Craft, Portland, Oregon, 2010). From 2015 to 2019 she was the Chief Curator at the Museum of Arts and Design, New York. She is currently Executive Director of Ox-Bow School of Art and Artists' Residency in Saugatuck, Michigan.

Ellyn Walker is a visual culture scholar and contemporary arts curator based in Toronto. Her work explores the politics of cultural production, representation and inclusion in the arts, and within visual culture more broadly. Collectively, her work is informed by Black feminist thought, Indigenous epistemologies, anti-colonial practices, critical settler studies and anti-racist methodologies; and draws

upon intersectional approaches and interdisciplinary frameworks. Ellyn's writing has been widely published, in the *Journal of Curatorial Studies*; *Public Journal: Art, Culture, Ideas*; *Prefix Photo Magazine*; and *Inuit Art Quarterly*. She contributed original book chapters to the recent anthologies *Desire Change: Contemporary Feminist Art in Canada* (2017) and *Sonny Assu: A Selective History* (2018). Ellyn is currently a PhD candidate in the Cultural Studies Program at Queen's University.

Namita Gupta Wiggers is a writer, curator and educator based in Portland, OR. Wiggers serves as the Director of the MA in Critical Craft Studies, Warren Wilson College, NC, the first and only low-residency graduate program focused on craft histories and theory. She is the Director and Co-Founder of Critical Craft Forum, an online platform for dialogue and exchange. From 2004 to 2012, Wiggers served as Curator, and later as Director and Chief Curator (2012–14) at the Museum of Contemporary Craft, incorporated into the Center for Art & Culture, Pacific Northwest College of Art since 2016. She serves on the board of trustees of Haystack Mountain School of Crafts, and on the editorial boards of *Garland* magazine and Norwegian Crafts. Wiggers served as the Exhibition Reviews Editor for *The Journal of Modern Craft* (2014–18). She is the editor of the forthcoming *Companion on Contemporary Craft* and collaborates with Benjamin Lignel on an ongoing research project on gender and jewellery.

INTRODUCTION

Anthea Black and Nicole Burisch

The New Politics of the Handmade: Craft, Art and Design takes on contemporary craft as a sphere of political action and debate. It responds to the last two decades of craft activism, which leveraged the aesthetics and values of handmaking to convey messages of political agency and optimism, collective organizing and anti-capitalist and antiglobalization critique. We begin with the premise that the increased circulation of craft, art and design within current economic, environmental and social contexts demands new modes of craft criticism and scholarship. Our aim is to use this book to have deeper conversations on the stakes for politicized making and thinking about craft, as it is intertwined with art, design and the flows of production-consumption in a transnational and global context.

To this end, we have assembled a group of authors and artists who are critically rethinking the role of the handmade across thirty years of artistic production, from the early 1990s to the present. This span of time is concurrent with the rise of neoliberal capitalism and a fundamental shift in the way we consume, communicate, live and work. As the demands on our labour, time and bodies have become increasingly shaped by the 'absoluteness of availability'[1] under late capitalism, so too has the role of craft in day-to-day life transformed. Craft in a global context is now mobile, flexible, available on-demand, highly desirable and ready-to-use. Craft is a meaningful shorthand, a sign, a symbol, a representational system that flows across multiple sites of knowledge and cultural production. Craft is found not only in materials and objects, nor simply in the processes or actions of making, but also in the qualities and experiences of the handmade as it conveys and challenges emotive, cultural, political or economic values. This publication also acknowledges and builds upon craft theory as a field of inquiry that is intimately tied to materiality, and to the making and use of objects. This makes craft particularly well-suited to addressing topics of labour and economics and leads us to read craft not only through aesthetic or cultural frameworks, but to insist that it is embedded within broader social and economic structures.

This brief introduction presents the texts in this volume, suggesting links between them and providing prompts for how they might be read together. Some of the authors in this book examine the links between material practices, progressive politics and social change; and they advocate for the ongoing potential for craft to address and creatively respond to pressing social and political issues. Others take a more critical stance to ask how craft might be reflective of, or even complicit in, aspects of late capitalism such as overconsumption, precarious labour, austerity measures and hyper-individualism. By bringing these texts together, our intention is to continue troubling the idea that craft is definitively aligned with any particular ideology or political philosophy. Rather, we build upon recent scholarship that advocates for craft as the basis for critical inquiry,[2] entwined 'in the fray' of amateur and professional ways of making,[3] 'the ultimate service discipline, [with] its utopian and communal values both politically alluring and easily appropriated',[4] 'a methodology'[5] for reading and understanding other fields of practice or 'vulnerable to manipulation and capable of being manipulative'.[6] Craft theory and practice are not *inherently* progressive, but through closer readings, we can examine objects as intricate knots of political meaning and subjectivity that are shaped by many (often opposing, or contradictory) forces. Our contributors thus draw from design, art, museum studies, fashion, architecture and critical race and post/decolonial theories, to build on craft discourse and the politics of making. This book is indebted to the scholarship of Elissa Auther, Julia Bryan-Wilson, Maria Elena Buszek, Namita Gupta Wiggers, Judith Leemann, Kirsty Robertson and Shannon R. Stratton, and many others whose ongoing work on craftivism and craft politics has shaped our own thinking about these fields as responsive, intersectional, dense and always ripe for criticism.

Our contribution, 'From craftivism to craftwashing' (Chapter 1), directly follows this introduction in presenting the themes that guide *The New Politics of the Handmade*. In it, we update our text 'Craft Hard Die Free: Radical Curatorial Strategies for Craftivism'[7] to look closer at the emergence of craftivism and indie craft through the early 2000s and trace how these 'movements' became aligned with radical politics and revolution. Focusing on the recent marketing and consumption of craft in contemporary art, craft fairs, museums and advertising, we critically examine how craft now functions as a sign of good affect and moral purity. We use the term *craftwashing* to describe the use of craft as a marketing ploy that performs political and social engagement while obscuring ethical, environmental and labour issues in the chain of production.

The reach of craftwashing is further addressed by Elke Gaugele in 'Ethical fashion, craft and the new spirit of global capitalism' (Chapter 2), which traces the 'ethical turn' in fashion through UN global governance strategies, non-governmental organizations and sustainable fashion initiatives. Gaugele applies work by sociologists Luc Boltanski and Eve Chiapello on the 'spirit' of capitalism, and postcolonial theorist Gayatri Chakravorty Spivak on human rights cultures to

critique marketing claims and charitable initiatives - from Vivienne Westwood's *Ethical Fashion Africa Collection*, to those of 'fast-fashion' companies like H&M. Gaugele shows how these campaigns link fashion and aid to perpetuate a form of 'cultural colonialism', where luxury fashion labels capitalize on the aesthetic and moral associations of the 'authentically' handmade.

Just as the global fashion industry's initiatives use craft as a development tool, artists, museums, curators and educational departments have recognized the potential of craft (and especially craft*ing*) for public programming initiatives, interactive exhibitions, performances and urban redevelopment. Often, these kinds of programs emphasize craft's accessibility, teachability and usefulness as a tool or prop for collaborative actions or projects.[8] The demand for craft-as-social-practice to 'gently' drive social justice initiatives relates to broader moves within museums that include 'social media, funding imperatives, and the pressure to attract younger and more diverse audiences'.[9] Amid this shift to social and experiential forms of culture-making, the value of craft has moved beyond objects and towards the actions of makers and the exchange of economic and social capital.[10]

In the first of six artist profiles, 'Selven O'Keef Jarmon: Beading across geographies' (Chapter 3), Nicole Burisch writes about artist Selven O'Keef Jarmon and his collaboration with South African beaders to create a large-scale public artwork in Houston, Texas. Linking this project to other relational and social craft projects, Burisch frames beading as a cross-cultural and temporal practice to examine how so-called traditional craft practices and materials circulate within a globalized contemporary (art) economy. Her writing highlights our aim for all the texts in *The New Politics of the Handmade* to chart the circulation of materials and techniques across broad geopolitical spaces and histories, while also urging for careful attention to local contexts.

Noni Brynjolson's 'The making of many hands: Artisanal production and neighborhood redevelopment in contemporary socially engaged art' (Chapter 4), considers the tensions between community engagement and economic redevelopment in artist-initiated projects Soul Manufacturing Corporation by Theaster Gates, and Project Row Houses and Trans.lation by Rick Lowe. She focuses on large-scale community works as spaces of self-determination for local residents, particularly in Black, Latinx and immigrant neighbourhoods. Brynjolson also negotiates the economic and social impacts of neighbourhood gentrification and tourism, which are accelerated as social capital accrues around artist-community projects, and engages larger conversations on the relationships between art and activism.

Shannon R. Stratton offers an experiential report on lifestyle crafting in North America in 'That looks like work: The total aesthetics of handcraft' (Chapter 5). She traverses between the takeout-food counter in Chicago, Half Cut Tea's romantic YouTube artist profiles and the highly aestheticized rural retreat of artist J. Morgan Puett's *Mildred's Lane* project. Stratton identifies a new circulatory

regime of curated lifestyle imagery that draws from and overlaps with craft and contemporary art practices, and examines how 'narrated handcraftedness' signals and exaggerates the political power of the consumer. The products and projects Stratton describes channel qualities of slowness, authenticity, sensibility, passion and ultimately, a desire for unalienated labour made visible through skill or its representations.

In Chapter 6, 'Craft as property as liberalism as problem', Leopold Kowolik evokes craft as a bourgeois character, somewhat unaware of its own pretensions as it perpetuates a philosophical lineage and economic position that is not critical of neoliberal capitalism nor counter to it, but rendered from the same beginnings. Kowolik charges that craft theorists and makers often rely on inherited misreadings of John Locke's ideas of liberalism and property without questioning their political roots. Tracing this history, he cautions against casual understandings of personal property and the individual 'right to create', just as his text clears the space for new formations and critical positions for craft in relation to capital.

In the second artist profile, 'Zahner Metals: architectural fabrication and craft labour' (Chapter 7), Peggy Deamer considers how new technologies influence architectural fabrication, by focusing on the skilled workers who manufactured copper cladding for architects Herzog and de Meuron's DeYoung Museum in San Francisco. She proposes that acknowledging craft, digital skill and the collaboration between architect-fabricator can refocus the field towards a more ethical understanding of labour that also reconciles historic craft/design divides. Deamer's text adds to global dialogues on exploitative labour within art and architecture, such as those of The Architecture Lobby's stance for a more socially responsible field,[11] or GULF Labor's advocacy for the migrant workers building the Guggenheim's international franchises.[12]

In 'Capitalizing on community: The makerspace phenomenon' (Chapter 8), Diana Sherlock considers the rise of makerspaces, through case studies including small grassroots collectives and large corporate-driven models in Calgary, San Francisco and Berlin. She describes how these spaces leverage social, intellectual and financial capital, thus reshaping public and private economic models for accessing resources for making. Sherlock is critical of the maker movement's 'optimistic rhetoric' of individual creativity and shared space, and of the true cost-benefit to creative communities. She argues that such social-entrepreneurial and micro-economic models can accelerate capitalism's reach and negative effects. She shows how the call to 'Make. Just make.'[13] cannot be divorced from the realities of expanding carbon footprints, urban gentrification, overproduction and divestment of public funding for public services.

Alexis Anais Avedisian and Anna Khachiyan's 'Morehshin Allahyari: On *Material Speculation*' (Chapter 9), offers a counterpoint to the glut of objects produced in makerspaces in their consideration of *Material Speculation: ISIS (2015–2016)* by Iranian-American artist Morehshin Allahyari. In the third artist

profile, they describe Allahyari's 3D-printed versions of antiquities destroyed by ISIS in Iraq. They call her work an 'archival methodology' that transforms and preserves material knowledge and lost artefacts through open-source and cross-disciplinary research. In Allahyari's work, both plastic (the ultimate material of the Anthropocene) and petrochemicals 'retain the aura of a biomorphic prehistory', and are just as deeply connected to the earth as materials like metal, clay and fibre. She poses digital craft technologies as tools of resistance and repair that can shift understandings of value and cultural heritage in a time of war, destruction and the aggressive privatization of intellectual property.

Deamer, Sherlock, Avedisian and Khachiyan trace the development of craft-based knowledge through digital production within architecture, makerspaces and contemporary art. In this focus, knowledge is produced and redefined not only by the hand of an individual craftsperson, but often by large cross-disciplinary teams and collaborators guided by new materials and tools. However, a focus on materials and their production reminds us that it is no longer possible to 'continue bad habits of thinking that allow humans to conceive of objects … as distinct from the processes of their emergence and decay'.[14] In light of the urgent need to address the causes and consequences of climate change and environmental catastrophe, it is time to ask how the craft and design fields account for their participation in overwhelming material excess and destructive extractivism. Though outside the scope of this volume, we are interested in how rereading craft politics within material culture could connect to emergent theories of the Anthropocene. What are the stakes for contemporary craft theory in a world brimming with stuff, when we consider making across geological time, and within the irreversible impact of our human epoch on this earth? The next group of essays builds on these themes of (over)consumption and material scarcity, ingenuity and reuse, connecting craft and materiality to survival.

In Chapter 10, 'From molten plastic to polished mahogany: Bricolage and scarcity in 1990s Cuban art', Blanca Serrano Ortiz De Solórzano traces shifts in Cuban art during the 'Special Period': a time of austerity measures that followed the dissolution of the Soviet Union. She examines how extreme material scarcity shaped everyday uses and adaptations of objects and domestic spaces, and in turn, how this 'provisional' aesthetic influenced artists and designers. Her reading of projects by collectives Desde Una Pragmática Pedagógica, Los Carpinteros and Gabinete Ordo Amoris considers their incorporation of bricolage, DIY and craft methods as a direct response to the economic and political conditions of the revolutionary project. Rachel Weiss has described the work of Los Carpinteros as a 're-estimation of artisanal value',[15] and Serrano further articulates how the creative reuse of objects was both encouraged as a patriotic return to traditional Cuban ways of life, and an irreverent approach to the intended uses for everyday materials, their material properties and histories.

Nasrin Himada continues to pare back the runaway romanticism of the handmade in 'Things needed made' (Chapter 11), to focus instead on what is truly

essential for life: that which enables survival. Himada engages in a close reading of the documentary film *Khiam (2000–2007)*, which shows the testimonies of six former prisoners as they describe the objects they made inside Lebanon's infamous Israeli-run torture prison. This writing bears witness to the images and objects that are produced with the most ingenious spark of necessity – a sewing needle made from an orange peel, a pencil made from a staple – the practical and creative impulse which gives life. Himada's text addresses how the gross injustices of the carceral settler state are amplified by technologies as large as prisons and can be resisted by very small gestures of making.

In 'Secret stash: Textiles, hoarding, collecting, accumulation and craft' (Chapter 12), Kirsty Robertson writes on extreme textile hoarding as a symptom of late capitalist excess. Robertson counters the recent pathologization of hoarding as a mental illness to suggest instead that it is a coping response to the conditions of overconsumption. Robertson draws together the recycled textile work of queer-feminist artist Allyson Mitchell, the transfer and acquisition of an artist's disorganized estate, the early hoard of the famous Collyer Brothers and the discussion boards of online craft communities. She considers the typical consumer cycles of 'purchase, discard, replace' to illustrate how the actions and collections of hoarders, crafters and artists both deviate from and intervene into capitalism, sometimes usefully and sometimes destructively.

The fourth artist profile resonates with Robertson's efforts to understand the sheer volume of textile objects and clothing that are produced and distributed around the globe. In this text, Julia Bryan-Wilson describes Shinique Smith's *Bale Variant* series and *Soul Elsewhere* in 'Shinique Smith: Lines that bind' (Chapter 13). These works powerfully connect a range of affective meanings between Black bodily experience, the global circulation of textiles, thrift, survival, intimacy and waste. Smith's (un)monumental accumulations link African American traditions of textile making and contemporary abstraction with conditions of 'contingency'[16] and making-do. This formal resonance with artists such as Mitchell and her use of discarded textiles, similarly addresses the 'cultural and economic meanings of cloth as it circulates between markets and bodies'.

While some of the texts above draw postcolonial discourses into relation with contemporary craft, the next section considers practices that directly respond to and resist ongoing legacies of settler colonialism. Capitalism functions through a series of 'technologies of colonialism'[17] that structure and consolidate white access to resources, land, state power and cultural expression. The 'invention'[18] and 'use' of craft (as both a word and a category of classification) have been concurrent with colonial expansion, and integral to building empires, industries and national identities.[19] Notions of authenticity in craft practice are not only central to the construction of craft as virtuous and politically conscious; craft's perceived authenticity is also underscored by the complex legacies of cultural imperialism, appropriation and fetishization of Indigenous cultural work as rare, 'untainted by

civilization', or 'powerfully expressive representations of a pure primitive soul'.[20] Craft's separation from high art, and its consequent marginality, is foundational to the Euro-Western art canon, devaluing works by women, people of colour and Indigenous communities. This categorical division has led to the exclusion of these makers from museums and galleries, or led to their misrepresentation within them.[21] However, a rising wave of cultural workers have called for repatriation of objects, with demands for accountability and new curatorial models. As we envision how craft can address urgent issues of our time, it is clear that Indigenous perspectives and voices must also be recentred within contemporary craft politics.[22] Writing about craft from a decolonial framework demands acknowledgement and action to address these exclusions. For many practitioners and authors within, this work begins by re-articulating craft as a world-making and geographically-specific aesthetic practice that connects to the land. As Ellyn Walker describes in her chapter, 'The sovereign stitch: Re-reading embroidery as a critical feminist decolonial text' (Chapter 15), 'renewable land-based materials, ancestral imagery and autonomous economic models represent practices of Indigenous sovereignty' that intervene into state, economic and museological power structures. We echo Heather Davis's proposition for decolonial work within feminist art practices, 'which cannot alone adequately address everything that needs to change … but they can provide means of imaging otherwise outside of colonial frameworks'.[23] We extend this to thinking about craft: while craft alone cannot topple such structures, it can offer ways of knowing, imagining and critiquing that counter ongoing colonial realities and contribute to cultural shifts.

Where Brynjolson provides a critical read on the stakes involved in pairing craft and social practice, the fifth artist profile on 'Margarita Cabrera: Landscapes of *nepantla*' (Chapter 14), insists on crafting together as a way to 'challenge systems of oppression, of mass production, of isolation, and of exclusion'. Author Laura August contrasts the free circulation of tourists and consumer goods across colonial borders against the US repression and incarceration of immigrants. She reads Cabrera's projects as shared enactments of *nepantla*, or in between-ness, for border communities. Cabrera's collaboratively sewn sculptures of cacti, made from recycled border guard uniforms speak to the uneasy flows of people, non-human organisms and objects across colonial landscapes. They remind us of the life-forms and cultural traditions that lived and moved freely before the violent imposition and maintenance of artificial borders.

In Chapter 15 Ellyn Walker asserts embroidery as an act of decolonial resistance and everyday sovereignty that echoes across three distinct geographies in the Americas. She considers Chilean arpilleras produced during the Pinochet dictatorship, huipiles from Chiapas, and *Walking with Our Sisters* by Métis artist Christi Belcourt to address moves from mourning to critical action and sacred space. Recognizing the limits of Rozsika Parker's *The Subversive Stitch*, Walker offers ways to read embroidery 'beyond the scope of settler colonialism' and

whiteness. She works towards new readings of embroidery at the intersections of feminized labour, cultural tradition and Indigeneity. Walker grounds her work in the proposal that decolonization begins with the land, and that geographically and culturally specific practices remain vital forms of resistance.

In the final profile, 'Ursula Johnson: Weaving histories and *Netukulimk* in *L'nuwelti'k* ('We Are Indian') and other works' (Chapter 16), Heather Anderson discusses artist Ursula Johnson's contemporary reworkings of Mi'kmaq basketry. Johnson's performances critique and mitigate the loss of Indigenous knowledge and ways of making, centring the bodies of living people, while drawing attention to the archaic structures and inherent violence of Canadian law in relation to Indigenous communities. Anderson articulates that the value of Johnson's work is not limited to confronting the colonial present, nor in critiquing museological classifications of Indigenous art as 'artefact', but also in striving for *Netukulimik*, or self-sustainability, the Mi'kmaq worldview encompassing one's relationship to the land and surroundings.

As Black, Indigenous and artists of colour have challenged museums and galleries to respond to calls for representation and decolonization, the politics of inclusion have in many ways 'failed to disturb ongoing colonial power relations'.[24] Calls to re-envision exhibitions and collections, increase curatorial transparency, and for equitable hiring practices across arts organizations and academia must go hand-in-hand with unsettling the historical divisions between craft, art and design. This book is driven by a desire to reshape contemporary craft discourse – there is still much work to be done in studios, classrooms, and scholarship alike.

The book concludes with '"The Black craftsman situation": A critical conversation about race and craft' (Chapter 17), hosted by Namita Gupta Wiggers, Bibiana Obler and Mary Savig for the Critical Craft Forum. This conversation begins with the 1972 correspondence between weaver Allen Fannin and Director Francis Sumner Merrit of the Haystack Mountain School of Craft, and continues to include contemporary makers Sonya Clark, Wesley Clark and Joyce J. Scott, who unanimously trouble and reject the boundaries between craft, generational knowledge, daily life and artmaking. This crucial dialogue on race and craft is 'a contribution to shifting the course'; debating questions, terms and exclusions of craft education and theory, with a renewed call to see race at the centre of the American craft story, rather than on its margins.

With *The New Politics of the Handmade*, it is our hope that readers gain expanded understandings of craft and contemporary craft theory as political, economic, environmental and social processes. It represents a call to practitioners and theorists to continue building more self-reflexive and critical readings of craft's political dimensions, and aims to bring attention to the role of the handmade as it circulates globally across varied sites. The texts within examine craft in familiar spaces alongside those less often considered, including protests, prisons, museums, advertisements, factories, takeout counters, craft fairs and broadly within popular

culture. As the authors in this book contend with the state of craft politics in the twenty-first century, they continue to shift ideas of craft itself. Within these pages, craft hovers between sensory experience and fixed object; it conveys the mutability of form alongside the fluidity of language; and finally becomes evidence of politics in-the-making. Craft, in all of its diverse forms, remains a mode of production that is intimately tied to adaptation of identity, culture and survival to meet personal and collective needs. This makes the new politics of the handmade not a singular way of thinking about craft, but an essential series of questions and methods through which we can continue to witness and address the urgent political issues of our time.

Notes

1 Jonathan Crary, *24/7: Late Capitalism and the Ends of Sleep* (New York: Verso, 2014), 14. See also Luc Boltanski and Eve Chiapello, *The New Spirit of Capitalism*, trans. Gregory Elliott (New York: Verso, 2017) and Lane Relyea, *Your Everyday Art World* (Cambridge: MIT Press, 2013).

2 Elizabeth Agro and Namita Gupta Wiggers, *Critical Craft Forum*, http://www.criticalcraftforum.com/about/ (accessed 30 June 2018). Clare M. Wilkinson-Weber and Alicia Ory DeNicola, eds., *Critical Craft: Technology, Globalization, and Capitalism* (London: Bloomsbury, 2016). Nicholas R. Bell, 'Acknowledgments', *Nation Building: Craft and Contemporary American Culture* (Washington: Renwick Gallery of the Smithsonian American Art Museum in association with Bloomsbury Press, 2015), 7.

3 Julia Bryan-Wilson, *Fray: Art and Textile Politics* (Chicago: University of Chicago Press, 2017), 4–8.

4 Jenni Sorkin, *Live Form: Women, Ceramics, and Community* (Chicago: University of Chicago Press, 2016), 2.

5 Judith Leemann and Shannon Stratton, 'Circling Back into That Thing We Cast Forward: A Closing Read on Gestures of Resistance', in *Collaboration through Craft*, ed. Amanda Ravetz, Alice Kettle and Helen Felcey (London: Bloomsbury, 2013), 219.

6 Amanda Ravetz, Alice Kettle and Helen Felcey, 'Collaboration through Craft: An Introduction', *Collaboration through Craft*, ed. Amanda Ravetz, Alice Kettle and Helen Felcey (London: Bloomsbury, 2013), 3.

7 Anthea Black and Nicole Burisch, 'Craft Hard Die Free: Radical Curatorial Strategies for Craftivism in Unruly Contexts', in *Extra/Ordinary: Craft and Contemporary Art*, ed. Maria Elena Buszek (Durham: Duke University Press, 2011), 204–21.

8 Nicole Burisch, 'From Objects to Actions and Back Again: The Politics of Dematerialized Craft and Performance Documentation, *TEXTILE*, vol. 14, no. 1 (2016): 54–73.

9 Kirsty Robertson and Lisa Vinebaum, 'Crafting Community', *TEXTILE*, vol. 14, no. 1 (2016): 5. See also Claire Bishop, *Radical Museology, or What's Contemporary in Museums of Contemporary Art?* (London: Koenig Books, 2014).

10 Kevin Murray, 'New Models for Craft Sustainability: Engaging with the "Experience" Economy', *Garland*, 3 December 2018, https://garlandmag.com/article/experience/ (accessed 15 May 2019).

11 The Architecture Lobby, of which Deamer is a member, states that: 'As long as architecture tolerates abusive practices in the office and the construction site, it cannot insist on its role in and for the public good', http://architecture-lobby.org/about/ (accessed 11 June 2018).

12 Gulf Labor Artist Coalition, https://gulflabor.org/ (accessed 14 June 2018,).

13 Mark Hatch, *The Maker Movement Manifesto* (New York: McGraw-Hill Education, 2014), 11.

14 Heather Davis and Etienne Turpin, 'Art and Death', in *Art in the Anthropocene: Encounters Among Aesthetics, Politics, Environments and Epistemologies*, ed. Heather Davis and Etienne Turpin (London: Open Humanities Press, 2015), 5.

15 Rachel Weiss, 'An Argument about Craft in Los Carpinteros', *Journal of Modern Craft*, vol. I, no. 2 (July 2008): 258.

16 Laura Hoptman, 'Unmonumental: Going to Pieces in the 21st Century', in *Unmonumental: The Object in the 21st Century*, ed. Richard Flood, Massimiliano Gioni and Laura J. Hoptman (London: Phaidon in association with New Museum, 2007), 138.

17 Eve Tuck and K. Wayne Yang, 'Decolonization Is Not a Metaphor', *Decolonization: Indigeneity, Education & Society*, vol. 1, no.1 (2012): 4.

18 Glenn Adamson, *The Invention of Craft* (London: Bloomsbury, 2013), xvi–xvii. Adamson describes how craft was ascribed 'positive qualities of creativity, rootedness, and authenticity', but how these very attributes were complicit in the colonial project of casting Indigenous cultures as dead, dying or in need of rescuing or reform. See also Ellen Easton McLeod, 'Embracing the "Other"', *In Good Hands: The Women of the Canadian Handicrafts Guild* (Montreal: McGill-Queen's University Press, 1999), 203–33.

19 Kristen A. Williams, '"Old Time Mem'ry": Contemporary Urban Craftivism and the Politics of Doing-It-Yourself in Postindustrial America', *Utopian Studies*, vol. 22, no. 2, 2011, 303–20.

20 Charles Lindholm, *Culture and Authenticity* (Oxford: Blackwell, 2008), 19.

21 Elissa Auther, *String, Felt, Thread: The Hierarchy of Art and Craft in American Art* (Minneapolis: University of Minnesota Press, 2010).

22 H. de Coninck, A. Revi, M. Babiker, P. Bertoldi, M. Buckeridge, A. Cartwright, W. Dong, J. Ford, S. Fuss, J.-C. Hourcade, D. Ley, R. Mechler, P. Newman, A. Revokatova, S. Schultz, L. Steg, and T. Sugiyama, 2018: Strengthening and Implementing the Global Response. In: *Global Warming of 1.5°C. An IPCC Special Report on the impacts of global warming of 1.5°C above pre-industrial levels and related global greenhouse gas emission pathways, in the context of strengthening the global response to the threat of climate change, sustainable development, and efforts to eradicate poverty* [Masson-Delmotte, V., P. Zhai, H.-O. Pörtner, D. Roberts, J. Skea, P.R. Shukla, A. Pirani, W. Moufouma-Okia, C. Péan, R. Pidcock, S. Connors, J.B.R. Matthews, Y. Chen, X. Zhou, M.I. Gomis, E. Lonnoy, T. Maycock, M. Tignor, and T. Waterfield (eds.)], (The Intergovernmental Panel on Climate Change, 2018), 360.

23 Heather Davis, ed., 'Proposition 2: On Colonial Patriarchy and Matriarchal Decolonization', in *Desire/Change: Contemporary Feminist Art in Canada* (Montreal: McGill Queen's University Press and Mentoring Artists for Women's Art, 2017), 134.

24 Kathleen Ash-Milby and Ruth B. Phillips, 'Inclusivity or Sovereignty? Native American Arts in the Gallery and the Museum since 1992', *Art Journal*, vol. 76, no. 2 (Summer 2017): 12.

1 FROM CRAFTIVISM TO CRAFTWASHING

Anthea Black and Nicole Burisch

Capitalism is destroying the planet. The two old tricks that dug it out of past crises – War and Shopping – simply will not work.

ARUNDHATI ROY, *CAPITALISM: A GHOST STORY*[1]

A craft movement may have the trappings of an uprising, but it will leave political and economic systems intact.

KATHLEEN MORRIS, 'YOU ARE NOT A LEMMING'[2]

This essay engages with questions at the heart of our research together and our work as editors of *The New Politics of the Handmade*: What is the relationship between artwork, direct political action and change that takes place over longer durations? What role does craft play in political action – whether as object, material, practice or sign? Our writing aims to understand the ways that craft *as* political discourse takes form, refuses form and repeats or re-enacts its own histories. We take the position that craft is not a progressive political movement; like other forms of cultural production, craft is *embedded within* broader histories and systems. Bearing this in mind, this text offers a counter to more optimistic views of craft's political potential and aims to sharpen the tools and vocabularies that we use to understand contemporary craft politics.

Craft is frequently described as both a fix and foil for the ills of capitalism and alienating conditions of industrialization. Despite a growing body of scholarship on craft's fluid relationship to the economy and industry, recent dialogues of the handmade continue to romanticize craft – and often textiles in particular – as simple, fulfilling, authentic, politically significant and even revolutionary work. Through this lens, we consider the broader implications of how craft functions within capitalist markets – however ethical they may seem. Much of craft activism

in recent years has centred on consumption-based approaches or the presentation of craft in the public space, and this text turns a critical eye on these approaches. Through these readings, we are interested in tracing how craft discourses in popular culture, galleries and museums, and academia contribute to the framing of craft as a progressive movement within the current economic and political system. We contend that there remains a need for more rigorous analysis of the forces that shape the creation, reception and circulation of craft as a form of politics in the making.

We begin by looking closely at the framing of craftivism and contemporary craft during the 2000s. Craftivism emerged in the late nineties as part of anti/alter-globalization and anti-war activism and gained recognition as a political movement through the early twenty-first century. Indie craft highlighted local craft economies and began to establish new networks that 'rebranded' the handmade as an ethical consumption practice, and a series of museum exhibitions celebrated the re-emergence of diverse forms of craft into contemporary art. These developments were in turn followed by a rapid uptake of handmade aesthetics into marketing and consumer cultures. To describe this phenomenon, we use the term 'craftwashing'[3] in relation to marketing that uses craft to perform political and social engagement while obscuring ethical, environmental and labour issues in the chain of production. We outline the shift from craftivism to 'craftwashing' in the first section of this essay and look closely at examples where craft is a shorthand, a supplement, an accessory and sometimes a tool to signify and instigate political action. We consider how craft has been evoked in publications, exhibitions, charity and marketing campaigns of the last two decades, and we call into question the myth of craft as an inherently progressive and democratic political form. Craft's many uses and meanings shift across these contexts, particularly when social and financial capital is exchanged. Where the 'craft' of craftivism depends on well-worn associations to confront political and economic issues, the 'craft' in craftwashing capitalizes on them.

Craftwashing also gains power from craft's historical position 'on the margins' of modern art, whether such exclusions have been constructed on the basis of gender, race, ethnicity, class or material. Craftwashing derives further power from whiteness and white liberal norms of property, choice and charity, when the myth of craft's marginality is coupled with cultural appropriation and amnesia about the origins of specific techniques. Later in the text, we expand our case studies to further critique the ways that craftwashing is used in marketing campaigns to perform local, national and global citizenship. As we chart this shift from craftivism to craftwashing from the early 2000s to the present, we are particularly interested in two ideas: that craft is unthreatening and fundamentally good; and that social or political causes often drive consumption of objects that are handcrafted, or made to look and feel handcrafted.

From craftivism …

It has been over a decade since the word 'craftivism' emerged to describe the blending of craft and activism. The term has since been applied to projects and actions as diverse as contemporary art works, public knit-ins, embroidered protest banners, yarnbombing, ethical fashion and indie craft sales, small-scale food production, traveling public workshops and pussy hats. Publications such as Betsy Greer's *Craftivism: The Art and Craft of Activism* and Sarah Corbett's *A Little Book of Craftivism* have focused on documenting or celebrating craftivism, stressing the political power of these forms of making. Greer, who first popularized the term craftivism with her website of the same name, writes that:

> Craftivism was, for me, a way to actively … take steps toward being an agent of change. Small change? Of course. But done continually and repetitively, small changes aggregate and spread … I talked to people about ways they can use their *individual interests* to help facilitate change … to express your feelings outward in a visual manner *without yelling or placard waving* … Craftivism needs your unique voice, via stitches or paintings or puppets or other crafty endeavor, to further spread the idea that *creativity can be a catalyst for change.*[4]

Craftivism's emblematic artworks from the early to mid-2000s created links between the handmade, individual creativity that Greer champions here, public space, collaboration and participatory democracy. These include hybrid works of contemporary protest art such as The Revolutionary Knitting Circle's *Peace Knits* banner, Cat Mazza's *Nike Blanket Petition*, Sabrina Gschwandtner's *Wartime Knitting Circle*, the *Pink M.24 Chaffee Tank* by Marianne Jørgensen and the Cast Off Knitters, among others. As we describe in 'Craft Hard, Die Free,' many of these works use a collaborative patchwork aesthetic. They publicly perform the act of crafting together as a form of protest that uses the sensory and affective qualities of textiles to counter the perception that activism is violent or destructive.[5] This tactic echoes Greer's notion of political engagement 'without yelling or placard waving'. Corbett calls the pairing of craft and social justice 'world changing,' and emphasizes that her collective's projects are effective because they are 'small, attractive, and unthreatening.'[6] Greer further argues that, 'the creation of things by hand leads to a better understanding of democracy, because it reminds us that we have power'.[7] Similarly, much earlier writing on craftivism (including our own) claims that small actions – from an individual stitch to crafting in public – might gradually contribute to significant social and political shifts.[8] Together these claims position craftivism and handmaking more broadly as modes of meaningful self-expression and empowerment. In turn they suggest that 'creativity' itself is politically progressive.[9] While many of these projects succeeded in rallying groups

around a particular cause or serving as a tool or prop for political action, we are interested in tracking how craftivism's sometimes exaggerated revolutionary language and progressive political claims have been extended to include more general forms of craft practice.

There is a clear distinction between the political intentions of activist works (and their historical precedents) just described, and commercial craft endeavours. However, the politicized language that characterizes craftivism is also often used to describe the North American 'indie craft movement', which has become increasingly commercial since its beginnings. Emerging out of the feminist Riot Grrl scene of the late 1990s, and drawing upon punk and DIY aesthetics, indie craft's revival and reworking of popular crafting has grown from small websites and local craft groups to now-massive enterprises like Etsy and the Renegade Craft Fair.[10] Most notably documented in Faythe Levine and Cortney Heimerl's 2008 book and Levine's 2009 film, *Handmade Nation*, marketing and media attention framed indie craft and DIY practices as a 'revolutionary' 'global movement'[11] that was 'radical', 'guerrilla', and alternative to mass-produced goods.[12] As stated in the 2003 *Craftifesto*: 'Craft is Political. We're trying to change the world. We want everyone to rethink corporate culture & consumerism.'[13] Alongside this claim that craftivism fosters personal agency, one assumption underlying indie craft is that individuals create change and participate in a democratic public activity by *making and buying* handmade things. While much of the politically inflected language has since disappeared from the promotion and discussion of indie craft sales, the idea of craft (and crafting) as an inherently progressive political form continues to have traction, as we will address in the rest of the essay.

It is worth focusing closely here on the language of individualism and self-expression in contemporary craft cultures. In the revised edition of *The Subversive Stitch*, Rozsika Parker describes a shift in the early-twentieth-century use of embroidery, not to support a selfless feminine ideal, but to 'transform the relationship of art to society'.[14] She speaks of embroidery by women artists who were active in both avant-garde art and revolutionary circles, then more broadly as means for women to express their own 'individuality'.[15] Parker suggests embroidery's shift to become 'a *manifestation* of the self'[16] contributed to its nostalgic uptake in 'counter-cultures and radical movements' of the 1960s and 1970s but often left gender, race and class stereotypes unexamined. A contemporary banner by London's Craftivist Collective reads 'Become Who You Are',[17] and shows how craftivism and indie craft continue to reproduce idealistic claims such as these: that authentic self-expression, 'becoming who you are', and individual choice *matter* and – while not antagonistic – they remain politically significant processes. In this sense, craftivist dialogues echo and easily reproduce neoliberal values of individual creativity and self-expression,[18] which are tacitly accepted as a form of lifestyle-based activism. This 'becoming' is expressed through self-styling and identity construction through consumer choice. In these contexts, consuming,

judging (and sometimes producing) craft is used to curate and communicate a politicized sense of individuality through good taste, and craft expresses personal and economic freedom of choice in a broadly disempowering sphere of market capitalism. The marketplace becomes an arena where 'conscious consumers' exercise the power to choose unique objects that reflect their progressive values. For makers, they participate in what have been described as 'feminized' micro-economies that often reproduce forms of precarious and exploitative labour.[19]

Alongside the growing consumer and lifestyle-oriented interest in craft of the last two decades, institutional focus has also reinforced a particular reading of craft in relation to art and politics. Craft theorist and historian Glenn Adamson describes two modes of idealism that are central to modern craft: a 'more personal, spiritual form … directed towards the *improvement of the self*, and 'countercultural craft, explicitly antagonistic to the mainstream'.[20] This antagonist ideal remains evident in exhibitions and catalogues of the 2000s that describe craft as dangerous, radical, countercultural or other: *Confrontational Clay* (2000),[21] *Radical Lace and Subversive Knitting* (2006), *Pricked: Extreme Embroidery*, (2007),[22] *Gestures of Resistance* (2010)[23] and publications like *Breaking the Mould: New Approaches to Ceramics*.[24] Further still, the UK-based reality TV show *Handmade Revolution* (in which Adamson himself appears as a judge) echoes this rebellious language while collapsing the boundary between popular media and institutional framings of craft.[25] While this sampling of titles with politicized overtones represents artists and craftspeople who are working in a variety of social and political contexts, the overall effect is clear: for contemporary craft to be interesting or relevant, it has to be distanced from its formerly domestic, feminine or traditionally passive connotations (or be seen to overcome them). Instead, these newer framings are invested with an aura of transgression and political urgency, in what Julia Bryan-Wilson describes as a declaration of contemporary craft's 'currency'.[26] However, the idea that craft becomes political or countercultural only when it enters public space relies on a false opposition between the public and private that feminist scholarship of the later twentieth century has aimed to challenge.[27] As Kirsty Robertson outlines, the multiple (and sometimes conflicting) accounts of craft activism in the 2000s are largely framed as departures from craft's feminized associations. For example, they 'place knitting as an act of individual emancipation'.[28] The crux of the problem is that these dialogues are 'disconnected from wider circumstances and unfortunately caught in unsettling a binary opposition between public and private – or more accurately, public space and domestic space – that has largely been made redundant by the consuming politics of neoliberalism'.[29]

Craft's renewed visibility in public spaces, museums, academia and the media is bolstered by the idea that craftivism and contemporary craft are forms of *revolutionary political action* and democratic participation, particularly in North America and Europe. This framing relies on the above understandings of craft as a marginal and countercultural practice in a state of continual personal reinvention,

and in indie craft's positioning as a community that reflects anti-capitalist values and allows for personal critiques of globalization. As Kristen A. Williams notes in her work on craftivism's connections to the values of self-sufficiency, sustainability and thrift, these ideals channel a nostalgic desire for the return of a simpler time. She describes this as 'a specific performance of individualism often understood as constitutive of American national identity'.[30] Craft is simultaneously cast as a conscious political choice and as an accessible pre-political practice through associations with domesticity, simplicity, honesty and moral purity.

Further, the framing of craftivism as a local or global *movement* of individuals working together to address a common cause, as in many of the examples mentioned earlier, assumes political unity among people who produce, promote or consume craft. As Robertson carefully counters: 'The politics of these groups … are often eclectic, ranging from ultra-conservative to anarchist.'[31] The idea of a unified, inherently progressive craft movement ignores these specific political and regional conditions that give handmade objects deeper meaning. Instead, when craft is read only through the lens of progressive politics, it operates more readily as marketable sign within local, global or transnational economies. This operation appears in broader public discourse and corporate branding: when handmade objects and raw materials are used to represent morality and charity; when craft is championed as the antidote to historical and contemporary forms of alienated labour; when it is romanticized as an anti- or pre-industrial mode of production and rural lifestyles; or offered as tangible ways to boycott or avoid purchasing unethically produced goods.

Revolutionary language and aesthetics of politicized craft are not only common within activist craft communities, indie craft and contemporary art. As we describe later, craft also features prominently in powerful marketing campaigns that leverage the political claims of handmaking and channel its affective power into the consumer sphere. In these cases, and in craftwashing broadly, we see the conflation of Arts and Crafts movement ideals with neoliberal language of entrepreneurship and individualism, that together draw significant power from the craftivist claims of the last two decades. These claims have contributed to corporate uptake of craft as a loaded political symbol and an aesthetic shorthand for 'reclaiming' all that is other, outside, oppressed. Marketing products based on these associations enables consumers to access and perform and what Nicole Dawkins has termed 'the moral value of handmade goods'.[32] With this in mind, we turn to our discussion of craftwashing using examples across a variety of economic models. Our examples range from multinational fashion brands, to small-scale design groups and non-profit organizations that promote the work of independent craftspeople. As we see, each construct personal consumer choice as an explicitly political process, and allow consumers in various markets to participate in the myth that making, supporting or buying craft is a form of progressive political action.

... to craftwashing

To describe how craftwashing works, we draw from the term 'greenwashing', which refers to branding strategies that make products seem eco-friendly while concealing their negative environmental impacts. As journalist Heather Rogers describes: '*green* has gone from just a color to indicating that something possesses what's needed to protect the earth's natural systems.' When a product is branded as 'green' or 'handmade', that label saves (and even dissuades) the consumer the trouble of thinking further about the environmental or economic impact of the product. This is especially powerful when claims of social or environmental responsibility are explicit parts of branding, as they are with the well-known brands Tom's Shoes, H&M and Levi's. Rogers notes that ecologically branded products can be 'a badge of honor, and in some circles a status symbol', that never require consumers to sacrifice too much and ensure that 'saving the planet can be fun and relatively easy'.[33] Craftwashing operates the same way: like greenwashing, it capitalizes on the individual consumer desire to do good – or be perceived as morally good – amid overwhelming, irreconcilable political anxiety and impending ecological collapse. By marketing affectively charged handmade objects (or their lookalikes) as solutions to pressing environmental, social and economic justice issues, craft aesthetics are twinned with notions of individual political agency and morality, while leaving existing power systems largely unquestioned and intact. As Rogers and others have noted, consumer-based actions can be a small part of the solution, but they rarely address larger (and increasingly urgent) structural problems in how we produce, consume and live on this planet, representing instead a 'catastrophic game of denial'.[34] To bring about substantive change, industry and policy leaders need to invest in broad-based structural shifts, rather than relying on consumer actions and marketing campaigns that do little to address the root causes or systemic problems.

The following paragraphs give concrete examples of craftwashing that are drawn from various economic scales. In each case, craft functions as a sign of the political, while strategically avoiding or concealing larger systemic inequities. We look at craft and design objects and marketing of consumer-driven charity projects by the Dutch independent bedding design company Snurk, and fashion brand Tory Burch and Lauren Bush Lauren's FEED Foundation. We begin to consider the relationship between craftwashing and cultural appropriation, where contemporary (craft) marketing encourages the consumption of craft as a way of performing national identity and (global) citizenship. We then trace debates on authenticity and belonging on the popular craft site Etsy and the Canadian Craft Federation's *Citizens of Craft* campaign. In these examples, we see craft is instrumentalized as a sign of individual agency and choice, moral goodness through self-sufficiency and entrepreneurialism, and private investment in the public sphere. Here, several constructs of neoliberalism come into focus.[35]

Dutch independent bedding company Snurk channels the positive associations of craft through the appearance of the 'granny' figure of maternal warmth and nostalgia in the 2012 advertising for their 'Granny Square' duvet. The advertisement copy reads: 'Take one crochet pattern from Grandmother's time, one pile of colorful yarn and a bunch of lovely ladies from the local craft club. Stir in some cookies, tea and bottles of Prosecco and before you know it, you've all crocheted the most cheerful looking bedspread.'[36] Here, words like 'lovely', 'local' and 'cheerful', signal a past era of domestic ease and togetherness through crafting. Evoking this bygone time presumably takes us far away from the political discontents of the public sphere, just as Robertson cites a disavowal of feminist activism as being central to rebranding craft(ivism) for the twenty-first century. Earlier in this text, we named several artworks that use individually knitted or crocheted squares to signify collective action. Recalling the associations of these works, the Snurk granny square motif operates as a sign of craft's complex meanings: instead of a collectively handmade textile or a nostalgic piece made by a lovely crocheting grandma, it is a high-resolution photograph digitally printed on the surface of the cloth. Similar digital images of knitted textures (and occasionally, actual knitting) have also appeared in advertisements for products as varied as milk, chain coffee shops or smoothies – many from multinational corporations whose actions do not always match the charitable aims or cosy associations of these campaigns.[37] What these campaigns have in common is their use of textiles as a sign of honesty, community, generosity and authenticity. In Snurk's product, a crafted textile, and its associations with traditional conceptions of gendered domesticity, comfort and inheritance of familial property, leverages the look of the handmade to add value.

If the image of a textile evokes associations of domesticity and warmth, the aesthetic of recycled or patchwork fabrication operates similarly to cue neoliberal values of resourcefulness, self-sufficiency and uniqueness. Another series of products from Snurk, the 'Le-Clochard' duvet and 'Le-Trottoir' sheets take the look of DIY and recycling to the height of farce, by aestheticizing homelessness as designer home decor. The quilt uses a printed image of a taped-up cardboard box (Plate 1) to signify a makeshift street shelter, advertised with the invitation to 'sleep on the street so a homeless youngster doesn't have to'.[38] Part of the proceeds from sales go towards supporting various foundations in Europe that assist homeless populations, totalling € 80,000 as of March 2017. These products aestheticize 'making do' and other tactics for surviving in the urban environment. Despite the object's self-conscious DIY irony, its marketing avoids addressing the economic inequities that separate buyers with disposable income and designer taste from people who (may) sleep on real cardboard boxes. The realities of homelessness and the suffering of people who are denied the comforts of home remain invisible – or worse, are used as a marketing stunt when Snurk's designer sleeps in Amsterdam's Dam Square under the duvet with cardboard signs directing passers-by to Snurk's website (Figure 1.1). The object itself capitalizes on the material and aesthetic associations of poverty. Objects like

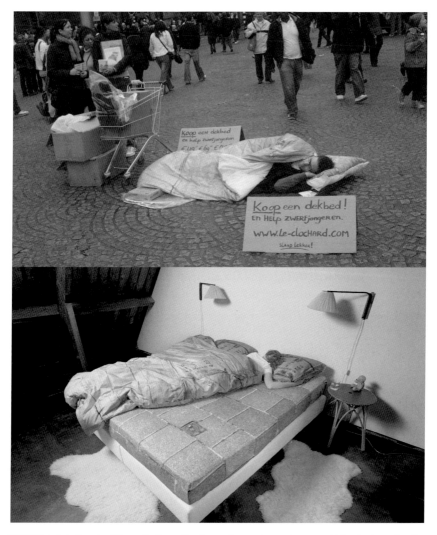

FIGURE 1.1 Snurk. 'To grab the attention of people and press, Erik slept under the Le-Clochard duvet cover in the middle of Dam square in Amsterdam.' The Netherlands, 2008. *Le-Clochard*, 2008, cotton. Photo credit (top): Theo van der Laan. Photo (bottom): Ram van Meel. Copyright: Snurk.

this encourage consumers to make a one-time retail purchase when they know a portion of the proceeds goes to charitable causes, while the broader structural and systemic issues that lead to homelessness remain unexamined.

The 'limited edition' FEED Foundation bag similarly exploits the rustic material associations of burlap fabric, and the aesthetic of the labour-intensive Colombian Mochila weaving used for its straps.[39] The FEED bags launched in 2012

as a collaboration between a for-profit company founded by Lauren Bush Lauren, luxury brand Tory Burch and high-end department store Holt Renfrew.[40] The bags are just one of a number of fashionable products by designers that claim to 'change the world', by fighting global poverty, increasing environmental awareness or 'rescuing' Indigenous craft traditions by empowering artisans (See Elke Gaugele, Chapter 2 for more on this topic). Like the Le-Clochard duvet, the FEED bags rely on an increasingly common gesture of soft-philanthropy: with each individual purchase, a portion of the retail price is donated to 'fight hunger and eliminate malnutrition around the world',[41] a model that requires little or no investment beyond a one-time purchase. Behind this problematic 'buy-to-give' equation, is the bag's status as a 'limited edition' craft object, complete with vaguely pastoral burlap, punk-rock stencilling of the FEED name and ethnic flair.

The early FEED designs and production blur the lines between DIY, appropriation of Indigenous craft practices, mass production and designer luxury-goods. However, as the brand has grown in popularity, fine leather, denim and intricate beading have replaced burlap, and the company's marketing claims to support artisans and use 'environmentally friendly materials … *whenever possible*'.[42] Notably, FEED also markets the project as a *movement*, stating that 'we've built a movement connecting our customers to the cause, one bag at a time'.[43] Here, the language and aesthetic draw publicity and capital to Bush Lauren, Burch and Holt Renfrew, while gender and race, as well as the moral and political underpinnings of handcraft remain unexamined, yet central, to the FEED brand. As we see with the FEED bag, craftwashing also intersects with appropriation of Indigenous cultural and craft traditions in the fashion industry.[44] In this sense, living cultural practices tied to survival, ritual, connection to the land and storytelling are whitewashed; consumerism reproduces and naturalizes ongoing forms of colonial violence by marketing Indigenous traditions as variously lost, rare and extinct, or as fascinating, noble expressions of true humanity. Just as gendered crafting becomes associated with transformative individuality as detailed earlier, the (neo)colonial gaze appropriates Indigenous aesthetics to position craft as virtuous and politically conscious. Globalization allows objects, materials and motifs to circulate and become available for wider markets and, in turn, crafted objects are marketed as progressive expressions of individuality and global consciousness.

In her discussion of indie craft, Dawkins describes how craft has been recast as an affective experience that is less concerned with the 'particular artisanal qualities or labour concerns' of crafted objects, but instead with what she identifies as 'the pleasures and transformative values of making things yourself'.[45] We extend this line of thinking to consider how craftwashing in the objects and marketing campaigns just discussed relies upon similar associations and experiences. Instead of accessing the pleasures of *making* things, objects like the Snurk bedding and the FEED bag offer the pleasures of selecting and *buying* things to craft an identity as a

socially conscious consumer. The feel-good values of the handmade are transferred and exploited here to conspicuously perform individual lifestyle choices and acts of charity, while downplaying questions about supply chains, labour practices, cultural appropriation and environmental impact.

In these types of (charitable) consumer experiences the promise of 'change' is not only troubling in its vagueness, but as with other forms of so-called conscious consumerism, a diversion from the urgent work of critically evaluating the systems that create and allow for these problems in the first place.[46] Eco-capitalism and greenwashing falsely propose that consumers might solve the environmental crisis *and* maintain the current economic system by simply buying different, better or more ethical *stuff*. Craftwashing operates in a similar way, leveraging the language and aesthetics of craft to encourage consumption as a viable solution to social and economic inequalities or environmental causes. Unfortunately, as sustainability experts outline in a report for the United Nations Environment Program, consumption-based approaches are often 'overly simplistic, ineffective or altogether misplaced'.[47] It is clear that we need to profoundly rethink our relationships to the things we produce and consume, not just at the individual consumer level, but as part of large-scale 'transformative systemic change'.[48]

Independent of what?

The examples mentioned show how craftwashing works when craft objects and buying practices are marketed as forms of conscious consumption or charitable activities. Perhaps in response to the increased marketing of craft as a political force, many communities of craft makers have also re-intensified their use of the symbols and language of independence and revolution. In this part of the essay, we track ongoing debates around the popular craft-selling platform Etsy, and analyse a recent marketing campaign by the Canadian Craft Federation. Both are navigating craft's recent commercial popularity by attempting to redefine and preserve the status of the handmade. These campaigns have often hinged on promoting craft's authenticity, by reinforcing the political value of craft as an alternative to mainstream production and consumption.

Following Etsy's 2015 move to become a publicly traded company, Etsy sellers were no longer restricted to exclusively selling products made by hand themselves. A number of articles maintained a strong position that craft sold on the site should be 'independent' of broader production and manufacturing. Their authors targeted Etsy's exponential growth and its newly relaxed criteria for accepting sellers on the site, with titles like 'How Etsy Alienated Its Crafters and Lost Its Soul'[49] or 'Can Etsy Blow Up and Keep its Soul?'.[50] The articles betray both an anxiety and awareness about how the handmade is being defined, marketed

and sold – and by whom. Within these articles and community forums, the word 'handmade' was the subject of debate, while the word 'soul' connoted the formerly unique position of makers selling their own handmade goods on the site. We might ask how a website has a 'soul' to lose, and what this loss signifies in terms of the role that craft performs as a feature of online communities. These anxieties reveal how the overall marketing of craft and the increasingly slippery definitions of words like 'handmade', 'craft' or 'authentic' affect the landscape for makers and buyers alike.

Long-time Etsy sellers are frustrated because they have relied on the site not only to sell their work, but also to authenticate it as genuinely handmade within an alternative economy of self-defined makers unified by supposedly shared values. Debates around defining the handmade were always present on the site, but were not as contentious when there were fewer sellers and less competition. For Etsy craft sellers, their 'authentic' work has value insofar as it remains distinguished from mass-produced goods, and this claim relies largely on the politicized language we have outlined earlier. The distinction between handmade and mass-produced is a false binary that not only ignores the global chains of production supplying North American craft producers with their raw materials, but also the ways in which mass-produced objects are no less the products of *someone's* (often invisible) time and labour. Like the indie craft scene, Etsy's success has largely been built on the idea that DIY craft is an ethical or alternative to buying from large corporations: 'At its outset, Etsy was a powerful tool for makers, by makers. We were a bunch of Davids, fighting back against the big-box Goliaths with artisanal slingshots.'[51] However, Etsy and its sellers are just as embedded within the market as big-box stores. As Kathleen Morris makes clear, 'While Etsy pledges to empower citizens to change the global economy by "bringing heart to commerce," this aspiration changes nothing about the capitalist institutions that safeguard Etsy's corporate for-profit status as a craft marketing powerhouse.'[52] Within the context of craftwashing, the Etsy debate foregrounds that craft's economic and social value is no longer defined by a particular way of making or by the producer. While this is no doubt troubling for some, it underlines the need to interrogate not only how craft producers leverage the aesthetic and political associations of the handmade, but also how defining 'craft' still privileges certain forms of making over others.

Similar motivations are behind the Canadian Craft Federation's 2015 *Citizens of Craft* rebranding campaign. The campaign aims to raise the public profile of craft, and market the work of Canadian craftspeople practicing in a variety of media from jewellery to bookbinding.[53] The campaign invites people to 'declare' themselves as part of a 'movement' with its own manifesto tinged in revolution, capitalizing on the persistent claim that craft is a form of political rebellion. Like the hand-drawn 2008 'Craftifesto' poster we cited earlier, *Citizens of Craft*'s sleek design sets short claims of craft's personal and political power in bright yellow and

black. It advocates for the purchase of craft products led by statements of the beliefs and progressive values that craft represents in society: originality, authenticity, diversity, with a connection to the maker's hand, that cannot be 'automated, manufactured or cloned'. Here, craft is again positioned as a mark of individuality and a trusted antidote to supposedly anonymous and mass-produced objects. As a result, Kathleen Morris states, craft is shoehorned into 'a reductive approach to neoliberal citizenry in which an individual is reduced to consumer'.[54] The website uses black and white photographs of a range of handmade objects to visualize each of the ten points in the *Citizens* manifesto including the iconography of a raised fist – this time adorned with a funky geometric ring by Canadian crafter Joe Han Lee (Figure 1.2). This well-worn image echoes the cover of Greer's *Craftivism* book, which features a blue fist stencilled on raw canvas. Both evoke the use of this image by workers' rights campaigns, Black Power, feminist and resistance movements that have historically used this emblem of a raised fist not for marketing products, but for demanding human rights. Another image, features a procession of small porcelain animals walking across a bridge by Janet Macpherson accompanied by the claim that 'while we all move to different drums', this newly minted class of craft (buying) citizens can 'move together' as 'each maker's unique expression bonds us to a richer community'.

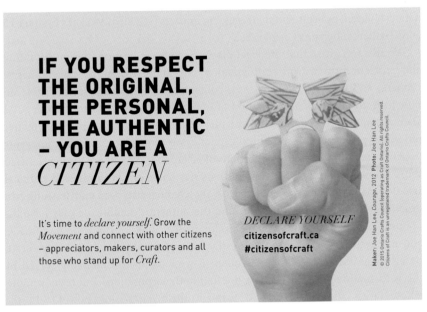

FIGURE 1.2 *Citizens of Craft*, 2015. Maker: Joe Han Lee, *Courage*, 2012. Photo: Joe Han Lee. Copyright 2015 Ontario Crafts Council (operating as Craft Ontario). Note: *Citizens of Craft* is an unregistered trademark of Ontario Crafts Council.

Positioning makers and consumers of craft as *citizens* taking part in a collective movement once again infers that individual self-expression through consumption is a form of politically engaged citizenship that matters. The campaign evokes constructs of Canadian national identity and progressive political values, but does not critique their limitations. To point 'craft citizens' in more critical directions might trouble the campaign's objective to raise the profile of local craft communities and act as a bridge to (international) consumers. The campaign shows how easy it is for even savvy communities of contemporary makers to participate in craftwashing: to use well-worn myths such as craft's inherent progressiveness, national unity or the false binary of handmade/manufactured. Craft has a complex relationship to histories of colonization and the articulation of national identities, in particular through 'the association of craft with cultural difference'.[55] This line of thought finds increasing urgency as craft communities negotiate the consequences of their growth and popularity, alongside the increased pressure to remain financially viable, and challenges from artists, scholars and activists to acknowledge colonial underpinnings of the historical categories that separated craft from fine art. Rather than activating craft consumption or craft activism as a reparative nation-*building* project that requires good upstanding citizens, we are interested in other moves for craft criticism and activism: addressing and reversing economic and institutional structures that marginalize the work of women and people of colour, understanding cultural appropriation and self-determination, and supporting artists, curatorial approaches and scholarship that examine craft's complex roles in the colonial nation-building projects and their ongoing impacts (see Ellyn Walker's Chapter 15 and Heather Anderson's Chapter 16).

We also recognize that the legal discourses of certification, design patenting and protectionism within craft practice[56] are applied unevenly to emphasize property and market share for *some* contemporary Western makers. These do little to rectify the lack of attribution of Indigenous craft or cultural property. As Dawkins notes, 'making as part of a larger aesthetic or moral calling [is] a matter of (white) privilege and of cultural capital'.[57] We remain sceptical that unevenly policing the boundaries and definitions of what kinds of craft are 'authentic', as in the examples earlier, will reclaim craft's market share or fully address the critical issues at hand. In fact, combined with the characteristics of craftwashing just described, this kind of labelling around the 'authentic' handmade may have the opposite effect: adding more dollar value to the 'look' of both the handmade, and the 'craftlike',[58] and heightening the buzz of words like 'handmade', 'craft', or 'artisanal'. As Kathleen Morris notes, if we look at 'who is being served by the perpetuation of this archetype, we find both corporations and organizations whose target audiences respond through their purchasing power'.[59] In the marketplace, it is the retailer and consumer – not the craft historian, theorist or activist – who has the power to choose a given object, regardless of whether its claims to authenticity are genuine.

Conclusion

This essay re-evaluates the political claims that surround contemporary craft activism and traces their development over the last two decades. It investigates how the particular qualities of craft, alongside histories of craft activism, have been conflated with notions of authenticity, individuality, citizenship, sustainability and radical politics, in both scholarly and popular understandings. In tracing a recent genealogy of craft activism and its collision with various economic models, we have sought here to identify and challenge the myth of craft as an inherently progressive political movement. We describe how the idea of 'revolutionary craft' forms a strong affective foundation for lifestyle-based marketing and branding today. As Arundhati Roy reminds, war and shopping will not save the world – and neither will craft. In our view, craft is neither good nor bad, moral nor immoral, revolutionary nor status quo.

We have looked at examples of craftwashing in action – from luxury goods, to indie designers and self-determined craft communities – where the use of craft as a marketing tool can obscure pressing issues of precarious labour, complex global supply chains, environmental catastrophe and the ongoing appropriation and preservation of cultural traditions. By casting 'craft citizens' to perform in a loop of supposedly ethical production-consumption, craftwashing forecloses on important critical questions about the structures that support these systems.

Through the recent resurgence of craft as a marketable phenomenon, and the appearance of craftwashing, individual acts of production and consumption may feel charged with political meaning. But political agency must not be confused with buying power or owning beautiful things. In short: if there is something political about craft now, it is not about buying more stuff. Within our current economic system and for a field so deeply connected to objects and materials, it may seem difficult, even impossible, to ask: What are the forms of craft politics that do not focus on the market? What processes and ways of thinking about craft can offer viable alternatives to the continued and destructive expansion of capitalism? We contend that these questions are still worth asking, for craft scholars and practitioners alike. While this text critiques the ways in which the language of craft activism has been used in consumption-based approaches, we nevertheless consider craft as a vital and ongoing frame for understanding the very nature of exchange and survival for all forms of life and matter. We remain hopeful that craft activism can continue to exist beyond the trappings of individual consumption, and instead offer tangible activations of self-determination, bodily autonomy and cultural memory intertwined with global citizenship and justice. These topics criss-cross through the chapters that follow in *The New Politics of the Handmade*, and together they activate craft theory as a particularly sharp set of tools for analysis, continuing to build the critical vocabularies for understanding craft politics today.

Notes

1 Arundhati Roy, *Capitalism: A Ghost Story* (Chicago: Haymarket Books, 2014), 46.

2 Kathleen Morris, 'You Are Not a Lemming: The Imagined Resistance of Craft Citizenship,' *Journal of Modern Craft*, vol. 9, no.1 (July 2016): 8.

3 We began using 'craftwashing' as a shorthand for examples of corporate marketing, and described it in a paper at the Textile Society of America conference in 2012. The term has also appeared in discussions about craft beer to describe a similar phenomenon, where large companies imitate and capitalize on the appeal of small independent breweries to market their products. We expand upon this use to show how 'craftwashing' can describe a wider range of materials, products and campaigns. The term 'artwashing' has also appeared recently to describe the use of art (or even creativity more generally) in the service of urban development and gentrification initiatives, or in the case of oil and gas companies sponsoring public art institutions, to 'soften' their corporate image. For more on this, see Oli Mould, *Against Creativity* (New York: Verso, 2018), 162–72.

4 Betsy Greer, 'Craftivist History', in *Extra/Ordinary: An Anthology of Craft and Contemporary Art*, ed. Maria Elena Buszek (Durham: Duke University Press, 2011), 175–83 (emphasis added). Greer too, notes her own ambivalence about the word 'craftivism'.

5 Anthea Black and Nicole Burisch, 'Craft Hard Die Free: Radical Curatorial Strategies for Craftivism in Unruly Contexts', in *Extra/Ordinary: An Anthology of Craft and Contemporary Art*, ed. Maria Elena Buszek (Durham: Duke University Press, 2011), 204–21.

6 Sarah Corbett, *A Little Book of Craftivism* (London: Cicada Books, 2013), 5.

7 Betsy Greer, *Craftivism: The Art and Craft of Activism* (Vancouver: Arsenal Pulp Press, 2016), 8.

8 See Black and Burisch, 'Craft Hard Die Free'; Julia Bryan-Wilson in dialogue with Cat Mazza, Liz Collins, Sabrina Gschwandtner and Allison Smith, 'The Politics of Craft', *Modern Painters* vol. 20, no. 2 (February 2008): 78–83; Nicole Burisch, 'Craftivism: Reevaluating the Links between Craft and Social Activism', in *Utopic Impulses: Essays in Contemporary Ceramics*, ed. Ruth Chambers, Amy Gogarty and Mireille Perron (Vancouver: Ronsdale Press, 2007), 158.

9 For more on the rhetoric and cooption of creativity into capitalism, see Mould, *Against Creativity*.

10 See Faythe Levine and Cortney Heimerl, 'The New Wave of Craft Timeline', in *Handmade Nation: The Rise of DIY, Art, Craft, and Design* (New York: Princeton Architectural Press, 2008), xiv–xix. See also the chapter 'Knit Your Own Job: Etsy and the New Handmade Culture', for an overview of this history, as well as the shifting language around its political claims in Emily Matchar, *Homeward Bound: Why Women Are Embracing the New Domesticity* (New York: Simon and Schuster, 2013), 71–93.

11 Betsy Greer, *Craftivism*. Sayraphim Lothian uses the term 'guerilla kindness' in the same volume, 11. See also Renegade Craft Fair's page 'About: Our History' which similarly describes a 'global indie-craft movement' http://www.renegadecraft.com/about (accessed 2 December 2017).

12 Faythe Levine (director), *Handmade Nation: The Rise of D.I.Y Art, Craft and Design*, 2009, 65 minutes (film). See also the *New York Times* article that calls *Handmade Nation* 'a new and growing community, one with its own esthetic, lifestyle and economy', and refers to the 'movement's anti-industrial, anti-institutional and highly entrepreneurial manifesto'. Penelope Green, 'The Ambassador of Handmade', *New York Times*, 3 September 2008, http://www.nytimes.com/2008/09/04/garden/04craft.html (accessed 17 November 2011). See also The East London Craft Guerilla website, http://www.craftguerrilla.com/page2.htm (accessed 2 December 2017). Their manifesto reads: 'The Craft Guerilla Army is taking on the world for a better hand made existence! We've had enough of soulless, mass produced tat and so has the average consumer.'

13 Amy Carlton and Cinnamon Cooper, 'Craftifesto', in *Handmade Nation: The Rise of DIY, Art, Craft, and Design*, ed. Faythe Levine and Cortney Heimerl (New York: Princeton Architectural Press, 2008), xx.

14 Rozsika Parker, *The Subversive Stitch: Embroidery and the Making of the Feminine* (London: I.B. Tauris, 2010), 189.

15 Ibid., 202–3.

16 Ibid., 203–4 (emphasis added).

17 Sarah Corbett, *A Little Book of Craftivism*, 44–45.

18 Nicole Dawkins, 'Do-It-Yourself: The Precarious Work and Postfeminist Politics of Handmaking (in) Detroit', *Utopian Studies*, vol. 22, no. 2 (2011): 263. See also Kristen A. Williams, ' "Old Time Memr'y": Contemporary Urban Craftivism and the Politics of Doing-It-Yourself in Postindustrial America', *Utopian Studies*, vol. 22, no. 2 (2011): 308.

19 Alex Williams, 'That Hobby Looks Like a Lot of Work', *New York Times*, 16 December 2009. Available at http://www.nytimes.com/2009/12/17/fashion/17etsy.html (accessed 1 March 2019); and Sara Mosle, 'Etsy.com Peddles a False Feminist Fantasy', *Double X*, 10 June 2009. Available at https://web.archive.org/web/20130329053942/www.doublex.com/section/work/etsycom-peddles-false-feminist-fantasy (accessed 22 April 2019). See also Dawkins, 'Do-It-Yourself'.

20 Glenn Adamson, 'Section Introduction to Modern Craft: Idealism and Reform', in *The Craft Reader* (London: Bloomsbury, 2010), 135 (emphasis added).

21 Judith S. Schwartz (curator), *Confrontational Clay: The Artist as Social Critic* (Kansas City, MO: ExhibitsUSA, Mid-America Arts Alliance, 2000).

22 David Revere McFadden (curator), *Radical Lace and Subversive Knitting* (2006); *Pricked: Extreme Embroidery*, (2007), (New York: Museum of Art and Design).

23 Judith Leemann and Shannon Stratton (curators), *Gestures of Resistance* (Portland: Museum of Contemporary Craft, 2010).

24 Rob Barnard, Natasha Daintry and Clare Twomey, *Breaking the Mould: New Approaches to Ceramics* (London: Blackdog Publishing, 2007).

25 Glenn Adamson, 'Goodbye Craft', *Nation Building: Craft and Contemporary American Culture*, ed. Nicholas R. Bell (London: Bloomsbury, 2015), 25.

26 Julia Bryan-Wilson, *Fray: Art and Textile Politics* (Chicago: University of Chicago Press, 2017), 258. See also Kirsty Robertson, 'Rebellious Doilies and Subversive

Stitches', in *Extra/Ordinary: An Anthology of Craft and Contemporary Art*, ed. Maria Elena Buszek (Durham: Duke University Press, 2011), 192. 184–203.

27 See Nancy Fraser, 'Rethinking the Public Sphere: A Contribution to the Critique of Actually Existing Democracy', *Social Text*, no. 25/26 (1990): 56–80.

28 Robertson, 'Rebellious Doilies', 192.

29 Ibid., 192.

30 Williams, ' "Old Time Memr'y" ', 305–6.

31 Robertson, 'Rebellious Doilies', 190. Williams, ' "Old Time Memr'y" ', 306, likewise notes that recent trends towards DIY and self-sufficiency have a relationship to practices and lifestyles from 'across a broad political spectrum'.

32 Dawkins, 'Do-It-Yourself', 262.

33 Heather Rogers, *Green Gone Wrong: Dispatches from the Front Lines of Eco-Capitalism* (New York: Verso, 2010), 4–5.

34 Ibid., 180. See also Naomi Klein, *This Changes Everything: Capitalism vs. the Climate* (New York: Simon & Schuster, 2014).

35 See Dawkins, 'Do-It-Yourself', 277 for further analysis around the relationship between neoliberalism and the indie craft scene.

36 This product is no longer on the Dutch or US Snurk site, they now have a duvet with an overall pale knitted yarn motif: https://www.snurkliving.com/bedding/yarn-duvet-cover-pink (accessed September 2012 and 20 December 2017).

37 See Innocent Smoothies' 'Big Knit' campaign, 'The Innocent Big Knit – About', http://www.thebigknit.co.uk/about (accessed 7 February 2018); see also Tamara Cohen, 'Innocent Accused over Charity "Con": Smoothie Giant "Failed to Hand Over Promised Cash', *Daily Mail*, 27 May 2011, http://www.dailymail.co.uk/news/article-1391521/Innocent-Smoothie-maker-defends-handing-520-000-charity-cash-2008.html#ixzz56RtDaMZM (accessed 7 February 2018). 'Lait: Source Naturelle de Réconfort' campaign for the Fédération des producteurs de lait du Québec, http://strategyonline.ca/2009/12/03/milkknit-20091203/ (accessed 7 February 2018). Tim Hortons' *#WarmWishes* campaign, http://www.timhortons.com/ca/en/corporate/news-release.php?id=8265 (accessed 7 February 2018); see also Sara Mojtehedzadeh, 'Tim Hortons Protests Sweep the Nation after Minimum-wage Hike', *Toronto Star*, 19 January 2018, https://www.thestar.com/news/gta/2018/01/19/tim-hortons-protests-sweep-the-nation-after-minimum-wage-hike.html (accessed 7 February 2018).

38 'Sleep on the Street so a Homeless Youngster Doesn't Have to', *Snurk Beddengoed*, https://www.snurkbeddengoed.nl/en/service-more/supporting-homeless-youngsters (accessed September 2012 and December 2017).

39 'The Tory Burch FEED Bag', http://www.feedprojects.com/feed-shop (accessed September 2012). As advertised the bag is 'Made from traditional FEED burlap fabric, with colourful mochila webbing handles', however a *Toronto Star* article reports that the straps are 'woven by artisans in Spain'. Derick Chetty, 'Lauren Bush Lauren Hopes to Save the World, One Bag at a Time', *Toronto Star*, 8 May 2012, https://www.thestar.com/life/fashion_style/2012/05/08/lauren_bush_lauren_hopes_to_save_the_world_one_bag_at_a_time.html (accessed September 2012). Bush Lauren says of Tory Burch that 'they found this amazing strap in the four different

colours', in the *Flare* interview, but the supply chain is unclear. Mosha Lundström Halbert, 'Canadian Exclusive: Tory Burch & Lauren Bush Lauren Create FEED Bag for Holt Renfrew,' *Flare*, 23 May 2012, http://www.flare.com/fashion/canadian-exclusive-tory-burch-lauren-bush-lauren-create-feed-bag-for-holt-renfrew/ (accessed September 2012 and 20 December 2017).

40 'General FEED Questions' https://www.feedprojects.com/help?page=1 (accessed 9 December 2017).

41 'History,' FEED Projects, http://www.feedprojects.com/history (accessed 20 September 2013), and product tag, Tory Burch + FEED, released April 2012.

42 'FEED is a social business, which means there is an enduring principle at the heart of what we do: people's choices of what to buy and wear have the power to change the world.' 'About FEED: We Make Good Products' https://www.feedprojects.com/about-feed (accessed 8 December 2017) (emphasis added).

43 'About FEED: Our Founder', https://www.feedprojects.com/about-feed (accessed 8 December 2017).

44 Urban Outfitters' appropriation of Navaho patterns, the racist neocolonial 'dsquaw' Fall 2015 collection by Canadian designers DSquared, and Victoria's Secret's use of a 'Native-American' style headdress in 2012 runway shows are only a few examples.

45 Dawkins, 'Do-It-Yourself', 263.

46 Mathew Snow, 'Against Charity', *Jacobin*, 21 February 2015, https://www.jacobinmag.com/2015/08/peter-singer-charity-effective-altruism (accessed 21 May 2019).

47 *Fostering and Communicating Sustainable Lifestyles: Principles and Emerging Practices.* United Nations Environment Programme – Sustainable Lifestyles, Cities and Industry Branch (UN Environment), 2016, 103. See also Nicola Spurling, Andrew McMeekin, Elizabeth Shove, Dale Southerton, Daniel Wlech, *Interventions in Practice: Reframing Policy Approaches to Consumer Behaviour, Sustainable Practices Research Group Report*, September 2013.

48 H. de Coninck, A. Revi, M. Babiker, P. Bertoldi, M. Buckeridge, A. Cartwright, W. Dong, J. Ford, S. Fuss, J.-C. Hourcade, D. Ley, R. Mechler, P. Newman, A. Revokatova, S. Schultz, L. Steg, and T. Sugiyama 'Strengthening and Implementing the Global Response,' in *Global Warming of 1.5°C. An IPCC Special Report on the Impacts of Global Warming of 1.5°C above Pre-industrial Levels and Related Global Greenhouse Gas Emission Pathways, in the Context of Strengthening the Global Response to the Threat of Climate Change, Sustainable Development, and Efforts to Eradicate Poverty*, (eds.) V. Masson-Delmotte, Masson-Delmotte, V., P. Zhai, H.-O. Pörtner, D. Roberts, J. Skea, P.R. Shukla, A. Pirani, W. Moufouma-Okia, C. Péan, R. Pidcock, S. Connors, J.B.R. Matthews, Y. Chen, X. Zhou, M.I. Gomis, E. Lonnoy, T. Maycock, M. Tignor, and T. Waterfield, (The Intergovernmental Panel on Climate Change, 2018), 315.

49 Grace Dobush, 'How Etsy Alienated Its Crafters and Lost Its Soul', *Wired*, 19 February 2015, https://www.wired.com/2015/02/etsy-not-good-for-crafters/ (accessed 7 December 2017).

50 Liz Core, 'Can Etsy Blow Up and Keep its Soul?' *Grist*, 4 March 2015, http://grist.org/living/can-etsy-blow-up-and-keep-its-soul/ (accessed 7 December 2017).

51 Dobush, 'How Etsy Alienated Its Crafters'.

52 'Etsy – Your Place to Buy and Sell all Things Handmade …'. Available at https://www.
etsy.com/ (accessed 16 June 2015), quoted in Morris, 'You Are Not a Lemming, 9.

53 Craft Ontario, *Citizens of Craft,* http://citizensofcraft.ca/ (accessed 6 December
2017). This campaign launched in Toronto, Canada, on 14 March 2015 at the *Crafting
Sustainability* conference. On 15 March, we delivered an earlier version of this
essay, that included a short analysis of the previous evening's launch in the context
of craftwashing. The term 'citizens of craft' is also used by Nicholas Bell to describe
the rise of a 'refreshing' new 'class of historians, curators, critics and practitioners
who are engaged in craft … from outside its traditional hubs' of the post-war studio
craft movement in America. 'Introduction', *Nation Building: Craft and Contemporary
American Culture*, ed. Nicholas R. Bell (London: Bloomsbury, 2015), 11–19.

54 Morris, 'You Are Not a Lemming,' 9.

55 Glenn Adamson, *The Invention of Craft* (London: Bloomsbury, 2013), xxi.

56 Kirsty Robertson, 'Embroidery Pirates and Fashion Victims: Textiles, Craft and
Copyright', *Textile: Journal of Cloth and Culture*, vol. 8, no. 1 (2010): 86–111.

57 Dawkins, 'Do-It-Yourself', 268.

58 Jenni Sorkin, 'Craftlike: The Illusion of Authenticity', *Nation Building: Craft and
Contemporary American Culture*, ed. Nicholas R. Bell (London: Bloomsbury,
2015), 75.

59 Morris, 'You Are Not a Lemming,' 10.

2 ETHICAL FASHION, CRAFT AND THE NEW SPIRIT OF GLOBAL CAPITALISM

Elke Gaugele

When the UN Global Compact, the 'world's largest corporate sustainability initiative … for achieving a better world',[1] was presented to the World Economic Forum in 1999, it established a new arena for the aesthetics and politics of cloth. In the years that followed, designers and fashion labels began to position themselves as activists struggling against climate change, ecological crisis, overconsumption and the exploitation of labour. Stripping for People for the Ethical Treatment of Animals, urging people to 'buy nothing' and to 'vote green' were some of Dame Vivienne Westwood's most important fashion messages from 2010 onwards.[2] And in 2012, Westwood launched her spring collection during London Fashion Week at the closing ceremony of the Paralympics dressed as an eco-warrior and unfurling a 'Climate Revolution' banner (Figure 2.1).

At least some years before punk's 40th anniversary in 2016 and its final co-option by the mainstream, Westwood referenced her own countercultural and punk roots by reinventing herself as a tempestuous climate activist, and by promoting ethical fashion and launching her 'Handmade with love' collection. The collection consists of hand-beaded clutches and key rings made by Maasai craftspeople, but also items made of recycled canvas, roadside banners and brass. Westwood's enterprise earnestly promotes these as being crafted in 'Nairobi's biggest slum'.[3] In the last decade, ethicality – and with it charitable notions of doing good – has become part of the core business of the fashion industry, not only for global luxury designers such as Westwood, but also by fast-fashion companies.

This 'ethical turn' in fashion and textiles is part of a new politics of craft and craftwashing (see Anthea Black and Nicole Burisch, Chapter 1) in the contemporary period of globalization, characterized by the expansion of neoliberalism after 1989. A parallel field of antiglobalization critique has emerged

FIGURE 2.1 'Designer Vivienne Westwood walks on the catwalk by Vivienne Westwood Red Label on day 3 of London Fashion Week Spring/Summer 2013, at the British Foreign & Commonwealth Office', 16 September 2012, London, England. Photo: Gareth Cattermole/Getty Images.

with non-governmental organizations (NGOs) like the Clean Clothes Campaign (CCC) and other environmental, human rights or labour rights organizations. This essay examines the background and critiques of the ethical turn in fashion, and draws upon a postcolonial feminist perspective on human rights cultures outlined by Gayatri Chakravorty Spivak in 'Righting Wrongs'.[4] In order to investigate the interrelations between capitalism and critique – the undertones of the contemporary politics of craftwashing at play in the examples addressed here – Spivak's theoretical perspective is read alongside concepts outlined in Luc Boltanski and Eve Chiapello's 2003 *The New Spirit of Capitalism*.[5] In order to better understand the contemporary political and economic framework of craftwashing and its connections to the global fashion industry, I outline the following two strands: the political sphere of bluewashing and craftwashing within global governance politics; and the UN Ethical Fashion Initiative's mission for African textile handicraft as a tool for governance and policy development in cooperation with Vivienne Westwood and other luxury fashion designers. The essay closes with a discussion on the integration of craft, sustainability and social critique into contemporary global capitalism.

Green(washing), blue(washing) and the UN Global Compact

The UN Global Compact is the historic starting point of the contemporary ethical turn in fashion and textiles, and will be discussed here in relation to craftwashing and its connections to the neoliberal economic agenda of bluewashing. The framework for the organization was set up under the normative umbrella of the United Nations, merging the economic interests of global enterprises with norm positing claims directly lifted from social, ecological and humanitarian antiglobalization activism. Like the term 'whitewashing', green- and bluewashing are also associated with textiles and connotations of craft techniques such as dyeing, bleaching or painting as a means to conceal or erase the truth. The term 'greenwashing' is defined as 'disinformation disseminated by an organization so as to present an environmentally responsible public image'.[6] The term was coined by groups who were active in the environmental movements of the 1970s and 1980s; previously they had used the colour green to signify connections to environmental issues and eco-friendliness.[7] Similarly, bluewash(ing) references globalization and the blue flag of the United Nations, and the term emerged as the United Nations began to address questions of sustainability and social justice through global governance. Bluewashing, which was first employed as a term to critique ineffective humanitarian intervention, now became a term to critique non-binding corporate partnerships formed under the blue flag of the UN Global Compact initiative. Following the increased involvement of NGOs in the 1990s, the UN invited non- and intergovernmental organizations and actors for international policymaking and normative positioning. Since then, NGO ethics have influenced the establishment of core global normative values on a UN-level much more than before. Consequently, possibilities for participation in these initiatives were opened up to business representatives in the 2000s.[8] Whereas NGOs such as CCC or the International Labour Organization (ILO) had consistently fought for solidarity and better working conditions for the workers and casualties of the sweatshops of the global fashion industry, in 1999 UN Secretary General Kofi Annan adapted their statements to launch the Global Compact as a programme for corporations who aimed to define their 'business as a force for good'.[9] The Global Compact's ten principles remain rather imprecise in their adaption of the Universal Declaration of Human Rights, the ILO's Declaration on Fundamental Principles and Rights at Work, the Rio Declaration on Environment and Development and the United Nations Convention Against Corruption.[10] The first principle states 'businesses should support and respect the protection of internationally proclaimed human rights' and principle two insists 'that they are not complicit in human rights abuses'.[11] Principles three to six refer to labour rights and claim that businesses

should 'uphold the freedom of association and the effective recognition of the right to collective bargaining', foster 'the elimination of all forms of forced and compulsory labour' and should work on 'effective abolition of child labour' as well as on 'the elimination of discrimination'.[12] Principles seven to nine concern environmental issues and such vague demands such as enterprises should 'support a precautionary approach to environmental challenges', 'undertake initiatives to promote greater environmental responsibility' and 'encourage the development and diffusion of environmentally friendly technologies'.[13] The tenth principle postulates anti-corruption: 'Businesses should work against corruption in all its forms, including extortion and bribery'.[14] However, participation in and control of the ten Global Compact principles in the areas of human rights, labour, environment and anti-corruption have been voluntary and unenforceable from the beginning. By the 2000s, most big companies had started to use the keywords and values determined by the UN documents to build their identities around corporate social responsibility and frame their activities.

A number of players within the fashion industry continue to use their commitments to social responsibility and humanitarian action as a public relations front and for their own economic benefit: Levi's Water<less jeans, H&M's Conscious Collection, Fast Retailing Ltd.'s (Uniqlo) donation of clothes for Middle Eastern refugee camps or Primark's (Associated British Foods [ABF]) doubtful self-representation as an ethical partner following the catastrophic collapse of the Rana Plaza factory building in Bangladesh in 2013. For example, the Primark website features a whole section on 'Our Ethics',[15] where, in 2016, the company described their compensations for Rana Plaza victims and, in 2019, shows a '360 virtual tour' through a tidy Bangladeshi factory, as well as its corporate partnerships with NGOs such as the Ethical Trading Initiative, Newlife the Charity for Disabled Children or the Partnership for Cleaner Textile. Last but not least, the fast-fashion company portrays itself as a model of ethical business practices by offering downloads of educational resources for teachers and students in business studies.[16]

As terms like 'organic growth', 'human rights' or 'sustained investment policy' have migrated from the principles of the Global Compact into annual reports for investors, an enormous number of fashion firms have started to issue press releases and include information on their websites to represent their social and environmental responsibility and humanitarian engagement. These documents often feature colourful images of racialized textile workers and craftswomen. Representations of Western ethicality are here signalled by images of 'exotic' and distant people, places and practices, enabling the industry to pursue its exploitation while making few concrete changes to their supply chain.[17] The British global fashion company Monsoon/Accessorize exemplifies this strategy with advertisements displaying 'beautiful pieces that have been handmade by craftsmen and women, using traditional techniques passed down through generations'.[18] The

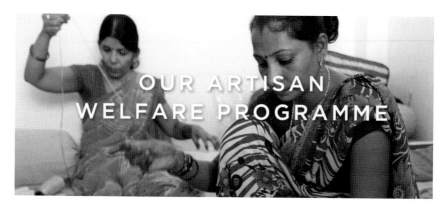

FIGURE 2.2 Monsoon/Accessorize Artisan Welfare Programme. Courtesy: Monsoon/Accessorize.

company even claims to run an Artisan Welfare Programme (Figure 2.2) for craft projects 'across Asia', currently based in India and Afghanistan, represented by images of women in colourful saris unrolling threads. However, scores from the Fashion Transparency Index, which investigates the one hundred largest global fashion companies, reveal that Monsoon/Accessorize has been rated below 10 per cent on its realization of the information published on their social and environmental policies, practices and impacts in 2017.[19] One could name this craftwashing as the firm articulates their corporate identity with catchphrases like 'artisan', 'ethical trading', 'charity' and 'sustainability'.[20]

The craftwashing strategies in the Monsoon/Accessorize campaign correspond with Development and Environmental Policy Project's specialist Chukwumerjie Okereke's analysis of the way that neoliberal appeal is closely connected to the promise to simultaneously deliver economic growth as well as environmental and cultural protection.[21] In this campaign (and others like it), textiles and crafts act as visual, physically sensible representations of humanitarian, labour and ecological norms and values established by the global agenda. Given this perspective, global craft can be discussed in relation to what Jacques Rancière terms an 'aesthetic metapolitics'.[22] For Rancière, metapolitics attempts to realize what politics can only give the appearance of achieving: to change not only the law and order of the state, but also the specific forms of individual lives. Thus, the contemporary ethical discourse, Rancière states: 'is only the point of honour given to the new forms of domination'.[23] Spivak also points out that an ethical imperative always acts as a force of hierarchization that 'may carry within itself the agenda of a kind of social Darwinism – the fittest must shoulder the burden of righting the wrongs of the unfit – and the possibility of an alibi'.[24] On a military level, notions of ethical responsibility and of making oneself a 'force for good' in the world are a common formula for justifying interventions in sovereign countries.[25] Likewise, economic

notions of honour, doing-good and participation in ethical discourses mirror new forms of domination on a global scale: a neoliberal shift that merges power relations of global governance policies with those of Western economies and societies. Further, we might consider how these initiatives impose Western taste on Indigenous production and crafts, perpetuating a form of cultural colonialism.[26]

The professionalization and institutionalization of communication among NGOs, and their cooperation with corporations, also partly weakens their claims.[27] In these new forms of governance, more than two-thirds of NGOs accredited by the United Nations are from industrialized countries, and this tends to influence majority-voting situations in UN discussions. This gives rise to overlapping interests of NGOs and industrialized countries with regard to questions of labour rights and environmental standards, which are denied in many countries of the global South because of over-regulation and protectionist arrangements. Though countries of the global South hold the majority of votes in intergovernmental arenas such as the General Assembly of the United Nations, they often cannot enforce their interests. And even when NGOs are based in the global South, there is no guarantee that they act in the interest of the local population instead of representing particular interests of global capitalist elites.[28] As a result of global governance initiatives within global politics, the United Nations has become one actor among many, and during the last decades many NGOs gained influence where traditional humanitarian organizations lost ground.[29]

From blue helmets to fashion and craft: Policies of global governance[30]

Making a political 'jump … from blue helmets, to food aid to fashion,'[31] in 2006 the United Nations turned to ethical fashion and crafts as a political tool for global governance with the establishment of the UN Ethical Fashion Initiative by the International Trade Centre (ITC) as a Joint Body Initiative of the United Nations and the World Trade Organization in Geneva. An article entitled 'Why Is the United Nations Working in Fashion?' questions the UN's shift from peacekeeping interventions and humanitarian assistance to fashion as a political tool for governance and development aid: 'To move from humanitarian assistance to development, one thing the United Nations does is to invest in economic development by helping such countries build the skills to export. And hence the jump … from blue helmets, to food aid to fashion.'[32] The United Nations first developed its ethical fashion program as a governance strategy for pacification in countries such as Côte d'Ivoire, Sri Lanka, Ethiopia and Mozambique that had experienced or were recovering from civil conflict. Aiming to bridge 'the work of development and the fashion system', the initiative mainly focuses on creating new niche markets for luxury fashion: 'We connect the poorest of the poor to the

markets of the world via fashion.'[33] In 2010, a second UN Ethical Fashion Initiative, titled Fashion4Development (F4D) and aimed at assisting African designers, began under the patronage of Bangladeshi supermodel and designer Bibi Russell. Since then, Russell has been replaced by role model Evie Evangelou, and F4D's concept has shifted to focus on charity events such as global runway shows and class-specific First Ladies Luncheons organized by Madame Ban Soon-Taek (the wife of UN Secretary General 2007–2016 Ban Ki-Moon) stressing that the fashion industry could lift people from poverty.[34] More recently with António Guterres as the secretary general, the event, still under the patronage of Evangelou, cooperates with the Organization of African First Ladies against HIV/AIDS (OAFLA).[35]

Currently, the Ethical Fashion Initiative works with African fashion designers to promote their work. In 2015, four designers were invited to Florence for the *Constellation Africa Show* at Pitti's menswear fashion fair: Nigerian label Orange Culture by Adebayo Oke-Lawal, South African knitwear brand MaXhosa by Laduma Ngxokolo, Projecto Mental by Tekasala Ma'at Nzinga and Shunnoz Fiel from Angola, as well as British-Ivorian Alexis Temomanin's label Dent de Man.[36] One year later, the Ethical Fashion Initiative's second *Generation Africa Show* showcased 'the creativity of Africa'[37] from a different angle. Featuring the Autumn/Winter 2016–17 collections of AKJP, Ikiré Jones, Lukhanyo Mdinigi and Nicholas Coutts and U.Mi-1, the show gained a lot of attention, as three asylum seekers were invited to model on the runway, staged to be looked at as 'part of an empowering international event celebrating creativity from Africa', 'to raise awareness on migration', to 'demonstrate fashion's capacity to support the betterment of society' and give 'them an opportunity to earn a wage'.[38] After the show, Simone Cipriani, leader of the Ethical Fashion Initiative announced a pilot program to assist asylum seekers with finding work in Italy's fashion industry, and training them for employment, if they would return to their country of birth.[39]

Since 2006, the Ethical Fashion Initiative has built a new globally governed ethical regime of fashion and craft with an economy based on more than 7,000 artisans mostly from African countries Burkina Faso, Ethiopia, Ghana, Kenya, Mali, as well as from Haiti, Cambodia and the West Bank of Palestine. The UN International Trade Centre has established bases in Haiti; Nairobi, Keyna; and Accra, Ghana, and it even aims to expand to new areas soon, notably in Brazil, India, Mexico and Peru.[40] Niche markets, and especially the production of crafts, described as 'the skills of the artisans',[41] are highly rated within both fashion and UN initiatives as strategies for so-called developing countries that are not set up to compete with high-volume, low-cost manufacturing states. Thus, each country is represented by its specific crafts: Haiti for 'horn with carving, fer découpé using discarded steel oil drums, papier-mâché, beadwork, paper beads and patchwork quilting'; Burkina Faso and Mali for dyeing yarn, spinning yarn, hand-weaving, bogolan (traditionally dyed cotton fabrics with fermented mud), basilan dyeing (using a variety of local vegetable tinctures, earth pigments and

minerals) and indigo textile design techniques and Kenya for 'beading, sewing, stitching, crocheting, embroidery, brass work, horn and bone carving'.[42] Though the Ethical Fashion Initiative praises itself for having 'access to the most talented craftspeople with artisanal skills linking back to their cultural heritage',[43] it trades crafts as though they were natural resources that can be mined for the global fashion industry, capitalizing on craft's association with authenticity, sustainability and ethics. This again coincides with Okereke's analysis of how the ethics of global sustainability intertwine with neoliberal ideas of justice.[44] He states that neoliberalism is not only a political and economic concept, but also an environmental and ethical project with distinctive modes of resource appropriation, property rights, as well as the intensification of ethnic, tribal and vernacular references, and the commodification of nature.

The UN Ethical Fashion Initiative fosters these neoliberal strategies by encouraging a broad variety of ecological textile techniques and traditional handicrafts, while positioning the skills of local artisans as a source of inspiration for the global market: 'This inspires fashion designers from around the world and gives fashion brands a unique opportunity to produce authentic ethical fashion goods.'[45]

Just as craftworkers are featured on the websites of the global fashion enterprises, the UN Ethical Fashion Initiative also uses marketing images of artisans wearing colourful dress, spinning, dyeing, sewing and hand-weaving in single or collective poses, such as a group of Black craftswomen in Burkina Faso working with cotton to spin yarn for weaving (Figure 2.3). The predominantly Black artisans and textile workers of the Ethical Fashion Initiative produce work mainly for white Western luxury labels and class-specific consumers of Carmina Campus, Sass & Bide, Stella McCartney, Stella Jean, Mimco or jeweller Chan Luu.[46] In an exemplary case, Vivienne Westwood referenced the economic angle of the UN Ethical Fashion Initiative when she produced her *Ethical Fashion Africa Collection* in Kenya.[47]

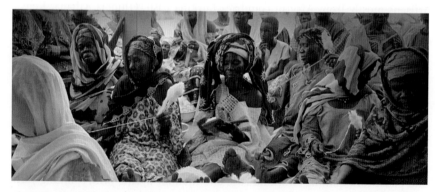

FIGURE 2.3 Women in Burkina Faso process cotton to make yarn for weaving. Courtesy: Ethical Fashion Initiative.

Westwood's collection became a flagship campaign for the Ethical Fashion Initiative with politically inflected catchphrases such as 'We are not a charity, this is work' and calling upon women's emancipation with a tone reminiscent of what Spivak has termed the 'white woman's burden of the fittest'.[48] Materials from the campaign state: 'Our overarching goal is to empower women.'[49] Cipriani, head of the UN Ethical Fashion Initiative speaks of the mutual benefit for luxury designers: 'we connect the most marginalized people to the top of fashion's value chain for mutual benefit.'[50] As part of this swap, Westwood receives and flaunts her status as a do-gooder. 'It's quite incredible to think that we might be able to save the world through fashion,'[51] Westwood has said in press interviews. Artist Juergen Teller, who photographed the *Ethical Fashion Africa Collection* in Kenya, did the same: 'we were part of something good, not such fashion-idiots.'[52] Nevertheless, Teller staged a promotional photograph of Westwood herself posed in a garbage dump wearing a draped dress printed with Rubens's 1618 painting *The Rape of the Daughters of Leucippus*, laced boots, ankle warmers, and carrying her Gold Label handbag with the slogan 'I'm expensive' (Figure 2.4, Plate 2). Though the colonial lens of a classy, white gaze the campaign betrays a 'slumming chic' where the brown-and-white colour palate and visual language of Westwood's baroque-printed gown stylishly match with pieces of garbage underfoot, signs of environmental disaster and the signifiers of poverty represented by the wooden shelters in the backdrop of the site. The campaign has been widely criticized, for example by Kyle Tregurtha from

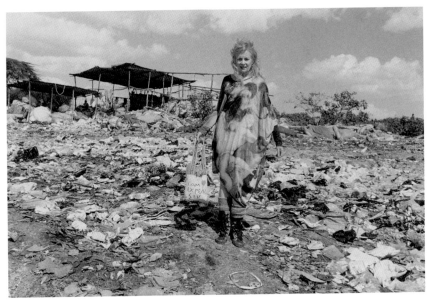

FIGURE 2.4 Juergen Teller, *Vivienne, Vivienne Westwood campaign, Autumn Winter 2011, Nairobi*, 2011. Courtesy: Juergen Teller.

Another Africa, who points out that the campaign's default position towards Africa is defined by 'poverty and calamity', is 'reminiscent of missionary work' as well as 'patronizing' in an outdated colonial manner.[53]

Correspondingly, the Ethical Fashion Initiative and its network of partners in the global luxury industry have distributed a new definition of 'luxury' that highlights the accumulation of ethical capital: today's luxury should be socially responsible and ethical, and should also be sustainable from an economic viewpoint. This definition was first proposed at the *International Herald Tribune* 2012 luxury conference entitled *Empowering African Artisans* by key actors from the Ethical Fashion Initiative like Cipriani, Fendi and Westwood under the patronage of fashion critic of Suzy Menkes, where they discussed Africa's potential as an ultimate consumer of luxury goods.[54] Under the auspices of so-called mutual benefit, a new 'fashion value chain'[55] emerged, thus fabricating a conscious class of ethically 'better' and morally superior consumers. In summary, the UN Ethical Fashion Initiative aims for both: peacekeeping strategies and a working business where – using Spivak's term – 'subaltern' artisans and textile workers manufacture ethical capital as an added value for Western consumers, as well as for the global fashion industry.

Following Spivak's diagnosis, we can identify an 'implicit connection between world governance and the self-styled international civil society.'[56] The International Trade Centre's Executive Director Patricia Francis even acts as a booster for the political interconnection between ethical fashion and governance on her level: 'The glossy world of fashion is far removed from blue helmets, food aid or peace treaties – but it is also part of the United Nations' work to ensure the world's people have better, safer lives.'[57] However, Spivak identifies important concerns about these kinds of global social movements:

> The leaders from the domestic 'below' – for the subaltern an 'above' – not realizing the historically established discontinuity between themselves and the subaltern, counsel self-help with great supervisory benevolence. This is important to remember because the subalterns' obvious inability to do so without sustained supervision is seen as proof of the need for continued intervention.[58]

Spivak also points out that contemporary human rights discourses are fuelled by relentless ideological pressure from the global North, even when they are initiated in the South.[59] According to her, ethical practices create hierarchical orders where the subjects and producers of the work of righting wrongs 'shared above a class line that to some extent and unevenly cuts across race and the North-South divide.'[60] It is remarkable that 'Righting Wrongs' uses textile metaphors to define the subaltern, emphasizing their removal from the 'dominant loom' as Spivak writes. She continues, 'see the same knit textile as a torn cultural fabric in terms of

its removal from the dominant loom in a historical moment. That is what it means to be a subaltern.'[61] The 'subordinate subaltern', is as diverse as the 'recipients of Human Rights activity'[62]:

> I use the word subordinate here because they are the recipients of human rights bounty, which I see as 'the burden of the fittest,' and which … has the ambivalent structure of enabling violation that anyone of goodwill associates with the white man's burden.[63]

From a historical perspective, practices of ethical fashion and its understandings of craft follow in the colonial tradition of white charity, and in the history of industrialization where textile labour had become a social instrument of gender and class distinction. In 1904, German philosopher Georg Simmel had already formatted a critique of fashion and honour in the modern age by underscoring the class-formative function of both: 'Fashion … is a product of class distinction and operates like a number of other forms, honour especially, the double function of which consists of revolving within a given circle.'[64]

Currently, the hierarchical structuring of class, race and gender through textile labour, craft and fashion are redefined and adapted by the neoliberal global economy under the signs of ecology, social justice and ethical consumption. Sociologist Patrik Aspers argues that global capitalism is still in an early stage, 'and in the same way as capitalism caused social commodities in the West during its Early Phases, global capitalism does in the developing world.'[65] These contemporary initiatives are historically connected to the class-specific gestures of welfare practices in the early stages of modern Western liberalist capitalism, where women in need were trained and employed for textile workshops and homework. Contemporary neoliberalism similarly leverages the idea of 'female empowerment', and in the case of the UN Ethical Fashion Initiative emphasizes that their employees live in 'slums' and 'rural areas'.[66] Stella McCartney calls upon this class-specific language of charitable action to advertise her Noemi Leopard Print Tote bag with: 'This tote bag is made with the United Nations International Trade Centre which provides work to disadvantaged communities in Kenya.'[67] McCartney's marketing positions handmade craft as a relic of a barter deal between the supposedly impoverished global South and Western ethical consumers: 'Each is created by hand from printing to stitching and our production has reached 160 people in poverty stricken areas.'[68] Following Spivak, the teaching of benevolence and to be a 'helper', is cultural absolutism at its worst. The simple economic act of remunerating people acceptably for their labour is thus transformed into a performative ethical act of class hierarchy. Just as Spivak highlights how 'the burden of the fittest' and the duty of re-territorializing 'the white man's burden'[69] currently touches the economic sphere, Simone Cipriani, head of the UN Ethical Fashion Initiative, claims to have created a new business model. He

calls this 'a system to organize employment and therefore give dignity to people', stating that 'another kind of fashion is possible, bringing social and environmental sensibility'.[70] However, Okereke argues that ecological modernization discourses and the related concepts of the 'good life' represent a very powerful handmaiden of the neoliberal project: 'The first fault line between sustainable development and the two neoliberal notions of justice lies in the way in which the idea of the good life may be conceptualized. The problem resides in the fact that, although sustainability as [is] an ideal order ... [it] does not accept complete heterogeneity in conceptions of the good life.'[71] Therefore, for Western fashion brands and consumers to create the illusion of doing 'good work', a Western ideal of the good life must be imposed through the chain of production.

Craft(washing), sustainability and the new spirit of global capitalism

In their 2003 book, French sociologists Luc Boltanksi and Eve Chiapello introduce *The New Spirit of Capitalism* as the relevant ideology that justifies engagement in capitalism.[72] Their argument draws from Max Weber, who defined the *ethos* as the centre of the 'spirit of capitalism' and as a set of ethical motivations. While *ethos* might at first appear foreign to capitalist logic, it in fact inspires entrepreneurs to further accumulate capital.[73] Weber stresses that rational modern capitalism simply exists through the ethical restriction of the legitimate forms of monetary acquisition.[74] The spirit of capitalism itself is characterized by historically variable patterns of values that mainly result in a dynamic relation between capitalism and critique.[75] Critique is the driving force in changes of the spirit of capitalism,[76] and Boltanski and Chiapello describe two forms of critique with historical roots in the nineteenth century: 'the artistic critique, which elaborates demands for liberation and authenticity, and the social critique, which denounces poverty and exploitation.'[77] While practices of institutional critique in the art world have been integrated into the discourse of capitalism and therefore partially satisfied during the 1990s, Boltanski and Chiapello suggest that we are witnessing the revival of social critique in the twenty-first century.[78] Following this, the discourses of ethical fashion signify a shift towards this new spirit of capitalism, where global capitalism aims to integrate social critique into its system. The values proposed by ethical fashion and the parallel rise of craft(washing) can be seen as part of such a 'new spirit', anchored in the social and ecological antiglobalization critique of the 1990s as well as its neoliberal adaptions by the Global Compact and enterprises described earlier.

As part of this commodification, fashion and handicraft become the carriers of emotions like love and trust or of virtues like honesty, and call upon ecology and sustainability. Marketing researchers have demonstrated in detail how love is named as the most important driver for the appeal of a 'handmade effect': made

with artisan love and containing love of a symbolic nature.[79] More precisely, this is a major incentive for craftwashing, as Western consumers follow this handmade affect and indicate stronger purchasing intentions and the will to pay more for handmade products, for example, when buying gifts for their loved ones.[80] At the same time, ethical fashion gains a quasi-religious implication 'in which ethical referred to philosophically guided actions and behaviours as determined by their impact on others'.[81] In response, the perception of honesty has become highly relevant in Western consumer decisions, alongside social responsibility and environmental consciousness. Today, apparel is regarded as a key market of green economics, and sales of textile goods has increased tenfold since 2000.[82] In 2014, several luxury fashion enterprises including the Dior Group, listed a growth of up to 12 per cent in organic fashion, perfumes, cosmetics, jewellery, wine and spirits.[83] Nevertheless, critical qualitative research in fashion and beauty has shown that the use of organic cosmetics is motivated more by 'egocentric than ecocentric concerns'.[84]

As Boltanski and Chiapello outline, capitalism requires reasons for committed engagement and must thus be orientated toward the common good.[85] Ethical fashion with its inherent shift from craftivism to craftwashing can be read as a dialectical operation, where global capitalism needs and uses the opponents of globalization to generate its ethos: 'As a result, it needs its enemies, people whom it outrages and who are opposed to it, to find the moral supports it lacks and to incorporate mechanisms of justice whose relevance it would otherwise have no reason to acknowledge.'[86]

NGOs like Clean Clothes Campaign have rigorously targeted the bluewashing of the Ethical Fashion segment of H&M.[87] Their adbusters-style critique of the *Conscious Collection* addressed the concerns for malnourished and underpaid workers in the Cambodian garment industry by redubbing the collection *Unconscious Collapses* and calling on H&M to live up to its 'conscious', 'sustainable' and 'responsible' declarations.[88]

Ethical fashion and its related interest in craft and textile labour mirror this dialectic and the ambivalent incorporation of antiglobalization critique into contemporary discourses of global capitalism such that, as Spivak says diversifies the 'subordinate subaltern' as the 'recipients of Human Rights activity'[89] and subordinates the structures of 'enabling violation' under the 'goodwill' of 'the white man's burden'.[90] However, the field of fashion theory and textile studies is slowly moving to offer critiques of the sustainability paradigm for its pioneering function in neocolonialist agendas. Presenting a rebuke to the 'ethics brigade', architectural critic Austin Williams has recently applied his critique of the emerging ethical and sustainability dogma to the field of fashion.[91] Similarly, cultural and fashion theorist Efrat Tseëlon has echoed Williams's questions on ethical fashion as a self-appointed authority that imposes itself on a so-called underdeveloped world.[92] Ethical fashion, Williams states, 'is a faddish interpretation of this

political agenda that provides moral authority as well as market leaderships'.[93] Showcases and marketing strategies for handicraft, the protection of artisans and traditional techniques, ethical object lessons, love, charity and sustainability are all preproduction modes for this neocolonial spirit of global capitalism. The craftivist politics embedded within 1990s antiglobalization critiques have been commoditized, transformed and craftwashed in service of corporate identities and the neoliberal and neocolonial economic order. Therefore, critical analysis of the paradigms 'sustainability' and 'ethicality' and questioning their function on the level of Global Governance is essential. It's time for a shift in fashion and textile studies toward decolonial queer-feminist perspectives on human right cultures and politics on a global scale.

Notes

1 'Our Mission', United Nations Global Compact, https://www.unglobalcompact.org/what-is-gc/mission (accessed 9 April 2019).

2 'Vivienne Westwood's Top Ten Political Moments', *Dazed*, http://www.dazeddigital.com/fashion/article/24335/1/vivienne-westwood-s-top-ten-political-moments (accessed 25 May 2016).

3 'Our Partners, Vivienne Westwood', Ethical Fashion Initiative, http://ethicalfashioninitiative.org/partners/vivienne-westwood/ (accessed 25 May 2016).

4 Gayatri Chakravorty Spivak, 'Righting Wrongs', *South Atlantic Quarterly*, vol. CIII, no. 2/3 (Spring/Summer 2004): 523–48, http://muse.jhu.edu/article/169150 (accessed 9 April 2019).

5 Luc Boltanksi and Eve Chiapello, *The New Spirit of Capitalism* (London: Verso, 2005).

6 *Oxford Dictionaries* (Oxford, 1999), www.oxforddictionaries.com/de/definition/englisch/greenwash (accessed 9 April 2019).

7 The term *greenwashing* became popular and was even branded in the *Greenpeace Book on Greenwash*, published on the occasion of the 1992 Earth Summit in Rio de Janeiro. Bruno Kenny, *The Greenpeace Book of Greenwash* (Amsterdam: Greenpeace, 1992).

8 Tanja Brühl and Elvira Rosert, *Die UNO und Global Governance* (Wiesbaden: Springer VS, 2015), 375.

9 United Nations, Global Compact, www.unglobalcompact.org (accessed 9 April 2019).

10 'The Ten Principles of the UN Global Compact', UN Global Compact, https://www.unglobalcompact.org/what-is-gc/mission/principles (accessed 3 June 2016).

11 Ibid.

12 Ibid.

13 Ibid.

14 Ibid.

15 'Our Ethics', Primark, http://www.primark.com/en/our-ethics (accessed 3 June 2016 and 9 April 2019).

16 Ibid.

17 Efrat Tseëlon, 'Introduction: A Critique of the Ethical Fashion Paradigm', in *Fashion and Ethics: Critical Studies in Fashion and Beauty*, vol II, ed. Efrat Tseëlon (Chicago: University of Chicago Press, 2011), 17.

18 'Our Artisan Collection', Monsoon, www.uk.monsoon.co.uk/uk/women/artisan-trade (accessed 30 July 2015).

19 Rebecca Ley, '#whomademyclothes: Transparency Poor in Garment Supply Chain, Study Finds', http://www.ethicalcorp.com/whomademyclothes-transparency-poor-garment-supply-chain-study-finds (accessed 9 April 2019).

20 'Our Artisan Collection', Monsoon, www.uk.monsoon.co.uk/uk/women/artisan-trade (accessed 30 July 2015).

21 Chukwumerjie Okererke, *Global Justice and Neoliberal Environmental Governance. Ethics, Sustainable Development and International Co-Operation* (Oxon: Routledge, 2008), 186.

22 Jacques Rancière, 'The Ethical Turn of Aesthetics and Politics', *Critical Horizons*, vol. 7, no. 1 (2006): 18.

23 Ibid.

24 Spivak, 'Righting Wrongs', 550.

25 Austin Williams, 'Fashionable Dilemmas', in *Fashion and Ethics: Critical Studies in Fashion and Beauty*, vol. II, ed. Efrat Tseëlon (Chicago: University of Chicago Press, 2011), 79.

26 Tseëlon, 'Introduction', 17.

27 Brühl and Rosert, *UNO und Global Governance*, 373.

28 Ibid.

29 Ibid.

30 This paragraph includes a short passage from 'From Blue Helmets to Fashion and Craft: Policies of Global Governance', which is a revised section of a previously published essay by the author, Elke Gaugele, 'On the Ethical Turn in Fashion – Policies of Governance and the Fashioning of Social Critique', in *Aesthetic Politics in Fashion*, ed. Elke Gaugele (Berlin: Sternberg Press, 2014), 216–20.

31 Natalie Domeisen and Prema de Sousa, 'Why Is the United Nations Working in Fashion?' *International Trade Forum Magazine*, no. 3 (2006), www.tradeforum.org/Why-is-the-United-Nations-Working-in-Fashion (accessed 9 April 2019).

32 Ibid.

33 Ibid.

34 United Nations, Department of Public Information, News and Media Division, 'Press Conference on 'Fashion 4 Development, A Global Platform to Advance the Millennium Development Goals', New York, 28 June 2012, www.un.org/News/briefings/docs/2012/120628_Fashion.doc.ht and www.fashion4development.com/2013-annual-luncheon (accessed 30 July 2015).

35 'F4D's First Ladies Luncheon', Fashion 4 Development, www.fashion4development.com/first-ladies-luncheon (accessed 8 April 2019).

36 ' "Constellation Africa" show at Pitti Uomo', Fashion Revolution, http://fashionrevolution.org/constellation-africa-show-at-pitti-uomo/ (accessed 2 June 2016).

37 'Pitti Uomo 89', Ethical Fashion Initiative, http://ethicalfashioninitiative.org/events/pitti-uomo-89/ (accessed 2 June 2016).

38 Ibid.

39 Luke Leitch, 'Four African-Designed Labels Get Their Big Break at Pitti Uomo', *VOGUE* online 14 January 2016, http://www.vogue.com/13387669/generation-africa-show-pitti-uomo/ (accessed 9 April 2019).

40 'Where We Work', Ethical Fashion Initiativewww.ethicalfashioninitiative.org/where-we-work/ (accessed 30 July 2015).

41 'Ethical Fashion Initiative', International Trade Center, www.intracen.org/exporters/ethical-fashion/the-initiative (accessed 30 July 2015).

42 'Where We Work', Ethical Fashion Initiative.

43 'Ethical Manufacturing', Ethical Fashion Initiative, www.ethicalfashioninitiative.org/ethical-manufacturing/#products (accessed 30 July 2015).

44 Okererke, *Global Justice,*172–86.

45 Ibid.

46 'Ethical Manufacturing', Ethical Fashion Initiative.

47 Vivienne Westwood, 'This Is Not Charity, This Is Work', *Vivienne Westwood Ethical Fashion Initiative Collection*, 28 January 2011, www.viviennewestwood.co.uk/w/news/this-is-not-charity-this-is-work (accessed 14 July 2013).

48 Spivak, 'Righting Wrongs', 524.

49 International Trade Center, Ethical Fashion Initiative, 'We Use Fashion as a Vehicle Out of Poverty, at the Same Time Fulfilling Fashion's Desire to Be More Fair', www.intracen.org/exporters/ethical-fashion (accessed 30 July 2015).

50 Suzy Menkes, 'A Matchmaker Helps Artisans Find Luxury Jobs', *New York Times*, 14 November 2012, www.nytimes.com/2012/11/15/fashion/a-matchmaker-helps-artisans-find-luxury-jobs.html (accessed 9 April 2019).

51 Olivia Bergin, 'Vivienne Westwood's Mission to Save the World, One Handbag at a Time. The British Designer's New Range of Handbags Will Benefit the People of Kenya Who Handmake Them', *Telegraph*, 9 August 2011, www.fashion.telegraph.co.uk/news-features/TMG8691362/Vivienne-Westwoods-mission-to-save-the-world-one-handbag-at-a-time.html (accessed 14 July 2013).

52 Elisabeth Raether, 'Es sieht gut aus in Afrika', *ZEITmagazin*, no. 41, 6 October 2011, www.zeit.de/2011/41/KollektionWestwood (accessed 30 July 2015).

53 Kyle Tregurtha, 'Vivienne Westwood, A Slight of Cast, Caste & Casting', *Another Africa*, 16 March 2012, http://www.anotherafrica.net/design/advertising/vivienne-westwood-a-slight-of-cast-caste-casting (accessed 9 April 2019).

54 'The Promise of Africa. The Power of the Mediterranean', *International Herald Tribune*, Luxury Conference, Rome, 15–16 November 2012, www.ihtconferences.com/luxury-2012/press-coverage.aspx (accessed 30 July 2015).

55 Menkes, 'Matchmaker Helps Artisans Find Luxury Jobs'.

56 Spivak, 'Righting Wrongs', 550.

57 Domeisen and de Susa, 'United Nations Working in Fashion?'

58 Spivak, 'Righting Wrongs', 535.

59 Ibid., 257.

60 Ibid., 524.

61 Ibid., 544.

62 Ibid., 546.

63 Ibid., 544.

64 Georg Simmel, 'Fashion', *International Quarterly*, 10 (1904): 133, www.modetheorie. de/fileadmin/Texte/s/Simmel-Fashion_1904.pdf (accessed 9 April 2019).

65 Patrik Aspers, 'A Note on Global Capitalism', in *Global Capitalism: The Road Ahead*, ed. Bharti Thakar (Hyderabad: Icfai University Press, 2008), 13.

66 'Ethical Fashion Initiative', International Trade Center.

67 Stella McCartney, http://www.stellamccartney.com/ca/stella-mccartney/tote_ cod45267317or.html (accessed 10 September 2016).

68 Ibid.

69 Spivak, 'Righting Wrongs', 538.

70 Menkes, 'Matchmaker Helps Artisans Find Luxury Jobs'.

71 Okererke, *Global Justice*, 50.

72 Boltanksi and Chiapello, *New Spirit of Capitalism*, 9.

73 Ibid., 8.

74 Gabriele Wagner and Philipp Hessinger, 'Max Webers Protestantismus – These und der neue Geist des Kapitalismus', in *Ein neuer Geist des Kaptialismus? Paradoxien und Ambivalenzen der Netzwerkökonomie*, ed. Gabriele Wagner and Philipp Hessinger (Wiesbaden: Springer, 2008), 25.

75 Boltanski and Chiapello, *New Spirit of Capitalism*, 4.

76 Ibid., 28.

77 Ibid., 346.

78 Ibid.

79 Christoph Fuchs, Martin Schreier and Stijn van Osselaer, 'The Handmade Effect: What's Love Got to Do with It?' *Journal of Marketing*, vol. 79 (March 2015): 100, http://dx.doi.org/10.1509/jm.14.0018 (accessed 9 April 2019).

80 Ibid., 98.

81 Sue Thomas, 'From "Green Blur" to Ecofashion: Fashioning an Eco-Lexicon', *Fashion Theory: The Journal of Dress, Body and Culture*, vol. 12 (2008): 533.

82 The Co-Operative Group, *Ethical Consumer Markets Report 2012*, www. ethicalconsumer.org/linkclick.aspx?fileticket=96yXzu8nyrc%3D&tabid=1557 (accessed 22 July 2013).

83 'Combined Shareholders Meeting', Christian Dior Group, 9 December 2015, www. dior-finance.com/en-US/Documentation/PresentationDesResultats/pdf/2014-12_ ag_slides_en.pdf (accessed 9 April 2019).

84 Tseëlon, 'Introduction', 61.

85 Boltanksi and Chiapello, *New Spirit of Capitalism*, 28.

86 Ibid.

87 'Conscious? Not Really ...', Clean Clothes Campaign, 24 March 2013, www.cleanclothes.org/news/2013/03/25/conscious-not-really (accessed 9 April 2019).

88 Boltanksi and Chiapello, *New Spirit of Capitalism*, 28.

89 Spivak, 'Righting Wrongs', 546.

90 Ibid., 544.

91 Williams, 'Fashionable Dilemmas', 69.

92 Tseëlon, 'Introduction', 3–68.

93 Williams, 'Fashionable Dilemmas', 79.

3 SELVEN O'KEEF JARMON: BEADING ACROSS GEOGRAPHIES

Nicole Burisch

There's a small village in the Czech Republic called Desna. For over 150 years, the village has been the site for the production of glass beads, including the Preciosa Ornela factory whose seed beads are distributed around the world and used by groups from the Kayapo in the Amazon to the Masai Mara in Kenya. The factory's beads are sold in over 100 countries, and find their way into projects that span personal, religious or ceremonial, decorative and tourist uses.[1] This text looks at beading practices and their associated materials to read connections between places, economies and cultures, and to raise questions about the ways that so-called traditional craft practices circulate within a contemporary global (art) economy. The factory in Desna is an interesting starting point, as its functioning relies on and emerges from a history of exchange across sites and cultures: from glassmaking technology originating in Venice and adopted by Czech artisans over four centuries ago, to beads traded by colonizers and incorporated into Indigenous production throughout the Americas and Africa, to beading supplies that circulate today in a globalized craft economy.

To think through these relationships, this text focuses on *360 Degrees Vanishing*, a project spearheaded by Houston-based artist Selven O'Keef Jarmon (Plate 3). The project used beadworking practices from South Africa's Eastern Cape to create an architectural installation on the facade of the Art League of Houston (ALH), an artist-run space in Texas. Starting in 2014, Jarmon collaborated with the ALH, the Eastern Cape Provincial Arts and Culture Council (ECPACC) in East London, groups of local volunteers, and beaders Zukiswa Meme, Ntombosindiso Maphini, Zoliswa Mkangaye, Nolusindiso Jekemane, Mvuzo Ntlantsana, Joyce Kelele, Nontobeko Ndiki, Tyhilelwa Bolana, Bukelwa Mhlontlo, Thembeka Maphetshana, Nongenile Nyoka, Nonceba Zweni, Nozukile Sandile and Nozuko Mahlombe.

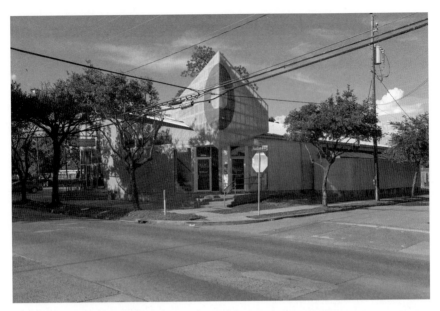

FIGURE 3.1 Selven O'Keef Jarmon, *360 Degrees Vanishing*, 2019. Photo: Alex Barber. Courtesy: Art League Houston.

Over a span of eighteen months, the beaders, from various Xhosa-speaking municipalities in the Eastern Cape and ranging in age from 22 to 78, travelled to Houston to work on the production of beaded panels, eventually assembled and installed in late June 2019[2] on the outside of the ALH (Figure 3.1). The large beads used in the *360 Degrees Vanishing* project are made of acrylic and sourced from The Beadery in Rhode Island, the last American company of its kind that produces such materials.[3] The final beaded installation with its circle of half green and half orange on a sparkling white background, takes production usually scaled for bodily adornment and increases it to an impressive architectural scale. The result covers the ALH building with the products of accumulated time and creative efforts of many hands, a visual representation of the communities that participated and the knowledge transmitted through the work of the beaders.

Most scholars of beadwork trace back the production and use of beads as one of the earliest forms of creative expression and exchange, with their circulation closely tied to the expansion and development of early trading networks.[4] Small, portable and highly desirable as a form of barter currency, beads have been manufactured and circulated since at least 40,000 years ago.[5] Métis beadwork scholar Sherry Farrell Racette describes how, in the nineteenth century, glass beads underwent processes of 'indigenization',[6] where materials introduced by colonizers became incorporated into the dress and traditions of Indigenous peoples: 'Women literally stitched new goods into daily and ceremonial life.'[7] Part of this process involves 'transferring older

meanings on to new forms'.[8] While Racette's writings are concerned with the history of beadwork in North America and its use by First Nations and Métis women, the process is similar for South African beadwork, with glass (and eventually plastic) beads replacing materials such as wood, shells, bone or seeds.[9] Thus, as curator Marie-Louise Labelle asserts, contemporary beadwork in this region 'can be seen as a continuation of a tradition that has been well established since time immemorial'.[10] The critical framing of beads within ongoing processes of indigenization unsettles the idea that an 'authentic' craft or art practice is necessarily tied to specific materials (as evidenced by the work of the many contemporary Indigenous artists who continue to incorporate a range of new materials into their practices). Instead this framing makes space for the fact that beading, like any other cultural practice, is rarely static or fixed. It is instead a dynamic and adaptable practice, specific to each place, that continues to evolve to this day.[11]

In southern Africa, small amounts of glass beads from India were introduced between 750 and 800 CE, the product of technologies and trade routes that 'were already thousands of years old'.[12] Specific beadwork patterns, styles and colours have been used to communicate information about the wearer, including leadership, age, marital status, spiritual practice or ethnic identity – while simultaneously being the product of cross-cultural exchange and influence.[13] Glass seed beads, like those produced in Desna, were introduced to the area in vast quantities following European colonization and trade in the early 1800s and adapted for local use, along with fabric.[14] Since then, both wearing and practicing beadwork have undergone shifts in cultural meaning, often in relation to the renegotiation of group identities and the artificial distinctions 'superimposed by successive colonial and apartheid regimes in attempts to entrench separate ethnic identities'.[15] In recent instances, the making and wearing of beadwork has been viewed by some as a 'symbol of resistance', a 'self-conscious statement of defiance against colonial and missionary attempts to redefine African culture and identity'.[16] Prior to this, beadwork was at times viewed as an outdated practice, and linked to broader conversations around the relevance and significance of wearing traditional dress.[17] Bulelwa Bam, manager of the Eastern Cape Arts and Crafts Hub, and the principal organizer of the South African participants for *360 Degrees Vanishing*, affirms that 'The Eastern Cape is made up of different tribes, and each tribe has its own traditional dress … distinct and different than the others'.[18] Bam also describes how, while these meanings and practices are still known and most people keep an outfit for ceremonial purposes, younger generations are less likely to adhere to the traditional determinations around colours and patterns, gender and age. Thinking through the connection to Desna and the Preciosa factory (who count the Xhosa-speaking groups in the Eastern Cape among their clients), beadwork remains a part of local traditions, while also undergoing changes due to modernization and the adaptation of the practice for sale to tourist markets.

FIGURE 3.2 Selven O'Keef Jarmon, *360 Degrees Vanishing*, 2014, artist's concept drawing. Courtesy: Selven O'Keef Jarmon.

360 Degrees Vanishing builds upon these developments, to draw attention to the skills and traditions of beadwork, and to counter the loss of knowledge around its uses. The ideas for the project emerged in the mid-2000s when Jarmon returned to South Africa, where he had previously lived and worked (Figure 3.2). As in his earlier projects, Jarmon sees *360 Degrees Vanishing* as a way to work with local producers to find ways to empower them through creative production. He became interested in beadworking, and the ways that older forms and techniques were being lost as beadworkers adapted their designs to appeal to tourist markets. Jarmon describes how previously 'these were not objects just meant to be sold on the streets to tourists as they are now. [They] had so much meaning and use in the culture: as a currency, in the house and in ceremonies. As these ceremonies disappeared and as people moved from the rural to the urban [areas], the significance and meaning was lost.'[19] The notion of a 'vanishing' culture is often perpetuated as part of colonial erasure and appropriation of Indigenous cultures. However, Jarmon's concerns about losing the knowledge of the traditional uses and colours of beadwork are echoed by Bam and the beaders themselves, along with the clear desire to maintain a connection to these histories. The *360 Degrees Vanishing* project addresses this situation, by centring the expertise of the older beaders in the creation of the installation in Houston. Most importantly, the beaders occupy a position of authority, their knowledge of beading practices and their significance remains at the core of the project (Figure 3.3, Plate 4). During their trips to Houston they taught beading to teams of local volunteers, and to

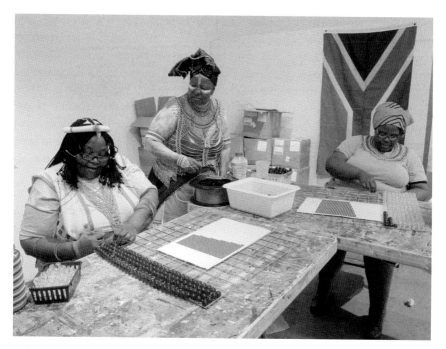

FIGURE 3.3 Selven O'Keef Jarmon, *360 Degrees Vanishing*, beaders working at Art League Houston, Houston, Texas, 2015. Photo: Peter Gershon.

younger South African beaders who were part of the visiting groups. Jarmon notes how this is a distinct contrast to how people from their area usually experience travel; most often they are sent abroad to *receive* training, whereas with this project they are the ones doing the training.[20] Not only is their knowledge and labour being valued (the beaders were all paid an honorarium), but because of their ongoing visits and presence, they are also connecting to and commenting on the culture of Houston as much as the other way around, in a way that unsettles the relationships between 'aid', 'visitors', 'experts' and 'tourists'.[21]

For Jarmon, the 'objective is to find a way to keep them in the creative seat while they think about other possibilities for what they could do with this thing they create … other markets, other perspectives'.[22] These aims are echoed in the 2014–2015 Annual Report of the ECPACC, which describes the project as a 'rare export of uniquely Eastern Cape skills to the international stage' and goes on to state that, '[T]his exporting of skills will result in immeasurable benefits for both the craft industry and our economy'.[23] Significantly, the language in both the ECPACC report and in Jarmon's discussion reveals a focus on how to monetize or 'find markets', as a key strategy for preserving and supporting beadworking knowledge. Value here, is clearly linked to the position of the practice within capitalist markets. Jarmon stresses that these practices 'already have value'[24] before

their incorporation into his project in Houston, suggesting that we might also question how various forms of cultural production might be valued, regardless of their viability within the market. In light of these considerations, it is worth unpacking the ways that value is communicated or acknowledged throughout the evolution of the project, and for its various participants.

In many ways, 'value' in Jarmon's project is constructed in relation to the position of the work within a contemporary art economy and the translation of a 'traditional' craft practice into this context, often in ways that emphasize process and community exchange. Jarmon and Bam both describe the ways that the project encourages dialogue, conversation, exchange and a sense of community. In this sense, *360 Degrees Vanishing* resembles other relational craft projects that focus on the performative and collaborative co-creation of craft as a core part of the work. This emphasis puts the project in line with those that capitalize on the performance and accessibility of social crafting in the gallery to engage viewer-participants and potentially effect social change (see Noni Brynjolson, Chapter 4). Similar to others like it, *360 Degrees Vanishing* raises questions about how to best acknowledge or document the labour of collaborative or relational craft projects: If value is centred around and produced through social exchange and collaboration, how are these relationships communicated, archived or supported during and beyond the run of the project?[25] And how are these aspects of the project represented in the final installation? *360 Degrees Vanishing* provided valuable space not only for the creation of the work, but also for the formation of relationships between participants and exchange between diverse communities – hopefully aspects that will continue to resonate in the completed installation.

In a related vein, *360 Degrees Vanishing* intersects with broader dialogues around the translation (and recent prevalence) of craft and other so-called outsider art practices within contemporary art spaces. These kinds of projects can highlight the problematic institutional politics and histories that frame this inclusion, particularly those that hinge upon the association of craft with 'outsider' or 'folk' art and the public performance of 'exotic' identity in relation to these frames. As curator Thomas J. Lax asks with regard to an exhibition at The Studio Museum in Harlem that combined objects and practices from Black artists working both within and outside the contemporary art world: 'What are the ethical, aesthetic and political consequences of transporting these objects into the context of a contemporary art museum?'[26] This line of questioning is invaluable and should continue to guide reflections on how institutions acknowledge the expertise, labour and creative autonomy of all artists – as well as the colonial histories that have shaped (and continue to shape) relationships between art and craft.[27]

360 Degrees Vanishing is also notable for the way it has leveraged funding across various private and public sources to support costs. Alongside the ALH and the ECPACC, the project received support from the Morgan Family Foundation, the Houston Arts Alliance, and institutional partners such as the

Houston Center for Contemporary Craft, Our Image Film and Arts, the City of Houston, Rice University, Texas Southern University, the Mitchell Center at the University of Houston and Workshop Houston among others.[28] Jarmon also raised funds through the sale of beaded souvenir items, a specially branded '360 Degrees' coffee blend, crowdfunding socials, South African themed cocktail events and soirees for wealthy art patrons. While these kinds of initiatives are de rigueur in Houston's art fundraising scene, there is nevertheless a substantial (and uncomfortable) difference between the community-based beading circles labouring to produce the panels and the elite partygoers featured in Houston's society pages attending these events. Value, in the form of cultural and social capital, is here accrued and leveraged across multiple sites and class registers. If economic advantages and new markets are part of the potential benefits for the project's creators and participants, it remains to be seen how these will be supported in the long term.

360 Degrees Vanishing is a multifaceted project that exemplifies one of the most interesting issues in craft and contemporary art today: namely, how so-called traditional practices accrue social, economic and artistic value as they move across geographic and cultural contexts. The historical and present-day global circulation of beads and the practice of beadwork make this an especially relevant project for thinking about these shifts, as well as considering how Indigenous cultural practices continue to circulate and function both locally and globally. With its emphasis on collaboration and empowerment, 360 Degrees Vanishing articulates one possible way for this work to take place. It also underscores the ongoing need for projects that place self-determination and a nuanced understanding of cultural economies at their centre.

This text begins with a factory in Desna, a small village whose connections can be traced across a global network of beadworking communities. At the time of writing, a story broke about another factory connected to bead production and glassmaking: Portland, Oregon-based Bullseye Glass came under suspicion for contributing to elevated levels of toxic and carcinogenic chemicals in the surrounding neighbourhoods. Bullseye suspended production of certain colours and in turn impacted a global community of artists and producers who relied on their products.[29] The Bullseye Glass example is a notable high-profile instance of the environmental impacts of beading materials coming under scrutiny, a kind of attention that could (and arguably should) be brought into any conversation around the production and circulation of craft. This case serves as a reminder that the raw materials for craft (whether glass or plastic) must always come from somewhere, and that this 'somewhere' is an actual place where people live, air circulates and rivers flow, and is connected not only to communities of crafters, but also to the land.

Notes

1 Rick Lyman, 'Glass Seed Beads Made in Czech Village Adorn Bodies of the World's Tribes', *New York Times*, 12 January 2016, http://www.nytimes.com/2016/01/13/world/europe/glass-beads-made-in-czech-village-adorn-bodies-of-the-worlds-tribes.html?_r=0 (accessed 24 August 2017). The article also details how the bead manufacturing industry as a whole has shifted over the last couple of decades, with cheaply produced plastic beads edging out smaller producers or family-run workshops in the village. Glass beads like Preciosa's are now often reserved for personal use or high-end projects destined for wealthy collectors.

2 The Art League of Houston suffered damage to its roof due to Hurricane Harvey, delaying the final installation of the project. Updates here: https://www.artleaguehouston.org/360-degrees-vanishing/ (accessed 5 January 2019).

3 Selven O'Keef Jarmon, email correspondence with the author, 21 September 2016.

4 Sharma Saitowitz, 'Towards a History of Glass Beads', in *Ezakwantu: Beadwork from the Eastern Cape*, catalogue published in conjunction with the exhibition of the same name at the South African National Gallery, 31 October 1993–29 May 1994 (Cape Town: South African National Gallery, 1993), 36.

5 Lois Sherr Dublin, *The History of Beads* (New York: Harry N. Abrams, 1987), 18.

6 Sherry Farrell Racette, 'My Grandmothers Loved to Trade: The Indigenization of European Trade Goods in Historic and Contemporary Canada', *Journal of Museum Ethnography*, no. 20 (March 2008): 69.

7 Ibid., 72. See also ' "Islands of Memory" and Places to Land: Haudenosaunee Beadwork in the Schreiber Collection', Alexandra Kehsenni:io Nahwegahbow, *NGC Review/Revue du MBAC*, (2018): 1–10.

8 Racette, 'My Grandmothers Loved to Trade', 71.

9 Saitowitz, 'Towards a History of Glass Beads', 41. See also Marie-Louise Labelle, *Beads of Life: Eastern and Southern African Beadwork from Canadian Collections* (Gatineau: Canadian Museum of Civilization, 2005), 51.

10 Labelle, *Beads of Life*, 2.

11 It is important to note that the ongoing work of rethinking outmoded colonial models for the framing of beadwork (and craft broadly) is a project that can be addressed through critical as well as curatorial approaches. The curator for the exhibition *Ezakwantu*, Emma Bedford, makes this goal explicit when she states that: 'Every attempt has been made to avoid presenting beadwork and the society which produced it as fixed in time and space; as if they had originated from a static or idealised past. The questionable notion of disappearing cultures has been abandoned in favour of underscoring the many and various ways in which beadwork has changed and continues to change.' Emma Bedford, ed., *Ezakwantu Beadwork from the Eastern Cape* (Cape Town: South African National Gallery, 1993), 10.

12 Dublin, *The History of Beads*, 140. See also Saitowitz, 'Towards a History of Glass Beads', 35–41 for an in-depth account of the history, development and use of beads in southern Africa, as well as details about their manufacture, export and trade.

13 Emma Bedford, 'Exploring Meanings and Identities: Beadwork from the Eastern Cape in the South African National Gallery', in *Ezakwantu: Beadwork from the Eastern Cape* (Cape Town: South African National Gallery, 1993), 14.

14 Labelle, *Beads of Life,* 49–51, Dublin, *The History of Beads,* 140.

15 Bedford, 'Exploring Meanings and Identities', 10.

16 André Proctor and Sandra Klopper, 'Through the Barrel of a Bead: The Personal and the Political in the Beadwork of the Eastern Cape', in *Ezakwantu: Beadwork from the Eastern Cape,* ed. Emma Bedford (Cape Town: South African National Gallery, 1993), 58.

17 See Procter and Klopper, 'Through the Barrel of a Bead', 56–65 and Labelle, *Beads of Life,* 153–65 for detailed accounts of shifts in the perception of beadwork as a formerly 'outdated' practice to its more current association with resistant or anti-colonial positions.

18 Bulelwa Bam and beaders, interview with the author, 11 December 2014.

19 Selven O'Keef Jarmon interviewed by Sixto Wagan, 'Selven O'Keef Jarmon: Fashion Designer/Visual Artist', University of Houston Center for Art & Social Engagement, Profiles in Leadership, http://www.uh.edu/cota/case/profiles/jarmon.php (accessed 24 September 2017).

20 Selven O'Keef Jarmon, interview with the author, 29 September 2015.

21 Harbeer Sandhu, 'Walking While Black in River Oaks', *Free Press Houston,* 29 August 2014, http://www.freepresshouston.com/walking-while-black-in-river-oaks/ (accessed 3 October 2017). The article details an incident where Bam was stopped and interrogated by a police officer for the 'suspicious' behaviour of walking in the wealthy neighbourhood of River Oaks where she was being hosted during the project. In the article, Bam also expressed criticisms of Houston's car culture.

22 Jarmon, interview.

23 *Eastern Cape Provincial Arts & Culture Council Annual Report 2014–2015* (East London: ECPACC, 2015), 30.

24 Jarmon, interview.

25 For more on this, see Nicole Burisch, 'From Objects to Actions and Back Again: The Politics of Dematerialized Craft and Performance Documentation', *Textile: Cloth and Culture,* vol. 14, no. 1 (2016): 54–73.

26 Thomas J. Lax, 'In Search of Black Space', in catalogue for the exhibition *When the Stars Begin to Fall: Imagination and the American South* (New York: The Studio Museum in Harlem, 2014), 10. Lax's exhibition makes a solid case for how this 'transportation' might provide a richer frame for understanding Black cultural production in the United States, particularly in the South.

27 See also the video 'Chika Okeke-Agulu on Cercle d'Art des Travailleurs de Plantation Congolaise', *Artforum* (May 2017), https://www.artforum.com/video/id=68168&mode=large (accessed 3 October 2017). In discussing his review of Dutch artist Renzo Martens's collaboration with Congolese plantation workers for an exhibition at the Sculpture Center, Okeke-Agulu asks: '[The plantation workers'] access to the international art world is determined by Renzo Martens. Is this a new form of dependency? Is this a new form of neo-colonisation through the art world?'

28 Bill Davenport, 'South African Beaders to Assemble Selven O'Keef Jarmon's Big Tapestry Project at Rice', *Glasstire*, 25 July 2014, http://glasstire.com/2014/07/25/south-african-beaders-assemble-selven-okeef-jarmons-big-tapestry-project-at-rice/ (accessed 24 September 2017). See also https://www.artleaguehouston.org/360-degrees-vanishing for a complete list of project supporters.

29 April Baer, 'The Global Reach of Bullseye Glass', *Oregon Public Broadcasting*, 26 February 2016, http://www.opb.org/news/article/bullseye-glass-portland-air-pollution-global-impact/ (accessed 24 September 2017).

4 THE MAKING OF MANY HANDS: ARTISANAL PRODUCTION AND NEIGHBOURHOOD REDEVELOPMENT IN CONTEMPORARY SOCIALLY ENGAGED ART

Noni Brynjolson

It is a sunny, late summer day in Dallas, and I am visiting Trans.lation, a neighbourhood art centre. From the outside, the building is nondescript: one of about a dozen storefronts in a beige strip mall on a busy street in Vickery Meadow, a neighbourhood located 10 miles north of downtown. While its outward appearance is unassuming, what goes on inside is a surprisingly diverse range of activities. During my visit, a group of people build several wooden planters that will become part of a community garden in the dusty back lot of the building. Inside, a few kids paint some jewellery display stands, while a meeting takes place between instructors, followed by an Arabic lesson. All of this takes place in the colourful space of Trans.lation: a neighbourhood art organization, community centre and public artwork rolled into one. I see only a fraction of the activities during my visit; there are also weekly painting and drawing classes, dance workshops and meetings to discuss tenants' rights. What I notice during my visit is an emphasis on activities focused on the collective, sometimes collaborative, production of art and crafts. There are paper flowers and beaded jewellery in the window and painted self-portraits on the walls. A few of the regular attendees are preparing for a craft fair and Ethiopian New Year celebration in a few days. Trans.lation was initially conceived by artist Rick Lowe as a public art project; Lowe has described his work as 'social sculpture', a term used by Joseph Beuys in the 1970s

to suggest the transformative role that art can play in society. Established in 2013 during a year-long public art festival organized by the Nasher Sculpture Center, Trans.lation grew into a permanent art centre that aimed to create sustainable, long-term change in the community.

Trans.lation, like many other socially engaged art projects, has organized a significant amount of its programming around craft production and artisanal markets, and the fact that this has become a recognizable feature deserves further attention and analysis. Pop-up shops, flea markets, swap meets and craft fairs have become familiar tropes in contemporary socially engaged art and are frequently presented as models of practice that offer the possibility of small-scale, localized economic change in disadvantaged neighbourhoods; Lowe's Project Row Houses in Houston also regularly holds craft fairs and pop-up markets. Similarly, in Chicago, Theaster Gates' Soul Manufacturing Corporation involved producing handmade objects in a gallery space through utopian models of labour. These objects may eventually be used in his housing renovation project, Dorchester Projects or sold to support Rebuild Foundation, the non-profit established by Gates.

Across these initiatives, the aim is to spur economic development in disadvantaged neighbourhoods and empower local residents through artisanal production. This essay considers both the benefits and pitfalls of focusing on local economic redevelopment through the production and sale of handmade goods. On the one hand, Gates and Lowe may be seen as responding directly to the desires and needs of the residents of poor, primarily African American neighbourhoods by providing economic opportunities. On the other hand, it may be argued that this type of project simply replicates structures of capitalist production and urban gentrification. I begin by discussing each project and its relationship to artisanal production – while they support craft-making, they also promote hands-on engagement with local politics and the 'crafting' of neighbourhood social spaces. Then, I consider these examples in relation to contemporary debates surrounding socially engaged art, as well as longer standing discussions related to labour, alienation and economic inequality.

The skilled makers of Soul Manufacturing Corporation

Theaster Gates is perhaps best known for initiating Dorchester Projects, a large-scale, long-term effort to renovate and repurpose abandoned houses in South Side, Chicago, a primarily African American neighbourhood. Many Black southerners settled in Chicago after the Civil War, attracted by expanding industrialization and the promise of employment, and the Black population grew from approximately 4,000 in 1870 to 15,000 in 1890.[1] The second great migration occurred between 1940 and 1960, when the city's Black population grew from 278,000 to 813,000.[2]

The majority settled in the South Side, due to discriminatory real estate practices as well as the hostility and violence experienced in white neighbourhoods. Gates was born in Chicago and grew up on the West Side. He holds degrees in urban planning, religious studies and ceramics, and these areas of experience coalesced in his Soul Manufacturing Corporation project, which he began to conceptualize around 2006. The project developed around Gates's investigations into the materiality of clay, which were inspired by the traditions of Japanese pottery making. He invented a character named Yamaguchi, a Japanese master potter who, in Gates's fictional narrative, visits Mississippi in search of a legendary type of black clay. The story allowed him to explore 'ways that African American culture rubs gently against the East'.[3] He was looking for ways to make his practice relevant to the community where he was working in Chicago, and to explore ways in which labour, race and economic inequality were connected. He asked himself, 'If I am to be engaged in production, why not have it grow in neighbourhoods that have real need and interest?'[4] Out of this inquiry came Soul Manufacturing Corporation: 'An attempt to think about the production of ceramic objects as a way of creating new and innovative arts-based economies.'[5] The project has been exhibited in three different locations, and in each site, the gallery space was transformed into a workshop space in which *skilled makers* (artisans specializing in a particular technique or material) produced clay, wood and textile objects by hand.[6] The makers performed similar tasks to fabricators or studio assistants, but their labour was foregrounded during

FIGURE 4.1 Theaster Gates, *Soul Manufacturing Corporation*, *The Spirit of Utopia*, 2013, installation view. Photo: Timothy Soar.

the exhibition (Figure 4.1). In relation to this point, Gates (pictured in Plate 5) has written about the sense of collectivity established in his projects and states that 'we are not together under utopic circumstances for the most part – I pay people to help me do things'.[7]

The first public exhibition of Soul Manufacturing Corporation took place at Locust Projects in Miami in 2012. In addition to the skilled makers, Gates invited a yoga instructor, a DJ and various readers to participate, and their role was to care for the makers as they worked. Readings included *Moby Dick, Howl* and an essay on Asian American experiences of the civil rights movement. Matthew Dercole, one of the skilled makers, made clay bricks by hand throughout the duration of the project, each one taking about 20 minutes. He described the experience as intensely physically demanding, since it involved heavy lifting and repetitive movements day after day. For him, the project 'was a way to breathe life into the production of objects by hand', and he felt the desire to 'make these things really beautifully and put myself into them, because of the environment and the way we were being treated and cared for in that space'.[8] He described the attachment he felt to the handmade bricks he produced, noting that each one was curved or pressed in a slightly different way and felt unique to him. Pei-Hsuan Wang, another skilled maker, worked on slip casting during the exhibition using moulds weighing anywhere from 5 to 20 pounds. She also commented on the 'resting and relaxation of the body' offered by yoga and readings, which for her, seemed like a necessary respite from the physical exertion involved in making the objects.[9] When Soul Manufacturing Corporation was exhibited at the Fabric Workshop and Museum in Philadelphia in 2013, the makers gathered each afternoon to eat lunch together and discuss art. The museum organized apprenticeships during the exhibition, and the makers had the opportunity to share their knowledge and skills with others. The third iteration of the project took place in 2013 at Whitechapel Gallery in London, where it was performed as part of *The Spirit of Utopia*, an exhibition that looked at the ability of art to construct alternate visions of the world. London poet Zena Edwards performed in the gallery space, while skilled makers produced clay pots and bricks.

Of the many objects produced by Soul Manufacturing Corporation, some were functional, others were not. Dercole described the bricks he made as 'objects with potential', and noted that some will become part of Gates's sculptural work while others may be used by the Rebuild Foundation, a Chicago non-profit founded by Gates in 2011 to manage programming and events at Dorchester Projects.[10] Soul Manufacturing Corporation emphasizes the importance of making things by hand. However, this should not be seen as a reactionary move that fetishizes the genius of the artist or the aura of the singular object. These objects are lacking in ornamentation and, instead, suggest functionality and everyday use. They are 'objects with potential' in the sense that they embody the activity of their production, and in the case of the bricks, are quite literally buildings blocks. The

difference between these objects and other mass-produced goods is the visibility of the labour involved in their production. In focusing attention on this process, Gates writes that he is interested in figuring out 'how a studio practice can have resonance not only in the art world through symbol and gesture but also in the lived world'.[11] The collective aspects of labour are key in this regard, and he points out that producing everyday objects in a shared studio space helped him 'to understand notions of transformation, care, and many hands working together to make beautiful things happen'.[12] In Dercole's opinion, Gates is not interested in 'empowering or helping people', and he tries to avoid the condescension prevalent in many forms of community-based art. Dercole says:

> He's not trying to offer a crutch to people who are limping, but instead, trying to offer resources and opportunities to those who are interested. The city is not investing here, we're closing down schools, shoving poor Black families into isolated pockets of the city, making food deserts, there is a real lack of opportunity, and he is making resources accessible and available.[13]

Soul Manufacturing Corporation highlights ways in which skill and collective labour can shape the economic relations of a neighbourhood. The title of the project suggests a rethinking of the corporation, in which makers derive purpose, meaning or even soul, through the fruits of their labour. Finally, the circulation and distribution of these objects is worth noting: as objects with potential, the handmade bricks and pots produced during these three exhibitions might become functional components of Rebuild's community-based projects in Chicago – literal building blocks in housing renovations, perhaps, or dinnerware for communal meals. Alternately, they might become part of Gates's fine art practice, potentially selling for large sums of money, which may then be reinvested in Rebuild. The movement between devalued and valued object is central to Gates's work. For example, a 2013 exhibition at Kavi Gupta gallery in Chicago, *Accumulated Affects of Migration*, featured pieces of debris removed from one of the Dorchester Projects houses and 'repurposed' as fine art – clearly a nod to the Duchampian ready-made. Some of these debris-works (including floorboards and countertops) were later sold by the gallery for more than $100,000.[14] Gates foregrounds the act of salvaging in his work, as well as the remarkable power of objects to change value depending on their social context. One major question that arises, though, is what happens when economic value is redirected back into marginalized neighbourhoods? Who benefits, and how are the aims of these projects shaped by their relationships with corporate partners? In 2018, Rebuild received $300,000 from JPMorgan Chase (a corporation that played a major role in the 2008 financial crisis, through risky subprime loans and questionable mortgage-bundling practices). This philanthropic gesture could be seen as an attempt to compensate for the bank's role in foreclosing homes, including many in Chicago's

South Side. The money will go towards building an Arts and Innovation Incubator. Speaking about the project, Gates said, 'artisan entrepreneurs on Chicago's South Side have the talent, drive and innovative ideas they need to succeed – and now they also have the space and institutional support that all entrepreneurs need. We're thrilled to partner with JPMorgan Chase to bring life-changing, hands-on training and mentorship to small business owners in this part of the city.'[15] In this statement, Gates emphasizes the links between art and entrepreneurship that have emerged in many socially engaged art projects – especially those that attempt to work on a large scale. In considering these issues, Gregory Sholette has noted how close Gates's practice has come to conventional forms of development, and that while it demonstrates 'the capacity to toggle back and forth between a market-based art practice and not-for-profit social entrepreneurship', much of the artist's work as a self-described 'trickster' seems to be intended mainly for the stage of the art world audience.[16] I return to a discussion of Gates and Soul Manufacturing Corporation later in this essay, but first, it is worth turning to Project Row Houses in Houston, a major influence for Gates,[17] and a project that raises similar questions about art, labour and entrepreneurship.

Community markets at Project Row Houses

Project Row Houses was initiated in the early 1990s when artist Rick Lowe, living in Houston's Third Ward, began to think deeply about the role that artists could play in the communities in which they lived. He recounts a story of a group of students visiting his studio who told him that the paintings he was making at that time reflected the community but were not 'what the community needed'.[18] After this encounter, Lowe began to think about making work that operated outside of the studio or gallery. Like Gates, he was thinking about how to create something in the world that was not purely symbolic. Lowe was inspired by the colourful, geometric paintings of row houses by artist John Biggers, and by the historical importance of the buildings within the Third Ward. The small, narrow structures (sometimes referred to as shotgun houses) are a common feature of many African American neighbourhoods in the United States, and historians have traced their origins to building practices in both the Caribbean and West Africa.[19] In 1993, Lowe received a grant for $25,000 from the National Endowment for the Arts, and alongside a team of artists and community organizers, he used the funds to purchase and begin renovating twenty-two row houses that were scheduled to be demolished (Figure 4.2). As of 2019, Project Row Houses takes up five city blocks and thirty-nine structures, including exhibition spaces, houses for young mothers, office spaces, a community gallery, a park and low-income residential and commercial spaces.[20] It is funded by a mix of private and public sponsors; including the Texas

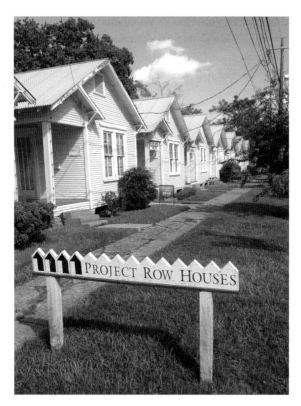

FIGURE 4.2 Project Row Houses, Third Ward, Houston, Texas, September 2015. Photo: Noni Brynjolson.

Commission on the Arts, First Unitarian Universalist Church, Southern Methodist University, The Bruner Foundation, The Andy Warhol Foundation for the Visual Arts, the Houston Arts Alliance, the City of Houston and Chevron.[21]

In addition to hosting artist residencies, Project Row Houses frequently organizes programming and events in the neighbourhood. During an initial visit there in September 2015, I saw an exhibition put on by local art students who had each been given studio space in one of the houses during the summer. The site has become a popular tourist destination, and there were several large groups and families wandering around, taking pictures and talking with the docents. When I walked around the surrounding neighbourhood, I noticed a mixture of abandoned houses and large, well-maintained brick mansions – often right next to each other. There were signs of change associated with gentrification, including new condos and park renovations. However, there were also signs of resistance, centred on engrained histories of the neighbourhood.

In the 1800s the Third Ward was home to the white elites of Houston, who built and lived in the Victorian-era homes. African Americans were segregated

in the northern area of the ward. After World War II, many of the white families moved to the suburbs, and the area became mostly inhabited by Black residents. The neighbourhood was home to the People's Party II headquarters, a Houston offshoot of the Black Panther Party. In 1970, 21-year-old activist Carl Hampton was shot and killed by police. Hampton was a charismatic resident of the Third Ward who spoke out against police brutality and helped to organize free childcare, health-care initiatives, food donations, home fumigations and support for elderly residents.[22] In the summer of 2015, Project Row Houses organized a memorial to honour Hampton and two other Third Ward residents who had recently passed away: Ayanna Ade, a neighbourhood activist who joined the Black Panther Party in 1972 and later worked as a midwife,[23] and Cleveland 'Flower Man' Turner, a local artist who decorated his home with discarded objects including toys, appliances, tools and an abundance of real and fake flowers. Project Row Houses purchased a home for Turner in 2003 after a fire destroyed his previous residence.[24] To commemorate the lives of the three individuals, neighbourhood residents were invited to build a garden together on the former site of the People's Party building. As I walked from Project Row Houses to the site of the garden, I passed by Emancipation Park, established in 1872 by former slaves as a site to hold Juneteenth celebrations. In 2017, the park received a $33 million makeover that was welcomed by some residents, and feared by others as a driver of gentrification.[25] Arriving at the site on Dowling Street, all that was left of the People's Party building was an empty lot, but the garden planted nearby communicated a sense of possibility rooted in the history of this place.

After walking around the neighbourhood, what became clear to me about Project Row Houses – and what is missing from a good deal of writing that focuses myopically on its status as either art or activism[26] – is how deeply it connects with the neighbourhood's African American history. One of the main functions of the project could be seen as reorienting this history towards current issues related to gentrification and economic inequality. This is visible in one of the most frequent events that takes place at Project Row Houses: community markets, which are often held during the opening of a new exhibition, or 'Round' of artist residencies. During the markets, local artisans are invited to bring their goods to the market and sell them. Recent markets have featured a diverse array of products, including beaded jewellery, metalwork, woodwork, printed T-shirts, soaps, lotions, dolls, purses, paintings, woven scarves, hats and gloves, and palm readings. The markets are intended to offer exposure and a secondary revenue stream to local artisans.[27] Organized by Project Row Houses Curator and Programs Director Ryan Dennis *Round 43: Small Business/Big Change: Economic Perspectives from Artists and Artrepreneurs* focused specifically on the relationship between art and local economies. In the text accompanying the exhibition, Dennis poses an important question that has been asked in relation to Project Row Houses: 'How, within a neighbourhood being gentrified, do we push against big-business models that so

easily find their way into small neighbourhoods without supplying any forms of support to small business?'[28] Dennis, along with Special Events Manager Cecilia Pham, told me that the idea for the markets came about as one way to push back – by offering residents a sense of community, an opportunity to meet one's neighbours, and a chance to support local artisans.

As models of practice, the community markets emphasize creative entrepreneurship, individual empowerment and the branding of one's products. It may be difficult, then, to distinguish this approach from the strategies of local community development agencies, which emphasize the growth of small businesses and creative capital as measures of success. According to this model, it is clear that those who have prior training, education or skills will benefit more than those who do not. The community markets bring up other contradictions and complicated questions surrounding Project Row Houses: Can these events attract tourists, but maintain their commitment to local residents? Can they promote individual entrepreneurship as well as community well-being? Can they prove to be economically beneficial for residents without contributing to gentrification? Can they promote social justice while also being sponsored by Chevron? These are complicated questions – on the one hand, the community markets seem to promote creative entrepreneurship, self-branding and an emphasis on individual empowerment. On the other hand, they draw participants into the community-directed activities of Project Row Houses, which often focus on critiquing structural inequalities related to race and class in the Third Ward. In further considering these provocative questions, it is worthwhile to return to a discussion of Trans.lation, to look more deeply at ways in which participants create, use and benefit from socially engaged art projects.

Meeting, making and organizing at Trans.lation

The Vickery Meadow neighbourhood in Dallas is home to about 30,000 people. Roughly half are African American or Latinx, while the other half is composed of recent immigrants. Nearly all of the residences in the neighbourhood are apartment buildings, most of them constructed in the 1970s for singles, with by-laws prohibiting families or children. This changed with amendments to the Fair Housing Act in 1988, which outlawed this type of discrimination. Following this, families from Africa, Asia, the Middle East and Mexico began to move in. Carol Zou, Trans.lation's program manager and artist-in-residence from 2015 to 2017, told me that there were often tensions between these different groups. From her experience of living and working in the neighbourhood, it can be a violent and conflict-filled place, in part because of the many traumas suffered by residents before moving to the United States, as well as a lack of economic opportunities.

However, she saw the possibility for a place like Trans.lation to connect people with their neighbours and encourage the sharing of labour and resources. She said:

> We collaborate with other non-profits in the area and we see ourselves as one more connector or advocate. We see the work that happens here as a form of developing relationships – the more relationships that are developed, the more these issues come to our attention. There are so many landlord abuses and code violations here, or instances of landlords raising rent before a lease is up. Most people do not feel empowered enough to speak up, but the connections built here enable them to report those abuses to us, or work together with other non-profits in the area. Part of our work is providing economic opportunity to counter the fact of rising rent, and part of our vision is to empower people through artistic production tied to cultural identity – to invest in and support the cultural producers who live here.[29]

I visited Trans.lation a number of times, and in addition to Zou, I met a handful of people who live in Vickery Meadow and who regularly visited to make things, attend meetings or take classes. I spoke with a gardener, Mohammed Abdul, who was there with his nephew, Faiyazul Ahmad. They recently moved to Dallas from Malaysia, where they worked as rice farmers. I met Nesreen Obaid, an Iraqi refugee who came to Dallas three years ago and was working for the International Rescue Committee, as well as for Trans.lation, where she teaches Arabic. When I asked her what she liked about the centre, she told me that she 'found herself here' and pointed out how culturally rich the neighbourhood was despite its economic disadvantages. While waiting for the Arabic class to begin, she and Zou discussed plans for a driving club for women who had recently moved to Dallas from the Middle East and had no prior driving experience. I spoke to Ome Acatl while she painted wooden stands for displaying jewellery, and she told me that she had worked at Trans.lation for two years as an Aztec dance instructor and Nahuatl teacher. Her contributions to Trans.lation were visible in every corner – bright, beaded jewellery displayed in the window, the Aztec calendar on the wall and the photos of dance costumes that were made during a workshop and worn during several recent performances. I asked her about the role that Trans.lation plays in the neighbourhood, and she told me that 'it's a place where people from different religions, cultures, and levels of education can meet face to face and get to know each other, and I think this affects how people relate to each other on the street'.[30]

Acatl's jewellery was a popular item at the pop-up markets that occurred regularly at Trans.lation, which were inspired in part by the community markets at Project Row Houses. Zou told me that she had had to rethink the pop-up markets, however, since they were attracting a lot of outside interest, and she was worried that they might become overly tourist-oriented. For her, the community-directed activities that made up the bulk of the programming at Trans.lation were the most

FIGURE 4.3 Craft table and fall celebration for Ethiopian New Year, Trans.lation, Dallas, Texas, September 2015. Photo: Lizbeth de Santiago.

valuable, and she tried to maintain an equal focus on finished objects and processes of making.[31] While Trans.lation offered space, resources and opportunities to make and sell crafted products, it seemed to me that its most valuable quality was its ability to act as a connector and a gathering place for residents. These two features were interwoven, however, and during my visits I noticed that one activity would lead to or merge with another – someone coming for Nahuatl lessons might end up working on a painting, for example, or an overlap in conversations and activities would result in new activities or plans being made: the Arabic teacher plans a driving club, the Aztec dance instructor helps to build a garden, an Ethiopian dinner is planned to coincide with the next pop-up craft market (Figure 4.3).

Craft and socially engaged art: Hands-on practices

The three projects that I have described reconsider relationships between art, craft, labour and neighbourhood redevelopment. This type of work, often labelled social practice or socially engaged art, has gained a great deal of attention in recent years from critics and audiences alike, and continues to expand as an institutionalized genre through museum shows, conferences and art biennials. Although social practice has gained popularity and validation as a genre, it has been criticized for its smooth alignment with neoliberalism, primarily the perception

that it offers social services once provided by the state.[32] It also clashes with recent calls for a return to aesthetic autonomy in contemporary political art. For example, John Roberts argues that a refashioned, politically relevant avant-garde must stand in advance of bourgeois culture, meaning and values – it must be an art 'in advance of capitalism'.[33] This suggests that art's critical potential lies outside the impure zone of capitalist exchange and consumption – a position that seems possible in theory but not in practice, as countless historical examples of the co-option of avant-garde art make clear. 'In advance of capitalism' implies distance as well as externality, two characteristics that supposedly enable avant-garde artists to see past the confines of everyday life, expose the untruths of neoliberalism and create revolutionary change. In Roberts's view, much socially engaged art is guilty of 'instrumental-activism'.[34] He believes that without a well-defined sense of aesthetic autonomy, such work is fated to disintegrate into life: it becomes part of the indefensible zone of social welfare work associated with non-profits, benefits creative entrepreneurs, and generally works alongside rather than in advance of capital. Critic Ben Davis has also criticized socially engaged art projects that claim to produce social change. His position is that such projects, if they were really committed to activism, would forego the art and focus all of their energy on activism. He points out that while Project Row Houses might have created some low-income housing in the Third Ward, it's a minor accomplishment compared to the demand that still exists in Houston. For Davis, Project Row Houses is too dependent on corporate funding, and demonstrates the inevitable co-option that occurs around radical gestures.[35]

Davis is right to point out the ways in which activist and participatory practices have been adopted by mainstream media and corporate culture. However, what he and Roberts do not acknowledge is that this type of work tends to move constantly, and often imperceptibly, in and out of the spheres of art, life and the social, to the degree that drawing firm boundaries around any of these categories becomes meaningless. This poses a problem for much contemporary art theory devoted to defending the political potential of the avant-garde, in which critics focus on weeding out vulgar, non-art or activist art practices that are seen as compromised and corrupted as soon as they leave the protected world of aesthetic autonomy. This results in observations of localized, situated practices being overshadowed by arguments prioritizing critical theory, which often do not take into account the complex web of relations between producers, consumers and social spaces.

Criticism of socially engaged art tends to lack a detailed analysis of practice and instead focuses mainly on laying out theoretical arguments. Projects are often described as inescapably instrumentalizing or compromised due to their attempts to create concrete rather than allegorical change. In this sense, it is worth noting certain similarities between craft and socially engaged art. Both have been described as degraded and impure forms of art or have been subjected to repetitive ontological challenges. They both claim to be useful, they both exist outside the realm of aesthetic autonomy, and they both tend to be seen as complicit with the

market. There are other similarities: they are associated with collaborative spaces of production, they have been feminized to a certain degree, and they focus our attention on processes of labour rather than, or in addition to, finished objects. They also rethink the category of use value in relation to contemporary art. Glenn Parsons and Allen Carlson write:

> As the functionality of an artwork becomes more prominent and difficult to ignore, its status or value as art seems to decline. Having been created for a purpose, or with some social or political aim in mind, such works remain forms of craft rather than art proper.[36]

According to histories of art centred on aesthetic autonomy, art lacks purpose, does not depend solely upon technical skill, nor is it designed to satisfy a particular demand. As Howard Risatti has argued though, craft objects do not operate in an autonomous realm. Instead, as purposive objects, they are 'subject to and governed by external rules and laws'.[37] This is similar to socially engaged art, which has been criticized by many – including Roberts and Davis – for operating outside of the autonomous realm of art.

Critiques of socially engaged art based on observations of practice might involve asking more nuanced questions about participants, sites and resources: Who benefits from these types of projects? Are they actually producing material transformations of urban space or have they merely adopted the fashionable rhetoric of social practice? In terms of projects that are attempting to create local economic changes, there are important questions to ask related to gentrification and creative capital as well. Are these projects capable of creating social change if they are not working 'in advance of capitalism'? Shannon Jackson's views on aesthetic autonomy are worth considering here in relation to the external, detached position offered by Roberts. She asks: 'What if we remember the contingency of any dividing line between autonomy and heteronomy, noticing the dependency of each on the definition of the other, watching as the division between these two terms morphs between projects and perspectives?'[38] The examples I have discussed raise important questions about how to support local economies without contributing to gentrification. Jackson's emphasis on contingency is worth noting here, and paradoxically, it seems to be the case that these projects contribute to gentrification (through tourism and the geographical concentration of cultural capital), while also offering the spaces, resources and social networks necessary to organize against it.

Questions regarding socially engaged art and its complicity with or resistance to market forces are especially relevant when combined with the emphasis on the handmade that I consider here. In the past decade, artisanal goods have become hot commodities, primarily for wealthy consumers who want to distinguish themselves from the ordinary consumer of cheaper mass-produced goods.

Farmer's markets, craft fairs and pop-up shops attract customers seeking unique, locally made or handcrafted products. Many items are now up-sold by adding the label 'artisanal' or 'craft' to their title: beer, whiskey, soap, leather, cheese and meat are just a few examples.

It is easy to view the handmade and the artisanal as 'ethical' or 'good' in and of themselves, and to overlook the ways in which these modes of production act as markers of exclusivity within capitalist economies. The projects I have discussed highlight the complexities inherent within these categories. Gates's Soul Manufacturing Corporation envisions a utopian environment in which skilled makers are cared for as they produce their work – a metaphor for the hands-on, collective labour that goes into renovating and repurposing the Dorchester Projects houses. Yet the project has also been criticized for Gates's affiliations with corporate investors, and for creating a safe haven for mainly white, middle-class art critics and curators to engage in ghetto tourism in Chicago's South Side.[39] Project Row Houses encourages community-oriented activities and events, but at the same time, promotes narratives of self-sufficiency, creative entrepreneurship and branding; its community markets are spaces in which creativity and culture are nurtured through the purchase of unique, specialized goods. Trans.lation also prioritized community-organized economic development, although it focused less on promoting narratives of individual entrepreneurship – perhaps, in part, due to its lack of corporate funding.

The notion that simply making and selling handmade goods is going to produce noticeable change, whether individual or neighbourhood-based, is simplistic and misguided. But with these reservations and criticisms in mind, there are many worthwhile aspects of these projects: first, they engage in practices under existing economic conditions and attempt to come up with solutions that will concretely benefit the everyday lives of residents. Second, they act as gathering places and operate through an emphasis on collective production. Making things by hand in a workshop or studio requires time, effort and skill. It requires a space conducive to cooperation and conversation, a space in which residents share experiences of daily life, make plans to cook, garden and visit together, or talk about ways to organize against landlord abuses. Third, these projects place an equal emphasis on object and process: on 'craft' as both noun and verb within hands-on practices.

Hands are involved in modes of knowing – my hands feel the surfaces, textures and outlines of the material world around me, and when I make something, my hands seem to possess their own knowledge and skill. Many scholars have commented on the uniqueness of human hands in gaining practical knowledge of the world and developing the ability to make skilled adjustments to our surroundings. John Roberts has emphasized the importance of the hand in gaining knowledge of the self and manipulating the world around us. He contrasts the 'operative hand' associated with the mechanical gestures of capitalist labour processes with the 'emergent totipotentiality' of the hand within artistic labour,

which he argues 'remains key to the 'aesthetic re-education' and emancipation of productive and non-productive labour'.[40] For Loïc Wacquant, skill relates to embodied knowledge and the competency we gain through hands-on experience, allowing us to make adjustments in the world as social agents.[41] His research focuses mainly on structural economic inequalities and how they relate to race and violence in urban spaces – yet despite his emphasis on the power and force of social structures, he leaves open the possibility for individuals to shape the world around them. So, it follows that while the handmade and the artisanal may be criticized for appealing to a privileged creative class, their redemptive qualities cannot be completely co-opted – categories, institutions and structures can always be remade, especially if enough hands are involved. These ideas connect with earlier forms of Marxist thought that emphasized artisanal production, for example, the Arts and Crafts movement in the nineteenth century – a reaction to the instrumentalization of labour and the alienation of the working classes. There are notable parallels between these historical critiques of alienation and socially engaged art projects that foreground collaborative labour, hands-on experience and exchanges between neighbours based on use value rather than exchange value.

In the projects I have discussed, making things by hand is intended to demonstrate non-alienated forms of labour and the handmade is endowed with political, almost spiritual qualities. Yet a pertinent question to ask is, what happens when these ideas are put into practice and confronted with the impurities of the capitalist market? Soul Manufacturing Corporation, Project Row Houses and Trans.lation do not operate from a (privileged) position of detached, utopian autonomy. Instead, they aim to create practical, everyday transformations in communities through the use of shared resources and collective labour. They emphasize the importance of being together in the same space, making things collectively and engaging directly with political structures on the level of localized, community-based practice. Across these projects, a focus on the handmade encourages the recognition that with our hands, we can make changes to the materials, institutions and structures around us.

Notes

1 Christopher Manning, 'African Americans', *Encyclopedia of Chicago*, Chicago Historical Society, 2015, http://www.encyclopedia.chicagohistory.org (accessed 5 October 2015).

2 Ibid.

3 Theaster Gates, 'The End of Clay Fiction: Yamaguchi and the Soul Manufacturing Corporation', *Studio Potter*, vol. 40, no. 2 (2012): 30.

4 Ibid., 31.

5 Ibid., 30.

6 Theaster Gates has used the term *skilled makers* to refer to the artists and artisans involved in Soul Manufacturing Corporation who are proficient in working with a particular material, or using a specific technique, such as slip casting or brick making.

7 Theaster Gates, 'The Artist Corporation and the Collective', *NKA: Journal of Contemporary African Art*, no. 34 (Spring 2014): 77.

8 Matthew Dercole in conversation with the author, 21 October 2015.

9 Pei-Hsuan Wang in conversation with the author, 24 October 2015.

10 Ibid.

11 Gates, 'The End of Clay Fiction', 31.

12 Ibid.

13 Matthew Dercole in conversation with the author, 21 October 2015.

14 John Colapinto, 'The Real-Estate Artist: High-concept Renewal on the South Side', *New Yorker*, 20 January 2014, https://www.newyorker.com/magazine/2014/01/20/the-real-estate-artist.

15 Alex Greenberger, 'JPMorgan Chase Gives $300,000 to Theaster Gates's Rebuild Foundation in Chicago', *ArtNews*, 4 October 2018, https://www.artnews.com/art-news/news/jpmorgan-chase-gives-300000-theaster-gatess-rebuild-foundation-chicago-11111/ (accessed 30 November 2018).

16 Gregory Sholette, *Delirium and Resistance: Activist Art and the Crisis of Capitalism* (London: Pluto Press, 2017), 138.

17 Nikil Saval, 'Three Artists Who Think outside the Box', *New York Times,* 3 December 2015, https://www.nytimes.com/2015/12/03/t-magazine/art/theaster-gates-mark-bradford-rick-lowe-profile.html (accessed 29 June 2016).

18 Michael Kimmelman, 'In Houston, Art Is Where the Home Is', *New York Times,* 17 December 2006, https://www.nytimes.com/2006/12/17/arts/design/in-houston-art-is-where-the-home-is.html (accessed 29 June 2016).

19 See Babatunde Lawal, 'Reclaiming the Past: Yoruba Elements in African American Arts', in *The Yoruba Diaspora in the Atlantic World*, ed. Toyin Falola and Matt D. Childs (Bloomington: University of Indiana Press, 2004), 291–324.

20 Rick Lowe, 'Project Row Houses at 20', *Creative Time Reports* (October 2013), http://creativetimereports.org/2013/10/07/rick-lowe-project-row-houses/ (accessed 10 October 2015).

21 See 'Sponsors', http://projectrowhouses.org/about/sponsors/ (accessed 24 February 2019).

22 Judson L. Jeffries, *On the Ground: The Black Panther Party in Communities Across America* (Jackson: University Press Mississippi, 2010), 22.

23 Cindy George, 'Humanitarian and Black Panther Party Member Dies', *Houston Chronicle*, 6 June 2013, https://www.chron.com/news/houston-texas/houston/article/Activist-humanitarian-Ad-was-compelled-to-give-4585096.php (accessed 2 June 2020).

24 John Nova Lomax, 'A Year After Houston's Flower Man Died, His House Will Join Him in the Great Beyond', *Texas Monthly,* 16 January 2015. https://www.texasmonthly.com/the-daily-post/a-year-after-houstons-flower-man-died-his-house-will-join-him-in-the-great-beyond/ (accessed 29 June 2016).

25 Lisa Gray, 'Friends of Emancipation Park Hope Renovation Revitalizes Neighborhood', *Houston Chronicle*, 1 November 2013. https://www.houstonchronicle.com/life/columnists/gray/article/Friends-of-Emancipation-Park-hope-renovation-4947655.php (accessed 29 June 2016).

26 For example, in Ben Davis's essay, 'A Critique of Social Practice Art', *International Socialist Review*, Issue 90 (July 2013), https://isreview.org/issue/90/critique-social-practice-art (accessed 29 June 2016) he portrays Project Row Houses as a diluted form of activism beholden to its corporate sponsors. Issues of race, the community's history and the perspectives of participants are not considered.

27 Ryan Dennis and Cecilia Pham in conversation with the author, 20 October 2015.

28 *Round 43: Small Business / Big Change: Economic Perspectives from Artists and Artpreneurs* ran from 24 October 2015 to 28 February 2016. See 'Project Row Houses, Round 43 Opening + Market', http://projectrowhouses.org/calendar/round-43-opening-market (accessed 10 October 2015).

29 Carol Zou in conversation with the author, 7 September 2015.

30 Ome Acatl in conversation with the author, 7 September 2015.

31 Ibid.

32 See Claire Bishop, *Artificial Hells: Participatory Art and the Politics of Spectatorship* (London: Verso, 2011).

33 John Roberts, *Revolutionary Time and the Avant-Garde* (London: Verso Books, 2015), 31.

34 Ibid., 177.

35 Ben Davis, 'A Critique of Social Practice Art', *International Socialist Review*, no. 90 (July 2013) https://isreview.org/issue/90/critique-social-practice-art.

36 Glenn Parsons and Allen Carlson, *Functional Beauty* (New York: Oxford University Press, 2008), 36.

37 Howard Risatti, *A Theory of Craft: Function and Aesthetic Expression* (Chapel Hill: University of North Carolina Press, 2007), 220.

38 Shannon Jackson, *Social Works: Performing Art, Supporting Publics* (New York: Routledge, 2011), 29.

39 Colapinto, 'The Real-Estate Artist'. https://www.newyorker.com/magazine/2014/01/20/the-real-estate-artist.

40 John Roberts, *The Intangibilities of Form: Skill and Deskilling in Art After the Readymade* (London: Verso, 2007), 4.

41 Loïc Wacquant, 'For a Sociology of Flesh and Blood', *Qualitative Sociology*, vol. 38, no. 1 (2015): 4.

5 THAT LOOKS LIKE WORK: THE TOTAL AESTHETICS OF HANDCRAFT

Shannon R. Stratton

One can't go far in any market place, be it a shopping mall, an online outlet or a specialty boutique without coming across the words 'handmade' or 'handcrafted'. Whether it's a hand-embellished sweater at The Gap or a boutique liquor store specializing in hand- and locally crafted small batch spirits, 'the hand' has become a remarkable tool for elevating the thing for sale. Similarly, a kind of blatant DIY craftsmanship that announces itself via a slightly off-kilter, soft-focus charm, natural tones and materials, imperfection, hobby-craft execution circulates as an aesthetic that is charged by lifestyle curating: from rooftop gardens to homemade bread to exotic cocktails made with foraged herbs, there are certain activities that the truly dedicated cultivator of the handmade indulges in. This handmade lifestyle is further aestheticized in magazines like *Kinfolk* (whose tagline is 'Slow Living') or *Hearth* (featuring 'artists and artisans that value the art of living and tradition'), not to mention countless food, craft, gardening and lifestyle blogs and Instagram feeds that document organic recipes, children's crafts and artistic practices that tacitly promise better living through the handmade and the artisanal.

Handcrafted is now applied as a distinction to things that were not previously required to be articulated this way. Food and beverages are particularly susceptible to this term, despite being touched by hands since the beginning of time, and many companies have adopted this adjective to raise the status of their products. But as 'handmade' crops up as an adjective and an aesthetic in more and more places – including where differentiating goods around handcraftedness seems absurd (sandwiches and graphic design) – it becomes compelling to consider *why* today's marketplace is so committed to the handmade thing, and *what* it is that consumers and citizens are looking for that the handmade proposes to satiate.

The personal touch

When I worked in downtown Chicago, I frequently found myself at Pret A Manger for a snack, a global food chain with locations in the United Kingdom, France, Hong Kong and the United States. A fan of their pre-packaged carrot cake (it is surprisingly moist and the cream cheese icing is spot on), I started studying the packaging, a small box that clarified: 'Handmade for Pret A Manger.' Looking around, I found that the words 'love' and 'small batches' were everywhere on their promotional materials, from soup stock to this very carrot cake: 'made from scratch, baked in small batches and popped into these flowery boxes.' Their in-store posters further personalized their products. One poster introduces 'Mike' the baker, with an informal biography pitching his likeability and skill:

> If we were on 'Who Wants to Be a Millionaire' Mike would be our 'phone a friend.' General trivia, politics … sport, he knows it all. More to the point, there's nothing he doesn't know about *artisan* bread, baguettes and pastries, which is very good news. Mike is our baker. He bakes our bread fresh, everyday with sackfulls [sic] of whole grain and delivers to this shop before dawn. Genius. (emphasis added).

This poster tribute was called, 'Passion Fact no. 17'. Surrounding me were also 'Passion Fact no. 64' about how many months they train their vegetable slicers (three) and 'Passion Fact no. 57' which claims that the company's ingredients are only processed by washing and basic preparation.

In her book *Our Aesthetic Categories: Zany, Cute, Interesting*, Sianne Ngai outlines an aesthetic spectrum that includes important categories that are otherwise marginalized in aesthetic theory. For her, the *zany*, *cute* and *interesting* represent aesthetic experiences under the hyper-commodified, information-saturated, performance-driven conditions of late capitalism.[1] Ngai theorizes that these categories index modes of production: 'zany' is an aesthetic category particular to affective labour, 'cute' not surprisingly is an indicator of a range of feelings around consumption that include tenderness as well as aggression, while 'interesting' is an aesthetic borne out of the movement and exchange of information.

Ngai's categories suggest another frame for understanding the aesthetic signifiers that come to mind when we identify craft, skill and craftsmanship in a product or marketing campaign. While 'genuine', as in 'the real thing', isn't one of Ngai's aesthetic categories, it nevertheless cues the idea of the autonomous worker, the unhampered expression of skill that is part of the appeal of handcraftedness: it looks like slow labour, careful labour and personal labour. The handcrafted is something made by a single, *genuine* individual in a small workshop who is reinvigorating the singularity of the artist through their personal touch. In comparison to globalized

mass production, the personalized nature of one pair of hands sounds positively rare. If 'zany' is the aesthetic that Ngai names as indicative of performance-driven late capitalism, the aesthetics and language of the handcrafted seem to mitigate capitalism's lunacy: 'passion' (as per Pret A Manger) sounds like love, albeit a bit dramatic, whereas 'zany' sounds totally unhinged. This articulation of happy productivity seems key to the application of 'handcrafted' or 'handmade' as a crucial product descriptor now. Even Chick-fil-A, the notoriously conservative Southern fast-food chain, describes their product as 'happily handcrafted … as always' alongside a picture of a spotless baker's table.

Of course, handcrafted is a popular term for foodstuffs like chocolate, beer and wine and frequently found in association with clothing, but it even shows up with some frequency in relationship to design work, a field that is already synonymous with individuality. Manos (get it?) is a 'Texas based studio, building handcrafted websites, mobile apps and brands for companies all across the Blue Planet'. Their URL is 'manoscrafted.com'. Their 'About' section claims: 'At Manos we're Creating, Crafting, Coding and Coffee-ing every single day' before introducing the staff via the header 'meet the craftsmen'. 'Craft, Tweak and Perfect' is one step in their self-defined 'wonderful process', with an icon of a handsaw hovering over the description of that process, which turns out doesn't involve saws at all.[2]

The design firm Creative Market sells 'beautiful design for all', and on their home page and their 'About' section turn to similar language to describe graphic design work. They clarify that graphic design isn't *really* hand-wrought in the old-fashioned way by saying: 'Creative Market is a platform for handcrafted, *mousemade* design content from independent creatives around the world',[3] and like Pret A Manger, they personalize the team behind their brand. Their bios read like dating profiles and are accompanied by hand-drawn portraits of each team member: Chris is a drummer, indoor enthusiast, basset hound lover, beer/wine/whisky/coffee drinker. Zack hearts San Francisco, the www, good design, fine wine, German cars, American guitars, puppies, his beautiful wife, baby girl and the first Guns N' Roses record. Maryam loves food, dogs and anything awesome.

The heartfelt and good

What appears to be at stake here is authenticity, and handcraftedness (whether actual, implied or named) is shorthand for that. For Pret A Manger, Manos and Creative Market, the descriptor 'handcrafted' is used to humanize the consumer experience by framing a service or a product with narrative. By identifying a 'maker' behind a product described as handcrafted, these companies are trying to convey a sense of authenticity. Across all of these marketing examples, the message seems consistent: handcrafted means real(er) people, it means passion, it means feeling, it means care. It is de-facto 'good'.

Prior to encountering Pret A Manger's 'Passion Facts', and drawing on Ngai's categories, I had conceived of the 'sensible' – both the ability to understand what cannot be verbalized and the demonstration of good judgment – as *the* aesthetic of the skilled handmaker. In other words: skilled making was a tactile, poetic and also sound response to a set of materials and needs. In light of the marketing strategies outlined here, 'Passion Facts' suggest a different possibility: that in relationship to seemingly anonymous production and efforts to personalize the corporate, it is actually *passion* that is the contemporary aesthetic of the handmade. Passion inflects making with agency, desire and the heartfelt, overriding the implications of wage-labour, boredom and detachment. As per Jacques Rancière, the meaning (of handcraftedness) shifts in relationship to the state of the world exterior to it.[4]

On the other hand, the sensible (as per its definition, not to be totally colluded with Rancière) understands that the somatic, experiential quality of handcraftedness lies in affect rather than rhetoric. The sensible is earnest. It makes good decisions. The sensible is recognized not just when we see the word handcrafted, but other markers that are aligned with it: wood-cut style fonts; illustrations that look hand-drawn; DIY making; small-batch this and that; soft, natural hues and finishes; recycled and natural materials; home-made food; homey touches; constructed and affected shabbiness. These qualities set up (false) dichotomies that situate soft, natural, rough and personalized as handmade; and hard, fabricated, smooth and anonymous as manufactured. In other words, handmade has a human narrative, whereas the manufactured is reproducible, cut-and-paste, code.

This aesthetic of the sensible can also be traced to the buy-local and slow food movements, a consumer aesthetic born out of Italy when a group protestors ate homemade pasta in opposition to the opening of a new MacDonald's near the Spanish Steps in Rome.[5] Publicly protesting via what you choose to eat is one action that might have an impact on local economies and workers, and while this strategy (along with others like buying local, handmaking and learning skills that might lend themselves to survival) may resonate as a meaningful endeavour, the message that one's choices as a consumer or labourer can have an impact on capitalism, and thus be political, has now been adopted at the corporate scale as a marketing contrivance. The collapse of qualities like soft, natural, rough and personalized into a shorthand for handcrafted and handcrafted into an aesthetic shorthand for both passion and good sense, has made handcraftedness easy to poach.

A considerable amount of time is spent conveying authenticity in a somewhat circular process: handcraftedness means this product (or the person buying the product) is more authentic, and you can know the authentic by its degree of obvious or narrated handcraftedness. Authenticity tests whether something is what it claims to be, the search for authenticity being, as Lionel Trilling had put it: the anxiety over the credibility of existence.[6] Perhaps this correlation has developed out of an

attempt to 'test' consumerism as a result of consumption being the primary way people have come to express themselves, and perhaps depressingly, their politics. Are these products credible? Am I, as a consumer, credible in my choices?

Pret A Manger and other chains in the food industry make it look *sensible for you* to support their sizable chains by conveying the personalized, handcrafted ethos *that you* as a consumer are drawn to as indicative of *your* informed choice. If 'Mike' is an expert on artisanal breads, and Pret A Manger acknowledges Mike publicly, then what do you have to worry about? You are a satisfied consumer, and any real social responsibility that you should exercise has been neatly displaced by a belief that your purchasing power is political. You eat at a chain that cares about, no, is *even passionate* about craftsmanship, and thus, must be a more credible, more authentic fast-food business.

The work of discerning authenticity in products or projects, and primarily in the *style* of these things, as they are marketed or communicated, detracts from the work of discerning political forms and patterns that need attention by citizens. Fussing at the border of aesthetic messages can miss the importance of the non-aestheticized, sociopolitical world.

In their scene 'Slow People' for Camel Collective's six-hour performance, *The Second World Congress of Free Artists*, Benj Gerdes and Jennifer Hayashida's Doctor Mikhail Patel describes this phenomenon perfectly. After introducing three participant researchers who have 'embraced some kind of radical alternative to modernity' like dumpster diving or becoming a locavore, he defines the 'politics of personal consumption':

> political life is reduced to individual action, and that action is defined along a horizon that is limited to a series of nonorganizational yes-or-no choices, between abstention and subsumption – choices that do not seek to upend as much as to ethically abstain, while falling short of coherent systemic indictment.[7]

He later goes onto a finer point that there is, 'in laypersons' terms, a genuine lack of large-scale responses that might give us, as a species … the ability to save the world'.[8]

Exquisite work

What is a total aesthetics of handcraft? That is, how has 'handcraftedness' potentially become a totalizing aesthetic viewpoint that when co-opted by corporations and marketing has both the effects of diluting criticism of corporate capitalism and the creation of abstract value as well as reifying enterprise in objects that become mere symbols of free-will 'work'?

In the fall of 2013, I embarked on the original version of this essay as a lecture for the symposium *The Deskilling and Reskilling of Artistic Production* organized by Luanne Martineau at Concordia University in Montreal, Quebec. I wrote it while a resident at Elsewhere, an artist's residency and self-proclaimed 'living museum'[9] housed in a defunct thrift and army surplus store in Greensboro, North Carolina. Surrounded by a grotesque number of things and embedded in the residency environment – a phenomenon that isolates and celebrates the labour of the artist as special and deserving of extraordinary treatment – I (perhaps naturally) became fascinated with the overlap between the *desire for skill* and how that desire is reified and aestheticized as artisanal images, experiences and objects.

While I was working on the lecture, I came across a video by the artist-duo Half Cut Tea about artist couple Nick Olsen and Lilah Horwitz who quit their jobs to build a cabin on Olsen's family land in West Virginia, and I reposted it on social media. The video features Nick, Lilah and their dogs, walking and hanging out around the property, discussing their respective art practices (photography and recycled fashion), and the project of building their cabin. They spent around $500 to make a simple structure, notable for its one wall constructed out of found windows (Figure 5.1). A significant part of the story is Nick talking about gathering the windows from antique and junk stores on a road trip, but the video seamlessly blends their reflections on making, whether about the house or their work. 'Working with materials and being hands on with the process … part of the reason I do things this way is the experience of it',[10] says Nick, while the camera

FIGURE 5.1 Matt Glass and Jordan Wayne Long, *Nick Olson & Lilah Horwitz: Makers,* 2012, video still, Half-Cut Tea.com. Courtesy: Matt Glass and Jordan Wayne Long.

captures him making a traditional tin-type photograph. As Nick reflects towards the end of the video about what 'title' he could give himself, he says, 'sometimes the easiest one is just saying you are an artist'. Here, the video cuts to Nick leaping from a ledge into a waterfall-fed pond, the accordion and fiddle music swells triumphantly and the original title comes back up:

<div align="center">

Nick Olson & Lilah Horwitz

{makers}

</div>

This example has a multifold purpose: first is the project Half Cut Tea itself. Produced by two Cranbrook Academy of Art graduates, Matt Glass and Jordan Wayne Long, Half Cut Tea, who dub themselves as 'inside art production', present short documentaries on artists, with new webcasts produced for release on their website and Vimeo. While their biographies describe both Matt and Jordan as having other artistic pursuits, they travel 'the country looking for artists and telling their stories through short documentary films' that have been featured on MSNBC, *Huffpost*, NPR, *This is Colossal* as well as being licensed for TV in seven countries.[11] Notably, their videos have a signature faded film quality, accompanied by melodramatic folk-music soundtracks that together give each short film a romantic and nostalgic character that works to create a total aesthetic across all of their projects and inflect the subjects they capture. Second, are the two subjects themselves and their project as documented by Glass and Long.

So why was I drawn to this video in the first place? I will be the first to admit that I have the privilege of *not* being trapped in a cubicle, and do enjoy a livelihood where I usually feel a considerable amount of agency. But the majority of my work boils down to significant amounts of immaterial labour, time spent on email, writing texts, grants, staring at spreadsheets and herding other cultural workers in the effort to produce meaning that often seems illusory. And of course, the infinite scroll: thumbing through Facebook and Instagram posts, only partially with purpose. I don't know how embodied I always feel, in my labour or in my free time, and so I am as susceptible to the 'dream of skill' as the next information herder. I probably reposted Half Cut Tea's video about Olson and Horwitz because on top of having visited and taught at several small and independent artist residencies over years, I was also spending summers hosting artists in rural Ohio with my partner on his family tree-farm. While onsite, I only *dreamt* about building packed earth cabins and retrofitting trailers into idiosyncratic structures, because instead, I spent most of my time either catching up on reading, socializing or simply continuing my regular work life – just moving my regular season office out of doors.

When I first watched the video and shared it, I didn't think too much about Nick and Lilah's age, or what they were wearing, I was caught up in my *desire* for skill. The comment thread that unfurled beneath my post was intriguing: it

eventually took to describing Nick and Lilah as 'hipsters', a pejorative term that describes young, predominantly white Americans. 'Hipster' also tends to imply economic privilege along with the visible markers of youth and race. Hipster is a powerful word in the American popular lexicon, with several contemporary writers taking the term and group to task in recent years. In short, applying that label to anything can immediately void any cultural production based on a loose association of styles. As Mark Greif points out in the *New York Times*:

> All hipsters play at being the inventors or first adopters of novelties: pride comes from knowing, and deciding, what's cool in advance of the rest of the world. Yet the habits of hatred and accusation are endemic to hipsters because they feel the weakness of everyone's position – including their own.[12]

Style is a notoriously unstable category. What was 'hip' fifteen years ago is certainly not 'hipster' now; rather the term has merely come to describe an idea (as there is no real certain definition) of a commoditized, fashionable, pseudo-counterculture that is devoid of the political. Canadian journalists Joseph Heath and Andrew Potter do an excellent job of summing up how counterculture is the very thing that drives consumer culture in their book *Nation of Rebels: Why Counterculture Became Consumer Culture*.[13] They outline how rebellion drives the marketplace, because the marketplace is driven by consumers who seek distinction from the masses: 'Social status, like everything else, is subject to diminishing marginal utility – the less you have of it, the more you are willing to pay to get some.'[14]

In fashion, that social status can be achieved through the aspirational brand, a product that many people want to own but can't afford. Sociologist Dick Hebdige describes fashion's intentional communication (of status and distinction) in *Subculture: The Meaning of Style*, as a loaded choice, whether expressive of 'normality' or 'deviance'.[15] A handcrafted thing (article of fashion, design, etc.) could stand-in as an aspirational fashion object as it signifies access to the unique and the singular, as well as to the knowledge of its whereabouts. Possessing the handmade object shows that the consumer knows where to find the uncommon, whether it's the next big thing, or something so rare that they are the only ones who have the distinction of knowing about it.

I'm sure there are many people who are uncomfortable with the idea that their purchasing of small batch gin, French theory and rare vinyl still makes them a consumer, but Heath and Potter are hard to argue with: the desire to stand out and prove that you do not participate in *mass society* ratchets up consumption in general – across a variety of goods and services. And as they point out, even if you save your money, it is simply lent back out by banks for someone else to spend. 'Consumerism' they point out: 'always seems to be a critique of what other people buy. This makes it difficult to avoid the impression that the so-called critique of consumerism is just thinly veiled snobbery or, worse, puritanism.'[16] They go

on to point out that taste is grounded in the sense of distinction, and given that everyone cannot have good taste (or no one would be distinguished), 'good taste' continually shifts to more inaccessible, less familiar styles.[17] Taste and distinction are constantly moving targets.

> Good taste, in other words, is a positional good. One person can have it only if many others do not. It is like belonging to an exclusive yacht club, or walking to work downtown or hiking through untouched wilderness. It has an inherently competitive logic. Thus any consumer who buys an object as an expression of her style or taste is necessarily participating in competitive consumption.[18]

Punk culture, according to Hebdige, was an attempted critique of capitalism through fashion that was comprised of a bricolage of illegible signs, 'signifying practices' that Hebdige saw as 'radical in (the) Kristevan sense, in that they gestured towards a "nowhere" and actively sought to remain silent (and) illegible'.[19] Today's 'hipster' style, rather than providing a cultural critique through personal adornment like punk's garbage bags and safety pins, is instead totally familiar and readable. Some might even describe it as a nostalgic collage of countercultural and popular fashion – a mix of lumberjack shirts and beards and floral skirts and Doc Martens and Kurt Cobain cardigans that make up a greatest-hits of American countercultural and popular fashion from hippies to blue collar workers through to grunge and right up to normcore. 'Hipsters' appear to restate bygone culture and values through their consumption and remix of a plurality of iconic (North) American styles. Perhaps hipsters are relatively speaking, conservative.

So, if we understand style and consumption as being driven by a desire for distinction, how might a person set themselves apart from others in terms of style, but less overtly through consumption? Not unlike the savvy fashionista who discovers the unique handcrafted bags on a side street in Italy or in an Etsy store online, the discoverer of amazing experiences is articulating their unique and distinguished relationship to the world through *what they do rather than what they buy*. And what could confer more distinction today than the individualism of the 'project' and the particularly enlightened quality of its implied labour? And what could be a more sensible, genuine project than those that are handcrafted and/or emerge from an autonomous, DIY framework?

'The formulation of diverse projects has now become the major preoccupation of contemporary man,'[20] says Boris Groys, in *The Loneliness of the Project*. Although he goes on to speak about more academic endeavours, and the inherent social isolation that ebbs and flows as projects are initiated and completed, Groys points out a few things about 'the project' worth reiterating:

> Each project is above all the declaration of another, new future that is supposed to come about once the project has been executed … But unnoticed somewhere

beyond this general flow of time, somebody has begun working on another project. He is writing a book, preparing an exhibition or planning a spectacular act of terrorism. And he is doing this in the hope that once the book is published, the exhibition opened or the assassination carried out, the general run of things will change and all mankind will be bequeathed a different future; the very future, in fact, to which this project has anticipated and aspired.[21]

The 'project' probably costs money, and is likely to be exchanged at some point for something else (cultural capital, credibility among 'creatives'), but it also takes attention away from traditional consumerism and retrains it on activity and authenticity. In art, Groys points out, attention has moved away from the art object itself and towards its documentation; heightening the importance of the *doing*, the productivity, the action over the product itself:

> Art documentation thus signals the attempt to use artistic media within art spaces to make direct reference to life itself, in other words: to a form of pure activity or pure praxis, as it were; indeed, a reference to life in the art project, yet without wishing to directly represent it. Here, art is transformed into a way of life, whereby the work of art is turned into non-art, to mere documentation of this life. Or, put in different terms, art is now becoming biopolitical because it has begun to produce and document life itself as pure activity by artistic means.[22]

Nick and Lilah's semi-functional house is a project that exists and circulates as art documentation within the framework of Half Cut Tea's video. It lives as pure activity and praxis with over 1.5 million views on YouTube alone, making it clear that there is a considerable draw to watching the narrative of the project, DIY skill and handcraftedness even if the results are not a permanently inhabitable structure. The string of comments on YouTube mostly express glee and awe at the beauty of the thing, or thoughts on the wonder of making something with one's own hands; critical commentary on the project itself or the video's framing of it are few and far between.

In current popular culture, particularly advertising and journalism, artists, craftsmen and designers are portrayed as the makers of meaning in American culture, and wield considerable agency in the production of signs. As Jacques Rancière defines it: art is the 'recomposition of the relationship between doing, making, being, seeing and saying'.[23] The contemporary cognitive worker, whether confined to a desk at a cultural organization, freelancing in a local coffee shop or sharing desk space in an incubator, is still abstracted from the material world, despite being situated in environments that suggest otherwise. For the worker tethered to their laptop or smart phone, the dream of re-embodiment is in the act of artistic production – in the *project* that will change the future after they publish

that article, complete that website or launch their start-up. Work that more-or-less continues later, back on the screen. Given that the average cognitive labourer spends all day on their computer, this re-embodiment is primarily imagined through watching it: the recirculation of videos and the re-pinning or tumbling of images. It is a virtual addiction to skill through the fetishizing of documentation (or in the case of object: handcraftedness).

Franco 'Bifo' Berardi poses an interesting question about what wealth is, in his treatise against the conditions of contemporary labour and the loss of sensuous life. He says:

> We can evaluate wealth on the basis of the quantity of goods and values possessed, or we can evaluate wealth on the basis of the quality of joy and pleasure that our experiences are capable of producing in our feeling organisms. In the first case wealth is an objectified quantity, in the second it is a subjective quality of experience … One could instead conceive of wealth as the simple capacity to enjoy the world available in terms of time, concentration and freedom.[24]

On one hand, the project is the very thing that Berardi feels has troubled the condition of labour in the digital era; that is the complete investment of all competences, all creative, innovative and communicative energies on the part of the cognitive worker who values labour as the most interesting part of their lives. The project (or 'enterprise' in Berardi's terminology) means invention and free will, but ultimately secludes the worker from social and sensual interaction as they become permanently wired to their production, or as Groys recognizes, isolated. On the other hand, the project represents work done by choice, in free time, and out of free will. It is the work that is possible given a certain privilege in terms of time and freedom, an opportunity for pleasure in experience, as well as the privilege to seek isolation and entertain the possibility of bequeathing a new future.

Perhaps without the privilege of time, and time to build skill, or without the existing resources that allow skill to be spent on projects that do not create other valuable resources, or maybe simply, without the privilege to think and act poetically (and fail at poetics, as much as succeed), there is a desire building *for skill itself, reified,* and what it represents as much as what it can actually provide. A desire that reflects a hope to escape the mundane space-time of wage labour, and in the case of many American workers, the mundane space-time of abstract, immaterial labour that leads the worker to desire inhabiting the role of producer of *things*: the role of artist, craftsman and industrial designer. At the very least, without access to the time, resources and skill to produce meaning in this way, the cognitive worker can circulate images of this work, playing a hand in the production of meaning as self-styled curators on Pinterest, Tumblr, Instagram and YouTube. Homemade houses like Nick and Lilah's (re-presented in documentation like those of Half Cut

Tea's), have the capacity to communicate skill, agency, independence and stability all in one neat package. Since these conditions cannot be 'bought', witnessing them (or at least their record) can fuel the desire for similar circumstances, and with it, the image of the *project* becomes something to be hungrily consumed.

Total art worlds

In *Understanding the Material Practices of Glamour*, Nigel Thrift writes about aesthetics and the construction of worlds as 'spaces formed by capitalism whose aim is not to create subjects … so much as the worlds within which the subject exists'.[25] 'Worlds have their own practices of *rendering prominent*', Thrift says, 'giving rise to a particular style of going on that consequently focuses passions'. He goes on to say that: 'The restlessness of the imagination becomes an asset that can be valorized as everyday life becomes a cavalcade of aesthetically charged moments that can be used for profit, not least because *every surface communicates.*'[26]

I read this excerpt of Thrift's as an attempt to understand the contemporary fashion for life*style*. And not lifestyle, as in habits or ways of going about things, but lifestyles as fully articulated worlds of interconnected aesthetic decisions. In the Half Cut Tea video, there is particular emphasis on the aesthetics of experience; the project can be understood as a gesture towards the construction of a self-styled world that Nick and Lilah inhabit. Thrift is quick to note that style is not about checking boxes, but about a series of modifications to being that produce captivation. For Thrift, glamour is a key quality for creating allure, and thus the captivation that style produces. It is a term that he chooses for its dual economic and magical force, for meaning the '*spell* cast by unobtainable realities'.[27]

In closing, I want to examine the *project* transformed into a world as it happens in the art practice and residency, Mildred's Lane. Mildred's Lane is a kind of lifestyle art piece initiated by artists J. Morgan Puett and Mark Dion, but increasingly the focus of Puett. Mildred's, as it is affectionately called by artists who have been residents, dinner guests and lecturers, is Puett's home on 96 acres in North East Pennsylvania. Dubbed an 'art complexity', Mildred's hosts a summer residency program where students pay to participate in three-week programs, Social Saturday dinner events and artist-directed projects. The Mildred's Lane website reveals that all of Puett's work – from her off-site exhibitions to homeschooling her middle-school son – are folded into the 'complexity' in an articulation of a lifestyle-turned-world that leaves no part of her life orphaned from the larger project, suspending herself indefinitely inside it.

The Mildred world is one of workstyles and comportment. Explained on the 'Philosophy' page of the website as a 'practice and educational philosophy (in an) attempt to collectively create new modes of being in the world',[28] Puett's *project* is self-aware of its world-making, future-changing proposition as per Thrift and

Groys. Puett goes on to say: 'This idea incorporates questions of our relation to the environment, systems of labor, forms of dwelling, clothing apparatuses, and inventive domesticating; all of which form an ethics of comportment and are embodied in *workstyles*.' Students at Mildred's Lane, the site explains, will negotiate these issues through rethinking 'one's collective involvements with food, shopping, making, styling, gaming, sleeping, reading and thinking. Every research session will be an intensive reconsideration of workstyles … (with) visits to alternative farms, discussion around food and cooking, cleaning and maintenance.'[29] Having been a guest at Mildred's, I have witnessed first-hand the 'workstyles and comportment' philosophy in action, where resident students and staff have adopted a fairly thorough aesthetic that guides their life and work, whether it's their mode of dress or their projects (Figure 5.2, Plate 6).

In many ways, staying at Mildred's Lane is like staying inside an art installation, with bits and pieces of Dion and Puett's work throughout the property as either full-fledged installations (as in some of the guest cabins) or as odds and ends throughout the house. Puett, Dion and their collaborators have cultivated a rather precise shabby-chic-meets-Victorian-study aesthetic on the property, with only vintage linens and glass in the kitchen, a library overflowing with books wedged between jars filled with scientific specimens, and an admittedly delightful outdoor porcelain bathtub. Puett and staff drift dreamily around the property in linen shift dresses and drawstring pants, everything seemingly white or neutral or grey. One feels untoward donning anything brightly coloured or patterned, as the environment seems to instruct that 'good' comportment, along with 'hooshing'[30] the homestead, is to affect a kind of anachronistic prairie manner.

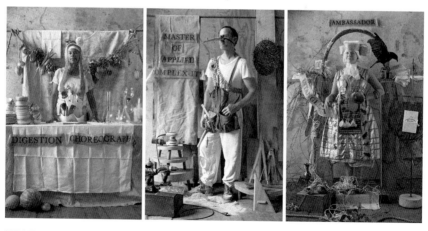

FIGURE 5.2 Rebecca Purcell, J. Morgan Puett and Jeffrey Jenkins in collaboration, *HumanUfactorY(ng) Workstyles: The Labor Portraits of Mildred's Lane. Cheryl Edwards: Digestion Choreographer, Paul Barlow: Master of Applied Complexity and J Morgan Puett, Ambassador of Entanglements*, 2014. Photo: Jeffrey Jenkins.

Perhaps it is telling that Mildred's has been featured in the *New York Times*[31] and *Food and Wine* magazine,[32] the former quoting frequent visitor Jorge Columbo as saying: 'Morgan has been making her own world as if the rest of the world didn't exist.' Later in the article, Puett says: 'What I'm interested in is the future and what it looks like … in inventing a future through history and material culture and art.'

Mildred's is known for its Saturday Socials, a dinner party that Puett and collaborators host on the property for invited guests and an extended group of friends and acquaintances. These events are a veritable who's who of the East Coast art world give or take a few Western or European visitors who might be nearby. Puett is truly a generous host in that regard, the door is always open once you've been to Mildred's, but it is this event, in relationship to the residents and the lessons in workstyles and comportment that I wish to focus on closely here.

When I visited Mildred's Lane in 2011, the residents were hard at work building tables and lanterns, decorating the trees, choosing linens and picking flowers in preparation for that evening's social. Ever the pragmatist, I wondered out-loud as an increasingly frustrated pair of residents worked out day two of a table design: *Why wasn't there a table from last weekend?*

'We make them for every event', was the matter-of-fact answer.
'Are there no parts left over in storage?' I asked.
'Well we don't have much room for storage', I was told.

This was where I saw the full effect of the 'workstyle', the handmade, the skilfully hand-wrought as aesthetic. The experiential event that was the Saturday Social wouldn't be the finely crafted, total artwork (or perhaps in this incident, art *world*) that was being constantly prepared at Mildred's, if a table hadn't been especially hand-built for that event. Of course, the diners might not realize this detail. Some would likely assume as dumbly as I, that the tables were broken down and stored until next week (and perhaps they are today, five years later). But the residents, at least according to the educational philosophy, were being taught to find art in every act of labour, and presumably joy in the aesthetic of simplicity, which is probably all that is possible for craft on such a short timetable.

At the same time, it's hard to examine Mildred's Lane and not be suspect of labour made so precious and of students-turned-production-assistants in the construction of another artist's world. While there is something to be said for finding or making the aesthetics of the everyday, the everyday of Mildred's is particular. It is noticeably nostalgic for an amalgamation of the aesthetics of olden times, when farm labour was by no means this lovely or charmingly inefficient.[33] By designing and upholding its workstyles and modes of comportment, Mildred's engages in a glamourizing of the domestic and agricultural labour it relies on for entertaining. The Saturday Social gathers an already glamorous set of individuals

to dine together, and the overlay of this set of individuals onto the heightened rural worlding of Mildred's casts the kind of spell of unobtainable realities that Thrift describes. For most, this home life, with its extensive cast of artists paying/volunteering to help 'make it' is unachievable.

Mildred's Lane is the ultimate project (or enterprise, to use Berardi's terms). It *is* the work that is only possible given a wealth of time, freedom and pleasure in every experience; the privilege to take pleasure in, and aestheticize, the domestic labour that is for many merely the dreaded chores wedged between jobs, children and other responsibilities. Like Nick and Lilah's cabin, there is an affected casualness in the aesthetics of this work, a handcraftedness that presumes accessibility,[34] but this 'work' remains in the category of enterprise. In presenting unobtainable realities that are aestheticized through the vocabulary of the handmade and the authentic, these qualities become a new kind of glamorous: the freedom to make, to be slow, to build worlds, to deploy skill for pleasure rather than pay. Coupled with the strange disconnect between the price and privilege required to gain access to the art world, and the extreme wealth that travels through it, this attempt to live a kind of aestheticized simplicity as an isolated artwork, often fails at being either critical of those economic circumstances that make such an act possible or truly celebratory of a legitimately simple life. What results is a kind of uncanny theatre, or as Hal Foster recalls in *Design & Crime,* a Gesamtkunstwerk that 'commingles subject and object'.[35] Referencing Adolf Loos's critique of art nouveau, Foster is wary of the total design of contemporary life, with the individuality of the owner expressed down to every nail. As Loos describes the man in his complete art nouveau interior: 'he (is) precluded from all future living and striving, developing and desiring. He (thinks), this is what it means to learn to go about life with one's own corpse. Yes indeed. He is finished. *He is complete!*'

Notes

1 Sianne Ngai, *Our Aesthetic Categories: Zany, Cute, Interesting* (Cambridge: Harvard University Press, 2012), 1.

2 'About', Manos, http://manoscrafted.com (accessed 28 October 2013). The website has since been taken down, but can be accessed here: https://web.archive.org/web/20131024152101/http://manoscrafted.com/.

3 Creative Market website, https://creativemarket.com/ (accessed 25 August 2016).

4 Jacques Rancière, *The Politics of Aesthetics* (New York: Bloomsbury, [2004] 2013), 61.

5 The International Slow Food Movement was founded afterward by participant Carlo Petrini, http://www.slowfood.com/about-us/our-history/ (accessed 10 September 2016).

6 Lionel Trilling, *Sincerity and Authenticity* (Cambridge: Harvard University Press, 1979), 93.

7 Benj Gerdes and Jennifer Hayashida, 'Slow People', in *The Second World Congress of Free Artists*, ed. Camel Collective (Denmark: Kunsthal Aarhus, 2013), 122.

8 Ibid., 123.

9 Elsewhere website, http://www.goelsewhere.org/ (accessed August 25 2016).

10 Matt Glass and Jordan Wayne Long (Half Cut Tea), *Nick Olson & Lilah Horwitz| Makers*, https://www.youtube.com/watch?v=YWvemw0nj7k (accessed 25 August, 2016).

11 Half Cut Tea website, http://www.halfcuttea.com/about/ (accessed 25 August 2016).

12 Mark Greif, 'The Hipster in the Mirror', *New York Times*, 12 November 2010, http://www.nytimes.com/2010/11/14/books/review/Greif-t.html (accessed 25 August 2016).

13 Joseph Heath and Andrew Potter, *Nation of Rebels: Why Counterculture Became Consumer Culture* (New York: Harper Collins, 2004). The Canadian release of the book is titled *The Rebel Sell: Why the Culture Can't Be Jammed*.

14 Ibid., 116.

15 Dick Hebdige, *Subculture: The Meaning of Style* (New York: Routledge, [1979] 1988), 101.

16 Heath and Potter, *Nation of Rebels,* 105.

17 Ibid., 125.

18 Ibid., 126.

19 Hebdige, *Subculture*, 120. Hebdige begins by pointing out that Kristeva in *La Revolution du Langage Poetique*, 'counts as radical those signifying practices that negate and disturb syntax – "the condition of coherence and rationality"', 119.

20 Boris Groys, 'The Loneliness of the Project', *Going Public* (Berlin: Sternberg Press, 2010), 70–83. Originally appeared in *New York Magazine of Contemporary Art Theory*, no. 1.1 (Antwerp: Museum van Hedendaagse Kunst Antwerpen, nd.). https://thomas-hersey.wiki.uml.edu/file/view/The_Lonliness_of_the+_Project.pdf (accessed 25 August 2016).

21 Ibid,. 3

22 Ibid., 5

23 Rancière, *The Politics of Aesthetics*, 42.

24 Franco Berardi, *The Soul at Work: From Alienation to Autonomy* (Los Angeles: Semiotext(e), 2008), 81.

25 Nigel Thrift, 'Understanding the Material Process of Glamour', in *The Affect Theory Reader*, ed. Melissa Gregg and Gregory J. Seigworth (Durham: Duke University Press, 2010), 295.

26 Ibid., 296.

27 Ibid., 297 (emphasis added).

28 Mildred's Lane website, http://www.mildredslane.com/ (accessed 25 August 2016).

29 Ibid.

30 'Hooshing' being the word-of-choice at Mildred's (that eventually infects one's own vocabulary for better or for worse after leaving), for not just tidying up, but giving your tidying a little extra 'sumpin-sumpin.'

31 Alastair Gordon, 'In Her Own World', *New York Times* 29 May 2008, http://www.nytimes.com/2008/05/29/garden/29puett.html (accessed 27 August 2016).

32 Jen Murphy, 'J. Morgan Puett: A Curator of Food Curiosities', *Food & Wine*, http://www.foodandwine.com/articles/j-morgan-puett-a-curator-of-food-curiosities (accessed 27 August 2016).

33 Mildred's Lane is not a working farm, although there is a garden. Cooking and cleaning are shared by participants in the residency or currently involved in the project. Other work, repairs and maintenance, including landscaping of the 96-acre site is assumed to be part of this shared labour as per the published philosophy.

34 This is to say, that the casualness of this work presumes that it is easy or readily at hand for anyone, if they simply made different choices. Of course, most working- and middle-class people cannot take months off to experiment in world making, let alone dedicate resources to lifestyle experiments. Artistic enterprise, while it claims to model possibilities, is only capable of modeling those possibilities as motifs.

35 Hal Foster, *Design and Crime (And Other Diatribes)* (Brooklyn: Verso, 2002), 15.

6 CRAFT AS PROPERTY AS LIBERALISM AS PROBLEM

Leopold Kowolik

Monsieur Jourdain: Est-ce que les gens de qualité en ont?
Maître de musique: Oui monsieur.

Monsieur Jourdain: J'en aurai donc.

MOLIÈRE, *LE BOURGEOIS GENTILHOMME*, ACT II

Satire grows like mould wherever a system or group or practice takes itself too seriously or when people are unaware of an error they are deeply invested in making. The more serious and the more myopic, the funnier. Satire often adheres to pretentious trappings – affectation or conceit that obstruct societal honesty and social improvement. It's what Molière was addressing, and although it took a century, the groups and pretensions he lampooned were eventually brought to task by revolution. His bourgeois gentleman doesn't understand the rules of the aristocracy, the deeply serious rules of vanity, and so blunders along, a self-deluding oxymoron, pursuing the bourgeois mantra that he must have what 'people of quality' have. Molière's satire is apt because it targets self-deluding and self-congratulating and in *Le Bourgeois gentilhomme* it centres on a character who acutely misunderstands the situation and positions himself ridiculously because of it.

It is easy enough to see how craft could be similarly satirized. Much of craft's identity seems to rely on overly serious self-reflection, strained gravitas, a weathered voice of profound personality and the creased hands of individual creativity, all set within an anti-capitalist counterculture with a deliberate obliviousness to price.

There are craftspeople, like British ceramicist Carol McNicoll, who know that their work – however brilliant and politically charged – cannot be pragmatically political and that, in truth, there is no such thing as 'counterculture'. Standing in her studio, discussing the active social statements of her anti-war series or the current

FIGURE 6.1 Carol McNicoll, *Freedom and Democracy*, 2011, ceramic, wire, found objects. Photo: Philip Sayer. Courtesy: Marsden Woo Gallery, London.

work that juxtaposes found-object made-in-China cheap vases with fractured handmade plates, we talk left-wing politics. McNicoll's work is clever, funny, political and useful (all her work is functional, however sculptural) (Figure 6.1). But she very clearly says: 'It doesn't matter at all.' No fruit bowl is going to stop a war; no vase will alter a banker's bonus. Her art and her creativity are pleasurable for her, but she is whistling in the wind of politics.

And yet, in parts of the discourse, craft has been situated as a foil or counter to the interconnected systems of neoliberalism and capitalism. Craft makes sincere claims against social inequalities, homogenization, industrialization and manipulation. As a practice and a dialogue, craft aspires to freedom and it is very serious. There are obviously acute global issues that need our immediate attention: use of labour, overproduction/waste in race-to-the-bottom market gluts, conscious disregard for environmental impact, dehumanized scales of production and consumption, the tyrannical instability of high finance. Craft might have some talking points for these issues. But for makers and consumers of craft to assume that it is plainly 'anti-neoliberal' is like Monsieur Jourdain thinking he can be a 'bourgeois gentleman'. It is crucial to properly understand craft's relationship to neoliberal capitalism, if craft is to stimulate real solutions to the pressing problems of our age.

Because craft (meaning craft theory, craft culture and craft as a mode of object creation) comes out of the very same political and philosophical construction as

liberalism, many of the assumptions that fuel neoliberal capitalism are also lively and at work within craft. Craft can indeed be thoughtfully political, as with the work of McNicoll. Whether at the level of the simple individual object or on a larger level as it engages with activism and socio-economic redress, craft has powers as a process and as a discourse to stimulate conversation. But is craft a foil to neoliberal capitalism, as some claims suggest? We must confront and understand the complex relationship between craft and neoliberalism before craft gets too proud of itself as a counter force.

This is a sprawling issue that draws in seventeenth-century history, political philosophy and its history, Enlightenment shifts in subjectivity, the development of economic theory and of course much of the geography and socio-economics of material culture. Ultimately there is a much larger, richer question to be asked that encapsulates the seminal and ongoing philosophical divisions of craft into art, science and industry.

So let me be quite clear – this essay is just a start. However, if we can begin to uncover what craft shares with neoliberalism, we might subsequently better position craft to discuss and propose incremental, even conservative, solutions in the ongoing discussion of better social systems. We cannot allow craft its delusion of inherent anti-capitalism; furthermore, we must reject the self-congratulatory tone of craft as a system, practice or object for differentiating oneself from the rest of society.

I will argue that craft in the West is part of late capitalism, not juxtaposed to it; and further, that craft is defined by the same political philosophy as capitalism. I will do this by discussing foundational concepts of property and individualism that are central to understanding both neoliberalism and craft. Each concept employs a warped version of the original liberal tenets. Craft does occasionally temporarily escape, embracing these twisted meanings or ironically toying with capitalism's underpinnings, as my examples will show. But we must be very careful how we read these moments. If we are blinkered to craft's genealogy and role, it becomes the very worst of capitalist variables: what economists Thorstein Veblen identified and Fred Hirsch labelled a 'positional good' – an entity used to create social distinction at the specific cost of equality. In essence, craft risks being reduced to a function of bourgeois snobbery.

Before we continue, two comments on vocabulary: I have already hinted at my understanding of the word 'craft' and this should become more (or less) coherent as we proceed. When I use the word, I am thinking not only of the objects but also the people, theories and entire discourse surrounding the material culture that is juxtaposed to mass production, industrial uniformity and uncreative design and assembly. Then, for the purposes of this essay I use the phrase 'neoliberal capitalism'. This is not to say that I think capitalism and neoliberalism are synonymous – one is an economic theory and system, the other a sociopolitical machinery or ideology; one is the subset of the other, though which is a subset of

which is no longer clear. In this essay, I am thinking of craft's engagement with the entire political-economic structure of contemporary Western culture and so frame my question on the basis that any foil or counter is set against all that is encompassed by the words 'capitalism' and 'neoliberalism'.

We can reveal some of the shared genealogy of craft and neoliberal capitalism by stepping backwards in time, through the swirling mists of Keynesian economics and Mercantilism, back through capitalism and democracy, before Thomas Jefferson articulated his ideas on a happy society. We arrive back at one of the originating moments in the history of democratic capitalism: seventeenth-century England, and to the political philosopher John Locke.

Locke on property

There are several beginnings of liberalism[1] but to better understand the DNA of neoliberal capitalism, Locke's philosophy is especially helpful. As the historian of political theory Nathan Tarcov puts it in his book on Locke, 'there remains a very real sense in which Americans can say that Locke is *our* political philosopher'.[2] If we want to take issue with contemporary neoliberalism bonded to capitalism as a homogenizing mode of unrestricted growth through consumption and economization, then it's fair to say that we're talking about American globalized industrial capitalism.

At the heart of this Americanized liberalism is confusion over the concepts that are contained in the concept 'Life, liberty and the pursuit of Property'. Thomas Jefferson adopted Locke's ideas for the foundation of a state as he and his colleagues created their new American republic. When the 'pursuit of happiness' appears to replace what in other early American documents came from Locke as 'property', Jefferson's choice was a very careful clarification and replacement. But in other places, especially in early American jurisprudence drawing from this migrated version of Locke, the pursuit of *property* in a more limited sense of ownership increasingly contaminated the idea, separating out *the pursuit* which was key to the original connection between Lockean 'property' and 'happiness'. Today, this pollution has so subsumed any other reading, that neoliberalism requires 'happiness' to mean 'the acquisition of stuff'. Understanding how 'stuff' came to define our freedom and happiness is essential to understanding the political counterposition attributed to craft.

This problem begins with Locke's use of the word 'property' in his political philosophy. Property lies at the core of the *Second Treatise of Government*,[3] in which he seeks to define the origin of and reasons for state power: 'Political power then I take to be a Right of making Laws … for the Regulating and Preserving of Property.'[4] The problem is that for Locke, property can mean specifics like land and goods but it also means something much broader. Throughout the *Treatise*,

'property' does include goods and possessions but it also includes everything a person is. In his introductory essay on the *Treatise* Christopher Hughes describes this broader meaning as: 'One's property is the whole of one's social personality.'[5] Locke says it quite specifically when he explains that people join society 'for the mutual Preservation of their Lives, Liberties and Estates, which I call by the general Name, Property'.[6] This is the 'social personality' that Hughes refers to. Another Locke authority, Peter Laslett, explains what this really means: 'it is through the theory of property that people can proceed from the abstract world of liberty and equality based on their relationship with God and natural law, to the concrete world of political liberty guaranteed by political arrangements'.[7] For Locke 'property' is not only 'ownership of stuff' but it is also a conceptual description of the guarantees of natural law. As Locke sees it, humans are 'all the Workmanship of one Omnipotent, and infinitely wise Maker; All the Servants of one Sovereign Master, sent into the World by his order and about his business, they are his Property, whose Workmanship they are.'[8] 'Property' is therefore a nebulous entity: it is the functioning encapsulation of sovereignty. It is a manifestation of our fundamental rights. 'Property', defined in this broad way, is what allows human beings to interact with one another in the same way that spirit defines our interaction with God.[9] Property is the agent or representation or container of human power, the vessel for the rights and responsibilities that define power's dispersal through a society. In Locke's thinking, humans are properties of God – containers of divine sovereignty in the world – correspondingly our sovereignty is contained in our 'property'. To be clear: these properties include things we own like land, but they also comprise everything we are – our skills included.

It follows that a misreading here leads to the situation we have today in neoliberal capitalism. If we think of our inherent qualities or properties – our skills and knowledge and labour – as the same as material properties like our lands and houses and coal, then everything about us can be exchanged or alienated. This *balance sheet* reading of property is how we end up with capitalism as Marx accurately identified it. C. B. Macpherson, the great Canadian reader of liberalism, most clearly articulated this reading of seventeenth-century political thought. His highly influential but slightly flawed interpretation of liberalism centres on what Macpherson calls the theory of possessive individualism. 'The possessive quality [of 17th century liberalism] is found in its conception of the individual as essentially the proprietor of his own person or capacities, owing nothing to society for them … Society consists of relations of exchange between proprietors'.[10] This reading is flawed because, as subsequent commentators have noted,[11] Macpherson has read 'property' in an economic sense – what I have been calling the limited definition of property. Writing in the 1960s from a progressive and Marxian-economic viewpoint, Macpherson's reading was necessarily economic. But Locke was not thinking like that at all, as his underlying intention was to establish theories of political power that would protect against absolutism. Locke's theories were a defence against

the Stuart monarchs specifically, though he intended his ideas to be a permanent political bulwark. Locke saw 'divine sovereignty' residing in the people (manifest in their 'property'), not in a divine right of kings as the Stuarts would have had it. He says clearly: 'By Property I must be understood here, as in other places, to mean that Property which men have in their Persons as well as Goods.' [12]

To read 'property' solely in the limited way, focused on ownership, is to misread Locke. He was describing the worldly manifestation of the unalienable natural rights of human beings in the face of tyranny. He was not talking in a limited manner about economic ownership. This is the misreading that leads to neoliberal capitalism, and this is the same misreading that craft continues to propagate. Capitalism thinks of 'property' as something that is owned and that this means it can also be traded. Neoliberalism goes the step further by bonding this property concept with the ruined version of happiness. So we end up with 'shop your way to happiness'. This is the wretched appropriation and misreading of Locke's word, with almost none of his meaning.

Reified craft production relies on this misreading of 'property'. When craftspeople speak of the skills that are visible in an object, or describe the characteristics of the handmade, when promotions of craft talk about the embodiment of the maker, craft is relying on a limited definition of owned property made available for the consumption of others. 'Skill', 'the characteristics of the handmade', 'the personality of the maker' – these are properties considered as owned by the maker in question. This is craft taking the same narrow reading of the word 'property' – that skill, for example, is something owned by the maker, something they can use as they see fit.

In a way, this is almost a minor point – after all this is not craft's fault. Craft is embedded in its historic context. But it is a mistake for craft to not see that the very same misreading of property into the bloodline of capitalism is the reading that craft uses to define itself. If we look carefully, we see that craft can momentarily offer some succour. Like Jefferson's originally intended *pursuit*, craft is aspirational. In the brief moments when workmanship flows through the maker, the maker's property – meaning their sovereignty – is expressing itself. In a secular revision of Locke's meaning, the human as an embodiment of natural sovereignty embodies his or her sovereignty in properties set to serve us. But this is aspirational because it is not achievable. As Jefferson's 'pursuit' implied, the 'working towards' is the key. Craft is a pursuit that aims for the reunification of property as an intangible container of self-generated political sovereignty (as meant by Locke) and property as the physical embodiment of an owned piece of stuff. This aspiration is worth the effort, but we will never achieve it: the moment we think we have achieved or acquired a physical encapsulation of sovereignty through making or buying a craft object, we have a capitalist piece of stuff.

We have only to acknowledge that craft can be owned or authored to see how far craft is from juxtaposition to neoliberal capitalism, and how craft is also deeply

invested in the limited reading of Locke. The breach of essential sovereignty takes place in both neoliberal capitalism and in the craft workshop: the difference is only one of scale and geography. Perhaps craft can offer a critical methodology for understanding that alienation, as long as it acknowledges its own engagement in the same system. If, even for a moment, craft can present skill not as property or possession but, rather, treat skill as a site of intangible reflection of personal political power, craft has engaged with freedom. But in so doing it only (only!) takes a stand against tyranny – which is great, but it's not anti-capitalist.

Property in craft

It is easiest to see how this observation applies to commercial craftspeople whose work is designed for sale. But this same argument holds for more theoretical works where sale is either not considered or intentionally ignored, of which craftivism is a subset.

Carrie Reichardt is a British ceramic-based maker whose artwork and political activist work has focused on large-scale mosaic. Reichardt positions her craft as far from capitalism's centre as possible and her work is vigorously political, often intended for public spaces, and often collaborative. Even her authorship is sometimes decentred with her 'Mad in England' trademark operating as something of a mask. But no matter how you cut it, Reichardt is still inside the current system working within the rules of democratic capitalism: 'Marketing oneself and selling one's work as a name is still a capitalist's tool that is hard to avoid.'[13] This acknowledgement doesn't undermine her work as an activist, but the creative act – the craft act – must be understood as an element of herself owned, packaged and offered into the culture. The activist statement in her work *History is a Weapon* (Figure 6.2, Plate 8), for example, is powerful and clear; but as soon as we start talking about the process of creation, the journey of the creative act from idea to physical object, we are using a conception of the human that relies on the same misreading of self-ownership that became capitalism.

Again, this might seem nettlesome, since such a widely defined net will catch almost everything in the act of being like capitalism. But the point would be equally valid with Reichardt's ceramic spray-paint can with Bansky-cum-Warhol overtones titled *Just my fucking luck, capitalism collapses as my work hits the art market*, or the mention on her website of 'affordable, subversive souvenirs' that 'tapped into the mood of national dissent' opposing the patriotism stimulated by the 2012 Olympics.[14] Even overt political monuments like *Mary Bamber* (Figure 6.3) enter into the flow of public dialogue and consumption. The revolutionary socialist and suffragette was vigorously anti-establishment, her actions were directly political. And the statue does educate and excite contemporary reawakening of Bamber's activism; but we must acknowledge that the craftwork and the process of its

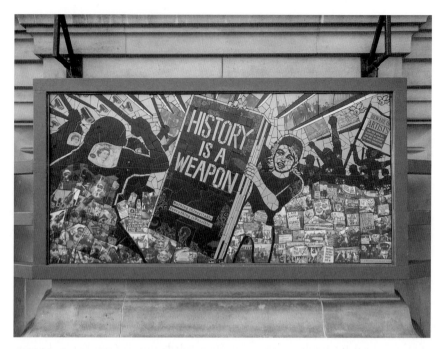

FIGURE 6.2 Carrie Reichardt and The Treatment Rooms Collective, *History is a Weapon*, 2014, ceramic intervention, Victoria and Albert Museum. Photo: Peter Riches.

creation use Reichardt's skill as property which is then objectified and discussed accordingly. I believe that craftspeople can be activists and I admire Reichardt's work enormously. But the very act of craft, regardless of its political claims or positioning in the political discourse, relies on the same conversion of self-ownership and alienation that lie at the core of capitalism.

An even more pointed example appeared in *Disobedient Objects*, a large exhibition at the Victoria and Albert Museum in 2014–15. This exhibition collected and presented a range of objects made as part of social movements and protests aimed at bringing about direct political action: 'Disobedient objects have a history as long as social struggle itself. Ordinary people have always used them to exert "counterpower." '[15] There were many examples of objects the curators felt embodied those struggles, from 2-litre plastic bottles turned into make-shift tear-gas masks, to currencies defaced with subversive slogans. The creation of such objects is often impressively improvisational and can be imaginative, witty, always serious (however goofy) and vigorously political. But as soon as we start discussing the skill or the object, we shift to evaluating it on the basis of capitalist property value. I am not suggesting that this undermines or devalues the activism. But the craft and the activism remain separate entities and however political the craft wishes to be, it must acknowledge the ground on which it stands as an externalization

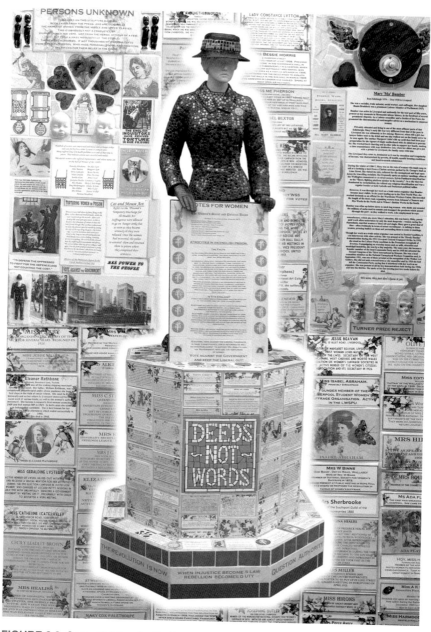

FIGURE 6.3 Carrie Reichardt with Nick Reynolds, *Mary Bamber*, 2011, printed ceramic, glass tiles and mixed media. Courtesy: Carrie Reichardt.

of a creative impulse. Objects are an inert product of human creativity housed in physical stuff. The same union banner or book-bloc shield is an object whether waved confrontationally at the police, exhibited in a museum or stored under the bed.

The making of protest objects is an extreme example in which the makers are so immediately and directly engaging with anti-capitalist action that it can be difficult to distinguish the craft from the action. But there is a difference and this is what makes it all the more important that we are precise in our understanding of craft's pedigree. A teapot does not make a tea party, and attributing political independence to an object is precisely what makes craft so easily co-opted into neoliberal capitalism. If we can look at it and discuss it, if we can collect and exhibit it, we are making an object of the original human property – this is what capitalism does.

A clearer example to end this point is of Canadian-born, UK-based silversmith Mary Ann Simmons, although her work is positioned at the opposite end of the political making spectrum. She produces large-object silver, especially decorative bowls intended as commemorative gifts. In 2008 she was admitted as a Freeman to the 700-year-old Worshipful Company of Goldsmiths of the City of London and became a Liveryman in 2013. When the company first accepted women, and then foreigners, to their august milieu a decade ago, they stated that they did so to recognise that the company's role was to promote excellence in the craftsmanship of silver and art metals.[16] This is craft most certainly, and Simmons must have felt the political relevance of her entrance to such an organization. And yet, all of the language and all of the actions surrounding her activities as a maker tie up at that original reading of skill as a tradable property of oneself (which is *not* what Locke said, and *is* what helps define capitalism).

The point is that craft shares this heritage with neoliberal capitalism whether the craft objects are intended for sale, exhibition, use, pleasure or anything else. The conceptual process of bringing into the world is where the overlap occurs and this is why if improvements are to be made in contemporary political economic society, craft cannot remain oblivious to the limited assumptions about self as property. This applies to craftivism just as much as it applies to expensive gifts for the bourgeoisie. Let's look now at another aspect of classical liberalism that might empower craft to change if the assumptions are challenged.

The 'I' in Locke's individualism

Pursuing these underlying principles further, I asked my students in the craft and design program at Sheridan College about their motivations: why they came to a studio-focused program to learn about ceramics, glass, furniture or textiles practices. I received a clear sense of craft's internal identity and with it another serious

connection and drift between presumptions about Locke's ideas in contemporary society: individualism. I have, incidentally, heard the same thing from senior level, highly successful crafts people, as from representatives anywhere else in the craft agora. The students however, have an honesty and clarity that makes their voices especially representative. They are also the future. And, practically speaking, they encompass a broad range of craft-types: from intellectual thinker-makers engaging the highest theoretical possibilities of craft with no thoughts about revenue all the way across the spectrum to absolutely physical craftspeople – sick of or oblivious to all the talk, interested only in making useful objects for sale. What we hear in their comments are craft's implicit modernist assumptions blaring out: I have a right to do this; I have a responsibility to myself to do this.

'I find pleasure in simple, thoughtful objects.'

'I enjoy working wood with hand tools, as this allows me to feel the textures I wish to create. For me, the art of furniture making is a visceral experience.'

'I have ignored the countless times that people in my life have doubted my drive and told me that what I wanted to be – a successful artist – was not a realistic goal.'

'Exploring glass has allowed me to release my inner creative mind and make what I've always felt I needed to.'

'The relationship I have with clay has always been therapeutic.'

'I hope to one day be able to see people using my creations in everyday life and think to myself "I made that".'

When we discussed the underlying assumptions that appeared in this exercise, we arrived at the question: From where did they derive this right? Makers feel 'rights' and 'obligations-to-authentic selfhood' due to perceived democratic-liberal rights of all social individuals. But this emphasis on individualism is craft's great mistake – a mistake shared with original capitalism that has furrowed back in on itself and become neoliberalism's major fuel source.

Again, we have to look to Locke; by returning to the origins of liberalism, we can see how tenets of the modern world overlap and distort in craft in particular and in neoliberal society as a whole. Because Lockean liberalism constructs a picture of sovereignty, power and liberty based on the singular person entering political society, the assumption grew that liberalism requires some sort of absolute individualism. But this is not why the individual was invoked in the original construction of liberalism. Right from the beginning, the use of 'the individual' is as a theoretical subset. Yes, the individual is the root of power (where sovereignty is vested by nature and identified by reason) but political power does not have an

external expression until that individual comes in contact with other individuals. To Locke, it stands to reason that there is no state – and subsequently no politics or power per se – until there is a collective:

> Political power then I take to be a right of making laws … and of employing the force of the community, in the execution of such laws, and in the defence of the Common-wealth from foreign injury, and all this only for the publick good.[17]

Locke's understanding of the individual is only as a piece of a community. In fact, it is not too much of a stretch to suggest that what we would imagine as 'individualism' would not even have crossed Locke's mind. The atomistic, economic and libertarian conception does not appear in Locke and as such, he would not recognize the neoliberal societal assumption that we see echoed in the statements mentioned earlier: 'I have the right, and obligation even, to do anything I like up to the point it interferes with anyone else's right to do anything they like.' This idea emerges later.

Locke makes it clear in Section 87 of the *Second Treatise*. In order for political society to function, it must be able to operate on behalf of the needs of the composite members 'there only is political society, where everyone of the members hath quitted his natural power, resigned it up into the hands of the community'.[18] Locke's notion of the individual, in the original liberal sense, was an almost purely theoretical construct that allowed him to discuss the origins of power. He did this to articulate and justify limitations on the English monarch's power. The 'individual' was not set up against the state or even to restrict a definition of government,[19] and it was certainly not a description of discrete, semi-combative political atoms with rights of autonomy up to the boundaries of any other individual that we are familiar with today. For craftspeople to describe their practice as an exercise of a right or obligation of individuality, is to take this latter day liberalism all the way into its current neoliberal capitalist manifestation: individualism is the justification for action which is applied in all of these quoted cases just as it is when advertisers sell us the next globalized, mass-produced tchotchke – 'I *can* buy. I *must* buy.'

Within neoliberal capitalism's appropriation of individualism, each unique, entitled, rights-protected atom must go out into society and bash against the other self-contained particles in a constant competition for resources or the right to take a day off. Craftspeople may be more friendly, collaborative even, but the emphasis on authorship or the entitlement to make what they feel they want to make, is precisely the same model of individualism as appropriated by neoliberal capitalism. Robert Pippin has questioned this process in his book *The Persistence of Subjectivity: On the Kantian Aftermath* by suggesting that if a historical epoch can be said to have a philosophical context, then ours would best be described by the slightly ironic phrase 'Bourgeois Philosophy':

This would be a philosophy that explains how it would be possible (whether it is possible) that individual subjects could uniquely, qua individuals, direct the course of their own lives, why it has become so important that we seek to achieve this state maximally ... The basic philosophical claim underwriting such an enterprise is the notion of the independent, rational, reflective individual, one who can act in the light of such reflective results. This is the ontological and the value claim that underwrites rights protection, claims of entitlement, and just deserts, and that begins to make pressing new sorts of philosophical problems.[20]

This passage introduces ideas of individualism that began with the Enlightenment and that turned into the sort of personalized experience of society that is now the norm and assumption. What matters for craft here is in the understanding of individualism as it was misread: if liberalism became neoliberalism, it was because primacy was given to the atomistic reading of the individual, and craft perpetuates that reading: 'I must make!' or 'I must consume uniquely made things!' Of course, this begins to overlap with the issue of 'the authentic experience', as if such a thing exists. The unique experience and the authentic individual tie up in craft's current vogue. But even without getting into that, we can see that craft's pride in its Marx-like revaluing of labour and associated definitions of work, not to mention the commoditized nature of authorship (which of course returns us to the issue of property), all show that craft assumes that the individual as constructed by capitalism is the root social element. It doesn't make a difference if craftspeople are working together or think of themselves as cosy communities: the objects themselves and the entitlement to creativity rely on that same bourgeois philosophy.

Look at the way artist craftspeople like Gord Peteran speak of their work. He says, 'I would like you to approach the pieces with a certain amount of trust and that you will believe what I am saying to be true.' This is a statement of the individual at work. Peteran is a Toronto-based conceptual furniture artist, who has pushed the definition of furniture in his exploration of human spaces (Figure 6.4, Plate 7). Glenn Adamson discusses Peteran in *Thinking Through Craft*, where he sees in Peteran's work that 'the handmade and the Readymade are locked in a tight embrace'.[21] This is conceptual craft and Peteran is undoubtedly an impressive artist, and he speaks like one: 'I thought that if I had five opportunities to make five or six comments on the human condition, what would those be?'[22] It seems perfectly reasonable for makers to speak of their work in terms like these of inspirations that deserve exploration and personal adventure through media and concept. For Peteran or Reichardt, their individual creativity is the element that makes them valuable to us personally and to society as a whole. Part of the appeal is their unique position of intersecting experiences, ideas and skills. But the celebration of absolute individualism of the artist or craftsperson and their work is also the marching tune of neoliberalism. When craft celebrates authorship and

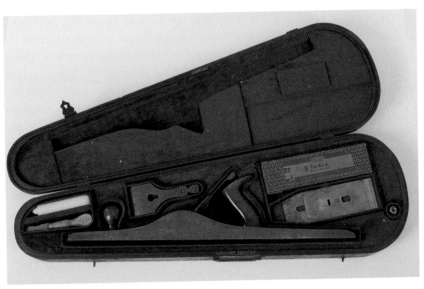

FIGURE 6.4 Gord Peteran, *Secret Weapon*, 2011, violin cases, hand planes, velvet, 24"
w × 8" d X 5" h. Courtesy: Gord Peteran.

the expression of the individual, it accentuates one of the problems it might seek
to resolve – that the individual is given primacy over the community. Or, to go
back to Macpherson, that the individual is 'the proprietor of his own person or
capacities, owing nothing to society for them'.[23]

This brings us right back to the neoliberal capitalist misreading of individualism.
Locke's individual didn't exist in the real world, certainly not as an active particle
outside the complete, integrated community. The economic model that developed
throughout the eighteenth century changed all that. The rise of democratic
capitalism and its emphasis on the individual parallels the development of
Renaissance and Enlightenment philosophies that separated art, then science and
then manufacturing into distinct disciplines, and away from the core concept of
craft. It was correct that the individual not be stamped or swamped by tyranny or
collectivism. But, as Macpherson said of individualism's shift through history: 'the
strength of the liberal theory in the seventeenth and eighteenth centuries …
became the defect of that theory about mid-nineteenth century.'[24] Now in the
twenty-first century the reading of individualism has become positively toxic.
Though several commentators have worked on this issue for over a century, it
is now worse than ever here in the heart of a neoliberal age, and craft is right
there too – from conceptual art craft to Etsy shop owners, craft is relished and
championed as an expression of individuality. Neoliberalism couldn't have a better
example for articulating the cult of the entrepreneur individual than craft.

How far we haven't come

In this context we begin to note the many correlations between craft and conservatism. Craft objects are often spoken of as numinous in the face of industry's soullessness, that is, they preserve a pre-scientific spirituality that has been denatured by modernity and industry. Craft objects are said to embody or represent familial and cultural lineage and they are meant to endure – that is, to be used and inherited – craft objects often feature prominently in a family 'estate'. Craft talks about sitting and slowly enjoying family meals, contemplating the (finely wrought) clothing and fabric and furniture of life, that is to say recovering the ceremonial (however casual) within domestic acts and behaviours. This celebration of luxury is of course the paradoxical obverse to craft's other romanticized notion as pre-colonialized, culturally pure or innocent. Of course, we could muse at length on the role of nostalgia (the engine room of conservatism) in craft. What we have seen here is that whether craft is intended for the shop floor, the art gallery or for progressive politics, it still contains these powerful assumptions that must be acknowledged and recognized for their connection to the political philosophies that contemporary craft often claims to oppose.

Neoliberal capitalism and craft have inherited their positions from a long and complex evolution of readings and misreadings. I haven't focused specifically on Locke here because the *Second Treatise* instigated all neoliberalism's flaws, nor because Locke is the only source to read craft's correspondence to neoliberalism. Rather, I have focused on Locke because it is specific misreadings of his ideas that have contributed to how we understand the question of skill as economic property, and because the individualism has become totally warped in subsequent centuries. These are two of the cardinal sins of capitalism and they are two of the defining characteristics of craft. By ignoring all this, craft risks not only making a fool of itself like Molière's character, but also committing a sin that falls right at the heart of neoliberalism. By ostensibly situating itself outside the capitalist system, while continuing to make the sorts of errors in true liberalism that are consistent with neoliberal thinking, craft makes itself into a 'positional good' that further aggravates the most objectionable elements of capitalism.

The term 'positional good' was introduced by economist Fred Hirsch in 1977,[25] and more recently applied by Joseph Heath and Andrew Potter to describe an economic goal separate from material goods themselves. Positional goods allow the owner to differentiate themselves from other parties in the same market.[26] Positional goods appeal to snobbery. Like being able to walk to work, or wearing the distinctly cool clothing item, positional goods allow us to demarcate ourselves from the masses, and to show that though the waters of homogenization may be rapidly rising, we are still dry and unique. Craft sales feed deeply from this. The unique, the handmade, the local, the hometown maker all pretends to something

different, not accessible to just anyone. This self-congratulatory sin is part of the larger dialogue of authenticity: the belief that if we can only just get away from the influence of social context our 'real' selves and beliefs can shine through. There is no such place, as those who have gone looking for it in Anthropologie or Etsy already know. What we haven't confronted is the role played by craftivists, the role played by an elevated conceptual, theoretical and often-academic craft discourse that hopes to keep its own feet dry against these issues. When craft fails to take into account that it relies on some of the same philosophies as neoliberalism, when craft takes to the streets (either figuratively or literally) it risks further improving the positional value of all craft and 'crafted' materials already for sale at a retailer near you. This is not craft's fault; but craft practitioners and commentators must acknowledge it.

And so, back to the beginning

The satire of William Morris by his contemporaries was always fairly friendly if a bit barbed – drawings by Edward Burne-Jones or Dante Gabriel Rossetti show him at worst as a pudgy inattentive husband. But he might deserve worse. Morris was the original conflater of craft and protest politics. He believed in good, ennobling design and the value of the handmade; he believed that the labourer could be freed from drudgery and he wrote socialist marching hymns and made frequent important speeches at rallies – most notably on the November 1887 Bloody Sunday rally and at another point he was arrested for hitting a police officer. But however much Morris was a craftsman and however much he was an activist, the two remain separate. He fails the most where craft is expected to service political ends. Almost all of the ways Morris believed that craft theories or objects could render political change failed. If contemporary makers and craft thinkers contend that yarn bombing a park bench is actively political, we make the same mistake. But I want to end on a positive note: craft can be political. Immensely so.

First, buying mugs and hats and chairs (when you need these things) from people who own their own means of production and who are compensated at reasonable rates, is better. It might change the shopping world. But buying any object remains a capitalist gesture in a staggeringly complex interconnected system of variables. Don't forget that economies of scale (mass production) *can be* more environmentally conscious and they *can be* far more labour efficient – those are costs that must be considered in the handmade good. So only *perhaps* buying handmade objects is better; either way it is certainly not an undoing of capitalism.

Second, more hopefully, are craft's possibilities of limited expectations. American art historian Cynthia Fowler offers the excellent example of textile artist Sheila Hicks, who was living and working in Paris at the time of the 1968 student

uprisings. These large political events contributed great inspiration to Hicks's subsequent work though, as Fowler specifically points out: 'Hicks was not directly involved in the political unrest in Paris but, as she summarized, "I lived through it." '[27] Hicks was a craftsperson, artist and citizen in Paris but she was not present at the protests. But, later, when Hicks started making large-scale work, she played a direct, specific role in the feminist movement's challenge to the institutional art world. Hicks herself denied any intentional connection to feminism but, as Fowler says: 'Women artists, regardless of their politics, needed exhibition space in order to succeed as artists, connecting all women artists, including fiber artists, to the feminist project of claiming space.'[28] Hicks's work became politically active, perhaps even against her intentions. If her work played an activist's role, it did so as alienated, commoditized objects created by an individual author. This does not change her achievements but rather allows us to position them in a broader system of variables.

Craft can engage with direct protest. But artists and craftspeople like Carol McNicoll and Carrie Reichardt who do engage with (often successful) activism do so as activists. The crafts they bring to the cause are comparable to the law the activist-lawyer brings to the protest – certainly it can work for the cause, but it is not, in itself, against the system. As I have shown, the underwriting philosophies are of and in the system.

Craft is aspirational, and there is much to aspire to in our world. But craft must understand its own underlying philosophy. Otherwise the risk to those aspirations is enormous, compounding the problem, leaving us at best with only the fractured possibility that craft is the apogee of the bourgeois society. It is the self-congratulation that must be quelled. There is too often an obliviousness to the connection between craft and the system it purports to counter and we end up looking admiringly at protesters with their homemade gasmasks thinking 'there's the authentic; there's the distinction'. This mantra of distinguishing oneself by appealing to the 'people of quality' is the heart of the bourgeois mistake and the aristocratic vanity that Molière lampoons in *Le Bourgeois gentilhomme*.

Molière's character doesn't understand that the joke is on him: Monsieur Jourdain doesn't see that seventeenth-century French society was specifically structured to make a 'bourgeois gentleman' an oxymoron. He might aspire, but he was too unaware of his context to see that everyone else – including the court of Louis XIV who first saw the play – was laughing at him. Pretensions must be watched and understood, as good satire points out. Like a writer quoting in the original French, there may be good reason to do so, but there's a danger that the reader will just find it conceited and that it obstructs the point. This is when the laughter stops. Craft is ripe for satire because it takes itself seriously (rightly so), but it hasn't noticed its own pretensions. Craft is powerful and enjoyable, and it can be political; but it is not the same as freedom.

Notes

1 In the interests of historical storytelling, it begins with the Glorious Revolution of 1688–1689: 'The revolutionaries created a new kind of English state after 1689. They rejected the modern, bureaucratic absolutist state model developed by Louis XIV in France … Their state sought to transform England from an agrarian into a manufacturing society, oversaw the massive military buildup that was necessary to fight a war against the greatest military power that Europe had ever seen, and sought to promote a religiously tolerant society. John Locke, often described as one of the earliest and most influential liberal thinkers, was one of these revolutionaries.' Steve Pincus, *1688: The First Modern Revolution* (New Haven: Yale University Press, 2009), 8. That is part of the larger story that will have to wait.

2 Nathan Tarcov, *Locke's Education for Liberty* (Chicago: University of Chicago Press, 1984), 1 (original emphasis).

3 For my discussion of Locke, I will be looking exclusively at his *Second Treatise of Government*. Locke wrote extensively and to conduct this analysis fully would require acknowledgement and consideration of his entire oeuvre. But the *Second Treatise* is representative enough for our purposes here – especially as the text to which later readers made reference.

4 John Locke, *Two Treatises of Government*, ed. Peter Laslett (Cambridge: Cambridge University Press, 1993), 268 (*Second Treatise*, section 3).

5 Christopher Hughes, 'Locke: The Second Treatise of Government', in *The Political Classics: A Guide to the Essential Texts from Plato to Rousseau*, ed. Murray Forsyth and Maurice Keens-Soper (Oxford: Oxford University Press, 1992), 157.

6 Locke, *Second Treatise* section 123, 350.

7 Locke, *Second Treatise* 103.

8 Locke, *Second Treatise* section 6, 271.

9 I must note in passing that the presence of this God/People and Sovereign/Servant tenet in the history of liberalism is of course of massive significance. How natural rights, predicated on a relationship with a Judeo-Christian, or rather a Protestant God, endure and develop as society secularized through the eighteenth, nineteenth and twentieth centuries is a defining theme in the matrix of democratic capitalism. It is part of the core assumption of liberalism and thus informs all of the issues between Church and State and in justifying the wealth/power distribution within unequal societies, not mention being part of the philosophical context of my own argument herein. But for our introductory purposes here, and to isolate the divergence between property as it was meant and property as read, we have to step backward over the secular shifts and understand the full conceptual housing of Locke's word 'property' – this means accepting as context the late-seventeenth-century assumptions in the relationship between people and God.

10 Crawford Brough Macpherson, *The Political Theory of Possessive Individualism* (Toronto: Oxford University Press, 2011), 3.

11 I'm looking here specifically at James Tully's emphasis that Locke's sense of property and self-ownership 'is moral, political and military, not economic. It is not concerned with the alienation of labor power but with political power or the power of self-defense.' Tully continues that in the original texts 'the individual, as well as the state,

is concerned with preservation, not consumption. Labor power appears here as the means to preserve oneself, not as something that facilitates utility satisfaction.' In Tully, 'The Possessive Individualism Thesis: A Reconsideration in Light of Recent Scholarship', *Democracy and Possessive Individualism: The Intellectual Legacy of C.B. Macpherson*, ed. Joseph H. Carrens (Albany: SUNY Press, 1993), 29.

12 Locke, 383 (*Second Treatise* section 173).

13 'Carrie Reichardt', www.carriereichardt.com (accessed 1 October 2015).

14 Ibid.

15 Catherine Flood and Gavin Grindon, eds., *Disobedient Objects*, exhibition catalogue, Victoria and Albert Museum, 26 July 2014–1 February 2015 (London: V&A Publishing, 2014).

16 The Goldsmith's Company, 'About the Company', www.thegoldsmiths.co.uk/about-the-company/ (accessed 1 October 2015).

17 Locke, *Second Treatise* section 3, 268.

18 Locke, *Second Treatise* section 87, 324.

19 Pincus, *1668*, 8.

20 Robert B. Pippin, *The Persistence of Subjectivity: On the Kantian Aftermath* (New York: Cambridge University Press, 2005), 1–2.

21 Glenn Adamson, *Thinking Through Craft* (New York: Berg, 2007), 37.

22 Both Peteran quotes are from 'Gord Peteran Recent Works', YouTube video, uploaded 2 September 2009, https://youtu.be/2RBos7tBK5l (accessed 26 September 2015).

23 Macpherson, *The Political Theory of Possessive Individualism*, 3.

24 Macpherson, 'The Deceptive Task of Political Theory', *Cambridge Journal*, no. 7 (1954): 560–8. Cited in William Leiss, *C. B. Macpherson: Dilemmas of Liberalism and Socialism* (Montreal and Kingston: McGill-Queen's University Press, 2009), 61.

25 Fred Hirsch, *Social Limits to Growth* (London: Routledge & Kegan Paul, 1977). See esp. pp. 102, 123, 137.

26 Joseph Heath and Andrew Potter, *The Rebel Sell: Why the Culture Can't Be Jammed* (Toronto: Harper Perennial, 2005), 120.

27 Cynthia Fowler, 'A Sign of the Times: Sheila Hicks, the Fiber Arts Movement, and the Language of Liberation', *Journal of Modern Craft*, vol. 4, no. 1 (March 2014): 35.

28 Ibid., 37.

7 ZAHNER METALS: ARCHITECTURAL FABRICATION AND CRAFT LABOUR

Peggy Deamer

In 2005, I visited Zahner Metals in Kansas City. I wanted to know what the workers involved in building the rainscreen copper panels of Swiss architectural firm Herzog & de Meuron's San Francisco de Young Museum actually were doing. Jacques Herzog and Pierre de Meuron are known for their material manipulation and for basing architectural design on the exposure of the chosen material's surface effects; hence, this building and its fabrication process were of particular interest.[1] The museum design, radical in its flat, plain façade of dimpled copper panels (Figure 7.1) that formed a screen to the museum itself, shook conservative San Francisco whose cultural institutions, especially in Golden Gate Park, were always polite and classical.[2] For me, the interest was less the design's neo-modernism than its fearless expanse of a single material displaying intricate but subtle manipulation. How did the fabricators interact with the architects? How much control did the workers at Zahner Metals have over the design of the panels, none of which were identical? Who ran the CNC (computer numerical control) machines? How many people did it take to work on one panel and what was the division of labour? Was there an assembly line process that divided tasks and segmented information? During my visit, I was struck by the cleanliness of the work, the groups of workers dispersed in corners of the open workshop, the small number of workers, the strange mix of 'blue-collar' workers manipulating digital inputs and the ingenuity required to position the panels to enable multiple hands to work on them simultaneously. And I was thrilled that Bill Zahner – the owner, and someone who has gained a reputation for treating façade-related steel work as an art – indicated the pleasure they all got from working with Herzog and de

FIGURE 7.1 Copper facade installation at De Young Museum, San Francisco, 2004. Courtesy: A. Zahner Company.

Meuron, who saw the interaction with the factory as one of mutual creativity.[3] But I was most struck by what Zahner told me about the workers there. They were the ones who had been interested in making the transition from mechanical to digital production, and the same ones who, before that transition, had been the best workers, inherently interested in quality and innovation. Yes, the work was intrinsically different, but the attitude of curiosity was the same. Before the switch to CAD-CAM (computer aided design-to-computer aided manufacturing), Zahner knew who would survive the transition; it had nothing to do with training or age, it had to do with the workers' desire to craft something as impeccable as possible. Likewise, the 'seamless' transition from drawing to fabrication that is part of the CAD-CAM rhetoric was anything but. While the architects' software gave intricate information about the formal parameters for the copper panels, it had no information about how those parameters related to assembly; how the panels were to be moved, held up, turned and made accessible to hammer and screw (Figure 7.2). Only the fabrication workers knew if the connections and supports were sized properly, not just for installation but for the act of fabrication itself; assembly had its own logic and software. It was heartening to know that craft intelligence was not just alive and well, but smarter than ever.

This inquiry was stimulated by my own confusion about the relationship between design and craft within architecture. On the one hand, I knew from my

FIGURE 7.2 Copper facade installation at De Young Museum, San Francisco, 2004.
Courtesy: A. Zahner Company.

architectural practice that architects have great pride in being good 'craftspeople', in knowing how to skilfully detail material connections and ornamental flourish for aesthetic effect, even as we ignore the input of the tradespeople who actually execute the directives of our drawings. On the other hand, I knew from my academic work that there was, in the nineteenth century, an antagonistic divide between 'design' (controlled by the architect via drawings) and 'craft' (executed by the makers/producers). What had happened to the debate about design and craft in our more labour-oblivious contemporary times? On top of this, new digital programs, principally CAD-CAM, were changing the nature of fabrication. Not only was there direct drawing-to-machine technology (by-passing shop drawings, themselves a kind of craft) but the capacity of the new machine production and its operator now needed to be known by the designer/architect up front in order to be drawn correctly.

As someone dismayed by the general disregard that we architects have for our builders, tradespeople and fabricators (the snobbery of aesthetic virtuosity over blue-collar vocation and the lack of choice architects have over who will build their designs), the changes brought about by these new kinds of production seemed healthy. Our twentieth-century way of designing – giving kudos to architectural 'craft' and absorbing it into our own, self-congratulatory rhetoric of

'good design' – completely by-passes the producers' contribution to and ownership of craft. Indeed, the new forms of collaboration required by digital processes seemed to finally address the suggestions of nineteenth-century architectural theorists for overcoming the design/craft opposition: one thinks primarily of John Ruskin, whose 'The Nature of Gothic', in *The Stones of Venice* was a plea for the stone masons of his era to hold on to their freedom to ornament and detail in the face of mechanized building production; of William Morris, whose workshop aimed to integrate industrial technology with craft-based autonomy; and of Adolf Loos, who proudly claimed to not make working drawings and instead direct the builders on site. More than this, digital collaboration actually put the fabricators' knowledge at the beginning, not the end of the process. Design and craft collapse.[4]

On reflection, it became apparent that the twentieth-century architectural pride in being good 'craftspeople' was the erasure of *labour* from the craft discussion. Yes, we architects have cared about material joinery and expression (ornamental or otherwise), but we really didn't know or care how it was done or who did it and under what conditions. What is so remarkable about the current period of digital fabrication is that labour is once again foregrounded. That this labour is less 'manual' is obvious, but the actual capabilities of the skilled workers who manage the information and output is paramount. Indeed, one could also say that material consideration falls by the wayside in this process, given that the machines – largely laser-cutters, routers and drills – are materially neutral (that is, cut and shape regardless of manipulating wood, plastic, metal or stone) in contrast to the specific tools of, say, the wood carver or the stone mason.[5] That is to say, the work performed, rather than the tools themselves, had to adjust to the various material demands.

The healthy reintroduction of labour into the design/craft dispute by way of new forms of digital labour does not imply the reintroduction of the hand or handicraft in the traditional sense. When Richard Sennett argues in *The Craftsman* that craft relies on the body, the hand and tactile affect to convey the special meaning it brings to objects,[6] he overlooks the contribution the contemporary digital craftsman makes through her procedural, not manual, know-how. Craft moves from the manipulation of the object to the management of the fabrication process. Indeed, even digital craft theorist Malcolm McCullough's insistence that contemporary craft *is* a sensual condition – because, he says, even in computer work our hands and eyes are actively engaged – is too nostalgic; it equates 'craft' unnecessarily with the body. Rather, I want to argue, digital labour incorporates craft because of the aesthetic risk that both designer and producer take on. As McCullough does rightly point out, 'In digital production, craft refers to the condition where [we] apply standard technological means to unanticipated or indescribable ends.'[7] Because parameters and equations are configured in lieu of descriptions of shape, neither designer not fabricator can predict the outcome; both share the risk of formal indeterminacy. When Herzog and de Meuron spent

days at the factory experimenting iteratively with the embossed dots and circular cut-outs on the copper panels to determine the final double patterning approach, they could only set the parameters for design permutations (Plate 9). When the Swiss architects left, they knew the approach, but they didn't know what any of the 7,000 panels would actually look like; this was unclear until they were actually produced. The task and the risk were equally shared by workers at the factory to execute, and architects who had left with only parameters identified.

And yet, one can't overlook that there is a difference between Jacques Herzog and Pierre de Meuron and the men (yes, there were no women) working on the factory floor at Zahner's. It is not a distinction between blue-and white-collar, material or immaterial work: these 'social' distinctions fall away as mutual dependency and respect reconfigure these divisions. The distinction, rather, is the manner in which both, with computer technology, have had to deskill and reskill. In an illuminating piece by John Roberts entitled, 'Art After Deskilling', in which he describes the change in art when modern artists such as Claude Monet and Marcel Duchamp no longer made their work, he argues, first, that the 'artist's' shift from artisanal to executive is the point where the distinction between artistic creativity and craft-skill is finally destroyed; second, that both executor/artist and producer/craftsman experience a process of deskilling; and third, that the artist confronted with deskilling in modern culture does not suffer the same creative marginalization as the productive labour because, as Marx insists, the artist, designing one-offs, is not subject to the real subsumption of labour associated with mass production in the way the factory/office worker is.[8] In other words, in the Zahner/Herzog & de Meuron example, Zahner workers are more vulnerable to economic forces resulting from the changes they experience than are the architects and their staff. As previously 'unskilled' labourers upskill with computer knowledge and those who do not catch up fall away, 'unskilled' becomes 'unemployed' and as fewer workers in total are employed, the sense of precarity in the factory increases. The architectural workers in their offices have learned new computer skills, but they have not shifted their value proposition or taken on an industry-shaking realignment. They have not, it could be said, been forced to shift their behaviour despite a clear paradigm shift. If both architect and producer, as I have argued, have assumed creative risk in sharing the new design/craft confluence, the financial risk is felt much more directly by the factory workers. Architectural workers are merely staving off an inevitable change that is just more blatantly apparent on the factory floor now.

There are a number of secondary observations that can be made at this point. One is that the fabricators' economic vulnerability filters back into the class distinctions that conceptually have been eradicated: the factory worker stays 'blue-collar' because of that vulnerability, not because they work with their hands. Another is that the factory worker should be held in greater esteem in this deskilling/reskilling scenario for taking on more risk, not just in aesthetic output

but in self-identification and income. A third is that the architectural profession is, in the long term, worse off for not having organizationally adjusted to the full implications of digital technology and clinging to a dysfunctional, nineteenth century (gentleman's) professional model. All of these conditions need to be explored. Architecture suffers for not thinking through the new attachments architects have to fabricators and construction workers, making us unable to appreciate the common bond we share with the makers of our designs. Architects' disgraceful attitude to construction workers in the Gulf – who, despite being largely unskilled labourers unlike those in Zahner's factory, are still essential to the completion of a quality product – is an example of an outmoded 'professional' attitude of superiority.[9] It suffers as well for not addressing the reconfigured production relations in the architectural office where there are no longer 'draftsmen' sitting below the master designer but, in its place, a more horizontal skill structure.[10]

But the larger points – that the hand is no longer the mark of craft and in its stead, risk-taking in aesthetic outcome and organizational realignment define 'craft'; that craft and design are no longer oppositional but share labour knowledge and mutual respect; and that deskilling and reskilling should be not just technically determined but economically and organizationally consequential – are issues that architecture needs to address immediately. As long as we do not appreciate the fundamental shift that has occurred in our design/craft capacity and downplay our dependence on fabricators and other industry specialists, we will fail to capitalize on the knowledge essential to innovation, especially when we equate 'innovation' not with angel investments to dubious social media monetization but with technical, material dexterity. We tend to admire the work of Herzog & de Meuron for their introduction of new materials to our architectural palette, but their real contribution of collaboration with those who know how the materials are manipulated is unacknowledged. This needs to be rectified.

Notes

1 The firm's highest profile museum is the conversion of the Bankside Power Station to Tate Modern in London, UK (2000) and today, the expansion of the gallery and its surrounding areas with the Tate Modern Switch House. Herzog and de Meuron are the architects of these other museums: The Goetz Collection (1992); Museum Küppersmühle in Duisburg, Germany (1999); Schaulager Basel, Laurenz Foundation: the Walker Art Center Expansion, Minneapolis, USA (2005); CaixaForum, Madrid (2008); TEA, Tenerife Espacio de las Artes, SantaCruz de Tenerife, Canary Islands, Spain (2008); Museum der Kulturen in Basel, Switzerland (2010); Museu Blau, Museum of Natural Sciences, Barcelona, Spain (2012); the Parrish Art Museum in Water Mill, New York, USA (2012); and the Pérez Art Museum, Miami (2013).

2 See various articles such as Julian Guthrie, 'De Young's Rebirth: It Had to Overcome Design Challenges, Lawsuits and a Lack of Funds. S.F.'s New Museum Opens Today, a Triumph of Creativity and Commitment', *SFGate*, 15 October 2005, https://www.sfgate.com/news/article/De-Young-s-rebirth-It-had-to-overcome-design-2564985.php (accessed 27 January 2019). It describes the hesitation of San Franciscans with regard to the project's design when going through the review process, an objection that lingered with many citizens after it was complete.

3 For 'star' architects, Herzog and de Meuron are singular for insisting that they are not 'artists' but 'technicians'. This contributes to a less 'snobbish' approach to design production.

4 For more on the historical, economic and conceptual change that occurred between the nineteenth-century architectural concern for the worker to twentieth-century modernism's dismissal of this concern see also my previous writing on this topic: 'Detail: The Subject of the Object', *PRAXIS: Journal of Writing Building*, vol. 1, no. 1 (2000): 108–15.; 'Work', in *The Architect as Worker: Immaterial Labor, the Creative Class, and the Politics of Design*, ed. Peggy Deamer (London: Bloomsbury, 2015), 61–81; and 'Architectural Work: Immaterial Labor', in *Industries of Architecture*, ed. Katie Lloyd Thomas, Tilo Amhoff and Nick Beech (Milton Park: Routledge, 2016), 137–47. Most of these observations have their origin in one made by Ford in which he says:

> Insofar as twentieth-century architects have concerned themselves with the social consequences of their work, they have focused on the way in which buildings affect the behavior of their occupants. Insofar as nineteenth century architects concerned themselves with the social consequence of their work, they focused on the way in which buildings (and particularly their ornaments) affect those who build them. There is perhaps no greater difference between the architects of the nineteenth century and those of the twentieth than that each group was so indifferent to the social concerns of the other. Edward R. Ford, *The Details of Modern Architecture*, vol. 1 (Cambridge, MA: MIT Press, 1990), 9.

My essay, 'Architectural Work: Immaterial Labor', connects this observation to the change in capitalism from a production-based economy to a service-based economy, bringing with it the change of concern from the producer (the builder/craftsman) to the consumer (the client/owner).

5 Of course, this is only true at the general level. The use of these computer-directed machines requires knowledge of the material's capacity to be cut, bent and so on.

6 Richard Sennett, *The Craftsman* (New Haven: Yale University Press, 2008).

7 Malcolm McCullough, *Abstracting Craft: The Practiced Digital Hand* (Boston: MIT Press, 1998). McCullough here harkens back to David Pye who in 1978 provided a definition of craftsmanship that also centres on risk:

> Craftsmanship … means simply workmanship using any kind of technique or apparatus, in which the quality of the result is not predetermined, but depends on the judgment, dexterity and care which the maker exercises as he works. The essential idea is that the quality of the result is continually at risk during the process of making.

For two excellent essays on risk and digital design, see both Branko Kolarevic's and Scott Marble's essays in *Building in the Future: Recasting Architectural Labor,* Peggy Deamer and Phillip Bernstein, eds. (New York: Princeton Architectural Press, 2010).

8 See John Roberts, 'Art After Deskilling', *Historical Materialism*, no. 18 (2010): 77–96. See also Roberts, *The Intangibilities of Form: Skill and Deskilling in Art after the Readymade* (London: Verso, 2007).

9 When Who Builds Your Architecture? (WBYA?) – an activist group asking architects to address indentured construction workers building their projects in the Persian Gulf – tried to get architects building in the United Arab Emirates to speak at their symposiums, not one wanted to participate.

10 The Architecture Lobby, to which I belong, is working to address both lapses in the profession (architecture-lobby.org).

8 CAPITALIZING ON COMMUNITY: THE MAKERSPACE PHENOMENON

Diana Sherlock

Perry and Lester invent things – self-replicating machines, robots, a franchise of networked generative theme parks, fanciful personalized inventions for every conceivable quotidian need and fantastical want.[1] Brilliant enough to be at the centre of industry, but smart enough to realize that there is no centre anymore, they are just one node in a network of autonomous far-flung makers who constantly develop, share and adapt Open Source software and 3D-printing designs to build worlds of their own making from raw imagination, post-industrial ruins and abandoned suburban malls. They and their collective of walkaways know that capitalism, built on scarcity and control, has failed. Multinational corporations cannot continually grow their profits and provide enough well-paying jobs, and the ones that do exist are mind-numbingly technocratic; there is too much waste and dwindling accessible raw resources. Young people pushed out to the peripheries because of gentrification feel disenfranchised from the system, and so become autodidacts and activists within their social media echo chambers, and leaders of their own post-capitalist subcultures.

Perry and Lester know 'Capitalism is eating itself. The market works, and when it works, it commodifies or obsoletes everything.'[2] In the race to avoid hitting bottom, 'if you want to make a big profit, you've got to start over again, invent something new, and milk it for all you can before the first imitator shows up',[3] invent, make, sell and repeat. There is enough change built into the system that it is counterproductive to be possessive about your intellectual property (IP), protocols and designs. Might as well share it all for free, but market the experience of social-entrepreneurial innovation; sell the social institution; sell

the movement itself. But Perry and Lester aren't interested in IP or money; they just want to make things.

Author Cory Doctorow's sci-fi characters from the 2010 novel *Makers*, are leaders of the New Work movement. In this essay, Perry and Lester stand in for thousands of real people who, like them, combine education, prototyping, crowdfunding and light manufacturing to make the world anew in makerspaces, Fab Labs and hackerspaces. Each of these is a type of membership-based co-working space in which interdisciplinary makers make, fabricate and hack the world using digital and analogue technologies. The purpose of this text is to chart the rise of the makerspace and to consider how this model of collective production is being utilized by hand- and industrial-producers alike, often to very different ends. As social institutions, makerspaces have their roots in guild structures, alternative pedagogical models, DIY movements and artist-run culture because they diffuse particularized knowledge through a shared means of production, shared practice and collective experimentation.

The rise of makerspaces certainly also relates to the 'material turn', a phrase currently used in the social sciences and humanities that expands on the cultural and linguistic turns of the 1980s and 1990s. It denotes a renewed interest in the complex social and power relations that underlie divergent definitions of materialism, materiality and matter – generally, these arguments seek to heal schisms between the material and immaterial, subjectivity and objectivity, between object and thing – to destabilize politically oppressive power structures.[4] The effects of these power structures, and perhaps even the desire to sublimate them, are seen every day in makerspaces, in how people relate to material things, as can be seen in the return to the handmade, and particularly explorations in digital craft. The world can no longer sustain the mass production of material things as separate from itself, so makerspace users attempt to remake the world for the mass-customized, ever-increasing immaterial, user-based consumer; another endpoint in American futurist Alvin Toffler's 'prosumer' culture realized.[5] Yet, these ideas are easily romanticized in the utopian rhetoric of makerspaces, even though they don't necessarily limit capitalism's reach or its often-devastating ecological and social effects, such as expanding carbon footprints and urban gentrification. Rather, makerspaces might, in fact, accelerate these effects in more individualized forms, providing greater capacity for the consumption of craft on demand.

In this text, I explore the economic models being developed in makerspaces in Canada, the United States and Germany, and the potential these models might have for makers. I use three case studies: TechShop Inc., San Francisco; several examples from the burgeoning makerspace ecosystem in Calgary, Canada; and Fab Lab Berlin. In the time between the initial draft of this text and its publication, much has changed in the accelerated world of maker culture. TechShop Inc. declared bankruptcy in November 2017 and TechShop Global dissolved in January 2019. Name and facility changes followed for the other examples I cite in Calgary

and Berlin. Thus these case studies demonstrate the ever-evolving knowledges, values and economies shared in makerspaces, and stress how each organization's structure makes possible who can benefit and how these spaces impact makers in their local communities. In some cases, I argue the makerspace clearly perpetuates Richard Florida's neoliberal 'creative cities' model.[6] In others, I see the potential for new hybrid, post-capitalist economic and social models, which might better sustain future economic and social needs.

My case studies demonstrate that the fundamental difference between makerspaces and democratic creative collective models, (such as artist-led non-profits, design cooperatives or even communal workspaces in publicly funded art schools), is their synergistic relationship to the capitalist economy; this is why we are currently experiencing the makerspace phenomenon. While resources for publicly funded, collective models of cultural production and distribution wither under neoliberalism, the makerspace is a growing business model that capitalizes on collective innovation and creative production, tied to education and industry. This is not coincidental. Most makerspaces and fab labs divert public resources formerly dedicated to research and development in health, education (particularly art and design education), arts production, urban planning and small-business development, into private for-profit businesses. Workshops, studio space and laboratories are expensive for schools, so partnering with a makerspace that has up-to-date gear and trained technicians, allows schools to divert *saved* space, staff and funds to serve other urgent institutional needs. Significantly, more costs are downloaded onto the student-user, and these facilities now operate outside of the public educational system and are thus vulnerable to market fluctuations. This is particularly true in TechShop's case now. Furthermore, makerspaces then use these and other public funds to support corporate research and development initiatives that would otherwise be paid for by corporations. While businesses pay for these services, it is still more cost-effective than maintaining their own labs, and they have access to communally developed solutions that they otherwise would not.

Even former president Obama's[7] administration made a concerted effort to foster a broad-based, economically viable makers' culture to diversify and grow the American economy into a 'nation of makers' through increased investment and promoting 'the national week of making,' which increased public access to STEM programs and several national research institutions particularly for marginalized youth. Here, makerspaces and fab labs as creative think-tanks are considered key to turning the United States manufacturing economy around. They merge the social and intellectual capital of the internet with real-time communal studios, and the model makes money by exploiting capitalism's ills and scarcities. However, these spaces are filled with generalists, not specialists, and critical discourse around what is being made and why is often lacking. On the other hand, there might also be something important to learn from the makerspace model about sustainable collective micro-economies that could potentially help rejuvenate traditional

non-profits that are floundering to maintain their ethics *and* pay their members living wages under neoliberalism.

The backstory

In his book *Makers,* Chris Anderson calls makerspaces the loci for 'The New Industrial Revolution.' This revolution is fuelled by the democratization of access to a proliferation of new, relatively inexpensive digital technologies, tools and networks, readily accessible niche markets, crowdsourced venture capital and a growing well-educated 'creative class' that often suffers chronic precarious (under) employment, or too many creative constraints within their day jobs. Couple these with the desire to solve the social and economic challenges of population, poverty and recurrent man-made ecological disasters; and add in a renewed interest in how things are made and in making things well – the material turn – and you have the Maker Movement. The movement comprises dozens of regional, non-profit umbrella organizations that host regional Maker Faires and related events. As of 2017, there are over 225 Maker Faires licensed in thirty-eight countries worldwide, with two flagship events, in New York and the Bay Area, which draw 1.5 million annual attendees.[8] The movement, according to Mark Hatch—the former CEO and co-founder with Jim Newton of the first commercial makerspace, TechShop Inc. (discussed later) – should inspire us to 'collectively use our creativity to attack the world's greatest problems and meet people's most urgent needs.'[9] However, my analysis will show how Hatch's optimistic rhetoric around 'creativity' is complicit with entrepreneurial models of capitalist speculation, which paradoxically, often underlie these very same problems and urgent needs.

Fab labs are not makerspaces per se, but a precursor to them. They emerged from MIT's Centre for Bits & Atoms after their director, professor Neil Gershenfeld[10] recognized the potential of fab labs to match individual inventive applications of new, networked digital fabrication technologies with real-world needs and materials in his experimental course 'How to Make (almost) Anything' (1998). Unlike most academic or corporate research and development labs, Gershenfeld's model demands open access to adaptable space and experimental fabrication tools within an interdisciplinary community. Fab Lab Berlin belongs to the non-profit Fab Foundation, which was formed in 2009 to facilitate the international development and networking of 545 global fab labs to support education, organizational capacity building, services and business opportunities. The Fab Charter (October 2012),[11] defines basic philosophical and technical requirements needed to further their mission to 'enabl[e] invention by providing access to tools for digital fabrication'.[12] Unlike Gershenfeld's MIT Centre for Bits & Atoms, which is primarily an educational space, Fab Lab Berlin is primarily a business, and a hub for businesses that need space and access to prototyping tools.

Case studies

TechShop Inc. was the bricks-and-mortar extension of *Make:* magazine[13] and the annual Maker Faire – each developed to 'hack the physical world'[14] and spread the word about the movement. Techshop Inc. was the model makerspace, self-defined as a 'community-based open-access do-it-yourself workshop and fabrication studio',[15] or what co-founder Newton characterizes as a 'FedEx Kinko's for geeks'.[16] Hatch's *The Maker Manifesto* outlines the meteoric rise of this makerspace within the white, well-educated, tech-savvy Bay-area city of Menlo Park, California in 2006. Built around an enthusiastic group of makers, TechShop grew into its own industry. Shops of 16,000 to 20,000 square feet in several mid-sized cities across the United States served approximately 7,000 members.[17] In Europe, the subsidiary TechShop Global headquartered in Dublin in 2014 opened a TechShop in Paris in October 2015, formed technical partnerships with Dublin City University and BMW Technical University Munich, followed by locations in Abu Dhabi, Tokyo and Lille, France. In 2015, TechShop had its sights ambitiously set on opening 1000 locations worldwide in the next ten years, with the help of educational and government partnerships that see makerspaces as key economic development partners that support the neoliberal creative cities model and new light manufacturing.[18]

Makerspaces require two types of capital to get off the ground: infrastructure capital for space and tools, and human capital in the form of a community of makers, who while learning, also maintain and run the space and educate new members. TechShop San Francisco was located in two rented *San Francisco Chronicle* newsprint warehouses on an impoverished, and soon to be gentrified, block of Howard Street. Since the 1990s, most of this neighbourhood had already undergone the twin effects of gentrification – the rapid displacement of social services, low-income single-room housing, working-class populations, and some of the oldest gay clubs in the city; and their replacement by high-end hotels, art galleries, software companies and other creative industries.[19] Indeed, I was a bit surprised to see how modest TechShop's San Francisco locations were in this area, but then found out that they too were soon to be displaced by the massive mixed-use, light-manufacturing hub, 5M Project.[20] TechShop's main warehouse included a retail shop, a large two-storey workshop with almost every conceivable tool, digital and otherwise; while the smaller warehouse had additional storage and rentable studios. In dollars, physical capital to launch a TechShop was between USD$ 3–3.5 million drawn variously from tenant improvement allowances, long-term low-interest loans from stakeholders, grants and pre-paid memberships.[21] These resources are drawn from both the public and private sectors using many public sector resources to support TechShop's for-profit mandate and franchise. Upon TechShop's closure, *Forbes* magazine argued that it was their failure 'to close

or transfer unprofitable studios and actively seek enough partnerships with local ecosystems (universities, companies, cities, etc.) to offset its operating costs' that resulted in its bankruptcy, demonstrating the reliance of their for-profit business model on syphoning money from the public sector.[22]

TechShop's human resources also used a hierarchical labour system that relied heavily on contract and membership-based labour. It included the virtual corporate team, which travelled constantly and lived all over the United States; paid full-time employees (25–40), plus a large pool of contract instructors (150–200). Up to 750–1000 members per TechShop – the San Francisco shop typically consisted of young (ages 24–34) white male artists, engineering students, blue-collar machine shop workers, programmers, and so on – had 24/7 access to shared workspaces for USD$ 150 per month.[23] Membership is key to makerspaces: each TechShop aimed for a minimum membership of 300–500 makers to form a critical mass of creativity to catalyse collaborations and add to the bottom line. Member-instructors were paid to develop the curriculum and teach the 200–300 classes a month about mainly technical 'how-to' subjects. This very marketable intellectual property earned TechShop San Francisco the bulk of their revenue, as well as satisfying their mission 'to engage, enable, and empower people to build their dreams'.[24] Other earned revenue streams included corporate events, tours and a retail shop. Sponsorships and partnerships spanned a variety of corporate, education, technology and training programs, including the U.S. Department of Defense DARPA Veterans program, as well as construction (Lowe's), manufacturing industries (Ford) and civic partners.[25] In the interview with *Forbes*, TechShop's CEO revealed their reliance on public funds through partnerships: 'A for-profit network of wholly owned makerspaces is impossible to sustain without outside subsidy from cities, companies and foundations, often in the form of memberships, training grants and sponsored programs. This kind of funding is readily available to non-profits, and very rarely an option for for-profit enterprises.'[26]

TechShop was very successful in leveraging these partnerships, in part because of the impressive record of innovative solutions that has emerged from these environments in recent years. It is difficult to assess if TechShop had a higher start-up success rate than regular business incubators because there is no hard data, but in my interview with San Francisco TechShop's Andrew Calvo in 2015 he maintained this wasn't the point. He asserted that their primary role was affordable access and education, not supporting start-ups: 'What we do is make things possible, not easier, but more possible.'[27] Yet it is difficult not to consider them one-and-the-same when the most persuasive arguments for makerspaces emerge from Maker Movement start-up success stories such as those documented in Hatch's manifesto: Inventibles, MakerBot Industries and Sparkfun Electronics, to name a few. TechShop fostered an on-demand, often crowd-funded, economy – low volume, high quality, mass-customized, micro-manufactured – producing products that Calvo observed would never get out of the concept phase in most

corporate contexts. Square – a digital card reader that allows for mobile transactions co-founded by artist James McKelvey and Jack Dorsey of Twitter at Menlo TechShop – was turned down repeatedly by venture capitalists because they didn't have a prototype, and McKelvey lacked a finance background. TechShop allowed them to tinker, make a prototype for $3000 and scale up to USD$ 10 million of venture capital faster, while maintaining ownership and control over the product.[28] Square, likely TechShop's most successful story, is now a publicly traded $5 billion-dollar company with 1000 employees. Square is indeed an innovative idea, but does a credit-card reader 'attack the world's greatest problems and meet people's most urgent needs'? Square and TechShop, would likely argue that it does precisely this by enabling independent entrepreneurship in any geographical locale thus disrupting the dominance of monolithic corporations. In this respect, as a platform, Square extends the same ideology animating makerspaces. This argument becomes a little more tenuous when considering another TechShop success, the collapsible Oru Kayak, that caters to those privileged enough to already have access to leisure time and fresh recreational waters.[29] And the same can be said for innumerable hobby-craft lifestyle products – Lumio lamps, or laser-cut birch San Francisco Bay Area models by Laurence Srinivasan – that allow individuals to make a marginal living or supplement their income from other jobs. Do these types of innovations really lead to systemic change and ethical alternatives, or do they merely fuel a cycle of demand that is about the seamless integration of even greater consumption of supposedly more ethical products into our existing economy?[30]

FIGURE 8.1 TechShop, *Makerbot, Joseph Schell*, 2015. Courtesy: TechShop.

Although many makerspace projects presumably exist solely for the edification of the maker, makerspaces *are* businesses and seem increasingly identified with revenue generation. However, makerspaces differ from start-up accelerators like San Francisco's Highway 1, who mentor product development and invest in selected hardware projects in exchange for a share in the company. Neither TechShop nor any other makerspace I could find, have yet to institute IP agreements with start-up companies. They have definitely thought about it, but, unlike Perry and Lester's fictional business partners, TechShop and others astutely recognize that their success rests on open-access membership, where makers know that what they make is theirs to keep. While it is a philosophical choice for TechShop to remain committed to open-access education, practically, they also know that start-ups are unlikely to deal away 3–5 per cent of the company for rent-relief and shop-access, so they have little choice if they want to encourage these users. Large makerspaces and some fab labs seem interested in moving towards providing start-up support, but right now, most makers are more likely to end up partnering with an independent start-up accelerator or being picked up by an investor trolling the workshops for the next big thing.

The other part of TechShop's business model followed Maker Faire's in that it too offered affiliate licensing. Instead of sharing in successful start-ups directly, TechShop cleverly avoided messy IP legalities and investment gambles, and instead made money from selling the TechShop model itself. Calvo explained that, 'we have already built the model, developed curriculum, we have essentially the template as well as a lot of the underlying core IP, which has everything including an internal customer relations management system and RFID badges [radio-frequency identification badges are networked all over the USA to track users].'[31] TechShop started the MakerSpace Academy to teach people, who could afford the hefty USD$ 4,500 fee, how to start their own TechShop in an intensive three-and-a-half-day course.[32] They saw this as way to spread knowledge of the movement and apply it to other contexts, including civic centres, libraries, schools and science centres. Note here how many of the targeted users are from the public sector; many libraries and science centres, for example, already provide mini-maker space opportunities to their members. 'We want to be able to give a complete brain dump on how we do it', Calvo said. 'Non-profits may also end up with some of the IP', he added,[33] even though in many cases this is IP that these non-profits are already generating in the public context. TechShop also started to repackage content for San Francisco's kindergarten–grade 8 AltSchool, a network of micro-schools that offers personalized learning to wealthy Bay-area residents. At the post-secondary level, Minerva Schools was to use TechShops globally to help students complete course work. These multiple iterations of the TechShop brand made it *the* prototype space for networked digital skill-based innovation and learning, that Newton argues makes up for what lacks in consumer culture and schools.[34] Lacks, I would add, which are exacerbated by repeated cuts to the

PART OF PROFIT
IS DONATED TO SZN,
HELPING HOMELESS
YOUNGSTERS

szn ///
stichting zwerfjongeren nederland

PLATE 1 Snurk,
Le-Clochard, 2008,
cotton. Photo: Ram
Van Meel. Copyright:
Snurk (Chapter 1:
From Craftivism to
Craftwashing).

PLATE 2 Juergen Teller, *Vivienne, Vivienne Westwood campaign, Autumn Winter 2011, Nairobi*, 2011. Courtesy: Juergen Teller (Chapter 2: Ethical Fashion, Craft and Global Capitalism).

PLATE 3 Selven O'Keef Jarmon, *360 Degrees Vanishing*, 2019. Photo: Alex Barber. Courtesy: Art League Houston (Chapter 3: Selven O'Keef Jarmon).

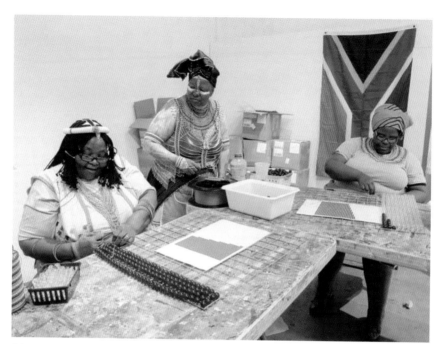

PLATE 4 Selven O'Keef Jarmon, *360 Degrees Vanishing*, beaders working at Art League Houston, Houston, Texas, 2015. Photo: Peter Gershon (Chapter 3: Selven O'Keef Jarmon).

PLATE 5 Theaster Gates, *Soul Manufacturing Corporation, The Spirit of Utopia*, 2013, installation view. Photo: Timothy Soar (Chapter 4: The Making of Many Hands).

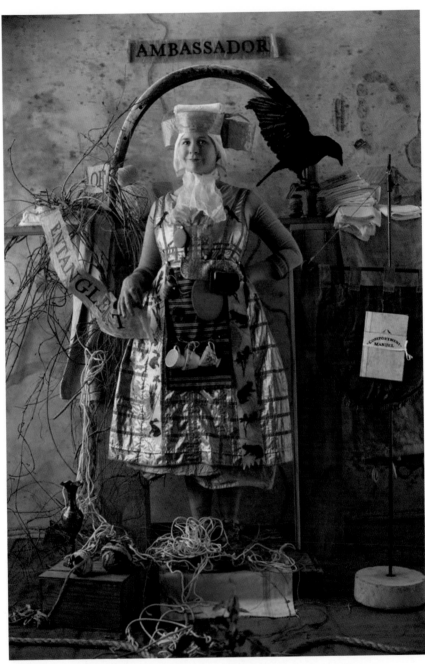

PLATE 6 Rebecca Purcell, J. Morgan Puett, and Jeffrey Jenkins in collaboration, *HumanUfactorY(ng) Workstyles: The Labor Portraits of Mildred's Lane*, 2014. Photo: Jeffrey Jenkins (Chapter 5: That Looks Like Work).

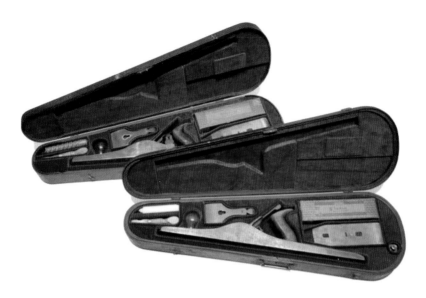

PLATE 7 Gord Peteran, *Secret Weapon*, 2011, violin cases, hand planes, velvet, 24" w x 8" d x 5" h. Courtesy: Gord Peteran (Chapter 6: Craft as Property as Liberalism as Problem).

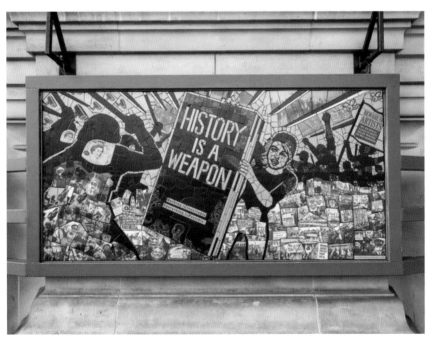

PLATE 8 Carrie Reichardt and The Treatment Rooms Collective, *History is a Weapon*, 2014, ceramic intervention, Victoria and Albert Museum. Photo: Peter Riches (Chapter 6: Craft as Property as Liberalism as Problem).

PLATE 9 Copper facade installation at De Young Museum, San Francisco, 2004. Courtesy: A. Zahner Company (Chapter 7: Zahner Metals).

PLATE 10 Fab Lab Berlin, *Samples*, 2016. Courtesy: Fab Lab Berlin (Chapter 8: Capitalizing on Community).

PLATE 11 Morehshin Allahyari, *Material Speculation: ISIS, Nergal*, 2016, clear resin, flash drives and memory cards. Courtesy: Morehshin Allahyari (Chapter 9: Morehshin Allahyari).

PLATE 12 Los Carpinteros, *Vanite*, 1994, wood, marble, oil painting. Courtesy: The Farber Collection (Chapter 10: From Molten Plastic to Polished Mahogany).

PLATE 13 Gabinete Ordo Amoris, *Sofá provisional*, 1995. Courtesy: Ernesto Oroza (Chapter 10: From Molten Plastic to Polished Mahogany).

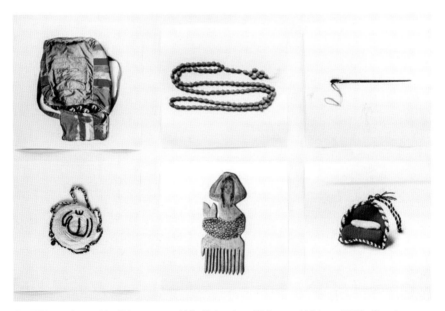

PLATE 14 Joana Hadjithomas and Khalil Joreige, *Objects of Khiam*, 2000. Courtesy: The artists. Photo: Alfredo Rubio, *Two Suns in a Sunset* at the Sharjah Art Foundation, 2016 (Chapter 11: Things Needed Made).

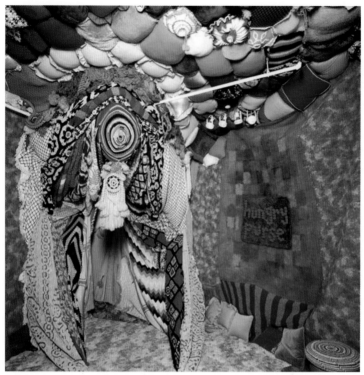

PLATE 15 Allyson Mitchell, *Hungry Purse: The Vagina Dentata in Late Capitalism*, detail, installation, Toronto Alternative Art Fair International, Gladstone Hotel, Toronto, Ontario, April 2006. Photo: Cat O'Neil (Chapter 12: Secret Stash).

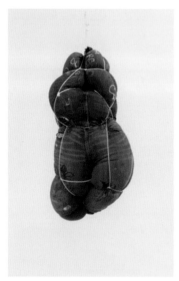

PLATE 16 Shinique Smith, *Soul Elsewhere*, 2013, artist's clothing, ballpoint ink, poly-fil and rope, 38 1/2 x 18 x 14 inches. Courtesy: Shinique Smith and SAS Studio, Private Collection. Photo: Eric Wolfe (Chapter 13: Shinique Smith).

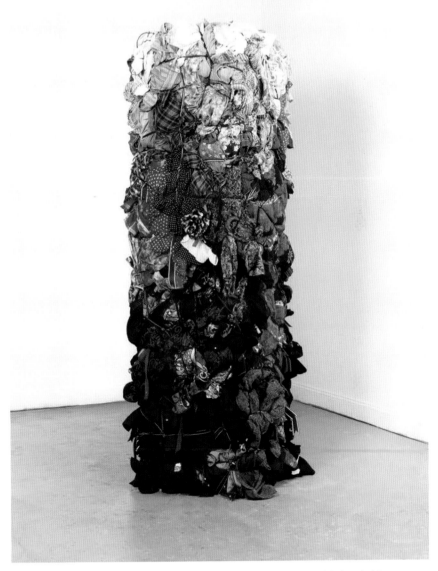

PLATE 17 Shinique Smith, *Bale Variant No. 0022*, 2012, vintage fabric, clothing, blankets, ribbon, rope, and wood, 90 x 30 x 30 inches. Courtesy: Shinique Smith and The Sandy and Jack Guthman Collection, Chicago. Photo: Eric Wolfe (Chapter 13: Shinique Smith).

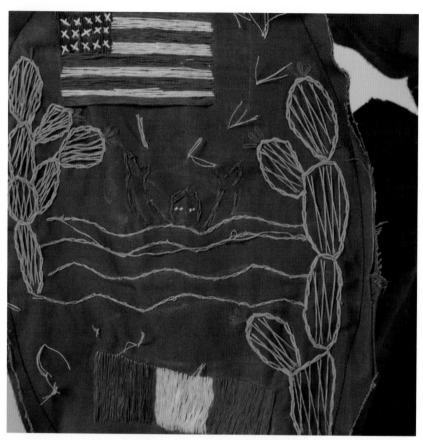

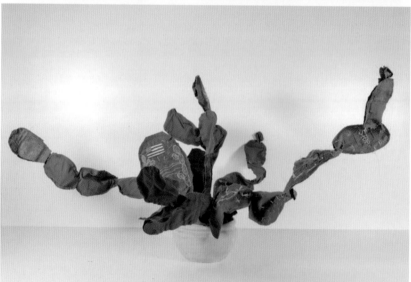

PLATES 18 AND 19 Margarita Cabrera in collaboration with Candelaria Cabrera, *Space in Between – Nopal detail* and *Nopal*, 2010, border patrol uniform fabric, copper wire, thread and terracotta pot. © Margarita Cabrera/VAGA at Artists Rights Society (ARS), New York, NY. Photo: Fredrik Nilsen (Chapter 14: Margarita Cabrera).

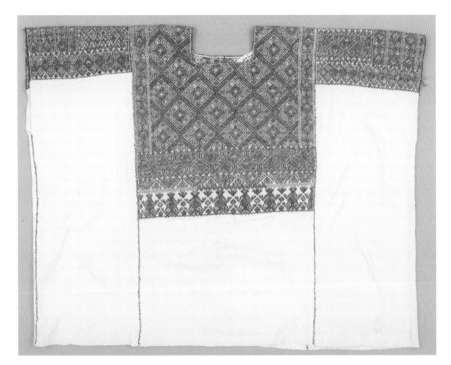

PLATE 20 Blouse, *Huipil*, San Andreas Larainzar or Magdalenas, Chiapas, Mexico, Tzotzil Maya, cotton, wool, mid-twentieth century. Opekar/Webster Collection, T94.0982. Courtesy: Textile Museum of Canada (Chapter 15: The Sovereign Stitch).

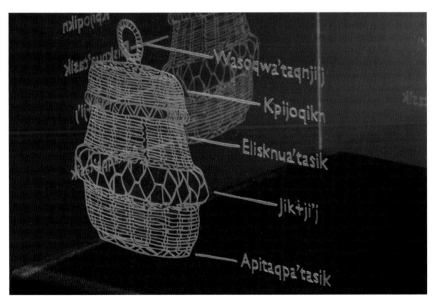

PLATE 21 Ursula Johnson, *Museological Grand Hall*, 2014, 12 etched Plexiglas vitrines of varying dimensions, installation detail from *Mi'kwite'tmn (Do you remember)* at Saint Mary's University Art Gallery, 2014. Photo: Steve Farmer (Chapter 16: Ursula Johnson).

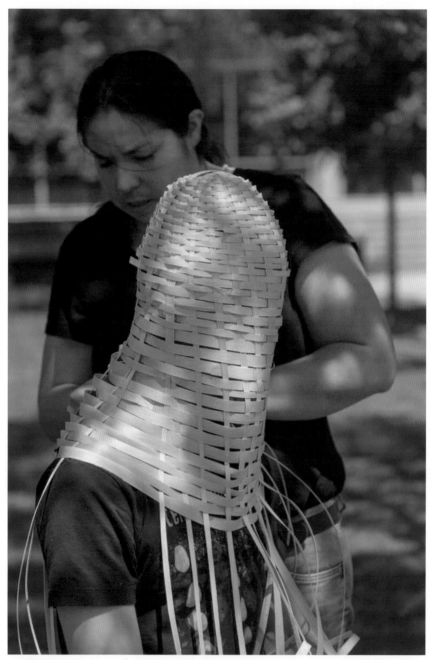

PLATE 22 Ursula Johnson, *Male Dis-enfranchised, L'nuwelti'k (We Are Indian)*, 2014, performance organized by Carleton University Art Gallery as part of *Making Otherwise: Craft and Material Fluency in Contemporary Art*. Photo: Justin Wonnacott (Chapter 16: Ursula Johnson).

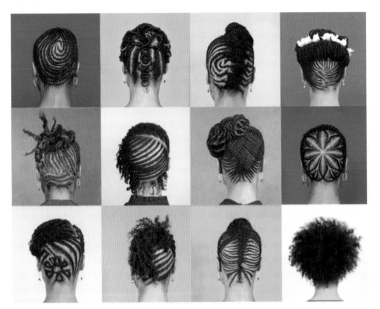

PLATE 23 Sonya Clark, *The Hair Craft Project*, 2013, featuring hairstylists Kamala Bhagat, Dionne James Eggleston, Marsha Johnson, Chaunda King, Anita Hill Moses, Nasirah Muhammad, Jameika and Jasmine Pollard, Ingrid Riley, Ife Robinson, Natasha Superville and Jamilah Williams. Collection of the Museum of Fine Arts Boston. Photo: Naoko Wowsugi (Chapter 17: 'The Black Craftsman Situation').

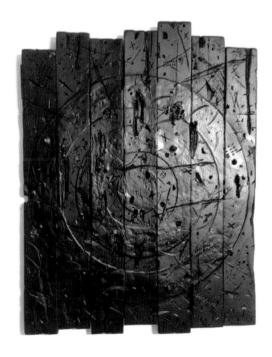

PLATE 24 Wesley Clark, *Black Don't Crack but it Sho' Catch Hell*, 2014, spray paint, acrylic, wood, 24 x 32 inches. Courtesy: Wesley Clark. (Chapter 17: 'The Black Craftsman Situation').

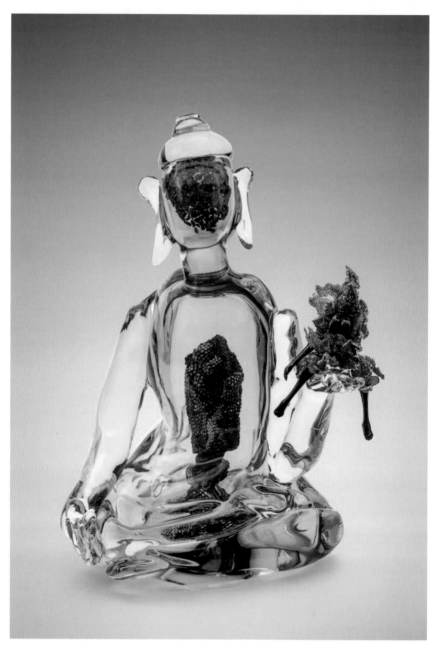

PLATE 25 Joyce J. Scott, *Buddha (Fire & Water)*, 2013, hand-blown Murano glass processes with beads, wire and thread. Photo: Mike Koryta. Courtesy: Goya Contemporary, collection of NMAAHC Smithsonian Institution (Chapter 17: 'The Black Craftsman Situation').

public sector and a rush to the bottom line in public education that TechShop and others have recognized as a great business opportunity. Perhaps their recent demise suggests public sector resources could not, or would not, sustain TechShop's desire for fast-paced global growth that attempted to monopolize the makerspace.

A makerspace ecosystem: Calgary, Alberta, Canada

Calgary is an affluent western Canadian city of approximately 1.3 million people located between the northern Rocky Mountains; the Athabasca oil sands; and the Sweetgrass-Coutts' Canada-US 24-hour commercial border crossing. It is also my home. Here too, there is a rapidly growing ecosystem of makerspaces, which illustrates how specialized makerspaces and networks develop within a particular community. The Calgary network started with Protospace, diversified to ARCHEloft and MakeFashion then expanded to planning for a very expansive Calgary Makerspace which has stalled and been supplanted by the FUSE33 Makerspace.[35] Most recently, in September 2017, Mount Royal University's Maker Studio opened to provide free community access to its facilities and training programs with priority given to Mount Royal University academic work.

Started in 2009, Calgary Protospace Ltd., a privately held non-profit company owned and run by its members, is the oldest and most well established. From its meagre beginnings in a basement, Protospace now operates 6,500 sq. ft. of light industrial space in northeast Calgary for the use of its 300-plus members. Although the member-directors I interviewed – two sculptors, an IT specialist, a computer scientist, an emergency services operator – identify the space as a makerspace, it is closer in scale and philosophy to a hackerspace, a community-run space whose members are often interested in counterculture invention, and consequently hack technology to serve purposes for which it was not originally designed. It bases its anarchist collective governance structure on one of the earliest hackerspaces, San Francisco's Noisebridge, and this also aligns it with smaller, urban collectives, which because of a lack of affordable space for making things that do not have recognizable markets, band together out of economic necessity. At Protospace, I heard repeatedly about the importance of peer-to-peer interdisciplinary, skill-based learning, 24/7 access to tools and space, the members' discussion Listserve, as well as future-thinking questions about what maker culture brings to wealthy, often exclusive, urban centres like Calgary. Questions about ecological sustainability, micro-economies and autodidactic pedagogy challenge dominant assumptions many Calgarians hold about how to value one's time, knowledge, environment, relationships and material possessions, contrary to what a petro-fuelled economy might encourage or allow. Protospace, like a mini-TechShop, offers a communal opportunity for members of every skill level to 'Tak[e] control

of [their] environment and solv[e] a problem by making a thing that [they] want',[36] with solutions tailored to the individual, not the market.

Fundamentally, Protospace sees itself as an experimental makerspace where members' needs and community collaborations outweigh entrepreneurial activities. Most of their members' activities span custom designs, hobby products and tech-geek experiments. Unlike TechShop, there is almost no professional prototyping, and while a few members have made small runs of commercial items, members do not pursue businesses. Logistically this is because the shop is run by volunteer labour with donated/loaned equipment, so it is too small and quirky to support the production necessary for businesses, but it is also because Protospace's members do not see their space as a business first. As with most non-profits starting out, memberships of $55 per month account for almost 100 per cent of the CAD$ 60–75,000 annual operating budget and all of it goes back into running Protospace.[37] As of this writing, they have very few formal partnerships, but they are collectively deciding to develop some with vendors, related robotics companies and donors who suit their members' needs, and they continue to showcase what they do at Maker Faire.

Protospace understands the need to diversify their revenues to keep membership fees affordable and grow the facility, but they are also unsure of where they fit into the non-profit landscape, and leery of the inevitable strings attached to non-member-related sources of funding that might negatively impact members' access. Non-profits that rely mainly on government grants tie themselves to administratively heavy bureaucracies that often dictate what is possible within given frameworks, restricting organizations' experimentation to keep them competing for ever-smaller portions of a shrinking pie. Corporate and private sponsorships also come with strings attached to particular projects, research and reciprocal support of the company's image, mandate and market. The reality is that most non-profits must use all of these sources, multiplying the strings to form a tight noose. A purely member-based funding model can alleviate these dangers, and potentially open up organizations like Protospace to develop new administrative and financial models. Already Protospace's members use consensus decision-making, share-and-trade economies around equipment, training and labour to facilitate member access. Yet, Protospace knows these economies rely on the re-appropriation of surplus, so they are working to actively recruit and diversify its membership base beyond the white, affluent, male members that have the privilege to participate and determine their direction.

An IT guy by day and a director of Protospace at night, Shannon Hoover and partner Maria Hoover started ARCHEloft/MakeFashion, originally known as Endeavour Arts (2010), to pursue a more disciplinary-focused vision. It started out as a mixed studio/exhibition space, wearables laboratory and mini-makerspace in downtown Calgary that combined both of their interests. ARCHEloft was a for-profit business where regular members could access textile tools, electronics

and 3D printers in a clean co-work project space for $50 per month. ARCHEloft dissolved in the summer of 2017, while MakeFashion, a non-profit founded in 2012, continues at FUSE33 Makerspace in southeast Calgary. MakeFashion combines the ingenuity of individual artists, designers, engineers and programmers in a fashion think-tank to produce wearable tech garments and touring events. Through MakeFashion, the Hoovers negotiate agreements with core-member fashion designers who pay $450 a month and facilitate related workshops and events to maintain access to dedicated 24/7 studio spaces. Core-members work in teams to develop new technological applications in fashion, such as 3D-printed, scanned components, laser-cut fabrication, LED-lit fibre optic details, heat- and motion-sensor systems. MakeFashion generates revenue by securing exclusive permission to tour the designs for one year following their initial launch, while makers retain control of their IP. MakeFashion's most recent iteration moves it one step closer to becoming a for-profit smart textiles design incubator that focuses on IP agreements and business development assistance with designers. One can assume MakeFashion will wield more control over IP and hold a larger financial stake going forward. MakeFashion has reduced its overhead by only running an office out of FUSE33. Some of the ARCHEloft designers have moved to independent spaces, some use FUSE33's studios and equipment, so the potential for creative brainstorming in open-access, communal studio environments seen at ARCHEloft now seems less of a priority. MakeFashion continues to launch and display their members' smart garments at MakerFaires and their own MakeFashion runway shows internationally. A growing list of technology partners, such as Zyris Software and Solarbotics, clearly recognizes future demand for such applications in the fashion industry.

One could question whether MakeFashion is a makerspace, or if it has crossed over to becoming a specialized business accelerator for the fashion-technology industry. If so, this does not negate the importance of the work, but rather serves as an example of how new organizational concepts, which are often broadly defined at the outset, are refined over time to settle into particular market niches. MakeFashion seems to have found their niche, and I argue that it is an early example of the type of project or disciplinary specialization that we will encounter more of as the makerspace movement becomes more widespread and monetized.

The economic viability of makerspaces and the access they can provide to promising start-ups was of foremost concern for Calgary Makerspace, a for-profit social enterprise incorporated in 2014 whose goal was to provide affordable access to reliable digital fabrication tools for individuals, businesses and schools. Calgary Makerspace planned to open a central 40,000 sq. ft. location after initially raising CAD$ 1.2 million through bond sales.[38] Modelled, in part, on TechShop, Calgary Makerspace, it developed its mandate relative to the local ecosystem. With some overlapping members, Calgary Makerspace looked carefully at how it could position itself amongst existing makerspaces, Protospace, ARCHEloft

and MakeFashion, and how it could extend its services beyond these spaces to assist start-ups or other makerspace-type initiatives that are developing through the Calgary Board of Education, public libraries, science centres and nearby post-secondary educational institutions, like Alberta University of the Arts (formerly the Alberta College of Art + Design) and Red Deer College. Projects that start off at Protospace or Mount Royal University, could migrate to Calgary Makerspace to scale-up production. Other revenue streams model TechShop's workshops, events, project storage, retail, corporate sponsorships, partnerships, small business grants and donations. Profits will be split between owners, operating costs and seed grants or shares awarded to meritorious projects, without sharing in IP.

In the end, Calgary Makerspace could not secure city space or funding and collapsed. In January 2018, it was supplanted by FUSE33 Makerspace in Forest Lawn, Calgary, an ethnically diverse and economically depressed area in the city's southeast. FUSE33 is a strategically located social enterprise started by the Hoovers and several investors who work with Calgary's International Avenue Business Revitalization Zone (BRZ), the economic development organization emergeHUB, the social and economic development agency momentum and other community organizations and businesses to advocate for positive social change and economic development within Forest Lawn and Calgary. Like Calgary Makerspace, it keeps at its core the idea of a physical production space in which members can share research and knowledge, network and build new innovations, experiment and develop new processes, and engage in informal and unscheduled activity, but perhaps with a renewed interest in incubating new small businesses. Steven Pilz, who for many years worked as a project manager for IBM and led the Calgary Makerspace team, observed: 'Big companies make amazing technology, but [they] don't know how to use it.'[39] If like MakeFashion, FUSE33 can support 'extreme hobbyists' or interdisciplinary projects to figure out how to apply and personalize new technologies that larger tech companies aren't nimble enough to discover, it is assured of some success. If six billion users can learn to adapt one piece of technology in a makerspace six billion different ways, the increasingly segmented technology market, will get a lot longer and shallower, faster than ever expected.

What is clear thus far in analysing the rapid expansion and change of makerspace models in Calgary is that they are becoming increasingly market driven and this will have consequences for the maker movement's more progressive ideals. Protospace and former Calgary Makerspace member-director David Bynoe suggests that, ideally, all of these organizations will become interdependent in this ecosystem, but admits this will not happen without gains and losses for each: 'Protospace is more chaotic [than Calgary Makerspace and other similar makerspaces], but it will be where all the innovation happens. Once you have to pay for use on a tool, it really limits what you can do with that tool.'[40] Significantly too, once public education, health and other non-profit resources are contracted out or privatized

by for-profit makerspaces, these resources are lost to the community because they become too expensive to reinstate.

Fab Lab Berlin

Fab Lab Berlin is strategically located at the centre of a new technological and cultural hub that encourages a live-work-play lifestyle that has proven increasingly productive for innovative individuals, corporations and cities alike. Or so Professor Hans Georg Näder, owner of Ottobock orthopaedic technology company, has been trying to convince the city of Berlin, in order to leverage public support for his project. He recently hired British architect David Chipperfield to redevelop the nineteenth-century Bötzow Brauerei in the now-gentrified Prenzlauer Berg district of the former Berlin, German Democratic Republic. In cooperation with Ottobock, Fab Lab Berlin (established in July 2013) moved into this new facility in June 2015, increasing their monthly operating budget from €15,000 to €50,000 in just six months.[41] Temporarily closed in July 2018 to prepare for their move to a larger, permanent facility in the historical buildings that will also house Ottobock's Future Lab, an Open Innovation Space connected to the Human Mobility Medical Centre, a culinary centre, spa, club, boutique hotel and beer garden. Näder, a contemporary art collector, will top all this off with a public gallery for his collection that will help ensure his access to this historic cultural site.

Their partnership is economically synergistic: Fab Lab Berlin gets purpose-built infrastructure with a built-in community, while Ottobock outsources their engineers to the lab for research and development that would otherwise be more regulated and expensive in a corporate lab. Ottobock taps into the maker network at Fab Lab Berlin too, which includes four full-time staff, eleven part-time staff and paid interns who run a laboratory with a comprehensive set of standardized fabrication tools, and every possible 3D printer for additive prototyping (Figure 8.2). In this digital think-tank, unusual ideas and processes can adapt to create orthopaedic solutions, among other innovations. Again, what Fab Lab Berlin members make is theirs to keep with no IP strings attached, but Fab Lab Berlin will negotiate relationships with makers on behalf of Ottobock if they are interested in taking a prototype to the next level, and most Fab Lab Berlin projects are autonomous of Ottobock. Fab Lab Berlin director, Wolf Jeschonnek respects The Fab Charter,[42] which states that commercial activities should grow *beyond* rather than *within* the lab, but this doesn't preclude pursuing a venture capital office in the future. Here, the economics seem to be at least equally important as the charter's ethical mandate.

Fab Lab Berlin is, after all, a for-profit limited liability company. Except for open days, members – mainly well-educated, tech savvy men, between 20–40 years of age who make up 70 per cent of the membership – pay to play.[43] Public tool access

FIGURE 8.2 Fab Lab Berlin, *i3*, 2016. Courtesy: Fab Lab Berlin.

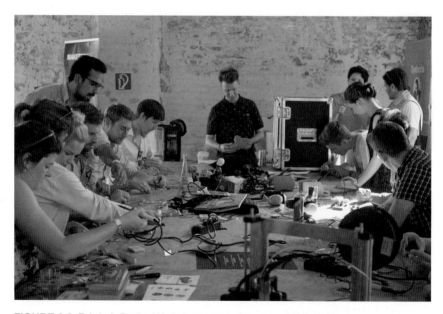

FIGURE 8.3 Fab Lab Berlin, *Workshop*, 2016. Courtesy: Fab Lab Berlin.

sells by the minute and users pay for consumables. Others rent basic co-work office space for €450 a month. Partners include freelancers, university partners and small-medium businesses that outsource products for fabrication. Main revenue sources beyond laboratory rental include workshops, individual consulting and tutoring, corporate events and major fabrication projects (Figure 8.3). The as-yet underdeveloped non-profit arm of Fab Lab Berlin is designed for community and education projects supported by sponsorships, government grants and philanthropy, different streams of revenue for public audiences that lever particular legal and tax advantages. Educational partnerships with Berlin Weissensee School of Art, NYU Berlin and several art and fashion programs are already underway, underscoring that, more and more, public educational institutions are outsourcing their students to labs that are better able to provide flexible and up-to-date service-oriented digital fabrication.

The sum of these parts

Mark Hatch writes in his *Maker Movement Manifesto*:

> In a mass-customized society with computer-controlled production – or with access to low-cost, short-run tools – we enter a new era in which the tools for production are cheap enough that labor can, for the first time, buy or rent capital as needed. This is revolutionary. It flips Marxism on its head. *Capital* is rented as needed, not labor.[44]

Yet any powerful social movement knows that the power is in the people, not just in the technology and the tools. Makerspaces, fab labs, hackerspaces and other co-work spaces know their greatest asset is in peer-to-peer learning and in building communal knowledge that can be networked for free. Whether makerspaces and fab labs are socially or politically powerful is yet to be seen, but this generosity, this sharing of content and the creativity it inspires, is valuable and is precisely what they are capitalizing on. As Tim O'Reilly rightly observes: 'It's quite clear to me that there is a new economy of content that is quite possibly larger than the old one, but just not as well measured, because we measure value captured, not value created for users.'[45]

So how do we measure the value created for users in this new economy of content? Makerspaces exist in what Chris Anderson calls the 'long tail' of the economy.[46] As editor-in-chief of *WIRED* magazine from 2001 to 2012, Anderson followed the bubble-and-burst dot.com economy closely. His 2004 article, *The Long Tail,* analyses the segmented market economy, which refers to the market shift away from the top of the curve, where supply-and-demand manufacturing models rely on mainstream products and markets, towards multiple exchanges

(hits) in diverse niche markets in the longer, shallower tail of the market curve.[47] Amazon, for example, operates in the long tail of the market. It is a huge market for small entrepreneurs: each of them serves a segment of the market, but they all pay Amazon. Makerspaces operate in a similar manner, wherein a seemingly inexhaustible number of makers make as many or as few items as they want and may or may not sell, but the makerspace gets paid for the service it provides. Makerspaces are also synergistic with the long tail of the market for three other reasons. One, they take advantage of capitalism's ills exacerbated by austerity, underemployment, job dissatisfaction and unsustainable production and consumption. Two, makerspaces encourage makers to experiment with diverse applications for new technologies, develop mass-customized products for the segmented market, and help to rejuvenate the light manufacturing sector in cities. And three, makerspaces efficiently tap the creative class – a large population with disposable income and advanced education who have been socialized and self-identify as *creatives*. Many of them are digital natives or at least tech literate, and most are self-conscious about consumption and want to do something good for the planet and future generations. All fear ennui.

Makerspaces belong to a class of creative entrepreneurship first developed from Charles Landry's creative cities model in the 1980s and subsequently discussed by Richard Florida as the creative class.[48] Under these models, creative hubs become magnets for urban redevelopment. TechShop was routinely approached by state redevelopment agencies because, 'People have figured out that a TechShop is a net economic benefit to a city or region', Calvo said. 'Other cities who are redeveloping urban cores, Pittsburgh, D.C., Arlington, are coming to us to try and figure out how to work it into their development plans because it is advantageous to them.'[49] But while creative solutions are undoubtedly beneficial to urban centres, the creative cities model often ends up sacrificing social and creative capital for financial gain. For example, the creative cities model accelerates gentrification as the creative class displaces vulnerable urban populations. Often this includes artists, craftspeople and designers whose labour does not pay enough for them to share in the 'creative ethos' co-opted from them by the creative class. One can criticize Florida's creative class for perpetuating these paradoxical structural inequities in class, gender and race, which include problematic redevelopment patterns and social hierarchies that could hold true in the future of makerspaces.[50] Paradoxically, the rise of the creative class coincides with a decline in public funding for education and culture in many Western countries including Canada, the United States and Germany. As Newton observes, these are precisely the societal lacks that makerspaces like TechShop rushed to fill. Formerly publicly funded activities in non-commercial research facilities, education or cultural centres now compete with private enterprise for these same dollars.

It is not coincidental that the rise of the makerspace coincides with the aftermath of the dot.com collapse of 1999–2000 and a floundering US economy. Governments

in Western Europe, the United States and elsewhere are supporting makerspaces as solutions to job loss and weak economies.[51] Anderson and others argue that makerspaces encourage innovations that spawn local start-ups and lead to light manufacturing and local supply chains that will reinvent manufacturing in the future. Distributed and networked digital manufacturing takes a maker's idea directly to the consumer, while keeping everyone, and their dollars, at home. Downloadable designs already exist on websites such as Instructables, and Thingiverse, and prosumers download, modify and upload redesigns to their communities for further alterations with Open Source software (Figure 8.4, Plate 10). So, even though the maker movement supposedly has a political conscience about consumption – often arguing for a financially kinder, ecologically gentler, circular economy – makerspaces do not necessarily mean *less* production or consumption. Rather they simply shift who produces what, and where and how it will be consumed.

Importantly, this shift qualitatively impacts multiple types of capital – not only financial but physical, human, social and intellectual – and this is important. Zaid Hassan in his book *The Social Labs Revolution*, recognizes that makerspaces generate new forms of capital and that this is essential to prevent the collapse of complex social systems.[52] He writes, recalling Michael Greer's theory of catabolic collapse:

> Human civilization is built on our ability to generate multiple forms of productive capital, which serves to meet societal needs for a period, before

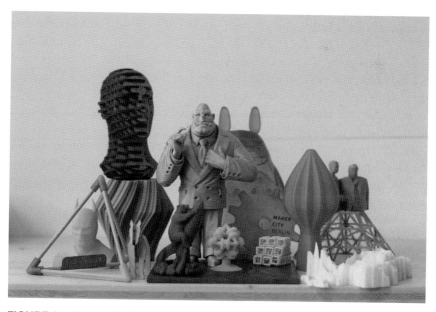

FIGURE 8.4 Fab Lab Berlin, *Samples*, 2016. Courtesy: Fab Lab Berlin.

being converted to waste … When the rate of waste being produced outstrips the rate of capital being produced – also known as the rate of consumption – then civilizations head toward ecological breakdown (what Greer calls *catabolic collapse*).[53]

Sadly, our overriding concern for financial capital has left us at the brink of collapse at the end of late capitalism. The question that remains is whether capitalism will cannibalize the maker movement, or whether a mass of digitally networked makers can remake capitalism itself.

Makerspaces capitalize on what many of us have known for a long time; making money is necessary, but alone is not enough to sustain a civilization. Even though makerspace models remain mainly in step with market capitalism, Hatch, Gershenfeld, Anderson and others are powerfully aware of the need for a shift in the economy that can capitalize on different modes of work and abundant new digital and information technologies. As Hatch notes, Techshop had 'begun to shift [members'] nonproductive, disposable, discretionary income and time into potentially productive investments while maintaining the same level of spending'.[54] This post-capitalist idea is gaining traction, but can only succeed for makers if fundamentally different economic models emerge.[55] Whether this can happen and improve the economic realities for makers remains to be seen.

Makerspaces are part of the late capitalist system, but the work that is happening within them points to a sharing economy beyond capitalism. By making available and reorganizing existing resources in the system, the power of makerspaces is in exactly what they don't own – the creativity of the maker community and re-appropriated public resources – but are levering against for the purpose of selling the idea of the makerspace and all it professes to bring to communities. Indeed, some in the US financial community have argued that TechShop's rapid bricks-and-mortar expansion and slow movement towards increased licensing agreements made their downfall.

In Doctorow's *Makers*, Disney wants to buy Perry and Lester out, but their friend Suzanne understands that they don't want the ride or the town; they just want the *creativity*.[56] In makerspaces too, the communal creativity *is* capital; the makerspace's creative sharing economy is so intertwined with neoliberalism that it cannot exist outside entrepreneurial capitalism. TechShop and other makerspaces understand this too, and this is precisely what they have put a price on. Makerspaces are sites in which capitalism seamlessly melds with creative makers and the sharing economy. At the end of Doctorow's *Makers*, Lester goes back to work with his life-long creative partner Perry and tells the financial gurus to go home: 'Perry Gibbons is the sharpest entrepreneur I've ever met. He can't *help* but make businesses. He's an artist who anticipates the market a year ahead of the curve.'[57]

Notes

1 Cory Doctorow, *Makers* (New York: Tom Doherty Associates, 2009).

2 Ibid., 11.

3 Ibid., 45.

4 Tony Bennett and Patrick Joyce, eds., *Material Powers. Cultural Studies, History and the Material Turn* (London: Routledge, 2010).

5 Alvin Toffler's famous books *Future Shock* (Random House, 1970) and *The Third Wave* (Bantam Books, 1980) could be understood as precursors to Chris Anderson's *Makers: The New Industrial Revolution* and Doctorow's novel *Makers*.

6 Richard Florida, *The Rise of the Creative Class* (New York: Basic Books, 2002).

7 'President Obama Speaks on manufacturing and Innovation', at TechShop Pittsburgh, Pennsylvania, The White House YouTube Channel, 17 June 2014. Also see Andrew Coy's 'Making the Maker Movement', the White House President Barack Obama Blog, 14 July 2016, at 5:29 PM ET, https://obamawhitehouse.archives.gov/blog/2016/07/14/making-maker-movement (accessed 15 April 2019).

8 Make: How to Make a Maker Faire, https://makerfaire.com/global/ (accessed 8 April 2019).

9 Mark Hatch, *The Maker Movement Manifesto* (New York: McGraw-Hill Books, 2014), 10. Since this article was first written, TechShop has closed its locations in the United States and Hatch is a Maker Movement Advisor, speaking, writing and consulting on the Maker Movement.

10 Neil Gershenfeld, *FAB* (New York: Basic Books, 2005). See also Neil Gershenfeld, Stuart Kestenbaum and Phyllis D. Klein, 'Digital Fabrication: Implications for Craft and Community', in *Nation Building: Craft and Contemporary American Culture* (New York/London: Smithsonian American Art Museum/Bloomsbury, 2015), 184–201.

11 FabFoundation, http://www.fabfoundation.org/index.php/the-fab-charter/index.html (accessed 8 April 2019).

12 The Fab Charter, http://fab.cba.mit.edu/about/charter/ (accessed 8 April 2019).

13 *Make:* magazine (founded in 2005) and the original Maker Faires were started by Dale Dougherty and Sherry Huss of Maker Media, with the support of Dan Woods and Tim O'Reilly of O'Reilly Media, which has made its fortune identifying trends and repackaging open-source content for big-name-roster conventions for corporate executives.

14 Mu-Ming Tsai, *Maker: A Documentary on the Maker Movement* (San Francisco, 2014).

15 TechShop Overview, TechShop, 2015, https://web.archive.org/web/20150803223524/http://invest.techshop.ws/ (accessed August 2015).

16 Jim Newton, interview in *Maker: A Documentary on the Maker Movement*.

17 Andrew Calvo, interview with author, TechShop, San Francisco, 29 September 2015.

18 Ibid.

19 Tanvi Misra, 'Mapping Gentrification and Displacement in San Francisco', *The Atlantic* CITYLAB, 31 August 2015, http://www.citylab.com/housing/2015/08/mapping-gentrification-and-displacement-in-san-francisco/402559/ (accessed June 2016).

20 5M Project, http://www.5mproject.com (accessed October 2015).

21 TechShop Overview.

22 Jean Baptiste Su, 'Report: TechShop Shuts Down, Files for Bankruptcy Amid Heavy Losses, Unsustainable Business Model', *Forbes*, 17 November 2017, 7:33 pm, https://www.forbes.com/sites/jeanbaptiste/2017/11/15/techshop-shuts-down/#36bd04876c26 (accessed 18 April 2019).

23 Andrew Calvo, interview with author.

24 TechShop Overview.

25 The Defense Advanced Research Projects Agency (DARPA) develops new military technologies for the United States Department of Defense. On 1 April 2015, Greg Petro for *Forbes* characterized Lowe's Companies Inc. as a Sci-Fi DIY home improvement company. The Ford Motor Company, founded by Henry Ford in 1903, developed large-scale manufacturing using assembly lines and engineered divisions of labour that are now known as Fordism.

26 Jeb Su, 'Report: TechShop Shuts Down, Files For Bankruptcy Amid Heavy Losses, Unsustainable Business Model'. *Forbes, November 15, 2017, 7:33 pm EST,* https://www.forbes.com/sites/jeanbaptiste/2017/11/15/techshop-shuts-down/#2b2e04ff6c26

27 Andrew Calvo, interview.

28 Ibid.

29 From Kickstarter to Today – Oru Kayak, https: //www.orukayak.com/pages/about (accessed June 2020).

30 Craft's use as a market branding strategy, or craftwashing, is an idea introduced and elaborated upon by editors Anthea Black and Nicole Burisch in Chapter 1 'From Craftivism to Craftwashing' in this volume.

31 Andrew Calvo, interview.

32 TechShop Makerspace Academy, http://www.techshop.ws/Maker_Space_Academy.html (accessed June 2016).

33 The TechShop Overview also outlines a three- to six-month Market Development Process for USD$ 100,000 that aims to get new TechShops up and running in less than two years with a projected 100 per cent growth compounded annually and new spaces to green in the first year. Andrew Calvo, interview.

34 Mu-Ming Tsai, *Maker: A Documentary on the Maker Movement.*

35 ARCHEloft Makerspace ran from April 2015 to June 2017. The Calgary Makerspace Project dissolved in June 2017.

36 Byron Hynes, interview with author, Protospace, Calgary, 13 October 2015.

37 Ibid.

38 Steven Pilz, interview with author, Alberta College of Art + Design, Calgary, 21 October 2015.

39 Ibid.

40 David Bynoe, interview with author, Protospace, Calgary, 13 October 2015.

41 Wolf Jeschonnek, emails to author, 5–6 November 2015. For 2015 growth is approximately 100–200 per cent, with projected revenue figures €650,000, up from just €50,000 in 2013.

42 The Fab Charter.

43 Wolf Jeschonnek, emails to author, 5–6 November 2015.

44 Mark Hatch, *The Maker Movement Manifesto*, 40 (original emphasis).

45 O'Reilly, 'About', www.oreilly.com/tim/ (accessed 3 November 2013).

46 Chris Anderson, *Makers: The New Industrial Revolution* (New York: Crown Business, 2012), 61–81.

47 Chris Anderson, 'The Long Tail, in a nutshell', About Me, http://www.longtail.com/about.html (accessed 3 November 2013). Steven Pilz and the author discussed this with regards to Calgary Makerspace.

48 Florida, *The Rise of the Creative Class*.

49 Calvo, interview with author.

50 There is a lack of hard data regarding the demographics in makerspaces.

51 Derek Thompson, 'A World Without Work', *The Atlantic* (July/August 2015): 50–61.

52 Zaid Hassan, *The Social Labs Revolution: A New Approach to Solving Our Most Complex Challenges* (San Francisco: Berrett-Koehler, 2014), 83.

53 Ibid., 84 (original emphasis).

54 Hatch, *The Maker Movement Manifesto*, 37.

55 Paul Mason, 'The End of Capitalism Has Begun', Economics: *Guardian*, Friday, 17 July 2015, http://www.theguardian.com/books/2015/jul/17/postcapitalism-end-of-capitalism-begun (accessed 17 July 2015). Mason's book, *Postcapitalism: A Guide to Our Future*, was subsequently published in 2015 by Allen Lane, an imprint of Penguin Random House, Great Britain, *Postcapitalism: A Guide to Our Future* (Great Britain: Allen Lane, 2015).

56 Doctorow, *Makers*, 388.

57 Ibid., 413 (original emphasis).

9 MOREHSHIN ALLAHYARI: ON MATERIAL SPECULATION

Alexis Anais Avedisian and Anna Khachiyan

In July 2014, as ISIS, the self-appointed worldwide caliphate, consolidated its hold on Mosul, reports began to surface of the group's demolition of surrounding Shiite mosques and shrines. These reports were swiftly corroborated by its release of videos showing the extent of the damage. Since then, ISIS has targeted more than two dozen cultural heritage sites in Iraq, Syria and Libya, including Christian churches, ancient and medieval temples and complexes and contemporary cultural institutions, including the Mosul Museum. The spree culminated with the demolition of parts of the ancient city of Palmyra in May 2015. In what has become the group's calling card, these events and others were heavily documented with footage designed to be streamed and shared on the internet, going viral as it was picked up by citizen journalists and international news outlets.

The unprecedented if bewildering use of social media to disseminate its message and recruit new followers by ISIS has earned it the nickname the 'digital caliphate'. Yet this use of media differs from other state propaganda organs in that it does not seek to cover up or sugar-coat the brutality of its actions, which include a spate of well-publicized beheadings of foreign journalists and aid workers and mass executions of 'enemy combatants'. Indeed, this nihilism is part of their appeal for a dispersed contingent of alienated and disenfranchised youth. To justify its barbaric acts, ISIS appeals to Salafism, an ultraconservative reformist doctrine that promotes a literal and rigid interpretation of Islam's holy texts. Where visual culture is concerned, this means the elimination of all historic examples of polytheism across the realm, including but not limited to depictions of people and animals.

Although ISIS sees itself as operating in accordance with the Muslim faith, it has taken advantage of its media portrayal as a band of lawless thugs that flouts international conventions of statecraft and warfare. In fact, this surface-level moral arbitrage provides a tactical upper hand: rather than being defaced or demolished outright, certain portable and therefore more prized items are looted, smuggled

and flipped to finance the group's activities, ending up in private collections and perhaps even cultural institutions.[1] Indeed the widespread speculation on the part of archaeologists, art historians and government officials that 'ISIS probably sells whatever it can and destroys large, famous treasures as a publicity stunt' was seemingly corroborated by a recent US-led raid on the home of a top Syrian operative which turned up 'gold coins, silver dirhams, old beads, terra-cotta fragments, an ivory plaque, an ancient manuscript and heavily corroded copper bracelets – mixed with fakes among his personal belongings.[2]

This is the reality confronted by Iranian-American artist Morehshin Allahyari in *Material Speculation: ISIS*, (Figures 9.1–9.3, Plate 11), an ongoing project that uses 3D modelling and printing to reconstruct selected antiquities destroyed by ISIS in Iraq, namely, a series of objects from the Assyrian city of Nineveh (2900–2600 BCE) and a suite of statues from the Roman-period city of Hatra

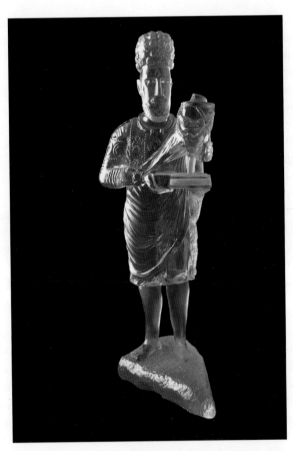

FIGURE 9.1 Morehshin Allahyari, *Material Speculation: ISIS, Eagle King*, 2016, clear resin, flash drives and memory cards. Courtesy: Morehshin Allahyari.

(200–100 BCE). Going beyond metaphoric gestures, *Material Speculation* offers a practical and political archival methodology for endangered or destroyed artifacts. Allahyari's reconstructions preserve the details and proportions of the originals – mainly individual stone figures and figural fragments depicting courtly or divine subjects as part of larger sculptural programs – but on a notably smaller scale, minus their historic context and in a transparent synthetic material that differs from their familiar stone fabrication to uncanny effect (Plate 11). The result is that the facsimiles exist in a kind of associative isolation, much like museum gift shop souvenirs. At the centre of this initiative is the figure of the Lamassu, an Assyrian protective deity depicted as having the head of a human male and the winged body of a bull or lion, that typically adorned the entry gates of cities and palaces (Figure 9.2). As an avatar of crimes against culture by ISIS, it is also symbolic of Allahyari's rehabilitative practice.

In line with Allahyari's previous work, *Material Speculation* also proposes 3D technologies as a tool of resistance. For this project, a flash drive and memory card containing data such as images, videos, maps and PDF files with information on specifications and provenance, is embedded within each of the objects – creating

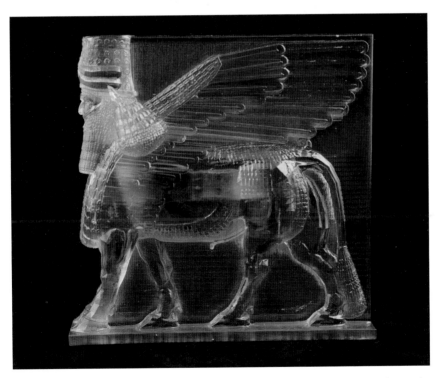

FIGURE 9.2 Morehshin Allahyari, *Material Speculation: ISIS, Lamassu,* 2016, clear resin, flash drives and memory cards. Courtesy: Morehshin Allahyari.

FIGURE 9.3 Morehshin Allahyari, *Material Speculation: ISIS, Marten*, 2016, clear resin, flash drives and memory cards. Courtesy: Morehshin Allahyari.

a kind of time capsule, sealed for future generations to discover (Figure 9.3). The historical materials used to develop Allahyari's designs are sourced through an intensive research process involving archaeologists, historians and museum specialists from Iraq and Iran. In the project's final stages, the 3D-printable files are made available online for download and unrestricted use by the public, changing the creative and economic terms of how we interact with and value cultural heritage – at a time when intellectual property traditionally held in the public domain is being aggressively privatized.

As ISIS has shown, the potential futures that digital technology promises almost always teeter on the ethically ambiguous – trapped in a crossfire of discourses that vary depending on who's doing the talking. In January 2016, responding to President Barack Obama's public statements that technology is allowing extremists to 'poison the minds of people', technology journalist Kashmir Hill wrote:

Technology and the internet are being invoked in fearful terms because it is easier to point the finger there than unpack the multifold and complicated reasons behind these acts – the growth of hateful ideologies, racial and ethnic tensions, the ease of buying semi-automatic weapons, the long-term effects of an ongoing war waged by drones and twisted minds that embrace violence.[3]

Allahyari refuses to accept this hypocrisy, which conveniently ignores the many intimidations and aggressions precipitated by the West. She recognizes that what has traditionally been considered public history is often made vulnerable: subject to co-option by organized violence and radical politicking in which both sides are equally implicated. The campaign of destruction by ISIS at the Nineveh Museum in February 2015, for example, can be seen as a means of using chaos and disorder to enforce social control, fabricate the historical record, and 'create a new reality for the present and future', as Allahyari recently told technology and science magazine *Motherboard*.[4] On the other hand, when Hillary Clinton, then acting as secretary of state in December 2015, urged the United Nations to partner with Silicon Valley to restrict suspected terrorists from gaining online access, she was effectively enforcing an equivalent form of control by chipping away at internet freedoms, as ISIS did to the artifacts of Assyrian and Greco-Roman civilizations.[5] Against this anxious geopolitical backdrop, cultural institutions, and encyclopaedic museums in particular, are seen as sanctuaries for knowledge that is continually being refined by academic scholarship, and gateways to narratives that are successively being refreshed by the societal urges of each generation. This makes forays by cultural institutions into the digitization of archives and collections seem like a natural next step in their overall function as custodians of history. Yet this, in and of itself, constitutes a process of authority building, and is therefore not immune to bias. Allahyari's work imbricates visual culture and global politics in a way that goes beyond the surface-level shock tactics and representations of protest art. Instead, she advances an elastic, phantasmagoric and mutually complicit conceptual critique of the cultural stakes.[6]

Over the past few decades, digitality has proffered a new form of history, one that is as much about self-documentation as it is about collectives, movements and other solidarities; increasing our investment in digital culture makes us more exposed, more self-aware, and putatively more accountable. In this shift Allahyari sees a potential for cultural archives to become accelerated: distributed, democratized and, paradoxically, more like data centres, which in themselves challenge the myth of the internet's immateriality with their necessarily physical existence. Contrary to techno-utopian narratives that capitalize on the art world and general public's technical ignorance of the physical infrastructures that enable digital spaces, Allahyari's work suggests that emancipation comes from an acceptance of materiality not the fetishization of dematerialization. In the *3D Additivist Manifesto*, co-authored with artist and academic Daniel Rourke, she writes of 3D manufacturing technology in similar fashion: 'Its potential belies the complications of its history: that matter is the sum and prolongation of our ancestry; that creativity is brutal, sensual, rude, coarse, and cruel.'[7] In a video that accompanies the online version of the text, an assortment of objects ranging from the organic to the ready-made – a horse, a mushroom, an oil rig, a Duchampian urinal – are seen bobbing in a quicksilver seascape (Figure 9.4). Suspended in this

FIGURE 9.4 Morehshin Allahyari and Daniel Rourke with sound design by Andrea Young, *The 3D Additivist Manifesto*, 2015, video essay, still. Courtesy: Morehshin Allahyari.

primordial soup of dreamlike associations is a cyborgian figure, the tubules that connote its bloodstream pulsing with pastel phosphorescence.

To concretize the metaphor, Allahyari and Rourke have spoken of crude oil being deepwater drilled out of the ocean floor and, later, converted from 'bacterioles' into the 'petrochemicals' that are used to make 3D plastic filament. A 3D-printed object – including Allahyari's own crystalline sculptures – thus retains the aura of a biomorphic prehistory, as if it has a memory of its own. In such a way, the *3D Additivist Manifesto* goes beyond revealing the electronic processes that make tangible products out of digitally rendered models; it fundamentally attempts to expose histories that are concealed in service of upholding the hyper-fiction that technology is a cure-all for the world's social, ecological and economic ills. Additivism does not re-inscribe structural power dynamics that are responsible for countless human and environmental tragedies. Instead, it considers material reproduction as a humanist endeavour, one that merits the same safeguarding as flesh and blood. The concept of 3D printing as symbolic of corporeality and mortality is defined in the *Manifesto* as 'infatuation', following the idea that the human body will undertake cyborgian evolution.[8] We want to become physically and cognitively immersed by matter, we want our data to be immortal. In Rourke's words, the Additivist practice exists in 'the space between the material and the digital; the human and the nonhuman'.[9]

Blind faith in digital technology is contingent on the belief that such advances are always made for human progress, when contrarily, they are often more indicative of aggressive intrusions designed to extract user data and pad corporate bottom lines. As an example of Rourke's in-between space, data analysts began

employing advertisement algorithms to search for emotional clues from Facebook users, a tactic which may allow social media networks to pre-emptively dissuade someone deemed at risk of being radicalized by ISIS.

Consequently, the hypothesis that 3D printing could launch an imaginative form of archiving, as each object in *Material Speculation* series seems to do, is subversive because it challenges conventional Western methods of archiving and preservation. It also reflects recent calls for cultural institutions to 'professionalize' by absorbing the market logic of technology start-ups rather than relying on an increasingly dried-up pool of state funding and charitable donations. As cultural institutions have scrambled to incorporate the gospel of disruption into their business plans and cultural programming, a growing critical discourse led by writers such as Astra Taylor, Jill Lepore and Jaron Lanier raises the question of whether Silicon Valley is an appropriate model for a sector that is largely non-profit and significantly non-Western.[10] In part, this nascent body of institutional critique examines the problematic nature of digital archives, which run the risk of being privatized and compromised, through such partnerships with the profit-making data-harvesting behemoth Google or its smaller competitor Artsy.

Allahyari and Rourke's conceptualization of Additivism embraces its own contradictions: that 3D printing employs plastic, a cheap, Fordist material which wreaks havoc on our environment; that it threatens to glorify industrial reproduction as yet another kind of 'sex organ', upgrading the body's inevitable mortality into a form of fetishist anthropomorphism; that its materiality, to some degree, dematerializes its own economic conditions. It is these kinds of covert and contradictory impulses that can be used as radical practice, perhaps the very thing that is needed to recognize the reasons behind various forms of cultural and physical violence and, alternately, provide a level of security against them. Allahyari is attempting to redefine the radical, not as a byword for violence – be it carried out by Islamic fundamentalism or Western capitalism – but as a strategy for changing the world around us through the advancement of ideological multiplicities.

The subjects of history are often defenceless from those who set out to record and revise it, but objects embedded with an Additivist framework retain some material agency even as their status and meaning shifts over time through ever-evolving contexts. As Allahyari continues to develop *Material Speculation: ISIS*, in part as an emotional and material response to terror, she also continues to develop her own experimental theory of preservation, simultaneously protecting objects from object-hood while navigating the materiality of digital information.

Notes

1 Contrary to the popular perceptions of ISIS as a rogue entity operating in a geopolitical vacuum, these circumstances point to a complex network of complicity

that spans national borders and time zones (the Salafi movement, which also encompasses other Sunni jihadist organizations like Al-Qaeda and Boko Haram, is globally sponsored by Saudi Arabia, the chief ally of the United States in the region).

2 Ben Taub, 'The Real Value of the ISIS Antiques Trade', *New Yorker*, 5 December 2015, http://www.newyorker.com/news/news-desk/the-real-value-of-the-isis-antiquities-trade. See also: Steven Lee Myers and Nicholas Kulish, ' "Broken System" Allows ISIS to Profit from Looted Antiquities', *New York Times*, 9 January 2016, http://www.nytimes.com/2016/01/10/world/europe/iraq-syria-antiquities-islamic-state.html?_r=0 (accessed 15 November 2017)

3 Kashmir Hill, 'Let's Stop Blaming "the Internet" for Terrorism', *Fusion*, 11 December 2015. http://fusion.net/story/243993/the-internet-and-terrorism/ (accessed 15 November 2017)

4 Ben Valentine, '3D Printing vs. ISIS', *Motherboard*, 25 May 2015, http://motherboard.vice.com/read/isis-vs-3d-printing (accessed 15 November 2017).

5 David E. Sanger, 'Hillary Clinton Urges Silicon Valley to "Disrupt" ISIS', *New York Times*, 6 December 2015, http://www.nytimes.com/2015/12/07/us/politics/hillary-clinton-islamic-state-saban-forum.html (accessed 15 November 2017).

6 Chloe Wyma, 'Hito Steyerl Shatters Reality, Pieces it Back Together', *Blouin ArtInfo*, 23 (March 2015). http://www.blouinartinfo.com/news/story/1120599/hito-steyerl-shatters-reality-pieces-it-back-together (accessed 17 November 2017).

7 Morehshin Allahyari and Daniel Rourke, *3D Additivist Manifesto* (2015), http://additivism.org/manifesto (accessed 15 November 2017).

8 Donna Haraway, 'A Cyborg Manifesto: Science, Technology, and Socialist-Feminism in the Late Twentieth Century', *Simians, Cyborgs, and Women* (New York: Routledge, 1991).

9 Allahyari and Rourke, *3D Additivist Manifesto*.

10 Jill Lepore, 'The Disruption Machine: What the Gospel of Innovation Gets Wrong', *New Yorker*, 23 June 2014. http://www.newyorker.com/magazine/2014/06/23/the-disruption-machine (accessed 15 November 2017). See also: Astra Taylor, *The People's Platform: Taking Back Power and Culture in the Digital Age* (Toronto: Random House of Canada, 2014), and Jaron Lanier, *Who Owns the Future?* (New York: Simon and Schuster, 2014).

10 FROM MOLTEN PLASTIC TO POLISHED MAHOGANY: BRICOLAGE AND SCARCITY IN 1990s CUBAN ART

Blanca Serrano Ortiz de Solórzano

In the early 1990s, Havana resembled a post-war scenario where food staples were hard to find and buildings were decrepit.[1] From 1989 up until the definitive fall of the USSR in September 1991, relations between the Soviet Union and Cuba gradually deteriorated for both ideological and economic reasons, and in 1991, president of the Soviet Union Mikhail Gorbachev announced the end of the four to five-billion-dollar annual subsidy to Cuba, as well as the withdrawal of Soviet advisors and troops from the island. The effects of these measures were dramatic: 80 per cent of Cuban imports were lost between 1990 and 1993, causing the island's economy to contract by 34 per cent.[2] The end of socialism in Europe resulted in severe isolation and economic hardship in Cuba, which was exacerbated by the reinforcement of the American embargo, delivering 'nearly existential shocks to the Cuban system'.[3] The recession directly impacted the material culture of Cuba, which underwent significant changes during these years: shortages of fuel, electricity, food, water and medicine turned into dramatic permanent features of everyday life. The limited supplies, changing cityscape of Havana and emerging local art market informed the materiality, style and subject matter of Cuban art during that period; and the 1990s appear as a turning point from which to re-examine the past, present and future of the nation, and reconsider the role of art and material culture on the island.

The bricolage phenomenon that emerged in Cuba after the revolution in 1959 and the beginning of the US embargo grew exponentially during the Special Period in Time of Peace, as the years roughly between 1991 and 1997 came to be known.[4] Since no new goods were entering Cuba, existing objects were recycled,

transformed or repurposed.[5] In order to address the deterioration of material goods on the island, the government strongly encouraged do-it-yourself family-based practices in Cuban homes. Between 1990 and 1991, the army published *El Libro de la Familia* (The Family Book) and *Con Nuestros Propios Esfuerzos* (With Our Own Efforts), two volumes on domestic tips focused on adapting to the shortage of goods. The manuals covered almost everything from agriculture, energy, transportation and construction to medicine, cleaning, clothing, toys and leisure; and included instructions on how to make myriad, sometimes fantastical, objects such as rice-peel bricks and a grapefruit 'steak'. These manuals promoted a return to traditional ways of life, and supported recycling and the creative re-adaptation of resources. They also obscured the necessity for such approaches, instead elevating Cubans' resilience to a matter of national pride. However, while these state publications backed responsible consumption both for ideological and economic reasons, they avoided any mention of the illegalities masked by most self-made creations, which ranged from stealing materials to skipping quality inspections.

Cuban material culture of the 1990s was impacted not only by bricolage as a consequence of scarcity, but also by the reforms package that corresponded with the Special Period, including the introduction of a series of austerity measures, the development of tourism and the opening of the island to minor private initiatives. The longing for foreign imports and need for outside revenue made it an inescapable state priority to render the Caribbean island more attractive to both international visitors and international investors, and it was during these years that the restoration and beautification of Havana's historic colonial quarter took place.[6] The opening of new, or renovated, resorts, hotels, museums, restaurants and bars made the island more appealing to foreigners, but it was perhaps the idea of Cuba as the last remaining bastion of pre-neoliberalism, pre-globalization and pre-internet media times, that was most attractive to people outside of the nation. The Old Havana restoration project brought about the recuperation of traditional artisan techniques that had long been in disuse, and trained several hundred young people as masons, carpenters, painters, plumbers, electricians and gardeners. Indeed, the program generated a network of training establishments that produced young specialists to perform the restoration work, re-establishing the status of these various artisanal skills.[7] The number and variety of modified, refurbished items and buildings increased to the point that these enterprises – both those improvised by citizens and those planned by the state – not only significantly altered Havana's cityscape, but also impacted the work of many visual artists. During these years, many Cuban artists used the image of Havana as a site, source and idiom for their work, creating a form of art inspired by ruins, recycling and craftsmanship, yet also largely conditioned by the scarcity of materials.

In this context, many artists turned to bricolage – the do-it-yourself process of constructing an object from odds and ends – as a formal and conceptual

language that best reflected the position of the visual arts at the heart of the Cuban revolutionary project. Recalling French anthropologist Claude Lévi-Strauss's conceptualization of bricolage, the Cuban citizens' combined use of the different materials at hand, which ranged from colonial furniture to Soviet vehicles, passing by 1950s American appliances, generated a unique cultural identity through the subversive intertextuality of artefacts across historical contexts.[8] Often regarded as a manual folk skill, devoid of the intellectual sophistication of the fine arts, bricolage was appropriated by 1990s Cuban artists as the most adequate language to reflect on the changing relations between art, society, market and the state.[9] This approach allowed many artists to work comfortably with the few materials available then and to establish a dialogue between their oeuvre and the improvisational nature of material culture in Havana. Furthermore, since bricolage in 1990s Cuba was already intrinsic to everyday life and domestic space, many artworks from that period were in dialogue with the home as a complex place where individual freedom, frustration, resistance and resilience often intertwine.

This essay analyses the myriad approaches to bricolage in the work of the collectives Desde Una Pragmática Pedagógica, Los Carpinteros and Gabinete Ordo Amoris, who respectively engaged in restoration practices, experimented with traditional handicrafts and studied Cuban vernacular design in their work. Further, it will reflect on these artist groups' take on the development of the revolutionary project and on the changing social status of the artist in Special Period Cuba. Two works by Desde Una Pragmática Pedagógica (Through a Pragmatic Pedagogy) illustrate the shift in artistic practices in Cuba over the course of one decade: *La Casa Nacional* (The National House) from 1990 and *La Época* (The Epoch), produced nine years later, illuminate the profound changes in Cuban material culture and the impact of Special Period reforms on Cuban society.

In 1989, artist and professor René Francisco Rodríguez founded Desde Una Pragmática Pedagógica, an artist collective and horizontal pedagogic project, which included himself and a number of fine arts students at the Instituto Superior de Arte.[10] The group dissolved in 1990, and was re-formed by its creator in 1997 under the acronym DUPP. Following in the wake of 1980s Cuban art collectives – such as Hexágono, 4x4, Puré, Grupo Provisional and Arte Calle – their goal was to 'make art cut into social life', and their actions often developed outside the academic milieu.[11]

La Casa Nacional was located on a land lot in Calle Obispo 455, in the heart of Old Havana. René Francisco Rodriguez, his colleague Ibrahim Miranda and his students María del Pilar Reyes, Acela, Dianelis Travieso, Tania Alina, Tania Rodríguez, Lucía Rodríguez, Alexander Arrechea and Dagoberto Rodríguez (the last two soon-to-become Los Carpinteros), remodelled an old building in La Habana Vieja and restored the inhabitants' belongings. The group performed daily chores for the tenants including laundry, cleaning and cooking – tasks that

were not easily accomplished during a period of material scarcity. The artists also partnered with residents to attend to their home renovation needs, such as repainting entrances, repairing furniture, adding apartment numbers to the front doors, hanging a cork bulletin board at the community meeting room and painting devotional images upon request.

A black-and-white photograph documenting the action shows two young artists sitting on a wooden bench in a domestic interior. Armed with long paintbrushes, they lean over an old, large seat cushion that they hold across their laps. With a look of extreme concentration, both women meticulously repaint the worn-out cushion with its original flower pattern designs as if they were restoring a precious antique. The scene seems absurd because of the painters' deteriorating surroundings – the fading colours of the scratched, cracked and chipped floor tiles, the precarious state of the bench where the seat cushion belongs and the scaffolding-like shelf in the background – makes their improvement work seem less urgent than other repairs. However, the image also illustrates how certain signifiers of social status, or the aspiration to reach them, were not relinquished despite times of scarcity in Cuba. On the contrary, they were cherished as symbols of dignity.

Rodriguez described the project as a 'political work of social reconstruction' and as 'the university of the street'.[12] Indeed, the artwork demonstrated the resident's needs, alongside the significance of the group's desire to learn aesthetic and conceptual lessons through experimentation with materials and techniques that were, at that time, more typical of a construction site than of an art school. Thus, the students' reparative project challenged the canonical definitions of fine art, and perhaps more importantly, subverted the official distribution of employment by industry and occupation in Cuba. On the one hand, it could be argued that the guerrilla manoeuvres of DUPP recalled Michel de Certeau's formulation of 'tactics' as the common people's everyday resistance to power structures through the seizing of unexpected opportunities. On the other hand, the fact that this action happened under the auspices of a state institution like the national graduate school of arts made the event less inflammatory than it might first appear.[13] Finally, the title of the piece, *La Casa Nacional* references both the building residents' duties as the Revolution Defence Committee of their block, and the flag colours and paint they chose to evoke the significance of the house as a microcosm of the Cuban society.

Los Carpinteros were influenced by their experience in DUPP's *La Casa Nacional* in the development of their interest in home improvement skills.[14] Founded by Alexandre Arrechea, Dagoberto Rodríguez and Marco Castillo at the Instituto Superior de Arte in the mid-1990s, in their early work Los Carpinteros experimented with manual remodelling and refurbishing techniques. They used found wood and adapted traditional carpentry techniques to create sophisticated pieces of furniture with academy-style oil-on-canvas scenes. These scenes

reflected race and class differences in Cuban history through references to colonial times, and the period from the 1950s to the Special Period. The resulting exuberant artefacts were a comical inversion of the domestic transformation of junk into utilitarian items that was so common in Cuba at the time. Their working process was often the same: Arrechea and Rodríguez, who trained with a professional carpenter upon the suggestion of professor René Francisco Rodríguez, did the woodwork and Castillo painted the scenes, in which his two colleagues were often depicted as the protagonists.

For the Fifth Havana Biennial in 1994, the collective presented a series of five works, called *Interior Habanero* (Havana Interior). Each work featured a painting framed by a cabinet-like wooden structure. In most cases, the artists obtained the wood from the luxurious chests, dressers and bureaus found at the abandoned mansions in the area of the art school, while in others they chopped down the mahogany trees on campus. The oil paintings on canvas were often carried out in an academic classical style that resonated with the elegant yet conservative fashion of the cabinetwork. The piece *Vanite* (Figure 10.1, Plate 12), titled after the Dutch and Flemish still-life genre that depicts the transient nature of all earthly life, consists of a lavishly carved dressing table, with drawer legs shaped as lion paws and a pristine marble top. In lieu of the mirror is a painting of the three group members, crowned by the word 'vanite' carved in wood. In the painting – an embodiment, performance and representation of craft by craftsmen – Arrechea holds a candle to illuminate Rodríguez, while he carves the acronym MAD with a chisel on Castillo's back.[15] MAD was the group's first name, composed of each member's initials, and therefore, although the scene also alludes to the scarce materials for art then available in Cuba, it perhaps more importantly serves as an embodiment of the sacrifice of individuality for the sake of the collective, not only in Los Carpinteros, but in revolutionary Cuba as well. As art critic Janet Batet has observed, 'the notions of guild and craft implicit in their work, also implied the examination of concepts such as participation and democracy'.[16] Overall, the contrast between the splendour of the dressing table and the darkness of the painting mimics the disparity between pre- and post-1959 Cuba, yet the title of the work unifies both elements. The work establishes a parallel between the excessive 'vanity' of those in power during both periods' regimes, perhaps in their ignorance of the people's needs.

Another work from the series is *Marquilla cigarrera cubana* (Cuban Cigar Label). Like a gigantic replica of a cigar box, this work displays a relatively small painted scene framed by a large piece of carved wood. The top and left sides of the frame present a decorative geometric pattern of rhomboids and flowers. The right side depicts a carved coat of arms: the emblem of Los Carpinteros, with two hammers, a paintbrush and the group's acronym. Below a text vignette captions the painting to read: 'Lord, we have lost everything in the game. Everything? Everything but one thing. What? The desire to gamble again.'[17] In the foreground

FIGURE 10.1 Los Carpinteros, *Vanite*, 1994, wood, marble, oil painting. Courtesy: The Farber Collection.

of the image, Arrechea, naked from the waist up, smokes a Cuban cigar while, far behind him, a nude Rodríguez runs in the background. The scene is set in an ornamented museum similar to the Hermitage, elegantly decorated with marble columns, glass ceilings, Turkish carpets and large, richly framed paintings resembling those of the European Old Masters. This piece pays homage to the handmade labour of cigar factory workers, traditionally Afro-Cubans, by elevating cigar manufacturing – from cigar rolling to box crafting – to the realm of the fine arts. Moreover, *Marquilla cigarrera cubana* challenges racism on the island by placing the naked body of a Black man, Arrechea, in the centre of the image, and by showing him as both artist and smoker, two roles from which Afro-Cubans were historically excluded.[18] The work is a statement of Los Carpinteros' determination to climb right to the top of both the social ladder and the art world, despite the local difficulties in making art.

Los Carpinteros presented *Interior Habanero* as their graduation project in 1995. After seeing the interest of international collectors in contemporary Cuban

art at the Fifth Havana Biennial first-hand, the group added a performance to the work that spoke to the recent phenomenon of the Cuban art market. When presenting the series to the thesis committee, Arrechea read aloud the letter of a Miami-based collector who was interested in acquiring *Interior Habanero*. In fact, Los Carpinteros had written the letter themselves but they did not reveal this until the hoax had spread through the media. This act illustrated how the possibility of earning a living in dollars fostered a relationship between Cuban artists and wealthy Cuban exiles.[19] The letter pointed to the paradox of how the increasing social differences in contemporary Cuba not only replicated those of the pre-revolutionary past, but also strengthened the link between islander and mainlander Cubans, one of the revolution's greatest enemies. Moreover, the fact that the action was also titled *Interior Habanero* called attention to the fetishization of the historical image of Cuba during the Special Period, which coincided with the renewed interest in the biennial of members of the social class whose once-opulent Cuban lifestyle was being addressed by the artists.

The title *Interior Habanero* also reveals how the domestic space became a metaphor for, and a refuge from, a feeling of disappointment with the public sphere in Special Period Cuban art. The use of stolen wood and small canvases in these works calls attention to the lack of available art supplies, and the recuperation of carpentry techniques that had long fallen into disuse, but that were partly being recuperated for the restoration of Old Havana, questions traditional media-based distinctions between craft and fine art, while also challenging the racial politics of job distribution on the island. Finally, the flamboyant yet academic style of the series was intended to be a provocation, although as scholar Rachel Weiss has argued, it might also partly reflect many Cuban artists' struggle then to 'contend with an artistic legacy of political critique, a rising art market and revolutionary exhaustion'.[20] In relation to this, Marco Castillo explains that they made 'pieces that appeared conservative' because they 'would be aggressive in that socialist climate'.[21]

The work of Gabinete Ordo Amoris also draws from Cuban domestic design, although the group found inspiration in the do-it-yourself practices of the Special Period, rather than in 1950s mansion furniture. Gabinete Ordo Amoris was founded in 1994 by Ernesto Oroza and Diango Hernández, two students at the Institute of Design of Havana (ISDI). Later in the same year, designers and artists Juan Bernal and Abel Francis Acea joined them.[22] The first solo show of Gabinete Ordo Amoris was the two-part exhibition *Agua con Azúcar* (Sugar Water) and *La Muestra Provisional* (The Provisional Show) organized by the Ludwig Foundation,[23] and held simultaneously at the Centro de Desarrollo de las Artes Visuales in Havana between January and February 1996.[24] *Agua con Azúcar* included a collection of vernacular design objects gathered by the artists in Havana, while *La Muestra Provisional* presented a series of sculptures and installations based on the Cuban culture of bricolage and carried out by the collective. This

was the first time that an exhibition by Gabinete Ordo Amoris included both found objects and objects they crafted that were not considered furniture or artworks but rather, in their own words, 'design solutions that carry the aesthetic language of provisionality'.[25] The double project *Agua con Azúcar* and *La Muestra Provisional* was presented as a reflection and open debate on the state of design in Cuba, and the exhibitions were accompanied by lectures and panels. The wall label at the entrance of the exhibition explained the provisional character of the objects displayed in the galleries: 'Working as archaeologists of the contemporary quotidian ... we wish to set order in a new form of Cuban visuality, which is based on the study of "provisionality" as an aesthetic and ethical category that we think should be recognized as part of our culture.'[26] Thus, while bringing to mind Charles Jencks and Nathan Silver's discussion of 'adhocism' in their efforts to give experimentation and spontaneity the weight of architectural theory, Gabinete Ordo Amoris did not consider their objects of study as the offspring of individual choice and aesthetic pluralism, but rather as the inevitable response to privation.[27]

Most of the objects gathered by Gabinete Ordo Amoris in the exhibition section *Agua con Azúcar* were fabricated in Havana and bought on the city's black market in 1995. These creations were either made with a material that had been returned to its malleable state, reassembled from different parts, or repurposed; and although craft techniques were sometimes used in their production, people generally worked through the complexities of operating borrowed or stolen industrial machinery in a home setting.[28] Many objects were based on standard Soviet objects, but many also included parts from American goods accumulated since the beginning of the revolution, as well as 'new' items to the island, such as beer cans and Monoblock chairs, that had appeared with the recent development of tourism. Moreover, in the words of Ernesto Oroza, these popular creations followed the same pattern because of the 'standardized' material culture, the 'standardized' poverty, and the 'standardized' education on the island, while each of them was also unique because of the singularity of its creation.[29] Following Oroza, these processes of active accumulation, recycling, reassembling and repurposing not only resisted the temporality of the capitalist object through ingenuity, but they also attacked the authority of the 'original' item by disobeying its unity and its sole function, and by seeing instead the potential of its bits and pieces.[30]

The objects in *Agua con Azúcar* included recycled flip-flops, cutlery, dishes, hair accessories and toys, shaped from molten plastic which displayed decorative colour swirls from original casts as reminders of the previous life of the object. A mouse trap built from carefully selected and cut-out pieces of a Lagarto beer can attached to a chunk of wood demonstrates how these objects searched for beauty in their design in spite of also satisfying urgent necessities. A champagne glass made from an eroded glass flask – an attempt at luxury when no champagne could be found on the island – indicates that desire could operate within necessity and yet exist outside the logic of capitalism by re-signifying the relation

between producer and consumer. A photograph of a three-section Russian Lada automobile constructed by merging several separate cars together points to the audacious inventiveness and the technical mastery of these creations. This image was printed in one of the first multi-page photocopiers in Cuba; a procedure that mirrored the fragmented constitution of the Lada.

La Muestra Provisional, the other part of the two-sided exhibition, was installed across from the *Agua con Azúcar* gallery.[31] This exhibition was a critical response to the new object-archetypes engendered by Cuban vernacular design, and it emphasized that there is not a single truth to an object. While some works amounted to an ironic take on how scarcity could push people to ridiculous – sometimes even violent – limits in order to survive, most of the pieces responded to the group's admiration of the ingenuity of Cuban bricolage, both from a technological and a design-oriented perspective. *Sofá Provisional* (Provisional Sofa) (Figure 10.2, Plate 13) features a group of random objects often used as temporary seats while waiting in line – unfortunately a typical situation in Cuba – joined under the phantom silhouette of a pencil-drawn couch. A blazer on a hanger suspended above a sack of sugar seemed to be an improvised solution for a closet, and was also a play on words since blazer, bag and the words 'I extract' are all expressed by the word *saco* in Spanish. Moreover, the blazer, an emblem of bureaucracy and business, appears to be supported by the sack of sugar, almost as if it were a statue on a pedestal, or a mannequin sustained by the labour of sugar harvesting. A large banner taken from a gas station and included in the

FIGURE 10.2 Gabinete Ordo Amoris, *Sofá provisional*, 1995. Courtesy: Ernesto Oroza.

exhibition reads *Hay aire* (There Is Air). At first sight, this decontextualized sign for pumping up tires looks like an advertisement for relief: at least there is air to breath. However, when the viewer continues reading, the fine print reveals a 20-cent charge.

As a large-scale installation, the quasi-encyclopaedic collection of Cuban vernacular design, and the creations by Gabinete Ordo Amoris were presented as two wings of a Wunderkammer, or cabinet of curiosities; as rarities waiting to be classified, testimonies of the charged, charted and defamiliarized micro-economies of Special Period Cuba. The two-part exhibition could be considered an artwork itself; it challenged the limits of the traditional 'white cube' gallery by blurring not only the boundaries between fine arts, design and crafts, but perhaps more importantly, between official and non-official Cuban visual culture. Thus, the collective's desire to incorporate handmade vernacular objects into the history of Cuban graphic and industrial design was twofold: first, it was a sincere tribute to the inventiveness of these creations, and second, it was also a sardonic comment on how pandemic scarcity had to be recognized as a defining condition of the island's recent past and present. By reminding the viewer that the bricoleur speaks both through things and with things, their pieces also illuminate new relations between art and the everyday in Cuba. Finally, *Agua con Azúcar* and *La Muestra Provisional* revealed the fraught ethos in Cuban inventive self-made design: though born out of necessity, it was also an impulse for creative freedom and autonomy.

As the decade was drawing to a close, Desde Una Pragmática Pedagógica's 1999 collective performance *La Época* (The Epoch), exemplified the evolution of bricolage in art from Special Period Cuba, and reveals the changes in the social, economic and political position of the artists over the decade. Between 1998 and 2002, Rodriguez took up his teaching workshop once again, this time under the acronym DUPP. Together with a number of students, he organized a two-day action at La Época, a mid-1950s modern style building located on Calle Neptuno, *Centro Habana* area's main artery, and one of the city's few shopping malls with dollar-only stores selling imported goods.[32]

The action was composed of a series of performances and installations scattered among the articles for sale on the mall's ground and first floors. The goal of *La Época* was to highlight the ambivalent role of the artists, both as creators and as retailers, and of the people, both as audience and as consumers. Moreover, *La Época* pointed to the increasing market value of Cuban art, while the futile and ephemeral nature of the action allowed the work to remain outside of the market logic. Furthermore, the 'poor' aesthetics present in most students' pieces, using found objects from the mall such as white plastic hangers and recycled nylon shopping bags, was in dialogue with Cuban do-it-yourself material culture, yet the elements of most works, such as the hangers and shopping bags were 'new' items to the island, and not accessible for many Cuban families. Thus, the artwork called attention to the disparities in wealth between the Cubans at the end of

the decade: it illustrated the violence of such social differences with seemingly absurd actions that wasted expensive goods in installations that resonated with the provisionality and improvisation of Cuban vernacular inventions. Finally, the title *La Época* was another reference to the changes that occurred over the course of the 1990s on the island, and an invitation to reflect on how Special Period economic measures had left a deep impact on the people, the city and the arts in Cuba.

Both of the works by Desde Una Pragmática Pedagógica/DUPP – *La Casa Nacional*, 1989, and *La Época*, 1999 – were collective actions that make use of non-traditional art media and techniques to interact with audiences outside of formal gallery spaces. However, they were almost opposite in their procedures and, more importantly, in their intentions. These differences exemplify changes over a decade in the Cuban art world brought about by economic measures that also deeply affected the social organization of the island. In *La Casa Nacional*, there was only one collective action in which all students participated, while in *La Época* each artist had his or her own individual project. In the first work, the relation between the artists and the building's residents was based on verbal agreements and on the free interchange of knowledge, its purpose to satisfy the necessity of restoring the old. In the second work, however, the use of a shopping mall as the setting for the action, turned the viewers into consumers, making their relation to the works seem like potential commercial transactions. In turn, it presented the artworks as fetish commodities; as products that are only desired for their exchange value. The location of the group's actions shifted from the private domestic space of the home to the public space of the store; from the realm of socialism and the Revolution Defence Committee, to a space symbolic of capitalism, the shopping mall. The differences between the two projects emphasize the dramatic transitions from the conditions before and after Special Period Cuba.

If the two actions by Desde Una Pragmática Pedagógica illustrate the changes that took place in Cuba from the beginning to the end of the 1990s, Los Carpinteros' *Havana Interior*, and Gabinete Ordo Amoris' *Agua con Azúcar* and *La Muestra Provisional* exemplify the mid-decade turmoil. Indeed, these works belong to the years when most economic and social reforms to temper the effects of the financial crisis were implemented: the introduction of dual currency, allowing private initiatives, the development of tourism and the restoration of Old Havana. While both artist collectives resorted to forms of *canibaleo*, taking the pieces of one device to use them in another,[33] their works responded to this changing climate through different engagements with Cuban design. Los Carpinteros' work evokes the luxurious lives of 1950s American and Cuban elites on the island, through the recuperation of fine cabinetwork traditions. In contrast, Gabinete Ordo Amoris' two-wing installation presents an aesthetic of the poor through provisional objects and Soviet standardized goods that were transformed out of necessity using improvised domestic technologies. Further still, Los Carpinteros' *Havana Interior* consists of non-functional furniture replicas, while Gabinete Ordo Amoris' double

exhibition is composed of functional original items.[34] Despite these differences, both Los Carpinteros' and Gabinete Ordo Amoris' projects demonstrate the artists' concern with the effects of Special Period on Cuban material culture, and their engagement with bricolage practices.

Indeed, Cuban art in the 1990s was shaped by material scarcity, the transforming cityscape of Havana and by the change in the social status of the artist. Many Cuban artists experimented with aspects of craft in their work from this decade because the functionality, the collective authorship and the relation to vernacular traditions allowed them to reflect on the direction of Cuban arts from an almost outsider position. On the one hand, the return to the quotidian and domestic sphere meant a detachment from the island's pervasive rhetoric on the collective ethos, while on the other hand, it also represented a search for answers at the heart of society and the revolutionary project. The artists' use of bricolage as a means to reflect on material culture and artistic practice in Cuba evolved throughout the 1990s in relation to the changes brought to the island by the Special Period reform package. In sum, through their engagement with bricolage practices, these artists reflected on the need, the purpose and the role of art in pre-turn-of-the-century Cuba.

Notes

1 Elzbieta Sklodowska summarizes reporter Lydia Chávez's memories of the Cuban capital as they appear in Chávez's book, *Capitalism, God, and a Good Cigar* (Durham: Duke University Press, 2005) as follows: 'a post-apocalyptic city, where waste itself became a rare commodity'. Chávez cited in Skolodowska, 'Reinventing the Wheel: The Art of Survival in Post-Soviet Cuba', *Figure in the Carpet*, vol. 11, no. 3 (November 2012): 4. Kevin Power refers to the pervasive joke in Cuba then which went 'little, less, nothing, nobody' (original in Spanish: '*poco, muy poco, nada, nadie*'). Kevin Power, 'Cuba: One Story After Another', in *While Cuba Waits: Art from the Nineties*, ed. Kevin Power (Santa Monica: Smart Art Press, 1999), 41.

2 Marifeli Pérez-Stable, *The Cuban Revolution: Origins, Course, and Legacy* (New York: Oxford University Press, 2012), 132.

3 Julia E. Sweig, *Cuba: What Everyone Needs to Know* (New York: Oxford University Press, 2009), 126. The 1963 US embargo was reinforced in October 1992 by the Cuban Democracy Act sponsored by Robert Torricelli – which prohibited foreign-based subsidiaries of US Companies from trading with Cuba, travel to Cuba by US Citizens, and family remittances to Cuba – and by the 1996 Cuban Liberty and Democracy Solidarity Act (known as the Helms–Burton Act) which extended the territorial application of the embargo. The Helms–Burton Act imposed further penalties on foreign companies doing business in Cuba, and allowed US citizens to sue foreign investors who use American-owned property seized by the Cuban government. Mick Hillyard and Vaughne Miller, 'Cuba and the Helms-Burton Act', *House of Commons Library Research Papers*, vol. 98, no. 114 (2000): 3.

4 The term 'Special Period in Time of Peace' borrows from the military jargon 'Special Period in Time of War'. The Communist Party first used this designation for a series of austerity measures in *Cuba en el mes* on 27 August 1990. On 28 September 1990, in a speech to the Committees of Defense of the Revolution, Fidel Castro announced the inevitability of the Special Period: 'Without doubt we are entering the Special Period. It is almost unavoidable that we will have to experience that special period in a time of peace.' There was no official end to the Special Period, and many argue that it is still ongoing. See Ariana Hernádez-Reguant, *Cuba in the Special Period: Culture and Ideology in the 1990s* (New York: Palgrave Macmillan, 2009), 17–18. In contrast with the term 'Special Period in Time of Peace', and in reference to both the crumbling aspect of Havana and the massive exodus of people post-1989, many artists dwelt on the idea of a post-war scenario in their work then, most notably Tania Bruguera in her 1993–94 project *Memoria de la Postguerra* (Postwar Memory).

5 Note that in this context, recycling refers to the act of returning an object to its original compound, that is, melting plastic; it does not necessarily imply having an environmentalist conscience.

6 Unanimously declared a World Heritage Site by the UNESCO in 1982, by 1993 the Decree Law 143 declared the city nucleus of Havana (known as Old Havana) a Conservation Priority Zone, and granted external funding for its restoration. The restoration area encompassed 214 square kilometers with 3,370 buildings ranging from the seventeenth to the twentieth centuries, including 551 architectural monuments of exceptional value, and a population of 66,742 people living in 22,623 homes. See Patricia Rodríguez Aloma, 'La Rehabilitación Integral de La Habana Vieja: Una Responsabilidad de la Nación', in *Patrimonio Cultural y Turístico Cuadernos 19-Políticas Públicas y Turismo Cultural en América Latina: Siglo XXI* (Mexico City: CONACULTA, 2011), 132.

7 According to historian Antoni Kapcia, 'the impact on skills has been enormous, the focus on artisan rather than artistic activity generating a network of training establishments to rival ISA [the Graduate Institute of Arts] in the arts ... Artisan skills have been developed more broadly ... and with greater opportunity for prestige, purpose, and a sense of belonging.' Antoni Kapcia, *Havana: The Making of Cuban Culture* (Oxford: Berg, 2005), 185.

8 Bricolage was first theorized in 1962 by Lévi-Strauss in his book *The Savage Mind*. See Claude Lévi-Strauss, *The Savage Mind* (Chicago: University of Chicago Press, 1968). Translated by John Weightman and Doreen Weightman.

9 With the founding of the San Alejandro Academy in the early nineteenth century, a clear division was drawn between artist and artisan in Cuba. Cubans of African descent were not allowed to enter the academy for decades, and craft and manual trade teaching was rejected at San Alejandro for not being considered appropriate for the Academy's well-off Caucasian students.

10 The Instituto Superior de Arte, known by its acronym ISA, is the National Graduate Institute of Art. Located in Havana, it was founded in 1976.

11 Chema González, 'Entrevista a René Francisco', 13 August 2008. http://blogcentroguerrero.org/2008/08/entrevista-a-ren-francisco/ (accessed 10 June 2015)

12 *La Casa Nacional* exhibition brochure, January 1989.

13 See Michel de Certeau, *The Practice of Everyday Life* (Berkeley: University of California Press, 1988). Translated by Steven Rendall.

14 The collective Los Carpinteros was founded in 1991 in Havana by Marco Antonio Castillo Valdes, Dagoberto Rodríguez Sánchez, and Alexandre Arrechea. Arrechea was part of the group until 2003, which dissolved in 2018.

15 Los Carpinteros explain the origin of their name in Gudrun Ankele, Daniela Zyman, Francesca von Habsburg and Paulo Herkenhoff, *Los Carpinteros: Handwork – Constructing the World* (Köln: König, 2010), 16–17.

16 Janet Batet, 'Los Carpinteros: Mecánica Popular', *Arte Cubano*, no. 2 (1998), 68. Original in Spanish: '*las ideas de gremio y de artesanía implícitas en su obra implican también un revisión de conceptos tales como participación y democracia.*' All translations by the author unless otherwise noted.

17 Original in Spanish: '*Señor, lo hemos perdido todo al juego.*' '*¿Todo?*' '*Todo menos una cosa.*' '*¿Cuál?*' '*Las ganas de volver a jugar.*'

18 For an extended discussion of race in Los Carpinteros' early works, see Beth Tamar Rosenblum, 'From Special Period Aesthetics to Global Relevance in Cuban Art: Tania Bruguera, Carlos Garaicoa, and Los Carpinteros' (PhD diss., University of California, 2013).

19 In an effort to make their guild economically more profitable, in 1993, artists, among few other sectors, were granted the permission to be freelance and self-employed, and to earn a living in US dollars. See Dominick Salvatore, ed., *The Dollarization Debate* (Oxford: Oxford University Press, 2003).

20 Rachel Weiss, 'Between the Material World and the Ghosts of Dreams: An Argument about Craft in Los Carpinteros', *Journal of Modern Craft*, vol. 1, no. 2 (July 2008): 255.

21 Ankele, Herkenhoff and Zyman, *Handwork*, 27.

22 The group lasted until 2003, but since 1996 only Diango Hernández and Abel Francis Acea were active members of the collective. The original name of the group was Gabinete de Diseño Ordo Amoris, as a purposeful way to distinguish their work and their aspirations from those of fine artists. The term 'cabinet' evoked the type of think-tank, laboratory-like experience that the group wanted to develop and according to which all ideas were shared with certain tasks individually assigned, while it also brought to mind a body of high-ranking state officials. The Latin words *ordo amoris* (the ordering of love) were a direct reference to Saint Francis's philosophy about the harmonious relation between all elements of nature.

23 The Ludwig Foundation is a private foundation dedicated to contemporary Cuban art headquartered in Havana. Its founder, Peter Ludwig, was a Belgian chocolatier and one of the main international collectors of Cuban art since the 1980s.

24 The show traveled in September of the same year to the Museum of Contemporary Art and Design in San José, Costa Rica, as a combined show titled *Evento Vernacular Design* and curated by Gerardo Mosquera.

25 Original in Spanish: '*soluciones de diseño que portan el lenguaje estético de la provisionalidad.*' As stated in the wall label of the exhibition.

26 Original wall label text in Spanish: *Criterios de curaduría muestras Agua con Azúcar y La Muestra Provisional: se pretende concluir de forma provisional, ya que forman parte de una investigación todavía en desarrollo, acerca del ordenamiento de una "nueva visualidad" cubana, investigación que se sustenta en el estudio de la provisionalidad como la categoría que genera no sólo una estética sino también una ética, y que el Gabinete de Diseño Ordo Amoris decide validar por su importancia para nuestra*

cultura y con el conocimiento que ante el cambio de las circunstancias desaparecerá. Por esta razón es que utiliza procesos museográficos referidos a la arqueología, sólo que en este caso pretende ser una arqueología de la cotidianeidad desde el presente, para a través de esta perspectiva comenzar a observar, en calidad de objet trouvé, los objetos que no solamente consumimos sino también los que muchas veces creamos.

27 See Charles Jencks and Nathan Silver, *Adhocism: The Case for Improvisation* (Cambridge: MIT Press, 2013).

28 Ernesto Oroza explains his understanding of the concepts of reparation, refunctionalization and reinvention in his blog. See Ernesto Oroza, 'Desobediencia tecnológica. De la revolución al revolico', last modified 6 June 2012, http://www.ernestooroza.com/?s=refuncionalizacion&searchsubmit= (accessed 24 January 2014). The artist has further reflected on the courage of the people to face complex technology, and to disrespect the object's authority, through the concept of 'technological disobedience'. See: Manuel Cullen and Ernesto Oroza, 'Revolución de la Desobediencia', *Hecho en Buenos Aires*, vol. 14, no. 161 (December 2013): 9.

29 See Oroza, 'Desobediencia tecnológica'.

30 See Ernesto Oroza, 'Réactions en chaîne: Interview with Ernesto Oroza by Baptiste Menu', last modified 2011, http://www.ernestooroza.com/tag/nececity/ (accessed 1 April 2019).

31 Substantial information on this double-sided exhibition has been provided by Ernesto Oroza, to whom the author is very indebted. Additional material has been provided by the Ludwig Foundation, Diango Hernández, and Francis Acea, to whom the author also expresses her gratitude.

32 Among the participants were Yunior Mariño, Ruslán Torres, Mayimbe, José Miguel Díaz, Wilfredo Prieto, Beverly Mojena, Juan Rivero, Iván Capote, Glenda León and Inti Hernández.

33 In Cuba, the term 'canibaleo' often refers to the stealing of parts of a vehicle to use as spare parts in another or to sell. By extension, the term applies to getting hold of something on the quiet.

34 Sklodowska compares Los Carpinteros' and Gabinete Ordo Amoris' works in terms of *objetos imposibles* (impossible objects) and *objetos de necesidad* (objects of necessity), respectively. Elzbieta Sklodowska, *Invento, luego resisto: El Período Especial en Cuba como experiencia y metáfora (1990–2015)* (Santiago de Chile: Editorial Cuarto Propio, 2016), 405.

11 THINGS NEEDED MADE

Nasrin Himada

Khiam (2000–2007) is a documentary film by Lebanese artists Joana Hadjithomas and Khalil Joreige that features on-camera interviews with political prisoners who were released from Khiam, the infamous detention camp in South Lebanon.

The film documents and archives the experiences of six prisoners inside a detention camp, alongside the story of their objects. The film's strength is the narrative it develops between the prisoners and the things they made while inside. The filmmakers focus on this relation between subject and object. Through the documentary form, a narrative is produced that honours the prisoners' work – they made a lot of things with little resources, risking their lives when gathering material, and in turn, the things made generated new ways of staying alive. As a viewer and writer, watching this film compels me to think about the relation between materiality and ethics, form and affect – specifically, in relation to how images tell stories, how they communicate information.

Khiam engages with the material process of making objects, and this focus on craft drives the story of the six former prisoners. The film's focus on the handmade pushes me to question how I want to be with these images of crafted objects, and reminds me of what it is about affect that makes this encounter of writing about art and craft genuinely insightful.

In *Khiam*, I am compelled to ask: How is the making of objects a poetics, a poetics that forms life? Poet and theorist Fred Moten writes: 'Poetry investigates new ways for people to get together and do stuff in the open, in secret. Poetry enacts and tells the open secret. Getting together and doing stuff is a technical term that means X. Something going on at the sight and sound center of sweet political form.'[1] While Moten writes these lines specifically for the practice of poetry, I want to extend on his thoughts to include the practice of craft as it is documented in *Khiam*. Inside this prison, people got together and did stuff in the open, and in secret. They gathered material, in secret, to *make together* in order to have what they needed; the making of things emerged out of urgency, poetry in the form of object.[2]

To take Moten's thought of 'sweet political form' further, while thinking alongside this film, and writing alongside the testimonies of the detainees, I'd like to draw on the scholarly work of Denise Ferreira da Silva, in particular, her concept of the 'poethical'. As da Silva writes: 'The intention is in itself ethical. *Poiesis* – the ability to make the world and to make the world anew, to create – guided by the *ethical* intention.' In Khiam, the prison, the political form of the handmade object clearly defines a relation that is contingent upon context. The intention, she continues, 'is to obliterate anything and everything that is deployed to *justify* (to render both morally acceptable and legal) colonial/racial violence'.[3] The prisoners' intention is to create to survive, and to challenge, question and resist the repressive powers of the prison system and culture. The prisoner's intention is to obliterate, in a mere instant and through processes of making, the effect of confinement. The poethics of *Khiam* in thought and in practice, conjoins art and life, object and subject. They are rendered inseparable here: craft as survival.

The documentary follows a traditional talking-heads format. The camera is set up as a close-up that tightly frames the prisoner's head and upper body. Each sits on a high chair, the background just a white wall. The viewer is not privy to the interviewer's questions. The editing is composed of quick cuts with each frame giving space to each prisoner who responds to the same question. They are each telling their story; but the composition of the mise en scène subtly builds on an overarching narrative of what occurred inside by using key moments that emerge from each prisoner's experience. The editing divides the film into parts that lead up to the story of the objects. In this way, the film begins by introducing each prisoner and how they got detained, and takes viewers through to life inside prison as it unfolds in the different spaces of interrogation, solitary confinement and the general population cell. *Khiam* creates a narrative, a story about prisoners who had to make things inside prison, the things they made were made in order to survive, to live through it all, to keep busy, to work, to write, to think, to experience love, solidarity, connection and intimacy in a place that tried not to let them do any of these things. Their story of survival is told through the process of making objects: the time it took to make them, the resources they needed to salvage, and the techniques and tools they used. The objects are evoked in great detail to contextualize the experience of each prisoner. The objects are given life again, and memorialized, through the stories told, and the images made here, in *Khiam*.

The prisoners are Rajaé Abou Hamaïn, Kifah Afifé, Sonia Baydoun, Soha Béchara, Afif Hammoud, Neeman Nasrallah who were all detained between the years of 1988–1998. Soha spent the longest inside Khiam, ten years, six of which were in solitary confinement. All were part of the resistance movement in South Lebanon that protested Israel's military occupation. During the 1982 Israeli invasion and occupation of South Lebanon, as Soha explains on camera, there was a rumour spreading about a detention camp called Ansar, which was infamous for torturing people with electricity and whips. In 1985, when Israel withdrew from

Sidon and Tyre, in South Lebanon, they closed Ansar and the army relegated their presence to the border, where a security zone was set up. There, a new camp called 'Khiam' was built, which quickly became notorious for its horrendous conditions. And as Afif, another prisoner, describes to the camera, Khiam was known to be 'as something mysterious, sombre, with lots more torture. There was a lot of talk about it but it can only become clear if you've been inside Khiam'. Kifah, however, had never heard of this infamous detention camp before. When she entered it for the first time, she was shocked to learn that it was controlled by Israel.

As spectators, we learn that upon arrival each prisoner was blindfolded, with a sack put over their head, and immediately taken to see an investigation officer. Each prisoner was assigned a number and could no longer use their name. As spectators, we learn that no sentence was ever given, so no prisoner ever knew when or how they were going to get out. Some stayed for ten, fifteen years, other stayed for more than twenty. We learn that the torture began right away. 'Because I refused to talk', Sonia tells the camera, 'I was whipped, made to remain kneeling, drenched in water, obliged to remain outside, to kneel in the toilets, they would come to piss near me, to humiliate me. Often, the man in charge would kick me and say: "Now, spill it." ' Neeman, a male prisoner who would get hit with a barbed wire, said that, 'where the spikes fall, they perforate the skin, you bleed. They use electricity too or they pour cold or hot water on you, the skin gets cracked'. But, Soha tells us, that worse than all this was the dark cell: 'I had heard about it, but didn't know it yet. It's like a tomb. It reminds you of the solitude of a tomb, of death.' The dark cell was 80 centimetres square. We learn from Rajaé that the longest a man stayed in there was fifty-two days.

The filmmakers allow each interviewee to answer the questions in detail, but don't linger on each one for long. The editing technique is used to allow each person to contribute to the telling of the story of Khiam. The filmmakers are constructing the story using each prisoner's response, as they cut, and edit, and cut again, to form a collective oral telling of the story, rather than an individual one. As spectators, we get to hear about each person's experience, but also get a sense of their collective camaraderie and kinship through the testimony, in having survived such a place. This editing technique works most powerfully when each edit cuts to each prisoner, as they describe the different techniques and methods used to make each object. It culminates in the effect of suspense as the audience waits to hear how each object was made in such a clandestine way, inside prison and under torture.

After having explained how they ended up in Khiam, and the beginnings of imprisonment and torture, the next part of the film delves into their interrogation sessions, then enduring solitary, boredom in the general cell block, and the need to start doing things besides just talking or passing the time.

All six prisoners decided that to survive, they need to figure out how to live inside, under such extreme conditions, and feel useful. In the film, there is a

part about feeling out time, thinking through time and passing time. In one scene, Rajaé says: 'Okay, we're through with talking, what do we do now? You can count eight or ten years of your life in one week. And repetition breeds boredom.' And in the next scene, a cut, Soha elaborates on this point, and says: 'How can one work on themselves to evolve within four walls? On the second day, I said: "Anything that comes into the cell must be put to use." ' Kifah continues, in the next scene, another cut: 'Everything was forbidden in the camp. Talking through the windows to the girls was forbidden, manual work, means of amusement too. Everything was forbidden.' Afif continues: 'No needle, no comb, no pencil, no paper. Nothing. These elementary things that enable one to live, to get along, not to forget, such as a pencil, don't exist. They say necessity is the mother of invention ... the fight begins within yourself: the needle must be created, it's needed.'

The needle

Once inside the detention camp, as viewers we learn, each prisoner is immediately given trousers and a shirt, but without attending to anyone's measurements. As Neeman explains, 'At the outset, the needle is to fix the clothes. You're given trousers and a shirt, the trousers may have belonged to a man who's 100 kilos when you weigh 50.'

The men first tested out an orange stem: 'We peeled it, dried it, rubbed it against the wall, pierced the top, and managed to get a thread in', Afif explains. Later, they found pieces of plastic from a Halweh box, that once contained a popular Middle Eastern sweet. Whereas Neeman describes another use: 'We broke them into small bits, rubbed them against the wall to thin down to half a centimetre. We sewed with that.' There were many trials and errors before perfecting a functional needle that didn't ruin clothing. They used tie-twists from a bread bag. In Soha's block they made needles from the tooth of a comb and used screws from Scholl slippers to make the hole. Finally, in the men's cell, they got a hold of cement wire. Neeman explains, 'We managed to obtain cement wire in small bits. We'd get a small piece, hold it at both ends and twist it. We didn't fold it into two, we kept it straight then twisted it. It became harder.' Then a cut to Soha, explaining her process: 'I had to make a hole in that piece of metal, which was ten millimetres. But how? The idea was to flatten it with my teeth.' Then another cut, Neeman continues, 'We got two stones from a man outside serving hard labour. He smuggled in two stones that large [size of hand], and I used them to hammer the cement wire between the two stones. It becomes so thin you can put a nail through it.' The narrative flows, and as viewers we're on edge, Soha continues, 'We noticed one of the women wearing Scholl slippers, and there are screws in those Scholl. We could perhaps try to make a hole in the metal screw.'

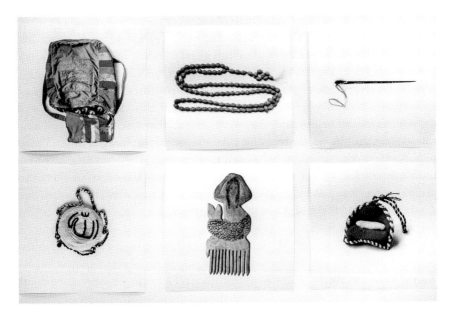

FIGURE 11.1 Joana Hadjithomas and Khalil Joreige, *Objects of Khiam*, 2000. Courtesy: the artists. Photo: Alfredo Rubio, *Two Suns in a Sunset* at the Sharjah Art Foundation, 2016

Next, Neeman goes on to describe his process of perfecting a functional needle, 'We started turning left and right. Finally, by turning, the nail pierced the iron. It took a lot of time, but necessity goaded us on. Finally, I made a hole in the first one. The first one is always difficult, the second easier.' Suddenly, the camera cuts to a close-up of Neeman's face, and he says, 'I made 300 needles. That's a lot!' And then, another cut to Soha: 'At last, we had an efficient needle, and used it for everything. To mend jeans, to sew, for our handicrafts' (Figure 11.1, Plate 14). Neeman continues, 'The guard saw it, the Israeli commander saw it, all the investigators saw it, they wouldn't believe it was handmade, they wanted to know how it had been done. They got 20 people out of their cells, tortured them for information. Luckily, I'd been very discreet.'

Thread and beads

The next part of the film focuses on what the prisoners were then able to do with a needle, besides mending clothing. And even with a needle, they still needed thread. As Afif tells it, 'We used undershirts and socks. If someone had socks we would unravel them, pull a thread. In the beginning, every time we pulled on thread, we'd get a bunch tangled up. We'd cut them, they were that short. We improved with time, we'd pull one thread from the toe up to the ankle, and we'd pull one or two threads unbroken.' Then a cut to Soha, explaining that someone had

mentioned a string of beads made of olive pits from the days of the other torture camp, Ansar. Neeman then says, 'I didn't know you could make beads out of olive stones. I grabbed an olive stone and rubbed it on the wall to shape it like a heart. It was too small, it wouldn't work. I took another olive stone, rubbed it at both ends, it got holes.' Then another cut to a headshot of Soha, 'That's where artistry comes in: the way I rub it, sharpen it, make it even smaller.' Kifah continues, 'We rubbed the stones until our fingers bled. They were so hard.' Then Neeman says, 'I pulled a thread from the blanket, threaded the olive stones, made a string of beads. I used to play with it, count the days.' Soha continues the story, 'The quantities increased, the blanket shrank, but it was no problem, it symbolized our will to last out in this camp.' A cut to Kifah, she says, 'We had coloured towels, we'd pull threads out and wind them around the olive stones to decorate them.' Each prisoner describes how valuable the actual process was to keep their spirits alive, and what other forms of life the object itself enabled. The relation between process and object here, as the prisoners describe it, constituted a way of life that kept harmful situations at bay. As Neeman says on camera, 'I found out that work is best to last out, because I didn't want to get involved in political discussions.' Furthermore, as Soha articulates, beyond function, the process of making is also engaged in skilled craft, in artistry. The artistic process is thought of in relation to the experiential, the sensible as the methodology for an aesthetic, that emerges out of duration, endurance, felt time (Figure 11.12).

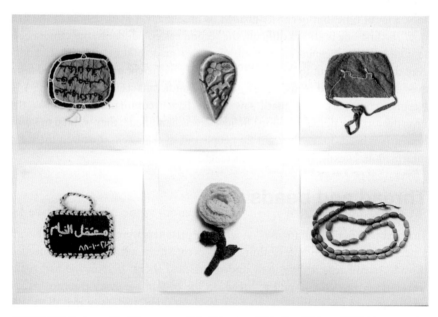

FIGURE 11.2 Joana Hadjithomas and Khalil Joreige, *Objects of Khiam*, 2000. Courtesy: the artists. Photo: Alfredo Rubio, *Two Suns in a Sunset* at the Sharjah Art Foundation, 2016

The pencil

This section of the film is the most moving. There is a cut to Soha, who expresses the most acute need, 'We have spoken of the needle, the tooth brush, … there are many other things, but the most important was the pencil.' In this section, as viewers, we learn of how important the pencil is as an instrument for many occasions. As Sonia puts it, 'There was an illiterate girl with us. She would have liked to study, but her parents didn't send her to school. We had an iron bar door. With a bar of soap – we were given one every 15 days – we wrote the alphabet, the letters on the door. She learnt them, and she memorized it. Then words and more words till she could write.' The camera cuts to Soha, 'We felt we needed a more efficient pencil, more rapid, practical.' Afif chimes in, 'We found a small battery. In it, there is a kind of coal piece we used for writing … We would [also] wet cigarette ash and shape the orange stem as a pencil.' Neeman says, 'Rice bags are sealed with a small piece of lead, we used it to write on bits of cloth or floor tiles. We obviously obtained all that secretly.' The gathering of material is revealed in this scene as key to any successful production, and as viewers, we find that it was always a clandestine act. As Afif explains, 'I may need this I bring it, I hide it. A small metal piece, part of a zipper, staples from cartons … may prove useful someday. Finally, we had a kind of small stock.' Once again, many different materials, tools and objects were used to test out what would make the perfect pencil, one that is practical, functional and long-lasting. Soha says, 'Later, we found out it was more convenient to use the aluminum foil wrappers of Picon cheese. They were really effective. Even if you used tiny characters, you could still read them. The paper was small, but could take many sentences.' Then the camera cuts to Sonia, 'She rolled very tightly the aluminum foil from the cheese box, giving it a pointed shape. She got the cardboard out of the box and made as if writing. As she was scribbling, letters appeared suddenly. She went crazy with joy. The writing was very fine, better than with a pencil. She started shouting: "Come here, and see how this writes." She had invented something.'

Conclusion

As a writer, I have felt a need to tread lightly when engaging with the subject matter of torture, especially in writing and thinking alongside *Khiam*, when my focus is on objects made by prisoners for survival. The practice of writing *with* a film and not *about* it allows me to think about the ethical implications of engagement and spectatorship. In this case, I am not only engaging with the artists' work, but with the political prisoners' testimonies of making that are documented and shown on screen. I want to make visible, in words, the effects of perceiving and receiving information while listening to and honouring the prisoners' stories as they retell

their experiences of having been tortured, giving accounts of daily routines of violence inside. How does responding to this film influence my ability to act, think and make? How does this practice affect my own craft and expand the definition of craft itself? How do we as writers and spectators engage with experiences of violence – and in particular, of torture – that are not our own, as they are made visible through contemporary art and craft works?

My aim is not to treat *Khiam* as a film, a document to be analysed, but as a work that encourages the practice of writing *alongside*: to write with the content of the film, *with* what the image and objects are doing. I want to be honest and forthright about my decision to write, my intention is to work from da Silva's notion that 'art must be thought of as poethical, with the obvious emphasis on the *ethical*, ... on one intention – the poet's (as creator, maker, composer), on the principles guiding it, on whether or not they attend to what I call *founding violence* (past and present expropriation of lands and labour) that produces/is State-Capital.'[4] What happens when an artwork is forcing us to think, and how do we then articulate that force in regards to a film that is documenting an experience, in this case, of six political prisoners who have been detained in a torture camp? Writing alongside that image involves thinking about how the image also forms the content for that which I am trying to articulate as affect. My intention is to produce a new composition of relation that honours what the work is doing. In this way, the ethics of a writer is revealed in the process. To create solidarity with the image and what it is doing, in order to tell a new story that is relevant to the struggles of our time.

On the one hand, the film documents and memorializes the prisoners' experience, and the objects made inside this infamous prison. In 2006, during the Israeli bombing of Lebanon, the prison was destroyed. The building was completely razed and turned to rubble. The stories of the survivors, as they have been documented in *Khiam*, and the objects they were able to bring outside upon their release are the only material proof that this prison existed. On the other hand, the film is significant because it communicates, by building on narrative, how the artistic forms of life enter into the everyday experience of the prisoners. In this case, context is key. The everyday is structured around the torture sessions and interrogations that take place intermittently, by the general manifestation of imprisonment, by prolonged solitary confinement, by the management and control of each body, each life. The film is important to consider because it documents how skilled craft is conditioned by this particular event. Craft emerges out of the immediacy of experience as each political prisoner encounters the trauma and violence of confinement. The film documents the ways in which forms of life emerge in an environment as restrictive as the prison and details the story, not just of survival, but of solidarity. The things that were needed were made, knowledge was passed on, techniques shared, objects used.

What it took to survive the conditions inside Khiam created the conditions for making: there was torture, but there was also the world of objects made

under duress to live just a little better. To think alongside the film *Khiam* and the prisoner's process of crafting objects of survival is to write through the urgency of making that is life forming. The film reveals that the making of objects constitutes a process of solidarity, not just with each prisoner, but with the persistence to live as the power to will. Forms of solidarity are accessed through and by and for the making of things. The artistic process in craft is a practical response to the lived experience inside Khiam, specifically, it is a response to creating sensible methods of survival that happen to engage the aesthetic in practice.

Notes

1 Fred Moten, 'Barbara Lee', in *B Jenkins* (Durham: Duke University Press, 2010), 84.

2 I would like to acknowledge that much of craft production for survival in other contexts is private, domestic, and/or undervalued labour, and that most of what is considered political craft is related to its emergence into the public sphere. Of course, notions of private/public are dramatically altered in the context of prison. This is why it is important to consider the work that documentary film does when it brings these issues to the screen, engaging a broader audience. The power of making a documentary film like *Khiam* is in how information can be disseminated and circulated through various media, and in many contexts, like the cinema or an art gallery.

3 Nasrin Himada, 'Interview with Denise Ferreira da Silva', *Counter-Signals*, no. 1 (Fall 2016): 11.

4 Ibid.

12 SECRET STASH: TEXTILES, HOARDING, COLLECTING, ACCUMULATION AND CRAFT

Kirsty Robertson

Several years ago, I went to *Hungry Purse: The Vagina Dentata in Late Capitalism*, an exhibition by artist Allyson Mitchell at the Textile Museum of Canada.[1] Mitchell had covered an entire floor of the gallery – including floors, ceilings and walls – in blankets, doilies, cushions, shag carpeting and other thrifted, knitted and crocheted articles. The installation played on the term 'hungry purse', a slang reference to female genitalia, and visitors entered through a doorway of pink blankets (Figure 12.1, Plate 15) – the vulva – before making their way through several rooms to the centre, the G spot. It was a deeply layered installation that commented on gender relations, desire, capitalism, consumption and waste, but also offered opportunity for relaxation and discussion in its woolly interior. *Hungry Purse*, according to writer Mary Smull, 'merge[s] the sensual with issues of production and consumption, creating a surreal and dichotomous portal of insight into the contemporary appetite for "more."'[2]

The experience of being inside of *Hungry Purse* was completely overwhelming. The once familiar gallery faded to the background, swathed in a multicoloured, suffocating blanket environment, a 'living room fort' made of 'enchanted vines',[3] atop orange and brown shag carpeting, and housing a few interlopers: a hot pink, fun fur squirrel; two fuchsia deer heads. It was disorienting and claustrophobic, but at the same time whimsical and comforting. Though not directly about hoarding, the hundreds of rescued blankets and cushions spoke implicitly of out of control collecting, of hanging onto what might otherwise be discarded and of objects saturated with the memories of their former makers and owners.[4] Being there made me want to both lie down and run away.

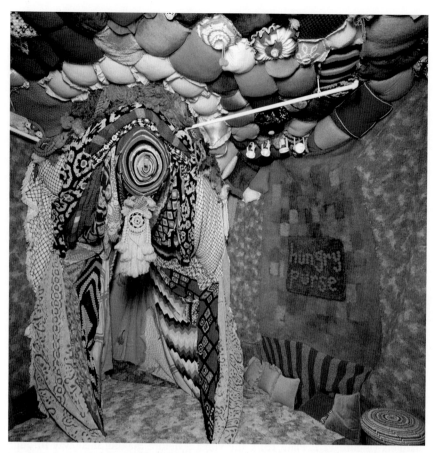

FIGURE 12.1 Allyson Mitchell, *Hungry Purse: The Vagina Dentata in Late Capitalism*, detail, installation, Toronto Alternative Art Fair International, Gladstone Hotel, Toronto, Ontario, April 2006. Photo: Cat O'Neil.

My experience of *Hungry Purse* was actively influenced by a very different encounter with hoarding that took place around the same time. In one of my classes, a visiting speaker gave a talk about his uncle, a well-known local artist who had recently died, leaving behind him a house crammed with boxes of slides, photos, magazine clippings, sketchbooks, half-finished paintings and diary entries, blankets crocheted by his mother, and far too much furniture for the small space, all carefully catalogued but coded in a way known only to the now-deceased artist. After the artist's death, the nephew had inherited the house and its contents and was given the Herculean task of sorting through, deciding what was important to memorializing the artist's career and what was not. He made decisions on the spur of the moment, boxed up what he felt was valuable, and moved it all to a room in his own suburban house, which he packed from floor to ceiling.

As the nephew continued his talk, it became clear that the accumulated stuff made him incredibly uncomfortable. The slides were covered in mould, which threatened to break out of the boxes and infect the rest of the items, some of the books seemed a little damp, there was dust everywhere. Though the amassed stuff was kept behind a closed door, it refused to stay put, seeping into the environment of his house. Eventually he was saved by a local curator who offered a tax receipt for a donation of what now changed from 'stuff' to a 'collection'. The nephew accepted the offer, and the process of sorting through the collection, cleaning the slides and disinfecting the documents began. Carefully catalogued and moved first from a tiny damp house, then to a bedroom in a suburban home and finally to an archive, the accumulation of five decades of material was given a stamp of approval – it was no longer evidence of a psychopathology of hoarding, now it was a carefully curated life history.

These introductory narratives present the complexity of hoarding. In this essay, I look first at the history of hoarding and bring this discourse up to date to examine the recent pathologization of hoarding as a mental disease through its 2013 acceptance into the *Diagnostic and Statistical Manual of Mental Disorders* (DSM-V). Second, because my interest is specifically in textiles, I examine the mass accumulation of yarn, textiles and other goods by crafters. Though fabric and yarn stashes can result in feelings of guilt, they are also understood as storehouses, loaded with the memories of past handmade items and the potential for future projects. Descriptions of craft hoards complicate understandings of hoarding as a 'curable' mental illness. Third, I consider how artists such as Mitchell have used hoarding and/or the representation of hoards as a strategy to address excess, waste, emotional attachments to objects and overconsumption. In the final section, I bring these threads together to ask whether the increasing presence of hoarding is simply symptomatic of changing patterns of consumption, and whether 'hoarding [is] less of a mental illness located in the brain and more of a socialized phenomenon located in the world at large'.[5] In other words, given the ease of accumulation under late capitalism, is it possible to think about hoarding as a creative response to the amount of stuff circulating in the world as much as it is a pathology? Does it provide a way of thinking through the full (long) life cycle of consumer objects, from their making through to their eventual disintegration? And can we do this by acknowledging that the line between hoarding and overconsumption is a porous one, granted seeming impermeability only insofar as the ambient accumulation of material objects symptomatic of late capitalism is pushed to the background? My overall goal here is to complicate the oversimplified discourse around hoarding through a discussion of the pleasures *and* guilt of ownership, collecting *and* use.

Walking through *Hungry Purse* while thinking about the story of the hoarding artist, I was struck by what had been kept and what had been thrown out in each case. While Mitchell's work resurrected textiles from the thrift store graveyard, in the case of the nephew and curator, everything that had been saved was document: slides, sketches, books and newspapers. The textiles – the clothes the artist wore, the blankets

that were all over the house and visible in the photographs and slides – were all gone, considered unimportant and too difficult to maintain in the archives. They had been packaged up and either thrown out or sent to charity stores. In turn, of course, they may have even provided the source material for Mitchell's installation. The lusty/dusty and comforting environment of *Hungry Purse* thus comments obliquely on the politics of what is kept and what is thrown away. *Hungry Purse* is made entirely of liminal objects; as Mitchell suggests, thrift stores are often replete with sentimental items, such as handmade blankets. The act of saving and displaying them en masse questions choices made in keeping and throwing items away and it also singularises and elevates their making, refocusing the quiet act of knitting and crocheting into a riotous cacophony of colour and a sumptuous consideration of desire and appetite that is both comforting and intense.[6]

Textiles are often replete both with memories and more physical traces of ownership: holes, tears, moths, bacteria, mould and mildew. '*Hungry Purse* is loaded with history', writes Ann Cvetkovich, 'including history as the dust and dirt of the items that come from other people's pasts'.[7] Bringing *Hungry Purse* back into conversation with the hoarding artist, one finds sentiment, value, memories, gifts, accumulation, collections, clutter, health and safety, hoarding in both: all of these threads unravel across and through these two stories, which are held together by wider assumptions about what is welcomed into galleries and archives and what is not, what is worth saving and what is not, what is an archive or a collection and what is a hoard.[8]

Until the mid-twentieth century, the term 'hoarding' was associated with keeping money rather than spending it. It connoted miserliness, penny-pinching and refusing to part with one's wealth. Hoarding as a practice was generally the purview of the already-rich.[9] Only in the mid-twentieth century was the hoarding of goods rather than gold, or trash rather than cash, recognized as an anomaly, and even then, it was regarded largely as an eccentricity. Somewhat later, in the early- to mid-2000s, the symptoms of out of control hoarding were regularized, and hoarding was pathologized. Over that decade, television series, books, websites, as well as social-workers, advocacy groups and the medical establishment worked to reveal the disorder in the disorder. Finally, in 2013, hoarding was classified as a mental disorder, and is now thought to be widespread, affecting as much as 5 per cent of the population and characterized by extreme accumulation coupled with an unwillingness to part with goods.[10] Pleasurable feelings are often associated with amassing and saving, but these are accompanied by extreme guilt and anxiety about parting with items. According to psychologists Randy Frost and Gail Steketee, hoarding is also often associated with disordered impulse control, compulsive buying and sometimes kleptomania. They characterize hoarding as mania and pathological collecting, often provoked by other mental health conditions or

trauma.[11] The work of Frost and Steketee and others has done a great deal to bring hoarding out into the open. However, the increasing medicalization of hoarding comes with its own set of problems, discussed later. It is perhaps the seeming ubiquity of hoarding that is unsettling, as its terminology is simultaneously used to describe mental illness and, in a much looser sense, overconsumption. As we shall see, the line between out of control consumption and hoarding as disease is a hazy one indeed.

The original hoarders, if they might be called that, were two New York brothers. Their story has been fictionalized (most notably in E. L. Doctorow's novel *Homer & Langley*), and mythologized, and then oft repeated as the archetypal example.[12] Homer and Langley Collyer were born to a wealthy New York family in the 1880s, in an area of the city that would become Harlem.[13] Issues of racism and classism cut through the Collyer narrative: the two brothers, who became increasingly isolated from family and friends, were vocally critical of the racial changes in their neighbourhood, including the flight of upper-middle- and upper-class white people and the influx of poorer African Americans into the area. They repeatedly expressed fears of invasion and Langley talked openly of installing traps to prevent thieves entering the house.[14] This had the unwitting result of suggesting that the house contained great wealth, and even during their lifetime, the brownstone house in Harlem attracted a great deal of attention.

In 1947, the NYPD received an anonymous message about a body in the Collyer mansion. Police visited the house, but found the front door jammed shut, blocked by a giant pile of paper, metres thick. After eventually entering the house through a second-floor window they found the body of Homer Collyer, emaciated and recently dead. Homer, who was blind and paralysed, had starved to death completely surrounded by stuff (Figure 12.2). The house was packed floor to ceiling, with rooms accessible only through what came to be known as 'goat paths' – narrow paths leading precariously through the piles of stuff, much of which had been booby trapped. It wasn't until eighteen days later that police found Langley's body, only about ten feet from Homer's. He had accidentally triggered one of his own booby traps; piles of paper had fallen, crushing him.[15]

The Collyer brothers' story has a macabre edge that has fascinated people for decades. Through their story, a very clear depiction of hoarding came into mid-twentieth-century consciousness: hoarders were eccentric, and that eccentricity was tinged with threat that was at once fascinating and repellent. Until recently, hoarding was seen as a kind of withdrawal from society, a passion for stuff and collecting and a refusal to confront everyday reality. Over time, the Collyer story has been associated with a few other famous examples. First among these is the story of the reclusive Big and Little Edie Beale (cousins of Jackie Onassis) at Grey Gardens. Though not technically hoarders, in that the decline of their property was forced upon them through penury, the presence of massive piles of garbage,

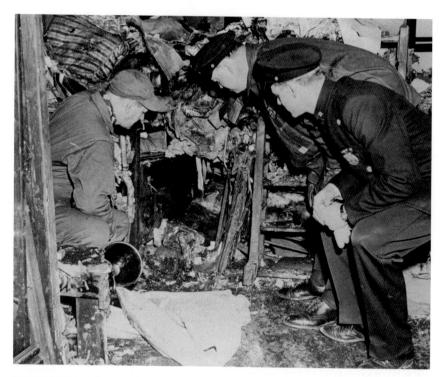

FIGURE 12.2 Policemen locating the body of Langley Collyer, Collyer Brothers' house, 1947, New York Public Library. Getty Images.

feral cats and pet raccoons in a now decaying and ramshackle former mansion added a sense of fading glamour to the popular perception of hoarding. Such melancholic depictions of hoarding were exacerbated following the death of artist Andy Warhol, whose 'frenetic shopping', and 'obsessive secrecy about his collection' meant that at the time he died, most of his friends had not crossed into the domestic space in which he housed his hoard.[16] Following his death, a Sotheby's auction of his things (ranging from Picasso drawings to a vast collection of cookie jars) attracted a media spectacle.[17]

More recently, and in keeping with the DSM-V inclusion of hoarding as a mental disorder, the famous cases have given way to explorations of the mundanity of hoarding. Since 2009, television shows such as *Hoarders* and *Hoarding: Buried Alive* have introduced numerous hoarders to the public through formulaic story lines that delve into the impact of excessive collecting and accumulation, before offering a 'solution' through intervention. Such contemporary narratives dealing with the seeming ubiquity of hoarding are far removed from descriptions of the Collyer brothers' story, though less than seventy years have passed since the discovery of their bodies.[18] Their collecting, like that of Warhol, was seen as

fascinating, but rarely did contemporary accounts describe any of the 'famous' hoarders as mentally ill or in need of treatment, the now-favoured descriptors and solution for out of control collecting.

In contrast, author Scott Herring sees hoarding as a moral panic, a fake (or at least overdiagnosed) disease conjured through the regulation of domestic material culture and the pathologization of abnormal relationships to stuff.[19] Herring argues that our anxieties about acquisition have resulted in the medicalization of the accumulation of stuff, which is funnelled into a search for physical or neurological symptoms, thus rendering obsessive accumulation diagnosable and treatable. Hoarders, he writes, 'function as visible reminders of how we should not engage with things'.[20] Herring draws on Foucault to show how 'psychiatry historically colludes with other policing systems to reproduce these discourses of "perversity and danger."'[21] In other words, except in a very few cases, which can probably be explained by other conditions (such as obsessive compulsive disorder), for Herring, hoarding as a mental illness does not exist as such, but is the result of a fear of others' abnormal attachment to objects.

I agree with Herring's argument that hoarding has been overpathologized. However, his argument is constrained by the messiness of defining hoarding itself. For Herring, hoarding is a static thing, an accumulation of already extant objects in semi-acceptable environments such as the home or in storage units. If, however, we take hoarding to include the full life cycle of the object – from making, to ownership, to being discarded – Herring's analysis leaves gaps for further contemplation. Seeing hoarding in a broader sense means expanding the question beyond the Collyer house to ask where the stuff came from, to see, as Allyson Mitchell does, that the blankets and cushions in *Hungry Purse* had a place in the world long before they ended up in her installation. Hoarding is supported by a whole process that moves from the extraction of resources, through the making of objects, past their accumulation and into the places where they are discarded. In short, there is a larger context that must be taken into consideration.

We live in a world overrun with stuff. In her popular book *The Story of Stuff*, Annie Leonard notes that in 2004–2005 US Americans spent two-thirds of their $11 trillion national economy on consumer goods,[22] while the *LA Times* reports that there are 300,000 items in the average US American home,[23] and the average North American throws away 65 pounds of clothing a year.[24] According to Leonard, these statistics are true not only of the United States; globally, we consume twice as much stuff as we did fifty years ago.[25] The repercussions for environment, labour and the distribution of wealth are difficult to calculate.[26] The stuff we make and discard does not leave the world, but remains in both measurable and immeasurable ways – in landfills, in toxic effluent, in objects cluttering houses and closets. Many of these objects enter an ever-quickening cycle of purchase, discard, replace. But while the above statistics and facts are shocking, they do, in fact, illustrate acceptable norms of consumption, particularly in North America.

There is one community where both Herring's theory of moral panic around attachment to objects, and the buy/discard, buy/hoard relationships are corroborated, undermined and challenged. That group is the craft community. Crafting has created a socially acceptable form of hoarding, one that is both celebrated and tinged with guilt. Crafters are implicitly encouraged to create 'stashes', or collections of raw material that can be used for future projects. Buying yarn, or wool or textiles means purchasing both the object and also its potential to be made into something else. The stash thus has a past, present and a future.

A quick search of the discussion boards on Etsy.com, an online marketplace for handmade goods, reveals more than two hundred threads devoted to the discussion of yarn and fabric stashes.[27] Ravelry.com, another popular site for sharing knitting patterns and building community, has hundreds of pages devoted to confessions about stashes – what they consist of, competitions for who has the biggest stash, projects to 'de-stash', descriptions of the mundane and bizarre places where crafters hide their stashes, and tips on how to sneak in new acquisitions. These websites reveal the specific language of stashes: participants on Ravelry discuss their fabric-aholism, their WIPs (Works in Progress), SEX (Stash Enhancement Expedition, i.e. buying more yarn), their stash busting techniques, and SABLE (Stash Acquisition Beyond Life Expectancy – the ownership of so much yarn or fabric that there is no possibility of turning it all into useable objects during a single lifetime). Collections are willed, they are insured and they are discussed in the semi-secret space of Ravelry as a guilty pleasure.[28]

The most conspicuous quilters, knitters and other hobby crafters in North America and on Ravelry are older middle- and upper-class white women, with significant leisure time and buying power.[29] Stashes are clearly indicative of overconsumption – these are not rag rugs or scrap quilts made from salvaged fabrics; the Ravelry stashes have very little connection to austerity, making do or thriftiness.[30] At the same time, in her article on the textile stashes of quilters, sociologist Marybeth C. Stalp argues that acquiring textiles on the sly and hiding them is actually a strategy for reclaiming time and space.[31] Stalp concentrates on an older cohort (similar to that found on Ravelry), for whom the third wave feminist focus on seizing leisure time as an emancipatory gesture does not really resonate. For the quilters and hobby crafters in Stalp's studies, crafting tends to be an individual pursuit, far removed from the communal aspect of the quilting bee, or the more recent Stitch 'n Bitch sessions, and often heavily focused on pleasure and consumption as well as production (which may actually be secondary to the accumulation of fabric).[32] Such pleasure is often hidden or 'stolen' from family time or other communal activities. Thus, community on Ravelry is a virtual addition or extension to individual time that importantly takes place in the same domestic space in which the stashing and creating is also located.

Yarn and fabric stashes are thus rarely about their owners behaving as 'pack rats' and 'chronic savers', as in the standard hoarding narrative. Instead, the

culture of hoarding associated with yarn and fabric stashes is much more closely associated with what is known as a magpie aesthetic: a wish to own and possess objects perceived to be beautiful. On Ravelry, there is a celebration of the liminal space between being a good consumer or a good capitalist with a collection that can inspire creativity, and having a problem with overconsumption, debt and credit. Online posters often oscillate between the two, documenting projects, and then guiltily admitting to having bought even more to add to their stashes.[33] For the most part, the tone on discussion boards is light, and users joke about their purchasing habits: 'It's not a stash. It's limitless potential captured in fibre.'[34] Occasionally though, there is evidence of conflict: 'I sometimes get my online orders delivered to work so there won't be confrontations at home', writes a regular poster on Ravelry.[35]

While a stash of yarn from leftover projects has long been a component of knitting, the gigantic stashes documented on Ravelry are a new phenomenon. In part this has to do with more leisure time, more disposable income and greater access to yarn. In keeping with the statistics just mentioned about the amount of stuff circulating in the world, the global trade in textiles and apparel increased by a staggering 68 per cent between 2004 and 2013.[36] In turn, those increases were primarily, though not entirely, due to the outsourcing of textile manufacturing from the global North to the global South, a process that began in earnest in the 1980s, and resulted in low prices, greater volume of textile goods and easy accessibility.[37]

Consumption practices rise rapidly with industrialization, but interestingly they rise even more rapidly with deindustrialization. As factories are replaced with immaterial labour, consumption actually skyrockets, in part because access to cheap goods made elsewhere increases as well.[38] But consumption also goes hand in hand with rising levels of debt and its corollary, anxiety.[39] In 2007, at its height, consumption in the United States equalled on average 96 per cent of income.[40] Similar figures from other countries that belong to the Organisation for Economic Co-operation and Development demonstrate extremely high levels of debt, driven by consumption large (mortgages contributing to household debt) and small (luxury goods such as a ball of yarn contributing to consumer debt).[41] Debt is increasingly the norm across the globe, such that consumer debt is rising rapidly both in producer countries and in consumer countries. The conclusion to be drawn is that at least in terms of textiles, as production has grown, so too has consumption, often followed by debt and anxiety.[42] If hoarding has only recently been recast as a mental illness, then this transformation must also be seen within the context of an increase in the availability of goods and credit.

What does this mean for crafters? First there is much greater accessibility of both high-end and mass-market craft goods. In the grey space between shopping addiction and hoarding is the mass availability and immense choice in yarns, textiles and other crafting goods. As such objects are added to stashes, the grey

space becomes even murkier, suggesting that it is really only the approach (language, joking, defensiveness) and acceptability of craft collections that 'redeems' the crafter as a collector rather than a hoarder. The photos of hoards on Ravelry suggest a certain normalization of wealth and conspicuous consumption. Though the process of buying and storing echoes the symptoms of pathologized hoarding, the possibility of making and transformation acts as the hedge against diagnosis. Indeed, some of the fears that underlie the pathologization of hoarding in the Collyer story and elsewhere – racialized fears of invasion, storing against an uncertain future, using goods as a ballast against poverty, are not typically present here.

But, on the other hand, the stores of potential in the stash also speak to a joy in making, to a vast history of unappreciated and uncompensated women's labour. Is a criticism of stashing just one more dismissal? As Ann Cvetkovich notes, discussing the pharmaceuticalization of depression and the introduction of drugs such as Valium and Prozac, 'the middle-class white woman has been central to medical histories of mental illness,'[43] an observation that can be extended to crafting, which has been seen, over the years as both a symptom of and a cure for mental illness.[44] Thus, if the discourse around and diagnoses of hoarding are expanding via the kind of moral panic described by Herring, then it would be possible to imagine the extension of that anxiety into the now protected confessional culture of Ravelry. But it is also equally possible to imagine the strength of community and shared experience, as well as the joking about acquisition acting as a barricade against pathologization.[45] For now, yarn stashes exist in a place between guilty pleasure and celebration, with relatively few negative associations.

One rhetorical strategy that crafters use to explain and legitimize stashing is to positively contrast the handmade with the 'shoddy craftsmanship' of cheap and accessible clothing and other goods. Perhaps it is not surprising that Ravelry and Etsy both emerged in the midst of a flooding of the textiles market. In short, as cheap clothing became available in ever-increasing quantity, new spin-off markets also developed for those wanting to resist this trend. Crafters who make for pleasure and crafters who make for profit often add a moral dimension to their actions, positioning the handmade as an ethical alternative to mass-produced goods and poor labour conditions.[46] Such sentiments are equally apparent in conversations on Etsy, Ravelry and elsewhere online, where the handmade is associated with thriftiness (despite the often extravagant cost of supplies) and in some senses with anti-capitalism. Online posters talk about 'getting back to basics', about 'not buying mass-produced goods', about 'living from the land', and so on. Many talk about the love and work that goes into making garments or toys, discussing how this might affectively transfer to the recipient of a handmade sweater or teddy bear.

Thus, on the surface, niche-marketing sites such as Etsy resist the allure of fast fashion and overconsumption through encouraging the purchase of individual goods and micro-capitalism. Nevertheless, as noted in the introduction to this

book, as the importance of micro-capitalism has grown, Etsy, which has moved crafted goods out of the home and into marketplace, represents both a resistance to capitalism and an overt capitulation to it.[47] If working outside of the home could be, in Betty Friedan's infamous argument, an answer to the 'strange feeling of desperation'[48] plaguing middle-class women, the return to the home through 'passion' labour, which involves making in the spare moments around domestic and career tasks, seems a perturbing reframing of a feminist argument that has been both disavowed by some contemporary third wave feminists and reclaimed by others.[49] On the one hand, marketplaces such as Etsy create venues for kinds of labour that have been consistently undervalued.

On the other, there is a high price to pay. Message boards on Etsy clearly demonstrate the weight of handmade careers. There are hundreds of threads documenting guilt at working, which at first seems at odds with the other guilty threads I mentioned earlier – those associated with buying and stashing. But in fact, they fit together nicely. Posters document their purchases, and they document their working hours, which include time spent away from family updating shops, labouring, making and selling their work. Maintaining a shop on Etsy means not just making products and hoping for the best, but time-expensive strategies of constant marketing, such as commenting on posting boards, advertising products and making online connections. It is a process that is infinite.[50] Further, most posters document how their stores are either 'hobbies' or secondary jobs that get fitted into the time around other, more stable employment. As money drips in, however, the hobby-jobs and passion work become essential, and numerous posters weigh out the costs of spending time with children or other leisure activities against the labour of making handmade goods that can be sold to pay for the stuff wanted by their families.

In a controversial article written in 2008, journalist Sara Mosle argued, 'What Etsy is really peddling isn't only handicrafts … but also the feminist promise that you can have a family and create hip arts and crafts from home during flexible, reasonable hours while still having a respectable, fulfilling, and remunerative career.'[51] Though more sympathetic in his coverage, *New York Times* reporter Alex Williams called it a psychic tax, a hoarding of time by a system that demands high commitment for low pay.[52] The yarn stash, passion work, niche capitalism: all of them are replete with conflicting meanings and messages. But perhaps this statement at least is verifiable: a fabric or yarn hoard, no matter how it is construed, is inevitably a part of the system it might seek to subvert.

The late capitalist demands to accumulate money and goods, and the demands of entrepreneurial labour to push oneself to achieve material wealth coexist in extreme antagonism in the craft world. Though there are a handful of people who have turned their Etsy shops (and other sites like it) into six figure salaries, for the most part this is not the case. The demands of the micro-capitalist system are too great, and the result is often a biopolitical one – the body shuts down, gets sick or

gives up.[53] The panacea and guilty pleasure of shopping, with the consequent rise of consumerism in periods of deindustrialization must be seen as a part of this. Shopping and buying have been oft noted as responses to anxiety and depression, as have hoarding and stashing.[54] Actual hoarding is the limit point, the site where the system is revealed as broken. I suggest that hoarding has received a great deal of coverage because it illuminates the dysfunctional limits of accumulation. 'At least I'm not at that point', many posters on Etsy and Ravelry joke.

It might seem that the answer here is to avoid the marketplace and its greedy management of time. After all, in Stalp's argument, time was something that was carved out and treasured. Craft is there described as leisure, as time away from tasks. And certainly, in this sense, craft does seem a seductive charm – a productive leisure-labour that allows for the pleasure of stash collecting, but that also unleashes the potential of the stash in the making of other objects. In turn these objects are often gifted, thus bringing additional pleasure and good feeling. Unfortunately, the trap here is the continued devaluing of women's labour (something Stalp certainly notes), and the reality that the undervaluation of craft-as-hobby limits attempts at turning professional, meaning that crafters can rarely recoup their own labour costs (not to mention the cost of assembling the stash). Craft solely as leisure means that it must entirely be a pursuit of the wealthy.

To begin to bring together my points, I'd like to return to hoarding and to craft as a discipline. Real hoarders, those who might be seen to have a diagnosable problem, break the typical cycle of purchase and discard – the rhythm gets interrupted so that the material goods, which are accorded very little value in a traditional cycle of obsolescence, are accorded importance far beyond their actual worth. The hoard of a hoarder is one over-replete with the memories accruing to each object.

Without the repetition of purchase and discard, hoarding represents not an anti-capitalist state but a kind of fugue of broken capitalism. Thus, the solution of garbage bags and therapy, the forced completion of the cycle, is too simple, for it denies the connection that most people feel to their possessions. Craft stashes, in turn, create a new category that encompasses past memories (in the leftovers from completed projects) and possibilities of future use that complicates discourses on hoarding, overconsumption and waste (in terms of thrift and environmental destruction). The line where things get out of control (the extreme SABLE) is fraught, both celebrated and masked.

To conclude this essay, I'd like to return to Allyson Mitchell's *Hungry Purse*. Mitchell's critique of capitalism in *Hungry Purse* is located firmly in the fact that these handmade objects, which visibly document labour, were discarded, but were not actually thrown out. There remains some kind of residual affect that

takes handmade blankets, cushions, and textiles to the thrift store rather than the dump. In valuing that resonance by rescuing the blankets, Mitchell intervenes in the cycle of buy and discard, while also creating an entirely different environment, one that illustrates what might be seen as the creative side of hoarding, a hint that austerity is perhaps not the only answer to current social problems, and pathologization might not be the only interpretation of hoarding.

In Mitchell's work there is a tension between a wish to accumulate and a wish to withdraw, a wish to fully participate in capitalism and a wish to break the cycle. Mitchell's work speaks to abundance, but it also refuses to separate that abundance from the process of making the work. Ultimately, acknowledging and celebrating the labour of the object, whether it is a handmade blanket or a cheap T-shirt, actually unsettles the cycle of buy/discard more effectively than does transforming latent waste into actual waste and adding its slow-decaying bulk to a permanent hoard of the landfill, the waterways and the environment. Completing the cycle turns the world into a hoard. Halting it offers a different alternative.

Thus, I return to where I began, with the two collections – one belonging to the hoarding artist, the other to Allyson Mitchell. In the case of the artist, his hoarding was an unwillingness to classify, a failed connoisseurship that was corrected by the curator and archivist who gave his collection a taxonomy and therefore a right to exist in the framework of the museum. In the case of Allyson Mitchell, the questions her work raises are much more complicated. Mitchell begins with something more like a discarded hoard – the detritus of a society uninterested in the handmade and in women's work – and reassembles it into an environment. And yet, in that it captures the wealth of emotion and the affective impact and potential memories of those objects, it more accurately reflects the emotional connections of a person to their things than does the archiving of the artist's collection, where emotions, and memory were erased in favour of clean and aesthetic storage. The archival collection of the artist is a slippage, an erasure of the personal engagement that he had with consumption. In Mitchell's work, the opposite is the case – the immense effort of sewing together the installation is everywhere present. It is a massive celebration of all that might be erased – labour, community, gender, desire, hoarding. Hoarding is not always clear cut, and it often spills over into other realms. *Hungry Purse* is right on a line: '[It] fluctuates between being gross and being gorgeous,'[55] between being the beautiful stash of hand-dyed wool and a repellent, dirty, dusty hoard. Perhaps, in this sense, we would do well not to forget that the Collyer brothers' house was greeted not just with a kind of voyeurism, but also with fascination, as was Warhol's collection. Imagining the hoard around him, the blind fictionalized Collyer notes in Doctorow's novel 'although with our riches as yet uncatalogued, the curating still to come', a sentiment that closely echoes Walter Benjamin: 'for what else is this collection but a disorder to which habit has accommodated itself to such an extent that it can appear as order?'[56]

Notes

1 Some of the ideas for this essay were developed as a part of *Secret Stash: Accumulation, Hoarding and the Love of Stuff*, an exhibition I curated in 2012 at the McIntosh Gallery, featuring the work of Allyson Mitchell, Kelly Wood, Germaine Koh and Payton Turner.

2 Mary Smull, 'Allyson Mitchell: A Room of Once Owned', *Fiber Arts*, (Spring 2011): 28–29.

3 Ibid., 28.

4 Allyson Mitchell, *Hungry Purse*. Available at http://www.allysonmitchell.com/html/hurgry_purse.html (accessed 1 November 2015).

5 Scott Herring, *The Hoarders: Material Deviance in Modern American Culture* (Chicago: University of Chicago Press, 2014), 5.

6 One avenue left unexplored in this essay, but deserving of more attention, is the relationship between hoarding and appetite. Allyson Mitchell writes: 'the *Hungry Purse* is not only the vagina dentata as it represents mortality and fear of women's bodies, but also the fear of all voracious, out-of-control appetites, whether for junk food, credit card debt, global commerce, or agri-business … keep making, keep buying', quoted in Smull 'Allyson Mitchell', 29. See also Ann Cvetkovich, *Depression: A Public Feeling* (Durham: Duke University Press, 2012), 185, and Elizabeth Freeman, *Time Binds: Queer Temporalities, Queer Histories* (Durham: Duke University Press, 2010), 91–93.

7 Cvetkovich, *Depression,* 186.

8 *Hungry Purse* was shown twice more, and is currently in a storage locker in Port Perry, Ontario. Author, Correspondence with Allyson Mitchell, November 2015.

9 Gail Steketee, 'From Dante to DSM-V: A Short History of Hoarding', *International OCD Foundation* (2010). Available at http://www.ocfoundation.org/hoarding/dante_to_dsm-v.aspx (accessed 1 November 2015).

10 Ibid.

11 Randy Frost and Gail Steketee, *Stuff: Compulsive Hoarding and the Meaning of Things* (New York: Houghton Mifflin Harcourt, 2011).

12 E. L. Doctorow, *Homer & Langley* (New York: Random House, 2009).

13 Ibid., 5; Kenneth J. Weiss, 'Hoarding, Hermitage, and the Law: Why We Love the Collyer Brothers', *Journal of the American Academy of Psychiatry and the Law Online*, vol. 38, no. 2 (2010): 251–57.

14 Scott Herring, 'Collyer Curiosa: A Brief History of Hoarding', *Criticism*, vol. 53, no. 2 (Spring 2011): 159–88.

15 Ibid.

16 Michael Lobel also follows Wayne Koestenbaum's suggestion that 'collecting is a code for homosexual activity and identity', in the case of Warhol. While I have left this unexplored in my brief mention of Warhol, it is worth noting that the same kinds of shaming explored by Mitchell in *Hungry Purse* with regards to fatness and queerness are here explored by Lobel in terms of Warhol's hiding of his collection. Michael Lobel, 'Warhol's Closet', *Art Journal*, vol. 55, no. 4 (Winter 1996): 44.

17 Lobel, 'Warhol's Closet', 42. See also John Taylor, 'Andy's Empire', *New York Magazine*, vol. 21, no. 8 (1988): 40–60.

18 See Herring, *The Hoarders*, 2011.

19 Ibid., 7.

20 Ibid., 8.

21 Ibid., 9.

22 Annie Leonard, *The Story of Stuff: How Our Obsession with Stuff is Trashing the Planet, Our Communities, and Our Health – and a Vision for Change* (Toronto: Free Press, 2010).

23 Mary McVean, 'For Many People, Gathering Possessions is Just the Stuff of Life', *LA Times*, 21 March 2014. Available at http://articles.latimes.com/2014/mar/21/health/la-he-keeping-stuff-20140322 (accessed 1 November 2015).

24 Mattias Wallander, 'Closet Cast-Offs Clogging Landfills', *Huffington Post*, 27 June 2010. Available at http://www.huffingtonpost.com/mattias-wallander/closet-cast-offs-clogging_b_554400.html (accessed 1 November 2015).

25 Annie Leonard, *Story of Stuff, Reference and Annotated Script*, 2007. Available at http://storyofstuff.org/wp-content/uploads/movies/scripts/Story%20of%20Stuff.pdf (accessed 1 November 2015).

26 Leonard, *Story of Stuff*, 146.

27 Discussion boards are no longer as central a part of the Etsy community as they were in 2012 when this research was done. An updated 2015 search, however, still shows nine pages of results for the search term 'stash', most of them blog posts from Etsy users documenting projects for upcycling or using objects, yarn, wool and textiles.

28 Also see Marybeth C. Stalp and Theresa M. Winge, 'My Collection is Bigger Than Yours: Tales from the Handcrafter`s Stash', *Home Cultures*, vol. 5, no. 2 (2008): 197–218, on how collections are assembled.

29 Marybeth C. Stalp, 'Hiding the Fabric Stash: Collecting, Hoarding, and Hiding Strategies of Contemporary US Quilters', *Textile: The Journal of Cloth and Culture*, vol. 4, no. 1 (2006): 106.

30 These crafters are different from those who tend to be covered in texts on 'crafting revivals'. Stalp's 2008 research shows that they tend to be older, more conservative, and wealthier than those participating in a third wave feminist craft revival. However, both, for different reasons, have largely disavowed second wave feminism, often because its call to leave the home is interpreted as disavowing domestic crafting (though in fact, this was not the case). For a discussion see Janis Jefferies, 'Crocheted Strategies: Women Crafting Their Own Communities', in *Textile: The Journal of Cloth and Culture*, vol. 14, no. 1, (2016): 14-35; Stalp and Winge, 'My Collection is Bigger Than Yours', 2008. See also Cvetkovich, *Depression,* 172–73. It should also be noted that Mitchell's *Deep Lez Manifesto* is skeptical of such divisions.

31 Ibid., 106–10.

32 Ibid., 116.

33 Discussion boards on Etsy.com and Ravelry.com were searched in December 2012, March 2014 and July 2015. Search terms included 'stash', 'stashing', 'hoarding', 'hoard' and 'hoarding problem'.

34 Jinniver, 'Ah, So This Is How You End Up with a Stash', 3 June 2015. Available at http://www.ravelry.com/discuss/ends/3215200/1–25 (accessed 1 November 2015).

35 pippinpuss, 'Ah, So This Is How You End Up with a Stash', 3 June 2015. Available at http://www.ravelry.com/discuss/ends/3215200/76–100 (accessed 1 November 2015).

36 The textiles industry, including apparel and textiles (which in turn includes yarn and wool) has undergone significant changes since 2004, largely due to the end of the Multifiber Arrangement, which controlled global quotas for the export of textiles and apparel. For further explanation see Kirsty Robertson, 'Embroidery Pirates and Fashion Victims: Textiles, Craft and Copyright', *Textile: The Journal of Cloth and Culture*, vol. 8, no. 1 (2010): 86–111.

37 Marsha Mercer, 'Textile Industry Comes Back to Life, Especially in South', *USA Today*, 5 February 2014. Available at http://www.usatoday.com/story/news/nation/2014/02/05/stateline-textile-industry-south/5223287/ (accessed 1 December 2015).

38 Jaewoo Lee, Pau Rabanal and Damiano Sandri. 'US Consumption after the 2008 Crisis', *IMF Staff Position Note,* 15 January 2010. Available at https://www.imf.org/external/pubs/ft/spn/2010/spn1001.pdf (accessed 1 November 2015).

39 Cvetkovich, *Depression*, 168.

40 Jaewoo Lee, Pau Rabanal and Damiano Sandri. 'US Consumption after the 2008 Crisis', *IMF Staff Position Note,* 15 January 2010. Available at https://www.imf.org/external/pubs/ft/spn/2010/spn1001.pdf.

41 OECD, 'Household Accounts', *OECD Data*, 2012. Available at https://data.oecd.org/hha/household-debt.htm (accessed 1 December 2015).

42 Ye Xie and Belinda Cao, 'China's Debt-to-GDP Ratio Just Climbed to a Record High', *Bloomberg Business*, 15 July 2015. Available at http://www.bloomberg.com/news/articles/2015-07-15/china-s-debt-to-gdp-ratio-just-climbed-to-a-new-record-high (accessed 1 December 2015).

43 Cvetkovich, *Depression*, 165. To be clear, crafting is practiced by many men as well, and by women of all ethnic backgrounds. Cvetcovich's observation here is used to parallel with those using Ravelry, who tend to be middle-aged, white and wealthy.

44 For the former, see Sigmund Freud, 'Femininity', in *Freud on Women: A Reader*, ed. E. Young-Bruehl (New York: W.W. Norton, 1990), 342–62. For the latter see Lee Gant, *Love in Every Stitch: Stories of Knitting and Healing* (Jersey City: Viva Editions, 2015).

45 Cvetkovich, *Depression*, 189.

46 Such discussions are typically not overtly xenophobic. However, a fear of racialized outsiders present in the Collyer story is found in occasional posts that describe fears of Chinese labour crushing US American industry.

47 Etsy garnered a great deal of controversy in 2013 through changing its seller policies to allow for large(r) scale manufacturing, allowing that only the idea must originate with the seller and that sellers must oversee production. See Liz Core, 'Can Etsy Blow Up and Keep Its Soul?' *Grist*, 4 March 2015. Available at http://grist.org/living/can-etsy-blow-up-and-keep-its-soul/ (accessed 14 May 2015); Grace Dobush, 'How Etsy Alienated Its Crafters and Lost Its Soul', *Wired,* 19 February 2015. Available at http://www.wired.com/2015/02/etsy-not-good-for-crafters/ (accessed 14 May 2015),

Hiroko Tabuchi, 'Etsy's Success Gives Rise to Problems of Credibility and Scale', *New York Times*, 15 March 2015. Available at http://www.nytimes.com/2015/03/16/business/media/etsys-success-raises-problems-of-credibility-and-scale.html?_r=1 (accessed 14 May 2015).

48 Betty Friedan, *The Feminine Mystique* (reprint) (New York: W. W. Norton, 2013), 4.

49 Cvetkovich, *Depression*, 168–69. See also Maria Elena Buszek (ed.), *Extra/Ordinary: Craft and Contemporary* Art (Durham: Duke University Press, 2011); Faythe Levine and Cortney Heimerl, *Handmade Nation: The Rise of DIY, Art, Craft, and Design* (Princeton: Princeton Architecture Press, 2008); Betsy Greer (ed.), *Craftivism: The Art and Craft of Activism* (Vancouver: Arsenal Pulp Press, 2014).

50 Alex Williams, 'That Hobby Looks Like a Lot of Work', *New York Times*, 16 December 2009. Available at http://www.nytimes.com/2009/12/17/fashion/17etsy.html (accessed 1 December 2015).

51 Sara Mosle, 'Etsy.com Peddles a False Feminist Fantasy', *Double X*, 10 June 2009. Available at https://web.archive.org/web/20130329053942/www.doublex.com/section/work/etsycom-peddles-false-feminist-fantasy (accessed 22 April 2019).

52 Williams, 'That Hobby Looks Like a Lot of Work'.

53 Nicole Dawkins, 'Do-It-Yourself: The Precarious Work and Postfeminist Politics of Handmaking (in) Detroit', *Utopian Studies*, vol. 22, no. 2 (2011): 274.

54 Before Etsy opened to manufactured goods, more that 96 per cent of people selling there identified as female. Mosle, 'Etsy.com Peddles a False Feminist Fantasy'.

55 Smull, 'Allyson Mitchell', 28.

56 Walter Benjamin, 'Unpacking My Library: A Talk about Book Collecting', *Illuminations*, translated by Harry Zohn, edited and with an introduction by Hannah Arendt (New York: Schocken Books, 1969), 60.

13 SHINIQUE SMITH: LINES THAT BIND

Julia Bryan-Wilson

The sculpture – a columnar solid that looms over the viewer some seven-and-a-half feet high – is muscular and commanding, filling the gallery space with its emphatic presence. Made out of hundreds of items of cast-off clothing and domestic linens that have been massed together and visibly tied with twine, the piece, entitled *Bale Variant no. 0022* (2010), belongs to Shinique Smith's masterful *Bale Variant* series (Figure 13.1, Plate 17). Though its scale is far from modest, the work also imparts an intimate, approachable quality, as the cloth appears to leak out from the sculpture's seams, with garments spilling onto the floor and shirtsleeves escaping the confines of the work's geometry. Smith has not compressed the fabric into this form at random, but carefully selected the material and composed the towering structure with an eye for colour and pattern, with darker textiles at the bottom grounding the piece and lighter ones rising up to the top.

With textured layers resembling geological strata, *Bale Variant no. 0022* looks like a giant core sample from an archaeological excavation. And like a core sample, the cloth contained in the sculpture holds traces of the past, carrying with it residue of the lives it has surrounded. The piles of used clothing confront both the overabundance of consumerist, capitalist excess and also reveal the tenderness of textiles, that is, how they can become surrogates for the people who wear them, how we attach affective meaning to garments and imbue them with character. Originally gleaned from her own closet and those of her friends, Smith now also uses cast-off clothing from strangers, and as they accumulate, they remind us how items once worn and even cherished are eventually thrown out to make room for new things.

Yet much disposed clothing never really disappears. Smith's bale shape consciously echoes the packing of clothing into cubes for ease of shipping, making reference to what author Andrew Brooks, in his book *Clothing Poverty*, calls 'the shadow world of used clothing', in which donated, discarded and surplus

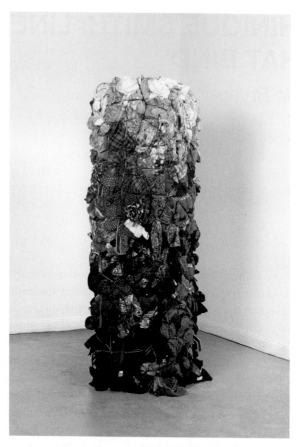

FIGURE 13.1 Shinique Smith, *Bale Variant No. 0022*, 2012, vintage fabric, clothing, blankets, ribbon, rope, and wood, 90 × 30 × 30 inches. Courtesy: Shinique Smith and The Sandy and Jack Guthman Collection, Chicago. Photo: Eric Wolfe.

garments in countries such as the United States and the UK are sold at profit to 'the poor in the global South'.[1] Smith's repurposing of used clothes is a persistent reminder about the material residue of obsolescence. Brooks writes: 'Consumers have responded to clothing availability and an environment of competitive consumption by purchasing increasing numbers of artificially cheap goods, and getting rid of old garments, in rapid cycles of acquisition and discard'.[2] Here the melancholy of textiles with their lingering smells and memories intersects with the melancholy, and inequity, of capitalist modes of production.

Bales are usually assembled mechanically by baling machines, but Smith's approach is distinctly corporeal and hands-on. As she notes in an interview with Kymberly Pinder, she thinks of tying, binding and wrapping as procedures that are connected to the manipulation of text, all of which she undertakes in a kind of 'frenetic meditation'.[3] Pinder connects Smith's textile work to her

history with graffiti, since 'graff is all about motion and so is your work.'[4] At once urgent and ritualistic, Smith's tying and wrapping are also ways to make evident and demystify her own efforts. Given that 'the labour activities associated with the collection, processing and export of second-hand clothes and the complex interactions between waste-making, donations and environmental acts are hidden in contemporary society', this visible labour is crucial.[5]

Smith's *Bale Variant* series take some cues from minimalist sculpture, with its staging of phenomenological encounters with the spectator, and it can be situated within other lineages, including Arman's assemblages of found objects, Judith Scott's bound-textile work and Howardena Pindell's Black feminist abstraction. Smith's work is often discussed within the realm of handicraft and fibre art, despite the fact that she does not utilize sewing or knitting or weaving. The textiles she uses are by and large resolutely industrially produced, though of course industrial production – and destruction – maintains an important component of bodily labour (even in their afterlives, when discarded textiles are shredded, there is still an element of hand sorting). Smith counts among her wide-ranging influences Japanese calligraphy, the writings of Italo Calvino, Tibetan meditation practices, 1980s punk and hip-hop and abstract expressionism. What these disparate sources have in common with Smith's sculpture is that they all negotiate an improvisational energy within a rigorous system of constraints and limits. Her use of fabric as both a formal and an emotional element has frequently positioned her work in conversation with other contemporary artists dealing with the cultural and economic meanings of cloth as it circulates between markets and bodies. South Korean artist Kimsooja, for instance, with her lashed-together fabric bundles, or *bottari*, invokes ties between women's labour, migration and the weight of memory. Many of these artists think critically about the gendered and raced dynamics of the textile industry, including Pakistani artist Risham Syed, whose quilts map colonial histories of, and resistance to, the British Empire cotton trade.

Smith recalls a childhood in Baltimore, Maryland, surrounded by fabric – her mother was a fashion editor and her grandmother had a flair for mixing patterns in her interior design, and she was often aggravated by the insistent presence of textiles in her life.[6] In graduate school at the Maryland Institute College of Art, she began gravitating towards experiments with fabric as surfaces for her abstract paintings, first utilizing vinyl as a canvas for its smoothness. Since then, Smith has continued to pursue an expansive multidisciplinary practice that includes paintings, collages, site-specific murals, sculptures, installations, printmaking, performative events, videos and collaborations with dancers. She has worked with acrylic, paper, ribbons, food wrappers, yarn and ink, as well as with second-hand belongings such as furniture, toys, pillows and shoes. Her work has been shown internationally in high-profile group shows that include *Frequency* (2005) at the Studio Museum in Harlem (featuring emerging Black artists) and *Revolution in the Making* (2016) at Hauser Wirth & Schimmel (highlighting women abstract

sculptors), as well as solo shows at venues such as Boston's Museum of Fine Arts and the Los Angeles County Museum of Art. [7]

The basic element that runs throughout much of Smith's work is the line – whether it be with a piece of rope, a song lyric, a mantra or a gestural mark on a wall, she is always scribbling in space. Her hybrid methods blur the conventional boundaries between media as she moves fluidly between making objects and producing more relational pieces that directly engage audiences outside the space of the museum, including elementary school students. Sometimes techniques that began in the studio, such as the organic tying together of fabric, are given a different valence when she takes them outdoors. For instance, during a residency at the Headlands Center for the Arts in northern California, Smith wrapped her own body in cloth and foam, photographing herself in the coastal landscape, resulting in lush digital prints that suggest masses of detritus that have washed up on the shore in *untitled [Rodeo Beach Bundle]* (2007). Already charged with meaning when located in the white cube of the gallery, her beautifully lumpy creations are newly animated on the beach by the palpable outline of a human figure underneath.

As her work with floor-based sculpture demonstrates, Smith is interested in the physical properties of gravity as well as in the spiritual qualities of weightlessness, and she often suspends her fabric bundles from the gallery ceiling. *Soul Elsewhere* (2013) is a bulbous denim sculpture that hangs in mid-air, its curves trussed with white rope that strains against the fabric (Figure 13.2, Plate 16). Two pairs of jeans have been sutured together at their waistbands and then stuffed, and the legs taper at the top and bottom to create an evocative hourglass shape. In Smith's work, denim is a fabric that solicits a wide range of responses; it connects everything from cross-cultural traditions of indigo dyeing to the corporate branding of jeans. Jeans can be a symbol of independence and freedom (as when Levis were eagerly sought out by those in East Germany after the fall of the Berlin Wall), but also mass production and crushing standardization (as in the 2005 documentary *China Blue*, directed by Micha Peled, which follows the lives of female factory workers in Guangdong to underscore the dismal, punishing conditions in which jeans are made).

A wardrobe staple that is prevalent across spectra of gender, race and class and is often heavily personalized, denim can signify cowgirl, mechanic or rapper. Its cultural malleability – denim can be used in everything from (literally) blue-collar work-wear to high-dollar status symbols – means that jeans are often treated as a blank canvas, open to resignification based on context and frequently embellished by an individual's own interventions. The jeans in *Soul Elsewhere* were the artist's own work pants, worn until they split, with evidence of both her labour and moments of leisure – paint spatters, bleached out scrawls and hand-drawn doodles – embedded in the fibres of the fabric. With its uncanny limbs and creaturely protuberances, the resultant sculpture recalls both the *poupée* of German surrealist Hans Bellmer and the clustered mattress works of US artist

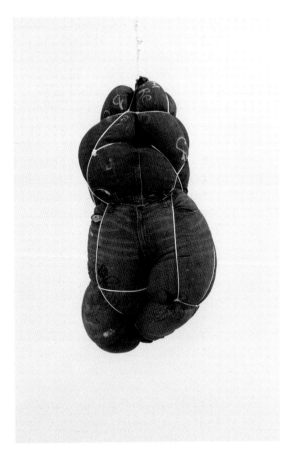

FIGURE 13.2 Shinique Smith, *Soul Elsewhere*, 2013, artist's clothing, ballpoint ink, poly-fil and rope, 38 1/2 × 18 × 14 inches. Courtesy: Shinique Smith and SAS Studio, Private Collection. Photo: Eric Wolfe

Nancy Rubins. They also evoke the stuffed grids of Pindell, mentioned earlier, whose work forms a crucial bridge between African American female traditions of textile making and contemporary abstraction.

At the same time, *Soul Elsewhere* is very much its own suggestive form, a present-day Venus of Willendorf-meets-butterfly cocoon made from a second skin of clothing that has cycled out of pure usefulness into the realm of the aesthetic. Though no longer worn by a moving body, the jeans of *Soul Elsewhere* enliven the space in which they are hung and appear to have an inner vibrancy. With both *Soul Elsewhere* and the *Bale Variant* series, Smith mobilizes figures-in-absentia. Her approach to sculpture pivots on scale: while the manipulated jeans trigger associations with the human body, the stacked monoliths overwhelm the viewer with their imposing size and have an architectural feel. The sculptural heft of her work is often balanced by the gestural delicacy of the strands that bind its

constitutive parts together: for instance, her *Bale Variant* series relies on a logic of accumulation and massing while she also plays with webbing, nets and knotting, generating a conversation between geometry and line.

In works like *Soul Elsewhere*, Smith's process of tying is also an act of discovery; rather than work towards a predetermined shape, she is not certain how the object will look when she's finished, instead endeavouring to let the materials move together. Her work, including *Bale Variant no. 0011* (2005), was featured in the New Museum's seminal exhibition *Unmonumental: The Object in the 21st Century* (2007–2008), a show which brought together artists who use everyday found objects to comment on conditions of dissolution, trauma and displacement with largely provisional and un-heroic art. According to co-curator Massimiliano Gioni, the unmonumental is characterized as 'a sculpture of

FIGURE 13.3 Shinique Smith, *Granny Square*, 2013, acrylic, spray paint, vintage crochet baby blanket on wood panel, 48 × 48 × 2 1/4 inches. Courtesy: Shinique Smith and SAS Studio. Photo: Jason Mandella.

fragments, a debased, precarious, trembling form'.[8] While her work made sense in this context, Smith is also keen to emphasize metamorphosis and renewal; all of the tangible stuff that she engages with – including actual trash like leftover fast-food wrappers – undergoes a transformation as she recycles and remakes it to give it a fresh narrative.

For instance, in *Granny Square* (2013), Smith repurposes a found crocheted blanket and uses it as the diamond-shaped centrepiece of an abstract painting (Figure 13.3). The blanket is both handmade and readymade, and *Granny Square* deftly integrates a typical household textile and methods of appropriation within the frame of painting, scrambling any sense of the inviolable distinction between craft and conceptualism. Smith has painted an elaborate border around the edges of the blanket, and the colours of the crochet and her energetic brushstrokes vibrate against a vivid yellow background. This piece takes the form of a tightly composed, symmetrical mandala; her use of this structure was influenced by childhood experiences she had watching sand mandalas being made and then destroyed. Smith's work, too, is about constant regeneration, as it acknowledges that all goods are part of an incessant and ever-changing flow: garbage can be transmuted into prized purchases, just as precious artifacts can degrade into neglected rubbish. Her bound bales and bundles of used fabric speak to personal and social stories of fabrication and connection as she advocates for a politics of abstraction, an abstraction that laces together the materiality of race, gender and economics. In Smith's hands, waste becomes sheer explosive potential, compacted together and ready to unleash on impact.

Notes

1 Andrew Brooks, *Clothing Poverty: The Hidden World of Fast Fashion and Second-Hand Clothes* (London: Zed Books, 2015), 98.

2 Ibid., 82.

3 Smith quoted in Kymberly N. Pinder, 'Unbaled: An Interview with Shinique Smith', *Art Journal*, vol. 67, no. 2 (2008): 6–17.

4 Ibid., 9.

5 Brooks, *Clothing Poverty*, 98.

6 Shinique Smith, phone interview with author, October 2015.

7 Thelma Golden, Christine Y. Kim and Michael Paul Britto, *Frequency* (New York: Studio Museum in Harlem, 2005); *Revolution in the Making: Abstract Sculpture by Women, 1947–2016*, ed. Jenni Sorkin and Paul Schimmel (Los Angeles: Hauser, Wirth, 2016).

8 Massimiliano Gioni, 'Ask the Dust', in *Unmonumental: The Object in the 21st Century*, ed. Richard Flood, Massimiliano Gioni and Laura J. Hoptman (London: Phaidon, in association with the New Museum, 2007), 65.

14 MARGARITA CABRERA: LANDSCAPES OF *NEPANTLA*

Laura August

Transformations occur in this in-between space, an unstable, unpredictable, precarious, always-in-transition space lacking clear boundaries. Nepantla es tierra desconocida, and living in this liminal zone means being in a constant state of displacement.

GLORIA ANZALDÚA AND ANALOUISE KEATING, EDS., *THIS BRIDGE WE CALL HOME: RADICAL VISIONS FOR TRANSFORMATION*

We have known since Ruskin that the appreciation of landscape as an aesthetic object cannot be an occasion for complacency or untroubled contemplation; rather, it must be the focus of a historical, political, and (yes) aesthetic alertness to the violence and evil written on the land.

W. J. T. MITCHELL, 'IMPERIAL LANDSCAPE', *LANDSCAPE AND POWER*

In Chicanx and Latinx writing, *nepantla* – the Nahuatl term connoting *in betweenness* – has signified a series of resistance strategies for survival in inhospitable places. 'Sometimes, [nepantla] is a reference to living in the *borderlands* or *crossroads*, and the process of creating alternative spaces in which to live, function or create … resisting the mainstream, while, reinterpreting and redefining cultural difference as a place of power', writes historian Miguel Leon-Portilla.[1] Writer, poet and queer feminist theorist Gloria Anzaldúa considers *nepantla* a space for healing the wounds of forced acculturation, for mending the scars of the conquest. The people who move inside the space of *nepantla*, Anzaldúa writes, are the *nepantleras*, the threshold people who facilitate passages between worlds. They are, she writes, 'boundary-crossers, thresholders who initiate others in rites of passage, activistas

who, from a listening, receptive, spiritual stance, rise to their own visions and shift into acting them out, haciendo mundo Nuevo (introducing change)'.[2] El Paso-based artist Margarita Cabrera uses craft to open a dialogue with communities that exist in spaces between citizenship and deportation, between fear and politics. For her multi-year project, *Space in Between*, she looks to *nepantla* as a framework for participatory making. For her, collaboration is both a craft-based practice, and a mode of convening fragmented immigrant communities.

Cabrera's artistic practice has long looked to the labour conditions of the large factories producing consumer goods for export, or *maquiladoras,* along the US–Mexico border. Since the early 2000s, Cabrera has created a series of soft sculptures of mass-produced objects, such as toaster ovens, waffle makers, sewing machines, blenders and automobiles, critiquing the labour practices that have sprung up along the *frontera*. Just outside the purview of the United States, Mexican factories staffed mostly by women mass-produce these items for North American markets, using toxic processes in an often-exploitative work environment that is illegal in factories north of the border. The United States turns a blind eye to the working conditions of these factories, benefiting from the resulting low prices of goods produced there. Cabrera hybridizes the machine, using sewn vinyl to replace the parts of each domestic appliance that were made in Mexican *maquiladoras*.

Cabrera's 2008 exhibition, *The Craft of Resistance* at Artpace in San Antonio, Texas, brought this labour critique into the museum, and incorporated it as part of her working process. The project included a makeshift factory in the artist's studio, where she trained volunteers to do a type of traditional metalwork native to Santa Clara del Cobre, Michoacán, Mexico. Together, she and the volunteers created an assembly line that produced 2,500 copper butterflies over the course of the artist's residency. Volunteers were seated in narrow cubicles at long tables in the Artpace gallery. The crude work stations, outfitted with basic tools, transformed the gallery space from one of object-display, to one of object-production. Making production visible is one of the central tenets of Cabrera's career-long investigation of craft and community. In many ways, when we make the production of an object invisible, we detach ourselves from the radical proposition underpinning craft: that making something together can challenge systems of oppression, of mass production, of isolation and of exclusion. Making copper monarch butterflies was also loaded with symbolic significance. With their annual migratory patterns, the butterflies suggested the importance of free passage across American borders. They pointed to the difficulties that Mexican citizens have in crossing the border into the United States, in stark contrast to the comparative ease with which US college students make annual spring-break migrations into Mexico, or the warm reception with which American expatriates are greeted upon moving south of the US border.

The copper butterflies were stamped on one side with the wing pattern of the monarch. On the other, they were stamped with an impression of the American penny. At the end of her Artpace residency, Cabrera installed the copper butterflies

FIGURE 14.1 Margarita Cabrera in collaboration with Candelaria Cabrera, *Space in Between – Nopal*, 2010, border patrol uniform fabric, copper wire, thread and terracotta pot. © Margarita Cabrera/VAGA at Artists Rights Society (ARS), New York, NY. Photo: Fredrik Nilsen.

in a private home in San Antonio. From the space of the workshop/*taller*, they entered the exchange of the marketplace. Here, Cabrera recreates certain labour economies that underpin much of the US consumption on a micro scale in the gallery. Like many goods produced in *maquiladoras* south of the border, their value was determined by the price the market was willing to pay, not by the objects' relationship to labour. That is, the participatory action of *making* the monarch butterflies became invisible in the work's final installation. This gesture of erasure was an intentional one, underscoring the distance between the space of production and the space of consumption and replicating the invisibility of the *maquiladoras* who make many familiar domestic electronics. There is a dividing line here, too, between what we buy and where it comes from.

For *Space in Between*, Cabrera invites members of communities in Texas, North Carolina and Arizona to work with her in a process of recycling discarded Border Patrol uniforms and transforming them into soft sculptures of Indigenous desert plants, such as the nopal and yucca (Figures 14.1–14.4, Plates 18 and 19). The soft plant sculptures are installed in terracotta pots, their zippers, buttons and labels peering through the plant's form. 'We immediately find out what we know as a group', Cabrera says:

We establish a sense of trust through dialogue, then we share experiences and stories that are embroidered on the surface of the fabric. During the embroidery

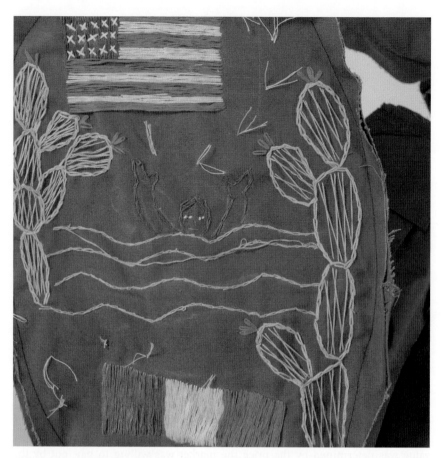

FIGURE 14.2 Margarita Cabrera, *Nopal detail*, 2010, border patrol uniform fabric, copper wire, thread and terracotta pot. © Margarita Cabrera/VAGA at Artists Rights Society (ARS), New York, NY. Photo: Fredrik Nilsen.

process, we find out what skills we bring and share them with the group … There is this amazing hybridity of different styles and our new embroideries just happen. We celebrate our heritage that way … craft, and art, and culture-making are at the heart of a community. If that disappears, we have nothing.[3]

Although Cabrera's works utilize several traditional techniques, their implications for craft are perhaps more firmly grounded in the appropriation of the *taller*/workshop model than in discussions of sewing, embroidery and metalwork. For Cabrera, the workshop model has the potential to restore context and history for communities that are distanced from the craft traditions of their native regions.

Process remains central to the politics of Cabrera's production. 'The experience of a community project has to be all-inclusive', she observes, 'everyone who comes

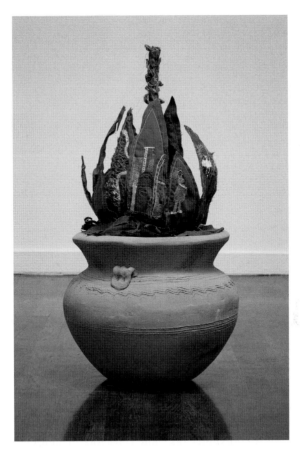

FIGURE 14.3 Margarita Cabrera, *Sabila*, 2010, border patrol uniform fabric, copper wire, thread and terracotta pot. © Margarita Cabrera/VAGA at Artists Rights Society (ARS), New York, NY. Photo: Fredrik Nilsen.

into contact with the work experiences some type of change. Not just at the individual level, but also at the institutional level. There are people coming into this project at different levels: organizations, funders, exhibitors, individuals.'[4] This combination of participants offers Cabrera a space for engaging with the economic, social and political structures that underpin the art world. 'The real value of craft at this moment has nothing to do with a stable ideology or indeed any singular quality inhering in the idea of "craft," but rather with craft's strange, pressured and contested position within the schematic of contemporary consumption', writes Julia Bryan-Wilson.[5] Indeed, to discuss Cabrera's craft in relation to histories of sewing and women's work is to see only one fraction of the objects' resonance. 'To be truly inclusive of our diverse communities all the way through the systems within which we work as a cultural community' is a way of fundamentally reshaping how those

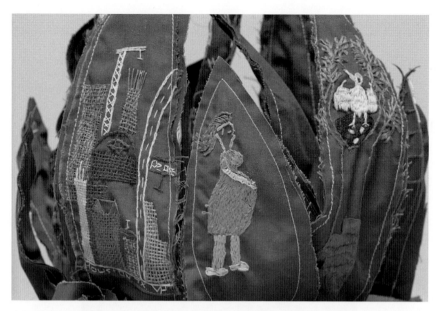

FIGURE 14.4 Margarita Cabrera, *Sabila detail*, 2010, border patrol uniform fabric, copper wire, thread and terracotta pot. © Margarita Cabrera/VAGA at Artists Rights Society (ARS), New York, NY. Photo: Fredrik Nilsen.

systems work, allowing and reflecting new ideas and ways of making, Cabrera says. Part of the work is

> challenging our curators, directors, [and] collectors, inviting them to accept our changing nation's demographics with more inclusive programming, making them aware of these changes, and opening them up to new communities ... it is so important for collectors to know their privilege, their responsibility ... [as participants in *Space in Between*] they start to live [in] that moment and think about it. I welcome them all to enter that transformative space of *nepantla*.[6]

In every iteration, *Space in Between* includes a series of lectures and talks related to craft and activism, botany, migration and immigration. It includes educational programming and scholarships, and it invites often-excluded members of local communities to participate alongside museum patrons, curators, institutional and local leaders: in Arizona, among other constituents, Cabrera invited Latinx, African American and Central American youth in area detention centres to join the workshops. Cabrera's invitations to often-overlooked communities are an effort to change the demographics of participation in the conversation around cultural objects. This kind of broad invitation places the participatory model of her workshops in sharp relief, the question becomes: At which point does inviting a cross-section of

the local community to make work with her critique the systems of production and consumption; at which point does it offer a centre for community identity and cultural pride, and how does it complicate the way we understand both of these processes?

Anzaldúa's *nepantla* is radical because it suggests an alternative to oppositional politics of us/them, positing the political potential for inclusivity and community-building through intersectionality. 'When you're in the place between worldviews (*nepantla*) you're able to slip between realities', she writes. 'A decision made in the in-between place becomes a turning point initiating psychological and spiritual transformations, making other kinds of experiences possible.'[7] In the American landscape of immigration, the space between places has become a hotly contested political territory. Cabrera's *Space in Between* has a particular resonance in Arizona, after the passage of State Bylaw 1070 in 2010, that required police to determine the immigration status of subjects arrested or detained, whenever they had 'reasonable suspicion' that these detainees were living in the United States without legal permission.[8] In Cabrera's workshop model, she valorizes the work of makers, of craftspeople. Whereas Arizona's laws target migrant workers for deportation and racial profiling, Cabrera invites members of the local community to labour with her, and connects them to the craft traditions of Mexico. She reverses the stigma of being a migrant worker, instead highlighting the importance of immigrant craft traditions, narratives and personal experiences.

In its Arizona iteration, ongoing since 2015, *Space in Between* works in collaboration with the Desert Botanical Garden in Phoenix. Founded in the late 1930s, the Desert Botanical Garden is a 140-acre garden and plant research institute for the conservation and celebration of desert plant life. The garden boasts more than 21,000 plants, including almost 140 rare, threatened or endangered species. The collaboration between Cabrera and the garden is significant because it makes this popular tourist destination a participant in the conversation about immigration; that is, the desert plants are transformed into symbols of political struggle and the experience of passage between countries. As a tourist destination, the garden's constituency is also significant. Tourists have access to travel and to leisure time. The activity of being a tourist is a dramatic contrast to the experience of being a migrant or an undocumented worker, for example. Whereas tourists can view a desert landscape as an aesthetic experience, the people who attempt to cross the border from Mexico into the United States have a much different – often violent, and dangerous – experience of this same landscape. Rather than romanticizing the desert landscape, Cabrera's *Space in Between* takes this unique landscape and its plant life as a site for understanding very specific human experiences. There is a dark side to landscape, as W. J. T. Mitchell reminds us and there are many ' "hard facts" embedded in idealized settings'.[9] In his article 'Imperial Landscape', Mitchell argues for the importance of changing landscape from a noun to a verb. Rather than describing landscape as an object to be seen or read, Mitchell proposes that landscape can be understood 'as a process by which social and subjective identities

are formed'.[10] The strong contrast between the tourist landscape offered by the botanical garden – what Mitchell calls 'a marketable commodity to be presented and re-presented … an object to be purchased, consumed, and even brought home in the form of souvenirs such as postcards and photo albums'[11] – and the handmade landscape that Cabrera and her collaborators stitch together offers a radical rethinking of how landscape is inscribed with affect, experience, history and trauma. 'As a fetishized commodity, landscape is … an emblem of the social relations it conceals', Mitchell writes.[12] By making a handmade landscape of cacti and desert plants, Cabrera slows down the way in which her collaborators and audiences consume the landscape around them. In the altered Border Patrol uniforms, she embeds the twenty-first-century American immigrant experience of border-crossing with the labour of stitching, of embroidery, of the handmade. And, in the process, she unveils the violence that is often concealed in the landscape of the American Southwest.

Negotiating one's path through *nepantla* requires a constant rethinking of the boundaries of community and how it is made, of political subjectivities and their place in a physical environment. It is, in the end, a gesture towards building a new American landscape that includes the complex experiences embedded in the borderlands. Immigration to the United States is a central foundation of the nation's history, even as the political climate becomes aggressively xenophobic and as laws are passed (and detention centres are built) to complicate the lives of new immigrants, or to force them out of the country. There are many lives lived in the borderlands (both literally and metaphorically), 'lives for which the central interpretive devices of the culture don't quite work', as historian Carolyn Steedman writes.[13] By looking to craft traditions and by co-opting the politics of the *maquiladora* workshop, Cabrera offers other interpretive devices, suggesting that American political discourse could benefit from a broader view, a more inclusive approach to the experiences of the many people who choose to make their lives in the United States.

Notes

1 Miguel Leon-Portilla, *Endangered Cultures* (Dallas: Southwestern Methodist University Press, 1990), 10 (original emphasis).

2 Gloria Anzaldúa and AnaLouise Keating, eds., *This Bridge We Call Home: Radical Visions for Transformation* (New York: Routledge, 2002), 571.

3 Margarita Cabrera, interview with the author, 12 May 2016.

4 Ibid.

5 Julia Bryan-Wilson, 'Sewing Notions', *ArtForum,* vol. 49, no. 6 (February 2011): 73–74.

6 Margarita Cabrera, interview with the author, 12 May 2016.

7 Anzaldúa and Keating, eds., *This Bridge We Call Home*, 567, 569.

8 Although other provisions of the bill were subsequently blocked by the U.S. Supreme Court, the so-called show me your papers provision remains official policy as of the writing of this text.

9 W. J. T. Mitchell, 'Imperial Landscape', *Landscape and Power* (Chicago: University of Chicago Press, 1994), 5.

10 Mitchell, 'Imperial Landscape', 1.

11 Ibid., 15.

12 Ibid.

13 Carolyn Steedman, *Landscape for a Good Woman* (London: Virago, 1986), 5.

15 THE SOVEREIGN STITCH: REREADING EMBROIDERY AS A CRITICAL FEMINIST DECOLONIAL TEXT

Ellyn Walker

What does it mean to imagine the sewing needle as a dangerous tool and to envision female collective textile making as a process that might upend conventions, threaten state structure, or wreak political havoc?[1]

JULIA BRYAN-WILSON

Art and craft have always served as important vehicles for political protest and cultural activism, particularly feminist activism(s), as their visual forms lend creatively to public dissemination, tactile and social engagement. Embroidery is no different, acting as a critical site of resistance and re-imagination for its creators, users and viewers alike. As an active material process, embroidery allows for a diversity of perspectives and histories to unfold, through a distinct tactile and visual language that operates as a critical *text*. Embroidery conveys the touch and negotiation of hands in motion, and allows space for individual agency, processes of undoing, redoing and intimate imagining. Like embroidery, 'the story of decolonization is one that has room for many voices, one where many people can find ways to belong on the land without dominating, destroying and displacing Indigenous societies,[2] and that can be practiced and evidenced through everyday acts of sovereignty such as stitching. Inuk art historian Heather Igloliorte nuances the meaning of 'sovereignty' as something that is unique to Indigenous societies and worldviews, explaining it is a 'fundamentally different formation than the idea of nationhood,[3] which has come to define historical and modern-day colonial nation states. Using the example of her own Indigenous culture, Igloliorte distinguishes Inuit people's understanding of sovereignty from the state,

emphasizing its dependence on the revitalization and preservation of culturally specific ways of knowing and doing, such as through art-making. She notes how this allows for the 'strengthen[ing of] our communities and cultivat[ation of] our cultural resilience',[4] which can enable long-term forms of sovereignty. This essay builds on Igloliorte's perspective, to offer a reorientation of dominant readings of embroidery as a feminized, and often Indigenized or culturally distinct material practice. I consider embroidery work from three distinct sites across the Americas: Chile, Chiapas and Canada, to reimagine its possibilities as a creative expression of critical feminist organizing, Indigenous self-determination, cultural resistance, remembrance and resilience – all of which are vital processes within the larger struggle for decolonization.[5]

Art historian Rozsika Parker's foundational book, *The Subversive Stitch: Embroidery and the Making of the Feminine*, offers a particular reading of the role of embroidery in women's lives throughout European and Western nation-building projects. In it, Parker critically asserts that, 'to know the history of embroidery is to know the history of women'.[6] She illustrates this history through a specific historiography of domestic and fine art examples spanning the past 500 years, which mirrors the timeline of European contact and colonization[7] on the lands now known as North America. With case studies that break down distinctions between notions of 'art' and 'craft', such as historical Victorian household embroidery, or the example of feminist artist Judy Chicago's well-known multimedia installation *The Dinner Party* (1974), Parker highlights the use of embroidery *by* women to advance discussions *about* women. In doing so, she offers an important, albeit incomplete, genealogy of embroidery as a (white) feminist archive. While *The Subversive Stitch* points to embroidery's potential as a site that constructs the feminine, while simultaneously offering a place to resist such constructions; Parker's consideration of women and the diversity of their subject positions is limited, as her text employs a Eurocentric lens characteristic of the context of second-wave feminism in which she was writing. Yet there remains enormous potential to build on Parker's perspective, to decolonize and expand its reading, in particular, through the examination of embroidery outside of a settler-colonial[8] feminist framework and beyond Eurocentric notions of border or national (and economic) sovereignty.

Parker's work, and others like it, is important to unsettle because it constructs a record of embroidery that privileges white cultural production over all others. In particular, elisions of Indigenous and culturally diverse examples render their presence and artistry invisible, which is especially problematic in light of the range of cultural identities and diverse practices possible within various sites of embroidery production over time. Following on recent interdisciplinary scholarship that explores the 'classed, raced, gendered and sexualized formations'[9] of textile production, a number of open-ended critiques emerge in response to Parker's markedly selective telling.[10] My analysis responds to *The Subversive Stitch*'s omissions through a focus on Indigenous, anti-colonial and other culturally

specific forms of embroidery. I consider the production of arpilleras in Chile, huipiles in Mexico and moccasins in Canada, as deeply land-based, matriarchal and politicized practices. While decolonization is by no means something complete(d) within the creation of a work of embroidery – as decolonization is neither a metaphor nor an endpoint[11] – Indigenous and diverse communities of women have used embroidery to attain cultural and economic sovereignty for centuries. Today, communities around the world continue to mobilize broader projects of social justice, truth and reconciliation. It is from this critical decolonial perspective that I approach textile works that speak from women's embodied experience(s), and that create renewed spaces for bodily and cultural sovereignty through creative and collectivized forms of making.

Following Igloliorte's assertion that 'the arts can play a determining role in [the] effort to reassert cultural sovereignty',[12] this essay explores examples of embroidery that afford a unique understanding of critical feminist, decolonial and emancipatory work. Specifically, I look at how Indigenous, activist and culturally diverse communities of women across the Americas use embroidery to expose histories of gendered, colonial and state-sanctioned violence, and create models of feminist making, community-building and Indigenous resurgence.[13] This research is framed within a hemispheric context and engages with writing in critical art history, Indigenous and cultural studies to consider the local and global implications of embroidery as a nuanced text representative of feminist and Indigenous resistance and cultural creativity. I view embroidery as a *text* because it operates as a site for close reading, which in turn, (and importantly), promotes new ways to *look*, *feel* and *listen* more deeply to cultural objects and their extended relations. This kind of intertextual reading also underscores the shared etymological roots of the words *textile* and *text*, which originate from the Latin word *texere*, which means to weave. As Janet Berlo writes, 'textiles are eloquent texts, encoding history, change, appropriation, oppression and endurance, as well as personal and cultural creative visions'.[14] The following examples evidence embroidery as a complex and multivalent space of resistance, remembrance and autonomy through its *close making* as well as its *close reading*.

Chilean arpilleras

Chile, a protracted strip of land between the Andes and the Pacific Ocean in what is now modern-day South America, was inhabited and cared for by Inca, Mapuche and other Indigenous groups for millennia before colonization by the Spanish in the mid-sixteenth century. Though successfully establishing independence again in 1818 as a sovereign republic, Chile's most notable political history is, perhaps, its most violent one: General Augusto Pinochet's ruthless and violent dictatorship from 1973 to 1989. Employing terror as a political strategy, Pinochet

used 'censorship, curfew, exile, prison, torture, and *desparecidos* (disappearance) – people taken by the police and never seen again' to frighten Chileans into silence and civil obedience.[15] Thousands of people, predominantly men, 'disappeared at the hands of Pinochet's secret police [and still] have yet to be found,[16] while Chile's second national Truth Commission Report on Torture and Political Imprisonment counts the total number of people officially registered as torture victims at 38,254.[17] Thinking about Chile's tragic reality is inseparable from the question of what role 'gender, women's experiences, and the struggle for human rights occup[ies] in this history'.[18] Chilean embroidered *arpilleras*, tiny patchworked images, exemplify these multifaceted roles, as they are 'made by hands of mothers, daughters, sisters, and wives – the living relatives of loved ones who have disappeared,[19] and make visible lives truncated by state and colonial violence.

Arpilleras are small, brightly coloured textiles that feature patchwork and embroidery as narrative devices. They are made by affixing vibrant scraps of fabrics onto a rectangular piece of burlap (*arpillera* in Spanish), which acts as the base. An artistic form unique to Chile, each arpillera tells a story 'where speech has not [before] been possible,[20] in a way that is at once delicate and powerful. More precisely, 'the arpillera signals what it means to have a life interrupted or suspended, a life that no longer exists,[21] where each stitch, in its repetitive circular motion, can be seen as a poetic gesture towards a reparative relation or future. In Marjorie Agosín's *Tapestries of Hope, Threads of Resistance*, she explains that 'each stitch mends the world and at the same time affirms a personal and universal history … [as they] take on the role of uniting families and sewing broken lives'.[22] The stitches insist on the women's survival in spite of their incommensurate losses, as well as the gruesome realities of how their loved ones were taken. With this perspective, the act of making arpilleras enables tactile and textual experiences of witnessing, storytelling and remembrance, which are essential parts of both healing and decolonizing processes. Arpilleras also call for truth-telling and national accountability despite ongoing denial by the state, what cultural studies scholar Roger I. Simon described as a critical 'remembrance practice' – a type of visual or material representation that 'rearticulates memory over and against the desire and necessity of forgetting'.[23] The rich intersections that exist between the culturally specific craft object, political gesture and alternative historical document demonstrate the complexity inherent in arpilleras and their making.

Arpilleras originated within the tradition of narrative textiles and began as 'a clandestine art made in the basements of churches or in the houses of marginalized women' during the first few years of Pinochet's regime.[24] The women used clothing from disappeared loved ones to imbue the arpilleras with the scents of the bodies that once wore them. Representative of illegal speech acts, arpilleras uniquely communicate in a dual language established by their makers, as their aesthetic qualities – such as the use of miniature dolls, bright colours or perfectly sunny landscapes – depict seemingly cheerful and childlike pictures that are, in actuality,

deeply subversive, dark and political. Arpilleras were initially made in secret 'under the auspices of the Comité Pro-Paz (Pro-Peace Committee) and then the Vicaría de la Solidaridad (Vicarate of Solidarity), a human rights agency affiliated with the Catholic Archdiocese of Santiago',[25] whose official status and religious affiliation granted the women relative protection from state surveillance and the ongoing threat of disturbance. Despite their classified production, women joined the workshops 'out of a sense of solidarity and wanted to offer their assistance by participating in a common humanitarian project'.[26] In this regard, arpillera workshops became informal centres of feminist and anti-colonial solidarity and community-building, where the act of gathering turned women's individual grief into collective outrage and creative resistance towards the state, and offered a place to remember and mobilize alternative tellings of Chilean history. Likewise, the embroidering process brought women together in spite of the state's terrorizing acts of familial rupture, isolation and gendered violence, creating spaces for women's collective healing and exchange.

Violeta Morales, a prolific arpillerista working during (and after) Pinochet's regime, made countless arpilleras in response to the disappearance of her brother Newton Morales in 1974. In her graphic arpillera work, *Sala de Torturas* (Chamber of Torture) from 1996 (Figure 15.1), Morales depicts a chilling scene of hidden

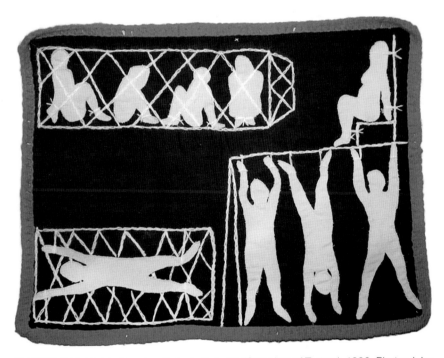

FIGURE 15.1 Violeta Morales, *Sala de Torturas (Chamber of Torture)*, 1996. Photo: John Wiggins. From the private collection of Marjorie Agosín.

and tortured bodies through their abstract representation as captives. This is made explicit through the depiction of bodies squeezed inside familiar shapes of furniture, and tied to chairs and bedposts; each figure is embroidered as a simple silhouette against an ominous background of dark fabric. Here, the strategic use of contrasting colours and figurative abstraction draw attention to the very real human lives involved and eventually extinguished in these harrowing yet colourful scenes of internment that reflect much larger experiences of state violence. While not as 'cheerful' as many popular arpillera scenes, this work nevertheless relies on similar conventions: using unusual colour combinations, bold graphic shapes and human abstraction. Though the illustration of torture is undeniably difficult, Morales's arpillera – no matter how disturbing it is to look at – insists on a truth that has for so long been denied and made invisible on both national and international levels. *Sala de Torturas* tells an important counter-story to Chile's 'official' history, making visible the lives of the disappeared, and insisting that they will not be forgotten.

The arpilleras' small size made them easy to roll, pack and conceal as 'illegal' objects to travel across borders, in the context of the reigning political regime that censored and murdered dissidents. However, it was not until later that arpilleras began to circulate more globally, as the international movement for human rights brought increased attention to a country in crisis. Their strategic portability allowed for extra-national movement through networks of 'Chilean exiles, feminists, humanitarian aid organizations, progressive church groups, NGOs, global trade gift stores',[27] among other Indigenous and anti-colonial organizations. It is important to note that arpilleras were not made exclusively by Indigenous women – as Indigenous identities in the context of Chile (and other Latinx communities) relate to complex histories of colonization, enslavement, diaspora and migration[28] that involve Indigenous, African, European, Spanish and other populations. However, arpilleras play an important role in the movement for decolonization, as their embroidered narratives refuse the injustice(s) of Pinochet's regime, which is just one piece of a much longer history of colonial occupation, dislocation and oppression in the Americas. Arpilleras also demonstrate how decolonization work, like commitments to social and environmental justice, is not only the purview of Indigenous makers and communities. Rather, the ongoing work of dismantling colonial structures and systemic forces that inequitably affect Indigenous people is relevant to all people and must involve everyone's efforts.

Arpilleras make visible the effects of violence that are specific to the Chilean context – representing familial and maternal loss and sometimes, torture and amputation. Notably, loss is often depicted as an absence within arpilleras, as in *Sala de Torturas* – outlined shapes of bodies that are clearly missing. Other scenes of 'absence' found in arpilleras depict families gathered around the dinner table with seats that remain empty. In conversation with these examples, decolonization

can be thought of as 'an [equally difficult to represent] elsewhere',[29] a future free of gendered violence, colonial oppression, disappearance and state denial, that inherently requires a different way of seeing, relating to and valuing life. Indigenous and cultural studies scholars Eve Tuck and K. Wayne Yang describe this different future as requiring 'a change in the order of the world',[30] perhaps one that cannot yet be made fully visible, amid society's current configuration(s). Yet the personal and forthright representation of human lives in arpillera imagery calls for a decolonizing gaze, one that sees outside of the purview of colonial state logics, and instead, insists on the recognition of human rights in the face of physical disappearance and denial.

While arpilleras are certainly not the only form of Chilean resistance practiced during Pinochet's terrifying rule, they were used to create a visual language for human rights at a time when human lives were seen as disposable. Agosín questions where 'the role of the arpilleristas fit in th[e] space of debate to rethink Chile in relation to the more visible civil participation that occurs in a country'.[31] Arpilleras call for and promote justice in multiple ways: through community-building, forming cooperative and collaborative relationships, and with feminist, anti-colonial and human rights activism. Indeed, through their collective making, individual or institutional collection, intra and extra-national dissemination, and public or private display, arpilleras represent sovereign cultural objects. They embody national truths and counter-narratives in spite of state suppression. Just as Parker articulates the reciprocal relationship between embroidery and women, the work of arpilleras 'utilizes the feminine by articulating the most intimate gestures, such as the long hours of dedication to manual work in order to create textiles that, from the universal and feminine perspectives, tell a story of the war, horror, and violence created by men'.[32] Their visual narratives insist on the lived experiences of their makers to mark the losses of their sons, husbands, fathers, brothers, uncles, cousins and friends. Even in the process of making, 'tying [the] ends, deciding on the colors that can speak of the detainment of a loved one or the torture endured', they tell a unique story and allow others to participate in a process of remembering.[33] For this reason, arpilleras are most often unsigned, remaining 'anonymous in order to ensure that [they] remain a collective expression of a historical period',[34] one that, indeed, must collectively never be forgotten. In this way, arpilleras reflect Simon's notion of a 'remembrance practice', rearticulating memory in the face of its denial and erasure. While the front of the arpilleras functions as an explicit public text, it is on the back that a small space for personal, more private communication is reserved: some arpilleras feature a tiny pocket on their reverse, a place where their makers can leave a personal message of love, mourning or hope that has 'the ability to mend, repair, and recover' underground histories.[35] Agosín elaborates on this significance, explaining that 'to find a message in a pocket is an act of communion and solidarity with the woman who made the arpillera'.[36]

As art historian Julia Bryan-Wilson puts it, 'once made by a threatened underground network of women', arpilleras 'have been incorporated into official spaces of memory and commerce as a source of national pride'.[37] Museum collections have focused on historical arpilleras made between 1974 to 1989, though small numbers of contemporary arpilleras are still being produced. Arpilleras embody personal histories of loss, but at the same time, of survival. As such, they represent a vital act of memory work, allowing others to bear witness to state and gendered violence and to remember the many human lives affected by it. In doing so, arpilleras demonstrate the creative resilience of women during a national terror campaign that desecrated their families, and rearticulate their bodily sovereignty and agency through embroidered testimony and truth-telling.

Chiapan huipiles

Chiapas, a free and sovereign state within Mexico bordered by parts of Guatemala and the Pacific Ocean, is home to one of the largest Indigenous populations in the country. Its most well-known municipality, San Cristóbal de las Casas, is located in the central highlands of Mexico and aptly translates to 'place in the clouds' in local Tzotzil and Tzeltal languages, as its elevation exceeds more than 7,000 feet. While much of San Cristóbal's history is representative of colonial expansion and contemporary Latin American tourism, its reputation has come to symbolize social and Indigenous justice on a global scale, when the world watched the masked Zapatista Army of National Liberation or *Ejército Zapatista de Liberación Nacional* (EZLN) storm San Cristóbal on 1 January 1994. This was the same day that the North American Free Trade Agreement (NAFTA) was signed by Canada, the United States and Mexico, where in Article 27, Indigenous land rights were neither recognized nor protected. Primarily made up of rural Indigenous people, this revolutionary and militant leftist group (also known as the Zapatistas or EZLN) declared war on the Mexican state in defence of their lands and resources, and they continue to live in sovereign communities or 'caracoles' across Chiapas. The movement's primary goals include addressing 'the basic needs of social development for farms and communities, education, healthcare, family-planning and women's empowerment, in a uniquely Indigenous way'.[38] Chiapan embroidery has played a significant role in Indigenous resistance movements such as for the Zapatistas, where the use of renewable land-based materials, ancestral imagery, feminist intergenerational production and autonomous economic models represent important practices of Indigenous sovereignty and resurgence. Uniquely, Indigenous peoples' 'relationships to land comprise their epistemologies, ontologies, and cosmologies', and as such, reflect 'creation stories, not colonization stories, about how they came to be in a particular place'.[39] One such epistemology is the Maize Creation story told by traditional Maya peoples, that describes maize

(corn) as having given birth to their original ancestors. In what is now present-day Chiapas, the cereal grain known as corn is said to have been first invented, where in the same regions of central and southern Mexico, Maya peoples cultivated this renewable crop that would become a staple of diet and culture for Indigenous peoples, and later, for people all over the world.

In the previous example of Chilean arpilleras, Marjorie Agosín described fabric as an intimate site of creation, as 'the experience of working with [textile] evokes the personal function of memory' and 'implies a close relationship between a person's hands and the history of the fabric itself'.[40] The same can be said of Chiapan embroidered huipiles, which reveal culturally specific images, creative practices, gendered customs of dress and natural resources grown from autonomous Indigenous communities located across the mountainous highlands of the Mexican state. Although huipiles are a popular Mayan dress in past and present-day central Mexico, they can also be found throughout parts of Guatemala and other regions of Central America, with slightly varied narrative symbols and aesthetic designs. This geographic expansion originally reflected the mobility of Indigenous peoples, and their resultant exchange; however, it has also come to represent the dislocation of many contemporary Indigenous communities due to increasing cartel violence enacted across the country, causing many 'rural populations to flee their land and homes'.[41] These traditional untailored women's garments tell stories reflective of the people who create them, and embody sovereign Indigenous knowledges. Their unique boxy shape (Figure 15.2, Plate 20) originates from early Mesoamerican times and continues to be the standard style – appearing like an oversized tunic 'constructed of one, two, or three rectangular webs of cloth sewn together lengthwise'.[42] Within the Chiapan example, huipiles are produced on a handmade back-strap loom that is shared among women, set up in modest one-room structures found within various caracoles – where girls have the opportunity to grow up around their mothers, grandmothers and great-grandmothers who all work on the same loom. By engaging inter- and multigenerationally in such long-standing traditions, the women who make huipiles 'highlight [the] cultural continuities' that Igloliorte emphasizes are an essential process in achieving cultural sovereignty.[43]

In historian Irmgard Weitlaner Johnson's study of Chiapan huipiles, he describes their construction as 'a variation of plain weave [and] paired warp interlace in an over-and-under fashion, with weft units composed of four singles'.[44] This is also known as a 'basket weave', which produces both a vertical and horizontal pattern of interlocking threads which hold together. He explains that the huipil's 'sewing is done on the reverse side by means of tightly worked whipping stitches' where 'the raw edges [are] reinforced with closely made blanket stitches' on the back.[45] Vertical slots are left unsewn on each side for narrow arm openings and again at the top for the small neck aperture – modest slits that lend themselves to the rest of the blouse's voluminous shape. This 'boxy' effect is not banal – as many believe it serves a ritualistic function that represents the woman as the centre of the symbolic world,

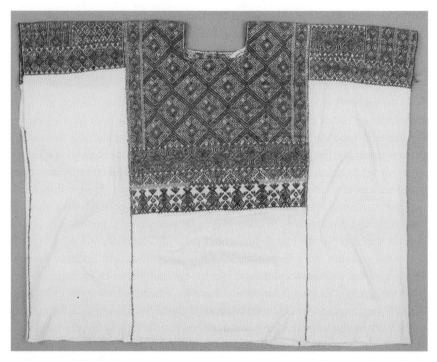

FIGURE 15.2 Blouse, *Huipil*, San Andreas Larainzar or Magdalenas, Chiapas, Mexico, Tzotzil Maya, cotton, wool, mid-twentieth century. Opekar/Webster Collection, T94.0982. Courtesy: Textile Museum of Canada.

as her head passes through the huipil's neck opening, representative of a mountain range or horizon line, seemingly into the sky. This poetic image brings to mind other considerations, like how the autonomy of resource and clothing production shares many connections with Indigenous epistemologies and ways of life, such as living off and with the land, and women-led communities. This is especially apt for Zapatista women, who were equal participants in the 1994 uprising, and continue to arm themselves and actively defend their communities, alongside men. Sadly, the realities of ongoing militancy have become increasingly needed in many Zapatista, Indigenous and rural communities, as cartel presence and power has come to affect the contemporary takeover of land, disenfranchisement and murder of Mexican people. Embroidered depictions of weapons, masks and EZLN insignias can now be found as common symbols on Zapatista-made huipiles.

In Magdalena Aldama, a Chiapan Tzotzil village near San Cristóbal famous for its weaving, local Indigenous storytelling is prominently featured on its huipiles. For instance, popular decorated huipiles typically feature vibrant geometric basket-weave patterns that incorporate Mayan iconography as trim at the bottom and along the edges of the neckline and sleeves. Such iconography might include

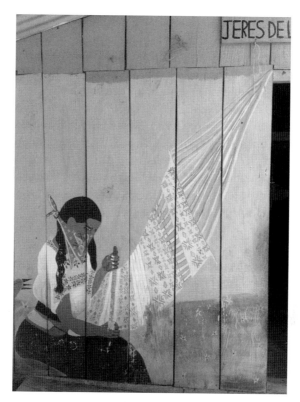

FIGURE 15.3 Woman weaving huipil, Mural, Oventic caracole, 1999, Chiapas, Mexico. Photo: Ellyn Walker, 2015.

thunderbirds, cacti flowers, burdock or ramshorn snails; or the previously mentioned examples specific to the EZLN. Embroidered on white cotton that has been cultivated, hand spun, dyed and pressed on a back-strap loom (Figure 15.3), the multicoloured threads sewn into the huipil tell a cultural and place-based story through their purposeful combination, such as the animals and plants that thrive on the same land shared with the Tzotzil and Zapatista people. Harvested from the insects that live on cacti found throughout Mexico, huipil fibres are dyed with cochineal – a natural dye that has been produced and used by Maya peoples for thousands of years. The importance of land-based perspectives is also evidenced by the survival and sustained use of early natural materials like yarn, cotton, yucca and sometimes feathers, which can be seen in formal huipiles worn on special occasions. While these pre-Hispanic natural fibres continue to be harvested and used within many Indigenous communities today; others have also been adopted, such as wool and silk introduced by the Spanish during colonization.

In addition to wearing these traditional items themselves, many Tzotzil women and girls who live in municipal areas and sovereign Indigenous caracoles weave

and embroider textiles to sell both inside and outside of their communities. These include huipiles that are decorated with plain-weave embroidery and abstract outlines of EZLN figures (easily indicated by their masked faces), or the iconic imagery of corn crops. They are sold directly to tourists, where the one-room huts popular among caracoles are carefully arranged in such a way that the huipiles for sale are located right at the entrance, with a larger area reserved for working in the back. Huipiles are also sold along the highways leading up to caracoles; or taken and sold in nearby towns, urban textile and tourist centres and worldwide Zapatista cooperatives. Thus, huipiles contribute to the empowerment of Indigenous women, their communities and their economic autonomy through their function as sovereign objects, like with arpilleras, made by 'sovereign subjects, as things, formed by power relations, materials, pressure and gravity'.[46]

Furthering this embodied sovereignty is the fact that the knowledge of their making is shared and repeated across generations, whereby huipiles take shape through the land-based, material and aesthetic teachings of Mayan women across time. In unifying the space between harvest-to-(re)production, the huipil's very material being connotes more than just physical survival; rather, it refers to the resilience of Indigenous peoples to survive and *thrive* in spite of settler-colonialism and its continued forms, which are particularly complex in the context of Mexico. Anishnaabe scholar Gerald Vizenor's notion of 'survivance' as 'an active sense of [Indigenous] presence' is relevant here, similar to Igloliorte's notion of cultural sovereignty, as it reflects the ways in which culturally specific Indigenous practices embody 'the continuance of native stories',[47] intimate modes of doing and knowing, and ongoing ancestral relations in a place. Huipiles embody this vital connection that Indigenous people have to land, place and being, and signify important sites of creative resistance to colonial, state and other emergent practices of domination and displacement.

It is important to recognize that the production of these kinds of textiles under the NAFTA is a significant and complex counteraction to global capitalist systems. The grassroots and land-based processes of huipil production also challenge the ongoing corruption within Mexico's national economy, where local and powerful criminally organized drug trafficking cartels[48] continue to take over land, control bodies and desecrate communities – a contemporary form of genocidal capitalism and alternative imagining of what can be considered *colonization*. Alongside the growing international drug economy, cartels continue to expand, spurring increase in their range of geographic control, measures of population displacement, and tactics of mass violence, including murder. Here we see both the specific and broad impacts of 'the drug trade and cartel activity on land use in diverse regions',[49] including its social, cultural, familial and environmentally destructive effects.

These are some of the economic and political circumstances that influenced the original Zapatista uprising in 1994, as well as the continued calls for Indigenous and basic human rights that have resounded since the Mexican Revolution,

which took place less than a century before. Today, increasing cartel growth and power, alongside events of government collusion, continue to mar and terrorize Indigenous and broader communities across Mexico, reflective of the urgent conditions many migrants today face. Because the making of huipiles focuses on Indigenous ways of being such as local harvest, production and sustainability, it remains important for their makers to be territorially and community-situated, to work close to the land from which the fibres, like their ancestors, originate – rather than in urban environs or cartel zones. Thus, the production of huipiles uniquely ties people to their land, and in doing so, also mobilizes Indigenous communities and knowledges through the sharing of women's intergenerational teachings and continuance of material practices, even amid shifting conditions, forms and realities of capitalism and coloniality. Huipiles also represent Indigenous resistance to Mexico's increasingly expanded cartel-dominated economy and related land-grabbing tactics, where the sale of huipiles both within and outside of Zapatista caracoles materially supports Indigenous cultural production and economic sovereignty in the face of a new colonial threat.

Aboriginal moccasin vamps

Bordered by three oceans, Canada is the world's second largest country in terms of total area mass and, like the above-mentioned locations, has been inhabited by Indigenous peoples for thousands of years. Similar to Chile and Chiapas, Canada has its own history of settler-colonialism, despite former prime minister Stephen Harper's vivid denial, when he infamously stated during the 2010 Toronto G20 Summit that 'Canada has no history of colonialism'.[50] Today, Canada is a land inhabited by Indigenous peoples, settlers, immigrants and refugees from all over the world. Yet despite its seeming 'diversity' and 'progress', it also has an epidemic of colonial violence, today acknowledged as a 'Canadian genocide', against its Aboriginal women. I use the word 'Aboriginal' here to invoke Indigeneity in the Canadian context, which includes people of First Nations, Métis and Inuit ancestry. While violence against Aboriginal women and girls in Canada sadly takes a variety of forms, I am focusing on works and practices that address their disappearance and murders; numbered at 1,200 women in the Royal Canadian Mounted Police's 2014 national report, and more recently at 4,232 by the Native Women's Association of Canada.[51] In response to this ostensibly increasing epidemic, Métis artist Christi Belcourt initiated the commemorative art project *Walking with Our Sisters (WWOS)* (2012–2020) to 'honour the lives of missing and murdered Indigenous Women of Canada and the United States; to acknowledge the grief and torment families of these women continue to suffer; and to raise awareness of this issue and create opportunity for broad community-based dialogue'.[52] Importantly, *WWOS* launched as a community-led action in spite of repeated (and, at that

time, unanswered) calls from Indigenous leaders and international human rights organizations for a national inquiry, which wouldn't begin until 2015 under Prime Minister Justin Trudeau's Liberal government. Through the project's assemblage of hand-beaded and embroidered moccasins vamps (tops), each pair memorializes a missing or murdered woman and the family, friends and citizens who have been affected and still think of her.

The loss of Indigenous women is a complex phenomenon, and, accordingly, *WWOS* is a multifaceted project. Described by Belcourt as a 'contemporary art installation', *WWOS* uniquely straddles the realms of art, community practice and Indigenous traditionalism (which refers to both sacred and nostalgic understandings of Indigenous identity). The installation consists of 1,700 pairs of handmade moccasin vamps donated by amateur and experienced makers alike who responded to Belcourt's public call for vamps to commemorate each missing and murdered Indigenous woman. Reflective of the fact that gendered and colonial violence in Canada is a social epidemic that implicates Indigenous *and* non-Indigenous people, the project was open to anyone who wanted to contribute, and 'the vamps were gathered without a curatorial filter [and] range from beautifully crafted fine art objects to aesthetically weak but affective expressions of sadness, rage, and solidarity'.[53] Since its beginnings, *WWOS* has been shown in art galleries, museums and community spaces – each context with its own set of specified conventions.

In the art institution, 'the exhibition is curator-free and abides by [distinct] protocols' such as location-based community advisory committees who set the rules of entry, and that, in turn, work to *Indigenize* the space.[54] Métis artist-curator David Garneau unpacks this process further, explaining that 'because the show is novel' in its multidisciplinary form 'and the sites are usually non-Indigenous, there are no specific protocols that cover it. Gatherings occur long in advance of the installation to discuss the right way to do things'.[55] This reflects a culturally specific, sovereign curatorial process that intervenes into dominant modes of institutional governance, curating and exhibition-making, as an exhibition's conditions for entry and presentation are normally set by its hosting institution, not its 'guests'. This reversal of the host/guest metaphor within *WWOS*'s institutional enactment offers particular relevance for conversations around decolonization, as it works to highlight the ways in which settlers are always guests on Indigenous lands in Canada (and many other places). The *WWOS* project dislocates contemporary art spaces from their traditional authoritative role, and re-centres them around Indigenous models of gathering, self-expression and sovereignty. While the project continues to be overseen by Belcourt, 'each venue is managed by a team of local women who adapt protocols and arrange the vamps according to their local meanings and needs', using the presentation of moccasins as substitutes for missing women within a site-specific framework.[56] Here, it is both their presentation and making that are of importance, where the different ways of

FIGURE 15.4 Christi Belcourt, *Walking with Our Sisters*, installation at Carleton University Art Gallery, 2015. Photo: Leah Snyder.

arranging the moccasins reflect Indigenous-only conversations and women's site-specific negotiations (Figure 15.4).

Belcourt's involvement of community-based committees also gives voice and agency to Indigenous women who have, in light of Canadian art and national histories, largely been silenced, misappropriated or ignored. The handmade vamps included in *WWOS* evidence a 'creative response that builds on and adapts tradition to express and critique a real issue faced by living Indigenous people' within a local context.[57] Alas, the ongoing crisis of missing and murdered Indigenous women and girls should be viewed as an urgent issue for all Canadians or people who now find themselves on these lands, as the open-ended participatory nature of *WWOS* reflects. This gives further relevance to the more than 230 recommendations to the federal government, police and larger Canadian public, to address this 'Canadian genocide', as outlined in the final report from the Inquiry for Missing and Murdered Indigenous Women and Girls.[58] Opportunities exist for people of diverse geographies and backgrounds to engage with the project's politics in a variety of ways: through individual moccasin creation, public exhibition viewing, attendance at the project's many parallel programs, or simply through learning more about the epidemic of violence against Indigenous women in Canada, and beyond.

Like the insight gained from studying the natural materials of Chiapan huipiles, there is also much to learn from looking at the materials that comprise Aboriginal moccasins. *WWOS* project contributor Sandra Benoit's moccasins,

for example, feature raw deer hide vamps with large peonies beaded at the top of each foot. The animal hide – that references its hunt, dissection, skinning, tanning and other preparatory acts practiced by many land-based Aboriginal communities – evidences the health of the maker's community or family with regards to their animal population, as well as knowledge of traditional methods of survival and crafts. Similarly, the practice of beading demonstrates the continuity of Indigenous cultural production, as beading has been an important artistic form for many Indigenous communities across North America, originally employing local natural materials like porcupine quills and Atlantic quahog and whelk shells, among others. Glass beads were later incorporated into both bead- and quillwork, once introduced via European contact, trade and increasing settlement across the continent (see Nicole Burisch, Chapter 3). Historically, beads were also used to record treaties, important events and oral traditions within Indigenous societies, as well as in exchange, or later as a form of currency with European settlers. The process of physically sewing beads into natural fibre or animal hide has been passed down through generations of grandmothers, where, as is the case in Chile and Chiapas, embroidery remains a largely women-centred practice within Aboriginal communities.

More specifically, beading plays a historical and pedagogical role in the practice of individual and cultural sovereignty, as its endurance across different generations of women most often went hand in hand with conversations about their community and its histories.[59] In such a setting, beaded creations embody critical cultural histories, feminist and intergenerational practices, as well as deeply personal meanings. With this perspective, the various makers of *WWOS* moccasins demonstrate their solidarity with the struggle for Indigenous and women's rights through their volunteer participation in the project, and continuance of culturally-specific practices. Each stitch that pierces the animal skin – akin to the individual and collective violence inflicted on Indigenous women's bodies – symbolizes a kind of 'repair', wherein the attentive connection of each bead stitched to the expanded object is a tactile example of a relationship of holding, as well as care.

In addition to their gathering and presentation, the act of making and contributing moccasin vamps is akin to materializing and holding space for human presence: for the women who have been lost or 'disappeared'. This reflects a simultaneous gesture of individual and collective 'remembrance', to invoke the words of Simon again, where the project's multifaceted processes of creation, collecting, organizing and visualizing allow for intimate moments of recollection. Moccasin beading, particularly within the *WWOS* project, also represents important evidence of cultural continuity and Indigenous survival in spite of ongoing realities of colonial oppression and gendered, genocidal violence, as the project's contributors are participating in an Indigenous-centred framework. Igloliorte describes the deeply politicized context in which many contemporary

Indigenous artists work. She outlines how their participation in 'the creation and appreciation of artwork that resists and subverts the legacies of colonization,'[60] works to directly support the larger struggle for Indigenous cultural sovereignty. Despite the alarming rate at which Aboriginal women and girls disappear or are subject to violence – twelve times more likely to be murdered than any other demographic in Canada[61] – women continue to thrive on this land and refuse to accept the realities of colonial injustice, as evidenced in their artistic work and collaborative imagining. The beaded and embroidered vamps embody hopefulness and resistance to domination using creativity as a vehicle to make visible the ways in which missing and murdered Aboriginal women are by no means forgotten, but rather, continuously remembered.

Conclusion

In the resistance to the violence of gender-based oppression, vibrant worlds have emerged.[62]

– Heather Davis

The continued use of piercing and knotting techniques in fabric – known also as embroidery – has enduring potential as a creative and tensive mode of feminist expression and resistance. Its use in diverse forms of artistic production over time demonstrates this relevance across varied practices, cultures and geographies. The significance of embroidery to Indigenous, activist and other cultural-specific groups of women runs throughout this text – as it reflects the ways in which oppressed communities mobilize unique and imaginative responses to colonial injustices through creative practices of resistance, sovereignty and remembering. For instance, the Chilean arpilleras underscore feminist and anti-colonial modes of counter-storytelling. The Chiapan and Canadian Aboriginal examples offer evidence of material ways in which 'decolonization offers different pathways for reconnecting Indigenous nations with their traditional land-based cultural practices [and how] the decolonization process operates at multiple levels', connecting personal and bodily agency and tradition with notions of broader cultural sovereignty. Thus, embroidery is an essential contribution to decolonial work that 'necessitates moving from an awareness of being in struggle, to actively engaging in everyday practices of resurgence'.[63] The arpilleristas, Zapatistas and rural Tzotzil women, and *WWOS* participants all demonstrate this shift from mourning and disempowerment to critical action through their creation of embroidered artworks. The varied case studies also remind us of the fact that decolonization is not only the project of Indigenous makers and communities, but rather, a different way of living and relating to the world that must involve all of us in both its undoing and remaking.

Several common elements exist across cultures that use textiles as a means of protest.[64] Rozsika Parker provides a partial account of the ways in which embroidery has coincided with social change and, alongside this, white women's empowerment. By looking at culturally specific examples of embroidery across three distinct geographies in the Americas, I am participating in an expanded analysis of feminist visual and material culture, and contemporary craft theory, informed by intersectional and decolonial approaches. Taking a cue from contemporary art curator cheyanne turions' notion that negotiation is an intimate form of sovereignty,[65] I hope this text honours the artistry and culturally-specific relationships that the arpilleras, huipiles, moccasins and their makers embody, and how they evidence unique practices of cultural imagining, continuance and sovereignty. I have attempted to demonstrate the usefulness of thinking about embroidery akin to decolonization, as both are *processes* – ones that involve multiple ways of doing and knowledge-creation, rather than singular or homogenous approaches. Embroidery also represents an important site of feminist agency, mobilizing women and their communities through processes of both learning *and* practice. While Parker's pivotal text on embroidery uses feminist art history to support nationalist narratives, this essay instead looks at particular examples within the frameworks of anti-colonial and Indigenous feminisms that contrast, complicate and unhinge such attempts. The pursuit of decolonization in the Chilean, Mexican and Canadian contexts requires rejecting dominant stories of feminism, nationalism and sovereignty, and demands 'figuring out what kind of story we intend to live in its place'.[66] Embroidery is an incredibly storied site, and, as such, has much to tell – *when we choose to listen.*

Notes

1 Julia Bryan-Wilson, *Fray: Art and Textile Politics* (Chicago: University of Chicago Press, 2017), 1.

2 Emma Battell Lowman and Adam J. Barker, *Settler: Identity and Colonialism in 21ˢᵗ* (Winnipeg, Canada: Fernwood Books, 2015), 121.

3 Heather Igloliorte, 'Arctic Culture, Global Indigeneity', in *Negotiations in a Vacant Lot: Studying the Visual in Canada*, ed. Kirsty Robertson and Erin Morton (Montreal: McGill-Queen's University Press, 2014), 151.

4 Ibid., 153.

5 'Decolonization' refers to both short- and long-term acts that counter the ways in which colonization constructs contemporary individual and social life. Cherokee scholar Jeff Corntassel describes decolonization as ongoing and 'everyday acts of resurgence' that regenerate Indigenous knowledges, epistemologies, and ways of being that can 'embrace a daily existence conditioned by place-based cultural practices' that centre on Indigenous land, sovereignty and ways of thinking. See Jeff Corntassel, 'Re-envisioning Resurgence: Indigenous Pathways to Decolonization and

Sustainable Self-determination', *Decolonization: Indigeneity, Education & Society*, vol. 1, no. 1. (2012): 89.

6 Rozsika Parker, *The Subversive Stitch: Embroidery and the Making of the Feminine*, 1st ed. (London: I. B. Tauris, 1984), ix.

7 'Colonization' refers to the act of establishing control over another sovereign area. Colonization uses the concept of 'terra nullius', or the belief that 'the land belongs to no one', to legitimize expansion into other territory as a 'civilizing' project.

8 'Settler-colonialism' is an ongoing form of colonization that is specific to the acquisition, claiming and theft of territory. It focuses on land as a resource and uses occupation as a way to dispossess Indigenous peoples from their original territories.

9 Bryan-Wilson, *Fray: Art and Textile Politics*, 5.

10 See also Janet Catherine Berlo (ed.), *The Early Years of Native American Art History* (Vancouver: University of British Columbia Press, 1992); Sophie Woodward, 'Object Interviews, Material Imaginings and "Unsettling" Methods: Interdisciplinary Approaches to Understanding Materials and Material Culture', *Qualitative Research*, vol. 16, no. 4 (July 2015): 359–74; and Allyson Mitchell, 'Sedentary Lifestyle: Fat Queer Craft', *Fat Studies*, vol. 7, no. 2 (Spring 2018): 147–58.

11 See Eve Tuck and K. Wayne Yang, 'Decolonization Is Not a Metaphor', *Decolonization: Indigeneity, Education & Society*, vol. 1, no. 1 (2012): 1–40; and David Garneau, 'Imaginary Spaces of Conciliation and Reconciliation: Art, Curation and Healing', *West Coast Line*, no. 28 (Summer 2012): 28–38.

12 Igloliorte, 'Arctic Culture, Global Indigeneity', 153.

13 'Resurgence' refers to the regeneration of Indigenous ways of being and thinking, and to culturally specific practices, knowledges and epistemologies of Indigenous peoples.

14 Janet Catherine Berlo, 'Beyond Bricolage: Women and Aesthetic Strategies in Latin American Textiles', in *Textile Traditions of Mesoamerica and the Andes*, ed. Margot Blum Schevill, Janet Catherine Berlo and Edward B. Dwyer (New York: Garland, 1991), 439.

15 Marjorie Agosín, *Tapestries of Hope, Threads of Love: The Arpillera Movement in Chile*, 2nd ed. (Toronto: Rowman & Littlefield, 2008), 2.

16 Ibid.

17 Chile's second national Truth Commission Report on Torture and Political Imprisonment, 2011.

18 Agosín, *Tapestries of Hope*, 21.

19 Ibid., 15.

20 Ibid., 24.

21 Ibid., 18.

22 Ibid., 27.

23 Roger I. Simon, *A Pedagogy of Witnessing: Curatorial Practice and the Pursuit of Social Justice* (New York: Suny Press, 2014), 4.

24 Agosín, 18.

25 Bryan-Wilson, *Fray: Art and Textile Politics*, 149.

26 Ibid., 150.

27 Ibid.

28 Indigenous peoples comprise approximately 9 per cent of Chile's population, wherein the Mapuche are the largest of the eight Indigenous groups that are currently state-recognized.

29 Tuck and Yang, 'Decolonization', 36.

30 Ibid., 35.

31 Agosín, *Tapestries of Hope*, 22.

32 Ibid., 19.

33 Ibid., 172.

34 Ibid., 73.

35 Ibid., 18.

36 Ibid., 73.

37 Bryan-Wilson, *Fray: Art and Textile Politics*, 159.

38 Duncan Earle and Jeanne Simonelli, 'Zapatista Autonomy in Cartel Mexico: Preserving Smallholder Viability', *Culture, Agriculture, Food and Environment*, vol. 33, no. 2 (December 2011): 135.

39 Tuck and Yang, 'Decolonization', 6.

40 Agosín, *Tapestries of Hope*, 16–17.

41 Earle and Simonelli, 'Zapatista Autonomy in Cartel Mexico', 133.

42 Irmgard Weitlaner-Johnson, 'Survival of Feather Ornamented Huipiles in Chiapas, Mexico', *Journal de la Société des Américanistes*, vol. 46, no. 1 (1954): 189.

43 Igloliorte, 'Arctic Culture, Global Indigeneity', 153.

44 Ibid., 192.

45 Ibid., 190.

46 cheyanne turions, 'Subjects as Things', blog post, 2 June 2014, https://cheyanneturions.wordpress.com/2014/06/02/subjects-as-things/ (accessed 15 November 2017).

47 Gerald Vizenor, *Manifest Manners: Narratives on Postindian Survivance* (Lincoln: University of Nebraska Press, 1999), vii.

48 I would like to complicate popular notions of the 'cartel', particularly in the context of Western notions of criminality, where cartels are solely understood as drug trafficking enterprises akin to a 'gang.' In Canada's colonial context, corruption and racism within the Royal Canadian Mounted Police as well as local and provincial police forces throughout the country are well noted, as known perpetrators of violence against Indigenous peoples. The RCMP and local police organizations can also be thought of as collective governing bodies of specific jurisdictions that operate as a kind of 'cartel'.

49 Earle and Simonelli, 'Zapatista Autonomy in Cartel Mexico', 134.

50 Derrick O'Keefe, 'Harper in Denial at G20: Canada Has "No History of Colonialism"', *Rabble*, 28 September 2009, rabble.ca/blogs/bloggers/derrick/2009/09/harper-denial-g20-canada-has-no-history-colonialism (accessed 2 June 2016).

51 John Paul Tasker, 'Confusion Reigns Over Number of Missing, Murdered Indigenous Women', *CBC News*, 16 February 2016, http://www.cbc.ca/news/politics/mmiw-4000-hajdu-1.3450237 (accessed 1 July 2016).

52 Christi Belcourt, 'Walking with Our Sisters', 21 June 2015, christibelcourt.com/walking-with-our-sisters/ (accessed 1 June 2016).

53 David Garneau, 'Indigenous Criticism: On Not Walking with Our Sisters', *Border Crossings*, vol. 34, no. 2 (Spring 2015): 5.

54 Ibid., 4–5.

55 Ibid., 5.

56 Ibid., 4–5.

57 Garneau, 'Indigenous Criticism', 5.

58 The final report, culminating with the Inquiry for Missing and Murdered Indigenous Women and Girls, was released on 3 June 2019.

59 See Janet Catherine Berlo and Ruth B. Phillips, *Native North American Art* (Oxford: Oxford University Press, 1998).

60 Igloliorte, 'Arctic Culture, Global Indigeneity', 165.

61 John Paul Tasker, 'Inquiry into Missing and Murdered Indigenous Women Issues Final Report with Sweeping Calls for Change', *CBC News*, 3 June 2019.

62 Heather Davis, 'Introduction', *Desire Change: Contemporary Feminist Art in Canada* (Montreal: McGill-Queen's University Press and Mentoring Artists for Women's Art, 2017), 4.

63 Corntassel, 'Re-envisioning Resurgence', 89.

64 Agosín, *Tapestries of Hope*, 19.

65 turions, 'Subjects as Things'.

66 Lowman and Barker, *Settler*, 120.

16 URSULA JOHNSON: WEAVING HISTORIES AND *NETUKULIMK* IN *L'NUWELTI'K (WE ARE INDIAN)* AND OTHER WORKS

Heather Anderson

Like their maker, Ursula Johnson's baskets are compelling storytellers. In Johnson's art practice, weaving gives form to memory and experience, narrating how colonialism and legislation mark Indigenous peoples' lives, while her critique of the museological treatment of Indigenous art forms and objects, and personal practice of *Netukulimk* (which can be expressed as 'self-sustainability' in Mi'kmaw), engage in processes of decolonization. Drawing on Mi'kmaq[1] cultural traditions from her upbringing on Waycobah and Eskasoni First Nations in Cape Breton, Johnson has developed the ash-splint basket weaving techniques she learned from her great-grandmother, Caroline Gould, into a performative and sculptural art practice. Woven from supple, blonde strips of black ash, Johnson's basket forms hold the shapes of individuals and their identities in her series *L'nuwelti'k (We Are Indian)* (Figure 16.1, Plate 22), enact a symbolic scalping in *Elmiet* and infiltrate the museum in *O'pltek (It Is Not Right)* and *The Archive Room*, while appearing as ghostly images in *The Museological Grand Hall*. Johnson's adaption of Mi'kmaw basketry transgresses and expands its conventions. She draws us into the story of its shifting status within museums, archives and contemporary art, and rekindles traditional knowledge and connections to the land through *Netukulimk*.

Storytelling is an essential part of craft, and as Walter Benjamin noted, 'the Latin word for "text," textum, means something woven.'[2] Among the stories Johnson shares in artist talks is how she first integrated Mi'kmaw basketry and contemporary art

FIGURE 16.1 Ursula Johnson, *Male Dis-enfranchised, L'nuwelti'k (We Are Indian)*, 2014, performance organized by Carleton University Art Gallery as part of *Making Otherwise: Craft and Material Fluency in Contemporary Art*. Photo: Justin Wonnacott.

for *Nations in a Circle*, an Indigenous art showcase at Dalhousie University's Arts Centre in 2003. Feeling alienated as one of the few Indigenous students at the Nova Scotia College of Art and Design where the curriculum didn't reflect her culture, Johnson undertook to weave a basket around herself. She recalls entering into this early performance with a naïve, art school bravado. Not having woven a basket since she was nine, she soon found herself humbly asking the elder Mi'kmaq basket makers present for help.[3] Once she had succeeded in enclosing herself in the woven structure, she desired to remain inside, protected by the basket and her culture.[4] Johnson restaged this endurance performance as *Basket Weaving (Cultural Cocoon)* in 2011 for *Debajehmujig Six Foot Festival* on Manitoulin Island, and for *Planet Indigenous* at Toronto's Harbourfront Centre in 2012.

In reaching out to members of her community, Johnson recognized that she needed her elders in order to understand her identity and art practice. In 2008, she

began studying Indigenous art forms in relation to *Netukulimk*, which she describes as the Mi'kmaw world-view encompassing one's relationship to the land and surrounding elements. While interviewing elders, Johnson was struck by her great-grandmother's concern that basketry would die out because the younger generation couldn't identify the trees from which baskets were made, let alone weave them. This inspired Johnson to investigate how Mi'kmaw basketry reflects *Netukulimk*.

In 2009 Johnson began to learn how to identify, harvest and prepare trees required to weave baskets. Squaring an ash tree, splitting it into splints and peeling it into strips for weaving is labour intensive, and, as she learned from her grandfather, requires deep knowledge and mastery. In her durational performance *Processing* (2014–ongoing), realized over several days at each venue of the exhibition *Mi'kwite'tmn (Do You Remember)*,[5] Johnson used family tools to process a white ash tree she had harvested. However, instead of creating strips used in basket weaving, she obliterated the tree into shavings that were left strewn on the floor to convey her generation's poor understanding of *Netukulimk*.

As black ash trees in Nova Scotia are scarce due to colonial overharvesting and susceptibility to disease, Johnson sources ash strips from Quebec from the same person her great-grandmother did. Her great-grandmother has been foundational to Johnson's development as an artist. Johnson honoured her by curating *Kloqowej (star): A 30-year retrospective of Caroline Gould* for the Mary E. Black Gallery in Halifax.[6] Gould inspired Johnson's own basket making and inquiry into how baskets are commodified and enter into private collections, or public museums as 'artefacts'. Johnson first made traditional forms like those of her great-grandmother, who taught her that a basket's foundation or base is the most important element. She also learned various techniques such as the star weave, and how to create curls, twists, bends and shapes that one could not imagine coming from a solid tree. Gould's teachings that the maker does not manipulate the wood, but rather the wood manipulates the maker into understanding what it can do,[7] is echoed in anthropologist Tim Ingold's assertion that the basket weaver must 'join with and follow the forces and flows of material that bring the form of the work into being'.[8] Gould's counsel underscores Indigenous recognition of materials participating with the basket weaver, akin to what Karen Barad describes as an 'intra-active relationship', whereby 'subject and object emerge' through intra-action and causality.[9] As feminist anthropologist Zoe Todd asserts, such Indigenous worldviews of the non-human as sentient and agential have been overwhelmingly overlooked in recent discourse of the 'ontological turn' with its 'breathless "realisations" that animals, the climate, water, "atmospheres" and non-human presences like ancestors and spirits are *sentient* and *possess agency*'.[10]

In Johnson's hands, the wood materializes stories of colonization's ongoing effects and processes, while also enacting steps towards decolonization. Her performance *Elmiet* (2010) arose from a 'conversation' she had with a statue of

Halifax's founder, Governor Edward Cornwallis, in an eponymous downtown park. Created for the city's *Nocturne* and *Prismatic* festivals, *Elmiet*, which means 'he/she is going home', commenced with Johnson, wearing a dramatic headpiece woven from ash, maple, cane reeds and sweet grass, being led through Halifax streets by *parkourists*.[11] Accompanied by musicians, they arrived after dark at the Grand Parade opposite City Hall. Johnson addressed the crowd, calling for a volunteer to participate in a 'scalping ceremony'. A man who came forward followed Johnson's instructions, placing his hands on either side of her head while she pretended to struggle, and violently removed her headpiece when a traditional song sung by Nathan Sack ended.[12] Johnson proclaimed this the last scalping in Nova Scotia. Throughout the performance, her entourage distributed postcards stating the wording of the British Scalp Proclamation, reissued by Governor Charles Lawrence in 1756, for which a bounty was paid for captured Indigenous persons or their scalps.[13] Johnson invited people to use the postcards to write to the government of Canada to demand the proclamation's removal, which has never been repealed despite requests by Mi'kmaq leaders and a public apology by Nova Scotia's government in 2000.[14]

Johnson's series of portrait busts, *L'nuwelti'k (We Are Indian)* (2012–ongoing), engages another piece of legislation with a long and problematic history: Canada's Indian Act and its definition of who is entitled to Indian status according to Indian Registration and Membership Codes.[15] To create each portrait, Johnson issued a call for volunteers who self-identified with a particular code, such as 'Male 6.1, Off-Reserve', 'Male 6.2 Disenfranchised' or 'Female, Métis, Nomadic', to participate in a performance. Each performance comprises Johnson weaving an inverted basket form that extends from the top of the participant's head to their shoulders, a process lasting about an hour (Figure 16.2).[16]

Woven from pale yellow strips of black ash, the minimal, undulating forms powerfully evoke a sense of their sitter's presence and individuality. The portraits are presented separately on plinths in the gallery, referencing the Western tradition of busts that commemorate important individuals. Yet Johnson's portraits remain anonymous, identified only by the Indian Registration and Membership Codes included in the titles on wall labels. In this way, *L'nuwelti'k (We Are Indian)* foregrounds the categories and criteria by which Indian status is conferred in Canada, parallel to the categorization of Indigenous objects in museums. Johnson eschews the museum practice of presenting ethnographic objects under Plexiglas, instead enabling viewers to experience these portraits more directly. Inside each woven form, she has tucked an artefact tag with the name of the individual and their status code as a private record of the portrait's making and interaction between artist and sitter.

Johnson's great-grandmother also taught her the vocabulary of basket making, underscoring that if younger generations didn't learn basket weaving, these Mi'kmaq words would be lost along with the art. This potential loss struck a chord with Johnson, who fluently speaks Mi'kmaw, her first language. *The Museological*

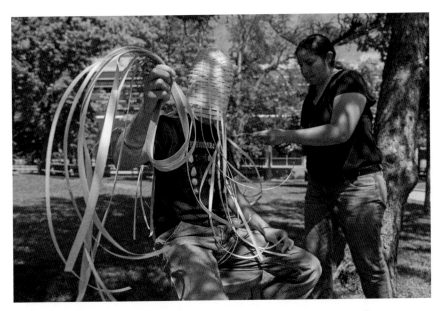

FIGURE 16.2 Ursula Johnson, *Male Dis-enfranchised, L'nuwelti'k (We Are Indian)*, 2014, performance organized by Carleton University Art Gallery as part of *Making Otherwise: Craft and Material Fluency in Contemporary Art*. Photo: Justin Wonnacott.

Grand Hall, created for *Mi'kwite'tmn*, features diagrams of various Mi'kmaq baskets and terminology as ghostly white drawings on the sides of the Plexi display cases (Figure 16.3, Plate 21, detail).[17]

Applying Gould's teaching that a good foundation is the basis for innovation, Johnson translates her sense of the world as an urban Indigenous person practicing *Netukulimk* into new basket prototypes. For instance, as part of the *O'pltek (It is Not Right)* series (2010–ongoing), Johnson wove the shape of a traditional fishing creel from black and white ash, maple, sweet grass and twine,[18] embellishing it to make it 'more like a purse' better suited to bringing farmed fish home from a store, rather than wild fish from a lake.[19] While these baskets initially read as traditional, one notices some are unusually small while others are unconventional, even anthropomorphic in shape. During a residency at Mount Saint Vincent University Art Gallery in 2012, Johnson played upon the authorship and authenticity expected of Indigenous objects by soliciting people to draw in her sketchbook 'what you think a basket should be'. Highlighting how discourses of anthropology, archaeology and museology frame understanding of Indigenous objects and their categorization in museum collections, Johnson hosted a 'cataloguing party', inviting the public to play the role of an 'ologist' and propose names for new basket forms using a 'Mi'kmaw Nomenclature Reference Guide' she created.[20]

Furthering this critique of how Indigenous objects are subjected to Western taxonomies, Johnson made a humorous catalogue database as part of her ongoing

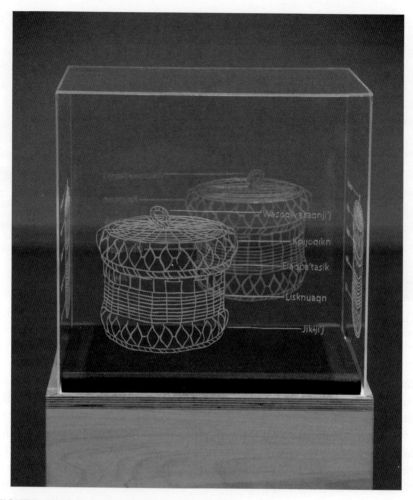

FIGURE 16.3 Ursula Johnson, *Museological Grand Hall*, 2014, 12 etched Plexiglas vitrines of varying dimensions, installation detail from *Mi'kwite'tmn (Do you remember)* at Saint Mary's University Art Gallery, 2014. Photo: Steve Farmer.

project *The Archive Room* for *Mi'kwite'tmn.* Participants don white gloves to select *O'pltek* baskets from shelving units to read, with the aid of a barcode scanner, Johnson's witty database entries that call museum collecting practices and presumed authoritative knowledge into question: a basket for holding a cell phone, a basket for house spiders, and a basket for a village clothing maker's buttons, among other more or less plausible forms.[21] By inviting gallery visitors to handle her works, Johnson counters the museum embargo on touch, enriching visual engagement with haptic experience. As artist/curator David Garneau advocates, it is through handling and using Indigenous objects that meaning and value are

conveyed.[22] *The Archive Room* expanded as more baskets were created during residencies and as *Mi'kwite'tmn* travelled.

With works such as *L'nuwelti'k (We Are Indian)*, *The Museological Grand Hall* and *The Archive Room* Johnson intervenes into museological practices whereby Indigenous objects are presented in ways so divorced from cultural context and contemporary Indigenous people and their experiences, that settler-audiences often assume the culture on display belongs to people of the distant past. Through interweaving craft, *Netukulimk* and contemporary art forms, Johnson tells a different story. Her works insert experiences of Indigenous individuals as part of contemporary, changing cultures into galleries and museums, confronting the role these and other institutions play in ongoing processes of colonization. As historian Amy Lonetree outlines, such critical engagements and collaborations with museums and galleries have the potential to begin decolonizing these spaces, which, given their histories and treatment of Indigenous peoples and their culture, 'can be very painful sites for Native peoples'.[23] Johnson's projects such as *Elmiet* and *L'nuwelti'k (We Are Indian)* speak 'hard truths of colonialism' through the poetics of material and performance 'thereby creating spaces for healing and understanding'.[24]

Although Johnson feels she has much to learn before becoming a basket maker of her great-grandmother's stature, she skilfully and beautifully weaves *Netukulimk* together with history, memory and narratives of power and identity. She uniquely integrates basket weaving with performance and installation, entering into conversation with contemporary Indigenous artists making baskets including British Columbia-based Meghann O'Brien (Haida-Kwakwaka'wakw) who weaves traditional cedar baskets, and Olympia, Washington-based Gail Tremblay (Onondaga and Mi'kmaw) who creates traditional Mi'kmaq basket forms using 16 mm film and other materials. These artists are among a growing wave seeking out and incorporating traditional Indigenous skills and knowledge into the production of contemporary art in ways that foster sustainability akin to *Netukulimk*.[25]

For Johnson, integrating basket making into contemporary art practice has become her way of practicing *Netukulimk*. In so doing, Johnson is reshaping Mi'kmaw basketry while weaving new strands into discourses and practices of decolonization. Her basket weaving, like storytelling, 'mirrors a mode of processing and reconstituting experience'.[26] The stories Johnson weaves articulate and speak back to the continued impact of colonialism, bringing new objects and experiences into being.

Notes

1 The Mi'kmaw language uses the singular Mi'kmaw with singular nouns and the plural Mi'kmaq with plural nouns.

2 Esther Leslie, 'Walter Benjamin: Traces of Craft', in *The Craft Reader*, ed. Glenn Adamson (London: Berg, 2010), 388.

3 Mary Elizabeth Luka, 'Nuji'tlateket (One Who Does It): An Interview with Ursula Johnson', *NOMOREPOTLUCKS 32:perform,* http://nomorepotlucks.org/site/ nujitlateket-one-who-does-it-an-interview-with-ursula-johnson-m-e-luka/ (accessed 27 September 2015). Johnson also related this experience in conversation with Cara Tierney at Carleton University Art Gallery, 20 June 2014.

4 Ibid.

5 *Mi'kwite'tmn (Do You Remember)* was presented at Saint Mary's University Art Gallery (7 June–3 August 2014), and toured to Kenderdine Art Gallery (26 September–12 December 2014); Confederation Art Centre (17 January–3 May 2015); Grenfell Campus Art Gallery (24 September–12 December 2015); University of Lethbridge Art Gallery (19 January–9 March 2017); The Reach, Abbotsford, British Columbia (21 September–31 December 2017); McMaster Museum of Art, Hamilton, Ontario (1 September–8 December 2018); https://www.mikwitetmn.ca/#exhibition.

6 The exhibition was held from 13 January to 27 February 2011 at the Mary E. Black Gallery.

7 Ursula Johnson, 'First Nations Cultural Preservation Through Art: Ursula Johnson', *TEDx Halifax*, 2012, https://ursulajohnson.wordpress.com/videos/ (accessed 27 September 2015).

8 Tim Ingold, 'The Textility of Making', *Cambridge Journal of Economics*, vol. 34, no 1 (2010): 97.

9 Karen Barad describes 'intra-action' as 'a new way of thinking causality. It is not just a kind of neologism, which gets us to shift from interaction, where we start with separate entities and they interact, to intra-action, where there are interactions through which subject and object emerge, but actually as a new understanding of causality itself.' See Rick Dolphijn and Iris van der Tuin, 'Matter Feels, Converses, Suffers, Desires, Yearns and Remembers. An Interview with Karen Barad', *New Materialism: Interviews & Cartographies*, http://quod.lib.umich.edu/o/ ohp/11515701.0001.001/1:4.3/--new-materialism-interviews-cartographies?rgn=div2 ;view=fulltext (accessed 18 July 2016).

10 As Todd makes clear, it is imperative to acknowledge Indigenous epistemologies and the scholars writing on these topics, as to do otherwise perpetuates colonization, the exploitation of Indigenous peoples and white Western supremacy within the academy. Zoe Todd, 'An Indigenous Feminist's Take on the Ontological Turn: Ontology Is Just Another Word for Colonialism', *Journal of Historical Society*, vol. 29, no. 1 (March 2016), 4–22 (original emphasis) or Todd's 24 October 2014 blog post of the same title, https://zoeandthecity.wordpress.com/2014/10/24/ an-indigenous-feminists-take-on-the-ontological-turn-ontology-is-just-another- word-for-colonialism/ (accessed 8 February 2016). See also Jessica L. Horton and Janet Catherine Berlo, 'Beyond the Mirror: Indigenous Ecologies and "New Materialisms" in Contemporary Art', *Third Text*, vol. 27, no. 1 (January 2013): 17–28.

11 *Parkour* is a practice of moving through an environment by running, climbing, vaulting, jumping, and so on. It evolved from military obstacle course training. *Wikipedia*, https://en.wikipedia.org/wiki/Parkour (accessed 11 April 2016).

12 David Murray, *Ea-pea Dave's Terra Nova*, blog entry of 18 October 2010, http://epterranova.blogspot.ca/2010/10/elmiet-october-16–2010.html (accessed 31 October 2014).

13 The British Scalp Proclamation was first issued by Governor Cornwallis in 1749 in response to ongoing clashes between the British and Mi'kmaq, which included taking scalps by both sides. Prior to returning to England in 1752, Cornwallis rescinded the bounty proclamation in an effort to make peace with the Mi'kmaq. Governor Lawrence reinstated the bounty in 1756. See www.governorconrwallis.com and http://www.ictinc.ca/aboriginal-peoples-the-mi'kmaq-people-of-nova-scotia (both accessed 22 October 2015).

14 See 'Two Hundred Year-old Scalp Law Still on Books in Nova Scotia', *CBC News* posted 4 January 2000, http://www.cbc.ca/news/canada/two-hundred-year-old-scalp-law-still-on-books-in-nova-scotia-1.230906; and 'British Scalp Proclamation 1756', http://www.danielnpaul.com/BritishScalpProclamation-1756.html, and 'All Doubletalk, Not Action on Repealing Scalp Proclamation', Daniel N. Paul web site http://www.danielnpaul.com/Col/2000/BritishScalpBountyStillOnBooks.html. See also 'Elmiet', https://ursulajohnson.wordpress.com/videos/ (all accessed 31 October 2014).

15 The Indian Act was developed through separate pieces of colonial legislation regarding Indigenous peoples across Canada, beginning with the *Gradual Civilization Act* of 1857 and the *Gradual Enfranchisement Act of 1869*. In 1876, these were consolidated as *the Indian Act*. The Indian Act has been amended several times, most recently in 1985 in response to a United Nations Human Rights Committee and the Canadian Human Rights Commission identification of Section 12 of the Indian Act as a human rights abuse and discriminatory along gender lines because it removed a woman's Indian status if she married a non-Indian man. Bill C-31 was passed in 1985 to ensure that those who had lost Indian status through marrying out and other forms of Enfranchisement could apply to regain status. Sharon McIvor successfully challenged Bill C-31 in the Supreme Court of British Columbia for only allowing those whose status has been reinstated to pass it on to the succeeding generation. In June 2009, the court ruled this limitation as unconstitutional and in violation of Section 15 of the Charter of Rights and Freedoms. The government is currently in the process of amending the Indian Act. See http://indigenousfoundations.arts.ubc.ca/home/government-policy/the-indian-act.html and https://www.aadnc-aandc.gc.ca/DAM/DAM-INTER-HQ/STAGING/texte-text/1876c18_1100100010253_eng.pdf, (accessed 20 March 2016).

16 *L'nuwelti'k (We Are Indian)* comprises twenty-two portraits to date, created in public and private sittings. Johnson follows each performance with a private debriefing with the sitter to discuss what emotions and reflections may have arisen for them, while they were at the centre of this public performance, about their Indian status. The first *L'nuwelti'k* performances were site-specific: four portraits were created in 2012 in the atrium of Dalhousie University's Schulich School of Law, where Johnson engaged future lawyers in conversation about the project; the next four were created in 2013 at the Galerie d'art de Louise et Reuben Cohen and Law Library at the Université de Moncton; and two more were created in Carleton University's quad opposite Ojigkwanong, the Indigenous students' centre. One portrait was created at Mount Saint Vincent University Art Gallery in Halifax in a public performance as part of Carleton University Art Gallery's touring exhibition *Making Otherwise: Craft and*

Material Fluency in Contemporary Art (2014). Johnson created two public portraits in Toronto, and two privately (2014); one additional private portrait in Saskatoon; two public portraits in Listuguj, Quebec as part of Vaste et Vague's programming (2014); three private portraits in Lower Sackville, Nova Scotia; and one in a public performance as a part of *Memory Keepers* (2014) at Urban Shaman in Winnipeg.

17 The images of the baskets and terminology are etched onto the surface of the four Plexiglas sides of each display case through a multistep laborious process. Johnson translates photographs of baskets into drawings on acetate that are then scored onto masking film to create silkscreen images, which are then 'stamped' onto the protective film covering the Plexiglas, and then sandblasted into the Plexiglas surface. Ursula Johnson, email correspondence with the author, 3 November 2015.

18 The *O'pltek* series was first exhibited at the Thunder Bay Art Gallery in the exhibition *O'pltek (It Is Not Right)* (2010), curated by Nadia Kurd. It is now part of *The Archive Room* installation.

19 *TEDx Halifax*, 'First Nations Cultural Preservation Through Art: Ursula Johnson'.

20 Ursula Johnson, email correspondence with the author, 3 November 2015.

21 Johnson created this database with the aid of a photographer and designer to parallel the kind of database that one might find in a major museum. Ursula Johnson, email correspondence with the author, 3 November 2015.

22 David Garneau, public presentation as part of Accessing the Museum, Ottawa Art Gallery, 3 May 2016. See also 'Marginalized by Design', *Bordercrossings*, no. 137 (March 2016), 62–65: http://bordercrossingsmag.com/article/marginalized-by-design (accessed 26 April 2016).

23 Amy Lonetree, *Decolonizing Museums: Representing Native America in National and Tribal Museums* (Chapel Hill: University of North Carolina Press, 2012), 1.

24 Ibid., 5.

25 I am thinking of artists such as Olivia Whetung (Anishinaabe) whose works translate spectrograph recordings of herself learning to speak Anishinaabe into beaded sculptural installations, and Nadia Myre (Anishinaabe) and Ruth Cuthand (Plains Cree) who create large-scale, conceptual beadworks that tackle political issues such as the Indian Act and diseases that have ravaged Indigenous populations respectively. Alexandra Nahwegahbow curated *Always Vessels* for Carleton University Art Gallery (11 September–12 November 2017), an exhibition that explored contexts and processes of learning, and the transfer and continuity of customary practices within contemporary Indigenous art.

26 Leslie, 'Walter Benjamin: Traces of Craft'. 387.

17 'THE BLACK CRAFTSMAN SITUATION': A CRITICAL CONVERSATION ABOUT RACE AND CRAFT

Sonya Clark, Wesley Clark, Bibiana Obler, Mary Savig, Joyce J. Scott and Namita Gupta Wiggers

Introduction

In 1972, Francis Sumner Merritt, director of Haystack Mountain School of Crafts in Deer Isle, Maine, was struggling to recruit African American instructors and students to a 1974 international summer session featuring instructors from African countries.[1] Merritt asked Brooklyn-based weaver Allen Fannin for help, acknowledging the dearth of diversity at Haystack: 'I realize that we just haven't taken enough initiative in developing the relationship ... I hope you could help us make some contacts for enrollment.'[2] In response, Fannin described the 'black craftsman situation' to Merritt (Figures 17.1–17.3). He suggested that while the political goals of the craft revival were devised with good intentions, they did little to address the everyday needs of non-white artists.

Merritt and Fannin went on to organize the 1974 summer session 'American Black Crafts' to coincide with the session led by African artists. The joint summer session was attended by established and emerging artists in the field, including Arthur Green and Joyce J. Scott. A few months later, one of the attendants, poet potter M. C. Richards, reflected:

> The one moment that still hangs in my memory like a question is the departure of the Africans, with much ado, swooped off by the 2 young guides + guardians

Mr. Fran Merritt 19 January 1972
Centennial House
Deer Isle, Maine
04627

Dear Fran:

Your letter of Dec. 29th has been sitting here
waiting for me to get Dorothy over the flu so I
could write back.

I am glad to have your comment in the letter on
the black craftsman situation. As strange as
it may seem to you, coming from me, I have had
almost as bad luck with getting black appren-
tices as you have in getting black students. I
have thought about the problem some length and
have talked with black friends also. There are
several factors that definitely turn black people
off to the craft scene, which for whatever reason
do not turn them off to "art" since there are a
good number of black artists. The first factor
that is the hardest to take is the almost total
and complete domination of craft world by middle
and upper crust whites who are, despite seeming
indications to the contrary, quite conservative
in their life styles. This is not true of the
art world, since artists are always into some
radical political activity or other. The fact
is that black people have very basic human needs
that the rulers of the craft world can in no way
relate to. Then too, we have the 53rd Street
crowd worrying more about making craft into funk
"art" than about how to use the technical and
design skills of craftsmen to improve the goods
that the general run of people buy and use every
day. This last is one of the basic needs that
I was referring to. People who have no really
nitty-gritty needs can afford to deal in terms of
funk "art". The lack of social concern evident
in the 53rd Street approach really turns off all
the black people I have ever talked with.

FIGURE 17.1 Allen Fannin to Francis Merritt, 19 January 1972. Francis Sumner Merritt papers, 1903–1979. Archives of American Art, Smithsonian Institution. Page 1.

Perhaps I could also point out that not enough has been done by those who are supposed to do those things, about getting people to understand that it is possible, with a broad enough approach, for a person to work full-time as a craftsman. You have to understand that being able to earn a living is one of the nitty-gritty needs that black people have and we are, jus- tifiably, not interested in playing around with something that still, as crafts does, has a leisure time activity connotation to it. Because of our background, we cannot afford to play a- round and no one has any business telling us to change our cul- ture so we can afford to play around.

I hope the brief explanation above will answer your one point as to why you have had so little response (black) to your of- ferings. However, your next sentence in the letter answers your point even better than I could: "...we haven't taken enough initiative in developing relationships..." One of the obvious reasons why you haven't taken that initiative is that it isn't your problem. You could continue perfectly fine as you have been doing and suffer no loss. Now in a sense, our response has been to simply discount the craft world as having little or nothing of relavence to our needs as blacks.

Now on the other hand, if you are, as I believe you are, sin- cere in wanting to do some things about the problem, then the first suggestion I can make is for you to try and see the problem somehow in terms of it being as much yours as ours. Then you may see some actual advantage to you so do something about it.

I think the first thing you have to try and do is take a strong position counter to what is happening on 53rd Street. I know how you feel about them and it would help if you were more vocal about it. With some change in the craft world, into a more so- cially concerned direction, you might just find more black people coming into it on their own. Parenthetically, your Soleri bit was not the way to do this since it was not immediate enough for our real needs and was far too abstract and far reaching.

The offering of scholarships, believe it or not is still not the approach, considering the trouble I had in trying to give away $3.000 of the Tiffany money to a black person. Black people are deluged with scholarships of all kinds from all over so the one they would accept is the one that offers the money in a con- text that really meets their needs. Right now, the craft world does not meet our needs. So, we still get back to your having to do something about the craft world.

Practically speaking, I can suggest further that you consider developing, together with whatever black craftsmen you can find,

FIGURE 17.2 Allen Fannin to Francis Merritt, 19 January 1972. Francis Sumner Merritt papers, 1903–1979. Archives of American Art, Smithsonian Institution. Page 2.

a special session that deals with some of the points I made
before. The session could be taught by a group of self-em-
ployed black craftsmen who would not only deal with the tech-
nology of their particular crafts, but more important with
the relationship that the craft world should have to black
needs. Now, one trouble with this, which will have to be well
thought out, is that there are black craftsmen, like everyone
else, who are taken in by the 53rd Street mentality and who
really have little or no concern for the basic needs of their
brothers. So finding people to teach the session will be hard,
but I'm willing if you are.

If you want some contact with black people who are involved
in crafts, let me suggest: Ms. Margaret Cunningham, c/o The
Hamilton Hill Art Center, 421 Schenectady St., Schenedtacy, NY.
Ms. Cunningham is the director and single-handedly has built
up a very fine thing. Try The Studio Museum in Harlem, Fifth
Ave. & 125th St., New York, NY., att. Mr. Burgess. He is their
director of something doing with education and has constant
contact with young people who are into craft. Also, Ms. Wilhel-
mina Godfrey, c/o NY State Craftsmen, Box 733, Ithaca, NY. She
has just established, with a group of others, a craft center
in Buffalo. Now, all of the above people are not craftsmen, but
have access to young people who might want to be. I would urge
you to express your concern with doing something about the im-
age of the craft world in the black community, to them.

Interestingly, your third paragraph about our not leaving our-
selves open to your standard remuneration relates very much to
what I have been talking about above. Because we are self-em-
ployed, and because of the lack of help from the craft world
in publicising craft as craft (not as art), we earn very lit-
tle money relative to our time. Together, working 12-14 hours
a day, Dorothy and I earned last year, after expenses, $3900.
So considering how hard it is to earn a living, need we ask
why so few black people are into craft. If more were done to
get more social relavence into craft world, perhaps the problem
wouldn't be so severe. Nevertheless, we believe our place is
behind the loom and money or not, that's where we intend to
stay.

If we can get together on any of this, let me know, I'll do
what I can.

(Allen A. Fannin

P.O. Box 376 GPO
Brooklyn, New York
11201

FIGURE 17.3 Allen Fannin to Francis Merritt, 19 January 1972. Francis Sumner Merritt papers, 1903–1979. Archives of American Art, Smithsonian Institution. Page 3.

from the state department, as if it were an honor to be black in America! I'm still wondering how that scene struck our black American friends, who are more likely to be arrested than feted for their appearance and ancestry, right? Ah me, the paradoxes.[3]

The observations outlined in these letters prompt comparison to the rising prominence of craft in art and culture. Although artists, writers and curators in the field of craft have engaged in multivocal discussions of gender, class and sexuality, generative considerations of race and ethnicity remain less prominent. In 2016, the Critical Craft Forum hosted a panel, chaired by Bibiana Obler and Mary Savig, at the College Art Association's annual conference to assess the state of the field some forty years later.[4] What assumptions are being made about race in the craft world today? What are the systemic realities in the field faced by artists of colour? How do history and legacy inform the current situation? Given the complexity of these questions, the panel – which took place in Washington, DC, and gathered artists based in Virginia and Maryland – focused on race-based issues concerning this region, where #BlackLivesMatter banners and Confederate flags dot the landscape from Baltimore to Richmond.[5]

The following transcription, collaboratively edited and abbreviated for publication by Bibiana Obler, Mary Savig and Namita Gupta Wiggers with final approval from all participating panellists, is a contribution to shifting our course. The speakers, moderated by Wiggers, Critical Craft Forum Director and co-founder, represent three generations of artists invested in craft: Sonya Clark, Wesley Clark and Joyce J. Scott.[6] The panellists began with brief statements in response to Fannin's letter and the questions just mentioned.

* * *

Sonya Clark (reading an excerpt from Ralph Ellison's *Invisible Man* [1952]):

I am an Invisible Man. No, I'm not a spook like those who haunted Edgar Allan Poe. Nor am I one of your Hollywood movie ectoplasms. I am a man of substance, of flesh and bone, fibre and liquids, and I might even be said to possess a mind. I am invisible, simply because people refuse to see me. Like the bodiless heads you see sometimes in circus sideshows, it is as though I have been surrounded by mirrors of hard, distorting glass. When they approach me they see only my surroundings, themselves or figments of their imagination, indeed, everything and anything except me.

I've been thinking about invisibility and about how to make the invisible visible. And I've been thinking about defining terms and about mentors. I've been thinking about these three things in the context of being a Black craftswoman.

Let's begin with the idea of invisibility. We (the panelists) were talking this morning about how comprehensive museums might not have many people who are of African descent represented in their craft collections. My immediate reaction is: it depends on how you define what craft is and where you're looking. Because comprehensive museums are actually filled with craft, and they're filled with craft created by people of colour. But that's not where we tend to define where craft is and where it is located within those museums. Making the invisible visible.

Also, invisible technological skills are often overlooked. Africans who were brought to other parts of the world through the Trans-Atlantic Slave Trade Route were not valued as human beings. We were valued for our skills and our strength. Our skills were often technologies like weaving, basket making and blacksmithing. All of these things. Making the invisible visible.

I think about mentors, because I wouldn't be here if it weren't for a grandmother who taught me how to sew. I honour her legacy every day as a fibre artist and as a woman. Because of her genetic pool and the genetic pool of those grandmothers and grandfathers that I did not know, all the unknown ancestors, I have the strength, fortitude and legacy to be with you today. I have mentors and friends like this lady sitting right here (Joyce J. Scott), and two of my mentors in the audience: Joan Livingstone and Anne Wilson, who were my teachers at the School of the Art Institute of Chicago.

I think about my peers who make the invisible visible. Artists like Simone Leigh who are craftspeople, and of her project which brought attention to caregivers in her *Free People's Medical Clinic* (2014). Caregivers as craft. I think about Theaster Gates's project *Shine* at the Museum of Contemporary Art in Chicago (2014), where he framed the idea of who is an artist by focusing the audience's attention to see the people who shine shoes in a new light. That's craft. In my own *Hair Craft Project* (Figure 17.4, Plate 23), where I think about hairdressing as a craft. I collaborated with twelve Richmond hairdressers to bring African and African American hairdressing into focus as a type of textile mastery. Making the invisible visible.

Joyce J. Scott: Sonya, I'm going to ask you to read with me what you read on Ellison. I don't have my glasses. Plus this is more theatrical. So would you start reading again?
Sonya: 'I am an invisible man.'
Joyce: I'm a woman and you see me all the time.
Sonya: 'No I'm not a spook like …'
Joyce: I am a spook.
Sonya: 'Edgar Allan Poe. Nor am I one of your Hollywood movie ectoplasms …'
Joyce: You know that's wrong, because I'm totally Hollywood.
Sonya: 'I am a man of substance.'
Joyce: I am a woman. I created substance.
Sonya: 'Of flesh and bone.'
Joyce: Flesh, bone, and fat.

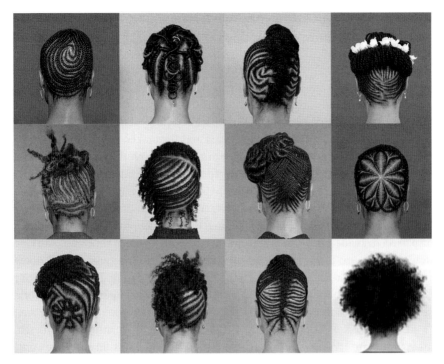

FIGURE 17.4 Sonya Clark, *The Hair Craft Project*, 2013, featuring hairstylists Kamala Bhagat, Dionne James Eggleston, Marsha Johnson, Chaunda King, Anita Hill Moses, Nasirah Muhammad, Jameika and Jasmine Pollard, Ingrid Riley, Ife Robinson, Natasha Superville and Jamilah Williams. Collection of the Museum of Fine Arts Boston. Photo: Naoko Wowsugi

Sonya: 'Fibre and liquid.'

Joyce: I use them all the time.

Sonya: 'And I might even be said to possess a mind.'

Joyce: It's been said.

Sonya: 'I am invisible.'

Joyce: No.

Sonya: 'Understand simply because people refuse to see me … Like the bodiless heads you see sometimes in circus sideshows, it is as though I have been surrounded by mirrors of hard, distorting glass.'

Joyce: Thank you. My job, the one that I've chosen, is to break that glass. It's maybe why I use glass in my work (Figure 17.6, Plate 25). I believe that I'm always seen, but you refuse to see my quality. I believe that my work is art. I believe that my work is craft. I deserve to be with anyone, any artist, and I deserve to make as much money as any artist. But to defy or to say that I'm not a craftsperson as well as a fine artist, means that I diminish, spit [on], forget my mother, my grandparents, my great-grandparents who were potters, and weavers, and all the things that they did.

So my job as an artist – and I don't believe it's every artist's job – is to shine, and to use all of the facilities that were given to me. It is to break that glass, take a shard, and cut through the next veil. Because that's what someone did for me.

Wesley Clark: My work is aesthetically based in the antique; the warmth of the colour of the wood, the texture just makes you think 'old'. It's meant to question why is it being salvaged and put in this gallery space My *Target* series, for example, deals with the idea of black people being targeted and the psychological effects that go along with that. The aesthetic is meant to draw you in with this beautiful warmth, and then to address the underlying issues. I'd not really considered how craft comes in for me, to be honest, until being asked to be on the panel. But it's in my process.

Historically, I come from a family of craftmakers. My grandfather was a craftsman. He built half the homes in Freetown and Glen Burnie (Baltimore, Maryland). When he passed, he made sure his tool set came to me because by that time I was working in wood. My aunt called me 'Little Gertrude' for a period, because I came home from college crocheting hats and making things of that nature. But I never really considered that to be anything. Now all these things are becoming part of my work, yet I've never considered it a craft. It's just the materials I used.

In the process of being in the studio, I am creating this narrative for myself, asking questions: What would a real craftsman do when he's finished his work? I'm playing a role as a craftsperson, so I consider myself to be a faux or fraudulent craftsman.

Namita Gupta Wiggers: Let's go back to terms. What *kind of craft* are we talking about when we're talking about craft? Fannin alludes (in his letter) to the '53rd Street mentality', which refers to what was then the Museum of Contemporary Crafts, and later the American Craft Museum and now the Museum of Arts and Design. He is speaking to that particular institution and location, but also about a group of supporters who separate out one kind of craft from other kinds of craft and art, as in the Studio Craft Movement.

For example, Wes brought up that he doesn't think of himself as a craftsperson … and in terms of the artwork that has been presented today, it's not so different than artwork I've seen in a number of contemporary art institutions. When Mike Kelley uses thrifted quilts, it's considered art. Yet there's a particular aesthetic perceived in connection to craft, an attention to materials that you cannot find in other parts of the art world. The question is, in being a 'Black Craftsman', is it more challenging because you're trying to operate within that Studio Craft Movement? Or is it that the Black artist – as opposed to the Black craftsman – has more opportunity because of the kinds of things that can be done in the art world?

Wes: I think, to a degree, it is about defining terms. What I knew to be craft, or what I consider to be craft, was my grandmother who made the quilts, or my

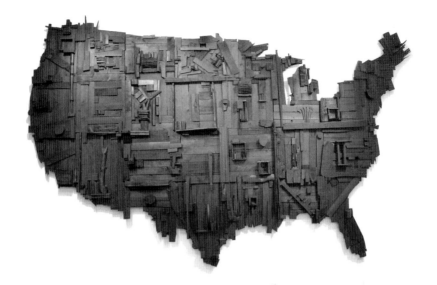

FIGURE 17.5 Wesley Clark, My Big Black America, 2015, stain, spray paint, latex, salvaged wood. Courtesy: Wesley Clark.

grandfather who built functional items. I never considered the use of wood in my art or my crocheting with yarn. For me, it was just a simple matter of materials that I chose to express whatever it was that I was dealing with (Figure 17.5, Plate 24). To some degree, it was always a separate line for me. There was artmaking, and then there was craft, and there's craft in art and art in craft, but somehow, I simply never knew the difference consciously. I never drew that line in the sand, so to speak.

My grandmother wasn't trying to be in an art gallery, but that's what I was aiming for. For my grandparents, it was all functional and skill-based. The quilt was used because they were farmers and self-sufficient. That's actually what drew me to wanting to know how to make a hat, and some of the other skills I've learned that were craft-based was out of this idea of self-sufficiency. I've never really thought of them as the means for aesthetics.

Sonya: Your grandmother's quilts – were they beautiful?

Wes: It was beautiful because of its history, to my mind. It's not really beautiful when you look at it, no. But it was beautiful to me.

Sonya: So I don't think art should be judged just on beauty, but I was doing that to reframe the way you might look at a quilt. If it's functional, then it does what it needs to do. If it has a story, if it belongs to your family, then it has a story,

and imbued in that story is its power, right? You know why Wes is here, right? Because we invited him. He was waiting for an invitation. We defined him as being a craftsperson and here he is.

Wes: Yeah, pretty much. Thank you.

Joyce: Some of this has to do with the belief that [craft is] a bunch of nannies and squaws, and people who have no true intellect, who can cook really well, but never went to school who make crafts. There's this whole feeling that something is 'not equal to' when one makes a cup. Some people don't make cups because they know that a cup is going to make them very little money in contrast to painting a picture of that cup. Many times schools, and galleries, and museums, and people who have the money and the power to direct people, say: No, that's fine art. You just used wood and you made a chair. Now he just made a deconstructed chair, but that's sculpture. You made a chair, and that's craft work. And they can't have the same value. There are some people who believe that [craft is] the stepchild or bastard kid in the art world who really won't get that great exhibition in a museum. I don't think that is true anymore; there are a lot of people on this stage and in this audience who worked very hard to get people to understand the brilliance and to give respect to crafts as in and of itself a fine art.

Sonya said it. We're throughout museums, but we're placed in other departments. If Jeff Koons wants to do a blow-up balloon dog, that's called fine art, but someone else does something similar out of crochet and it sells for $1,000. That's not talking about whether people are great critics. That's talking about something else deeply rooted, I believe, in the arts. And if someone who considers herself to be both … I hear things. I've been told: Stop calling yourself a craftsperson; if you keep being rooted in the crafts, then you're not going to get the respect and the money that you deserve.

And then I say, 'How can I tell those Black people who raised me and made the things that I use as my touchstone, that I can't say [I am a craftsperson]?' That's like saying, 'Joyce, don't respect yourself. Go and put on another mask and go on out, or the face you have, just cover up that part because that cheek is not worthy of the rest of your face.'

A painter told me that when he saw the Gee's Bend denim quilts, you know the ones made out of overalls? He said, 'I've been trying to get the way that blue blends my whole life.' And they did it. And they're still blue jean quilts. It's bullshit. It's what humans do to each other.

Sonya: It's hegemony and it's racism and it's all sorts of things. Sexism, too. There's something even more deeply rooted than that, which is the Western notion of the mind/body split. We're still suffering from the Western construct of intellect and intelligence that resides in what we call painting and sculpture, versus things that are clearly made from the intelligence of our bodies, through kinaesthetic intelligence. It's as if paintings weren't made from the body and weavings weren't made from the mind. The strategy is so binary and antiquated but it still has resonance.

Namita: An image circulated recently on the internet: 'White privilege is your history being part of the core curriculum, and mine being taught as an elective.'[7] I think each of our panellists addresses this issue in a number of different ways. It is evident in Fannin's letter, in which he states 'that offering scholarships, believe it or not, is still not the approach' to take.[8]

We need systemic change. This isn't just about adding numbers, diversity, and/or meeting quotas. It's about sitting down and reworking the system that is not recognizing the breadth of work that has been made and what is being made now. That involves changes to museums and academia. It involves thinking every day about how we live.

Let's continue by thinking about some of those systems and to move this discussion towards what you think can be done: where is the problem and what needs to happen to fix the problem?

Sonya: It's deeply rooted in our culture (the separation between), tech schools versus liberal arts schools is part of the problem. Now fast-forward to what happens with where students end up going to school, and what they end up studying. I got 800, a perfect score on my math SAT. And I was a Black girl, I was supposed to be an engineer. But in everyone's story you can find a serendipitous connection of dots. That happened between my grandmother and meeting lots of other people in whom I found a like-mindedness. I came to believe that my mind and body work together, and craft could be a repository for ideas, thoughts, queries. It seems laughable when I say this out loud. Of course, the mind and body work together.

One of the things that happens is that Black students, if they're first generation college-bound, or even if they're not, their parents say, 'You're going to go to art school. Okay. Well, maybe you should become a designer because there might be money in that, in the design field.'

Here's the thing. Craft is all about design and about function. So we should be getting those students; making smart utilitarian objects is exactly when a design works, right?

Namita: So why aren't Black students showing up in the materially based programs?

Sonya: Some of them *are* because of serendipity, but it is about defining the terms. If we define craft by its utility and its connection to design, that's a way of connecting to those students whose parents say interior design, graphic design, fashion design, all good. Craft should be on that list.

If you are interested in art because you're interested in connecting to your culture, you just heard the three Black people on the panel say we do craft because of our legacy. So that becomes another way. It's more how we are telling the story, who is telling the story of craft, and who has the biggest megaphone.

Joyce: If you look at what's happening in the United States with Flint, Michigan and Black Lives Matter, I think some kids are scared to go to schools where they will be marginalized, and will be seen as very, very different.[9] I think it's wonderful that art schools exist where folks can just come and be real, be artistic. But in talking to kids, they think 'I'm not going to do well.' I always say: there is not a critical mass of Negritude. So you're the only one, you're one of three, you go through your entire undergraduate life where you are the Other.

Some people rally to you for all reasons. One is because you are the Other, and they see that light from you and they want to get it. Because some students wander around in some of these schools and they do cleave to their mentors, to their teachers, because they can in some senses, be lost. And I know that the Maryland Institute College of Art has suffered because of the uprising that happened last year because parents were scared to send their kids there.[10] Well that's all parents, not just white parents.

Sonya: Should be Black parents …

Joyce: And the other thing that you [Wesley] said that is so incredible to me – because my parents were sharecroppers – is the difference between the head and the heart. I don't think there's much difference, but it's the application, how we think about it.

I was at Haystack (Mountain School of Crafts) in 1974 (for the international summer sessions organized by Merritt), and I went back to be an instructor in 1976, which was the bicentennial year. That was the year that there were Indigenous professors; all of the Native American instructors were there, just like Black History Month where every Black person is working as a Black person.

When you were with Africans and when you were with Native teachers, they really didn't separate the two (head and heart). It's really helped me to be a better teacher when I'm teaching. You might be singing while you're weaving. You might be imbuing that thread with a different kind of spirit. You might talk about the use of the garment, or use of whatever you're making, the taste that you get from holding this cup and the cup being a certain colour, or the cup having a certain shape. And whether it won't ever get hot, but you can feel the warmth, that kind of thing. And that's the combination of the two. I've been in classes where it is so skill driven that it never comes up. This is a big loss.

Namita: Let's open this up to the audience.

Fo Wilson [speaking from the audience]: I want to pick up on something that both Sonya and Joyce said about the African identity. What gets confusing for the African-American experience is that we live in a society that privileges the Western way of thinking, of philosophical thinking about art and life. In many

cultures, not just African cultures, the idea of beauty is not separate from utility. It wouldn't occur to us as part of our genetic heritage to think about those things differently. But when you come to a university to be academically enforced, that's how it is. That's the way the power structure is. Your work [the artists'] to me is a form of resistance to that power structure because you're working against it. I want more scholars in craft that write from different points of view, from outside of that Western paradigm and French philosophy.

I also have a graduate student who happens to be African American. He is very rooted in African American tradition. He says he has to spend 30 minutes teaching the faculty and students about his culture before he can talk about his work. I said, 'You can tell them to do that work before they come to your crit. It's your right to do that and say, "Look, I'm going to be talking about this. You're going to get a lot more out of it and you're going to be able to give me better feedback if you read this article."'

Namita: You've hit on a couple of places where there are things that can be done. Look for people who are writing and thinking outside of that Western philosophical construct. Go find them, they may not be in academia. Find somebody who is going to break down those boundaries and encourage them to write about your work. Bring them into the conversation.

Second, figure out how you're going to accept that teaching comes from many places, and help the system value your grandmother and the lady down the street who taught you to embroider as teachers. Figure out how to bring them into the academic environment in other ways.

Sonya: How can we together cultivate intellectual humility? We don't know everything, but if we're curious, we can learn together, right? If you do that in the classroom, then what your student was doing would just be natural. It would just be a natural thing, if that's at the heart of what we're doing together as educators.

I've been in academia now for twenty-two years. I stick with academia because I know that I can change something within the system. But I also happen to be a chair of the department, which means that I can hold people accountable for what they're doing in the classroom, too.

So for all the African American students and students of African descent, or students of colour, or whoever feels like they're Other in that situation, I'm not only looking to you and me, but *they're* looking to everyone in this room who might not look like them. And knowing that there's some level or cultural competency there. Cultural competency is something that I actually hold my faculty accountable for, because you can't teach craft without teaching about the world. It is impossible. So if you're managing to do that, stop. Revisit how blinding your privilege has been, and then let's figure out how to get these notions of other cultures and other

ways of thinking and being, and making, and evaluating, and critiquing into the classroom.

The second thing is to cultivate intellectual humility. Because I don't know everything. I don't know everything about Africa. I don't know everything about the Caribbean, Jamaica, Trinidad. I don't even know everything about myself. I really don't. Cultivating intellectual humility allows the space for us to say we don't know; how can we learn it together? And it is such a great antidote to privilege that blinds us. I say this as someone who is privileged. I'm aware of the privileges that I had. I grew up middle class, I went to prep schools, and I'm always trying to say, okay, is that my privilege blinding me, because I'm also a Black woman who got followed around in stores as a kid because store owners thought I might steal something.

Wes: I was thinking about Fannin's point that we have other issues as Blacks: we have to eat, we have to put food on the table, and the idea of value formed in my mind. It's the same thing, for instance, when I came home and was amazed that my family crocheted. I don't remember it growing up. It was a skill that was around me because I was on this blanket every day, but no one ever told me my grandmother made it. So there are these skills that aren't being passed on, or the idea of working with your hands. There's a certain level of value I felt that is missing early on. You can make a hat instead of buying that $50 J. Crew hat that is crocheted. I can make that hat; I can then make anything. Once you have the skills, you can take that in other realms, but if you weren't introduced to the idea of crocheting in your sculpture class, even made to do it as part of the actual assignment, then it's going to get lost.

Sonya: Do men in your family crochet?

Wes: No, men do not. But when I was teaching in elementary school I taught the boys to do it and they loved it. I don't really know what to say as far as gender, simply that if you're taught it then you can do it. When boys aren't being taught it unless they actively seek it, and I guess no one ever thought to teach me.

Sonya: Sometimes as children, we don't know what's possible if we don't have role models or mentors. So if you crochet, then it becomes possible for a young man who looks like you, or looks up to you to say, oh, that's possible. That's not just something women do. That's one of the things that is also really important: to not only know our histories, but that fibre arts and textiles are not gendered across the globe, in fact. But also to be the role model in *this* place and when we teach, to make sure that we're sharing those models. And making sure we're not engendering more of them either.

Joyce: I was thinking earlier that if I were the audience, and I were white – I'm saying this because we talked about the cleave sometimes between ethnicity and class in the classroom – and I was doing everything that the panellists have so sweetly described to you, I might feel a little bit like, 'wait a second. I'm already … what can I do?' For me, it's about getting close to a person that's not doing it. When I say get close, I don't mean have sex with them, or go out and have drinks, that's not what I mean. But sometimes you know that someone has great ability and it's manifest in what they do in class or what they do with their students. Sometimes you have the real ability to just be human with another human. Help people with what could be perceived as an academic shortcoming. It really is all of us working with each other. I think that's how change happens.

Joan Livingstone [speaking from the audience]: I was intrigued by the title of the topic, 'The Black Craftsman Situation,' and I know we referred back to this incident in Haystack as a kind of historical precedent for asking the question. But I'm curious if you could talk about what is the Black craftsman situation that we're referring to? I think there's meat there to talk about.

Joyce: A thing that spoke to me about change was just seeing a feature on Art Smith in *Essence* magazine. A lot of people are like, who? Art Smith was one of the leading art jewellers starting in the 1950s. But the article now is in pop culture. They had one of his necklaces, and on the next page featured a young contemporary Black jeweller.

I looked at the jewellery in the article. They were jewellers who were really pushing to have a really wide audience. So it wasn't just about Black Art Smith who did one of a kind work. It was, to me, much more about designers in a broader group. Anyway, my point was when that guy (Art Smith) can be in an everyday lexicon *and* some commercial thing, *that* says to me there's a very slow creeping difference. Because he's this mentor, but he's also in a magazine that talks about who your boyfriend is and something else. Well, that means he's in everyday conversation. Wow, that's a difference.

And the other difference is that because of what we do, we are by proxy instigating crafted everyday stuff. I've been making jewellery for a long time, but I've been selling since I was 16. Every year, we artists get together and have a Christmas show. I have people who have developed a real knowledge about jewellery, and they come wearing that necklace I made at the age of 16. They don't have a lot of money so we try to cap it at maybe $600. And they come back to our show every year and they'll say, 'I went to the museum. Your work's in the museum, and I understand why this looks like this.' Wow. I like that it's an everyday conversation being worn by everyday folks. So that to me is a real change. And it's a change because they're more and more, I think, 'Black people are doing that.'

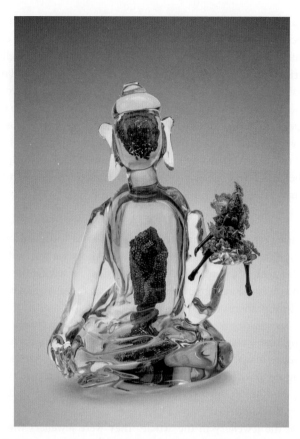

FIGURE 17.6 Joyce J. Scott, *Buddha (Fire & Water)*, 2013, hand-blown Murano glass processes with beads, wire and thread. Photo: Mike Koryta. Courtesy: Goya Contemporary, collection of NMAAHC Smithsonian Institution.

Sonya: Joan, when I was bringing up the idea of defining the terms, I actually had written down to define the terms of crafts, to define the terms of Blackness, to really dig in at what you were saying. In this panel we've talked about a lot of things, a lot of definitions that we could use for what craft is. We haven't really dug into the constructs around race. Maybe a couple of us said what that is, talked about African Americans as people of African descent, people from Africa. But I think the situation is that there are not enough people who are recognizing craft by people who are Black. And there are not enough Black students who are here, who are making work. There are not enough craftspeople in the power structures.

There's not enough in the classrooms, there are not enough teachers. We have been talking around it, so I really appreciate defining the terms. For me, that's the situation: there are not enough of us. There's not enough light being shed on the work that's already been done, the work that has to be done, and work that

is currently being done. To your point: What are we writing about? How are we writing about what we're writing about?

And that is not (a question) that is for Black people only. That is for every people. And it's necessary by design in this nation. In this nation in particular, it's necessary.

Joyce: That's what it is. You just said something that rings true to me. It's not just for Black people, it's for every people. We still have the [issue that] people don't see that we're Americans, and that what we do belongs to you as well, and it's all that stuff that you want to know, too. Sometimes we're not even in decision-making positions that would encourage the administration or even the student body to see us as a power force.

I can tell you one way that has changed. We're here talking to you. Not so very long ago, we might have been in the audience, but never chosen to be able to talk to you about Blackness.

Notes

1 Founded in 1950, Haystack Mountain School of Crafts is an international, non-profit, studio program in the arts, offering a residency program and workshop sessions to craftmakers and visual artists, led by prominent faculty artists. 'Mission & History'. Haystack Mountain School of Crafts, 2014. http://www.haystack-mtn.org/about-haystack/mission-history/ (accessed 23 May 2016).

2 Francis Sumner Merritt to Allen Fannin, 29 December 1971. Francis Sumner Merritt papers, Archives of American Art, Smithsonian Institution.

3 M. C. Richards to Francis Sumner Merritt, 22 August 1974. Francis Sumner Merritt papers, Archives of American Art, Smithsonian Institution.

4 Critical Craft Forum offers on-line and on-site platforms for dialogue and exchange on critical questions in the craft field. Founded in 2008 by Namita Gupta Wiggers and Elisabeth Agro, and led by Wiggers since 2012, CCF has offered an annual session at College Art Association since 2010, a daily-moderated discussion via a Facebook group, and a podcast. 'Home'. *Critical Craft Forum*. http://www.criticalcraftforum.com/ (accessed 1 May 2016).

5 #BlackLivesMatter was created by Black organizers Alicia Garza, Patrisse Cullors, and Opal Tometi in 2013 in response to the acquittal of Trayvon Martin's murderer, and as a call to action against anti-Black racism in US society. The chapter-based organization works to broaden conversations around state violence against Black people in the United States and globally. 'Black Lives Matter Freedom & Justice for All Black Lives', *Black Lives Matter RSS2*. http://blacklivesmatter.com/ (accessed 19 July 2016).

6 The Critical Craft Forum Session from which this interview is taken took place on 6 February 2016 at College Art Association, Washington, DC, and is available as a downloadable podcast at www.criticalcraftforum.com. Absent due to unforeseen circumstances were quilt-maker and scholar Joan M. E. Gaither and artist and curator Diana N'Diaye.

7 Thesociologicalcinema. 'Thesociologicalcinema', *The Sociological Cinema*, http://
 thesociologicalcinema.tumblr.com/post/132334458625/white-privilege-is-your-
 history-being-part-of-the (accessed 1 May 2016). Photo credit: Perry Threlfall.

8 Allen Fannin to Francis Merritt, 19 January 1972. Francis Sumner Merritt papers,
 1903-1979. Archives of American Art, Smithsonian Institution. Page 2.

9 For information on the lead pollution in the city of Flint, Michigan's water system,
 see Abby Goodnough, Monica Davey and Mitch Smith. 'When the Water Turned
 Brown', *New York Times*, 23 January 2016, http://www.nytimes.com/2016/01/24/us/
 when-the-water-turned-brown.html (accessed 24 July 2016).

10 See 'Timeline: Freddie Gray's Arrest, Death and the Aftermath--Baltimore Sun',
 Baltimore Sun, http://data.baltimoresun.com/news/freddie-gray/ (accessed 23
 May 2016).

INDEX

conceptual art 110
Constellation Africa Show 39
consumerism 16–17, 22–3, 83, 86, 88, 192
 cultures 14
 goods 7
consumption of craft 2, 19, 126
contemporary art 2, 4–6, 15, 18, 56–7, 72–3,
 230, 245
contemporary craft theory 5, 8, 224
Cooper, Cinnamon 29 n.13
copper 4
 bracelets 148
 butterflies 208–9
 facade installation *118–19*
 panels 117–18, 121
 Corbett, Sarah 15, 28 n.6, 29 n.17
Corntassel, Jeff 234 n.5, 237 n.63
Cornwallis, Edward 242, 247 n.13
counterculture 86, 97, 133
craft
 activism 1, 13, 17, 26–7
 amateur 2, 230
 in American education 8, 69–70, 126–32,
 136, 139
 anticapitalism 99, 190
 artisanal 3, 5, 22, 24, 40, 61–75
 aspirational 86, 102, 113
 authenticity 3–4, 6, 23, 25, 40
 charity, charitable 14, 18–19, 37, 39, 184
 Citizens of 19, 24, *25*, 32 n.53
 and collaboration 4, 15, 22, 120, 208
 collecting 6, 181–7
 consumer-driven charity projects 19
 consumption 2, 19, 126
 criticism 1–2, 72
 curating 79, 193, 230
 and decolonization 217–19, 233
 definitions of 1
 digital 5, 120, 126
 fair 2, 9, 61, 74
 feminized associations of 17
 function 2, 13, 19
 in global context 1
 handcraft 22, 79–93
 and high art 7
 hoarding 6, 181–93
 indie craft 2, 14–16, 18, 22
 Indigenous practices 228
 individuality 17, 22, 25, 110

Industrial Revolution 128
 labour 4, 117–22
 as lifestyle 3, 17, 27, 79
 on margins/marginality 7, 14, 17
 methodologies 2, 5, 103
 and moral value 18
 movement 13, 16, 18, 28 n.11
 national identity 18–19, 26
 politics 2, 5, 7, 9, 13
 as property 97–113
 public space 14, 17, 103, 165
 simplicity 18, 92–3
 slowness 3–4, 80, 82–3, 93 n.5
 social practice 3, 7, 71
 socioeconomic status 99
 subversive nature 153
 sustainability 18, 27, 34, 44
 theory 1–2, 8, 98–9
 traditional practices 3, 210, 212
 value 3, 23, 211
craft and socially engaged art 71–5
Craft Guerilla Army 29 n.12
Craftifesto (Carlton and Cooper) 16, 24
craftivism 2, 14–18
Craftivism: The Art and Craft of Activism
 (Greer) 15, 25
Craftivist Collective, London 16
Craft Ontario 32 n.53
craftsmanship 83, 123
craftspeople 17–18, 24, 33, 97, 102, 108–9,
 119–20, 254
craftwashing 2, 14, 19–23, 28 n.3, 35–8,
 44–6
creativity 4, 15–16, 97, 106, 109, 118, 121,
 139, 189, 219
Critical Craft Forum 8, 253, 265 n.4, 265 n.6
crochet 20, 40, 182, 184, 205, 257
Cuban art 5, 157
Cuban Liberty and Democracy Solidarity Act
 166 n.3
cultural capital 26, 73, 88
cultural imperialism 6
curating 79, 193, 230, 241
Cvetkovich, Ann 184, 190, 196 n.43

Davis, Ben 72–3, 75 n.26, 77 n.26, 77 n.35
Davis, Heather 7, 10 n.14, 11 n.23, 233
Dawkins, Nicole 18, 22, 26, 30 n.35
Deamer, Peggy 4–5, 10 n.11, 117, 123 n.4